The Private Lives

OF THE SUN SIGNS

Dedication

IN MEMORY OF ANTON PAWLOWSKI
—A QUINTESSENTIAL SCORPIO
AND COMPANION OF THE HEART.

FIRST PUBLISHED IN 2015 BY

Glitterati
INCORPORATED

New York | London

NEW YORK OFFICE:
630 Ninth Ave, Ste 603
New York, NY 10036
Telephone: 212 362 9119

LONDON OFFICE:
1 Rona Road
London NW3 2HY
Tel/Fax +44 (0) 207 267 9739

www.GlitteratiIncorporated.com | media@GlitteratiIncorporated.com for inquiries

First edition, 2015

Library of Congress Cataloging-in-Publication data is available from the publisher.

Hardcover edition ISBN 13: 978-0-9903808-6-3
Design: Sarah Morgan Karp / smk-design.com
Printed and bound in China by C P Printing, Limited

10 9 8 7 6 5 4 3 2 1

The Private Lives

OF THE SUN SIGNS

KATHARINE MERLIN

FOREWORD BY PAMELA FIORI

Glitterati
INCORPORATED

New York | London

A CELESTIAL ATLAS

COMPRISING

A SYSTEMATIC Display OF THE HEAVENS

IN A

SERIES OF THIRTY MAPS

— Illustrated by —

Scientific Descriptions of their Contents,

And accompanied by

CATALOGUES of THE STARS

and

Astronomical Exercises.

By ALEXANDER JAMIESON, A.M.

Author of a Grammar of Logic & Intellectual Philosophy, Rhetoric & Polite Literature &c.

LONDON,

Published by G. & W.B. Whittaker Ave Maria Lane, T. Cadell, Strand,
and N. Hailes, Museum Piccadilly.

1822.

Contents

Foreword

PAMELA FIORI

PLATE XXVIII.

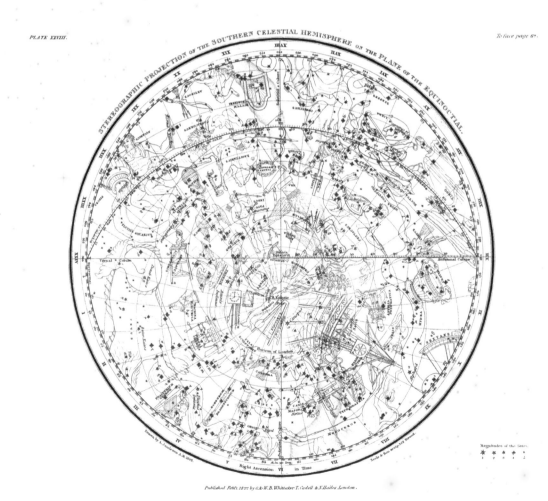

STEREOGRAPHIC PROJECTION OF THE SOUTHERN CELESTIAL HEMISPHERE ON THE PLANE OF THE EQUINOCTIAL.

Published Feb.1.1877 by G.& W.B.Whittaker T. Cadell & N.Hailes London.

K atharine Merlin is a professional astrologer. She doesn't have a crystal ball. She doesn't read tea leaves, palms or tarot cards. And as far as I know, she doesn't possess a voodoo doll that she sticks pins into or perform séances for those who desire to speak to the departed. What she does is study the stars.

I met Katharine in 1993, shortly after I became editor in chief of *Town&Country*. She had been writing the magazine's monthly Horoscopes column since 1989. I didn't know a lot about Katharine, but I did know this much about her column: it was, by far, the most popular page in *T&C*. There were many alterations that I, as a new editor, wanted to make, but deep-sixing the Horoscopes page wasn't one of them (no fool I).

When Katharine and I finally set eyes upon each other, I was surprised (but probably shouldn't have been) that she was so grounded. A down-to-earth astrologer…who would have thought? She was pretty, soft-spoken, deferential and, I learned, a Libra, which means she was born under the sign of the Scales. That told me that Katharine was fair-minded, even-tempered and well-mannered—all great qualities for a writer whose main job each month was to inform her readers about their near-futures. I knew there and then that the magazine and its audience were in capable and caring hands.

How does one become an astrologer? For Katharine it was—pardon the expression—in the stars. And, as it turns out, it was also part of her family history. In tracing her great-great-grandfather Charles Winterburn, a physician who migrated to New York from England, she says: "I made the startling discovery when I stumbled upon an article written in 1882 that he was *also* an astrologer and a very good one. It blew my mind."

Born in Arlington, Virginia, and raised in Westchester County, New York, Katharine started studying astrology when she was 19 with a teacher she describes as "a very respected and revered astrologer in Boston named Isabel Hickey." Her studies continued with various other astrologists as well, she says, "and at the Jung Foundation in New York, which deepened my understanding."

Katharine began writing the Horoscopes column for *Town&Country* four years before my arrival and is still at it even though I left in 2010. That's a quarter of a century of prediction-making. In the 1990s we added a new service—a 900 number (at a price) that readers could call on a weekly basis. When my husband and I were looking to sell a house in Connecticut, I consulted that number several times. One day, my husband asked me to stop because, he said, the predictions were too eerily accurate.

I am not a devout advocate of astrology, but I do believe in some (not all) of the traits associated with the signs. I eagerly awaited Katharine's column just like every other devoted fan, and I still do. As a Pisces, I have a creative bent. Many of the people I worked with in a long career in magazine publishing were also Pisces. Coincidence? I don't think so. On the other hand, Pisceans are supposedly wafflers. Not this one. I relish making decisions and sticking to them. One decision I made early on was to stick with Katharine.

In the main, I'd say that certain aspects of astrology more often than not hit the mark. What makes Katharine's approach—both sensitive and sensible—so fascinating lies in her mode of expression. Nothing she writes ever sounds trite, and you always get the feeling that she put a great deal of thought into every sign's entry.

I asked Katharine several questions about her craft, and she answered each one of them with typical directness. There was one, however, that prompted an unexpected reply.

> **Q:** *How much do your followers depend on you, and how do you explain that, even when armed with the information they glean from your column, neither you nor they have control over their destinies?*
>
> **A:** *Actually, I do believe that people have control over their destinies, and I don't encourage my clients to depend on me. I believe that astrology gives us perspective, not that the stars influence our affairs. In fact, what I do tell people when they become too concerned over difficult aspects is what a very renowned astrologer, Dane Rudhyar, once said: "It's not the event that happens to the person, but the person who happens to the event."*

In some ways, this book could be regarded as an event that happened to Katharine Merlin. And if it happened to her, perhaps it will, upon your reading of it, also happen to you.

By the way, Merlin *is* her surname. Seriously.

Sun Signs

1	0°	♈	ARIES, *The Ram*	21 MARCH – 20 APRIL
2	30°	♉	TAURUS, *The Bull*	21 APRIL – 21 MAY
3	60°	♊	GEMINI, *The Twins*	22 MAY – 21 JUNE
4	90°	♋	CANCER, *The Crab*	22 JUNE – 22 JULY
5	120°	♌	LEO, *The Lion*	23 JULY – 22 AUGUST
6	150°	♍	VIRGO, *The Maiden*	23 AUGUST – 23 SEPTEMBER
7	180°	♎	LIBRA, *The Scales*	24 SEPTEMBER – 23 OCTOBER
8	210°	♏	SCORPIO, *The Scorpion*	24 OCTOBER – 22 NOVEMBER
9	240°	♐	SAGITTARIUS, *The Archer*	23 NOVEMBER – 21 DECEMBER
10	270°	♑	CAPRICORN, *The Sea-Goat*	22 DECEMBER – 20 JANUARY
11	300°	♒	AQUARIUS, *The Water-Bearer*	21 JANUARY – 19 FEBRUARY
12	330°	♓	PISCES, *The Fish*	20 FEBRUARY – 20 MARCH

Introduction

KATHARINE MERLIN

PLATE I.

To face page 7.

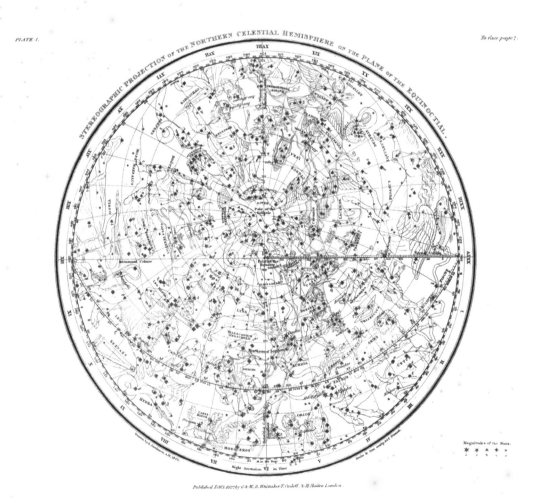

STEREOGRAPHIC PROJECTION of the NORTHERN CELESTIAL HEMISPHERE on the PLANE of the EQUINOCTIAL

Published Feb.1.1822.by G. & W. B. Whittaker,T. Cadell, & H. Bailie, London.

H aving been involved with astrology for more than forty years, I still find it amazing how perfectly Sun sign astrology pins down our basic traits and personalities. Of course, the Sun signs—the zodiacal sign the Sun occupied when we were born—don't tell the whole story as far as our horoscopes go, not by a long shot. But the information they have to offer is invaluable. Knowing about my own Sun sign has helped me to accept and understand myself, and I'm sure that knowing the birth signs of my friends and partners has helped me to be a better partner and friend to them.

Being a Libra (October 1), I've always been reluctant to make waves and very concerned about pleasing people. These are traits typical of someone born under the sign of the Scales, and ones I've sometimes viewed with dismay. When I was a child these qualities may have made me easier to get along with, but I always felt like a wimp in contrast to my take-me-as-I-am Leo sister, who boldly demanded what she wanted and swept into rooms as if she owned them. But by now, I think I've managed to come to terms with my Libran traits and even to enjoy them. I don't seem to have much choice. It's like my hair color, which I've sometimes altered but which I can't permanently change—it's just the way I am.

Of course, to really get an accurate idea of what astrology is and what it has to offer, you need to get a birth chart based on the exact time, place and date of your birth and interpreted by a trained astrologer. A birth chart shows the precise positions of the planets as well as of the Sun and Moon, and also how they interact with each other—a fascinating dynamic which is very revealing. But the truth is that the Sun is really the star of the show, because the Sun is the only actual star in the whole picture. Astrologer Linda Goodman who wrote the wonderful and popular book *Sun Signs*, writes that the "Sun signs will be approximately eighty percent accurate and sometimes ninety percent," as a "reliable method of analyzing people and...understanding human nature."

This statement might sound sweeping, but it's not off the mark. People's personalities will generally be true to their Sun signs no matter where all the other planets fall in their chart. The planet Mercury may define how they think, the planet Mars will define how aggressive they are (or aren't), but it will be the Sun that all the other characteristics will

filter through. The only exception to this will be if the Sun in someone's chart is badly afflicted and weakened by an aspect to another planet, or if someone with the Sun in the bold sign of Aries, for instance, also has a disproportionate number of planets in a very dissimilar, gentle sign like Pisces.

The Sun signs cover the period during which the Sun travels through a particular constellation—approximately thirty days. But what most people don't realize is that the Sun travels through the signs at a different rate each year (due to the fact that there are 360 degrees in the zodiac and 365 days in a year), so that the times when a sign begins or ends may change, with the Sun entering, say, Pisces at five in the morning one year and late in the afternoon, or sometimes even on the following day, in another year. This leads to a lot of confusion, and I've had readers of my column in *Town&Country* write in to hotly declare that the magazine has got a sign's starting or ending dates wrong, because they've come across slightly different dates in another publication.

The start and end of each sign are very definite within a given year, but these dates can and sometimes do vary a little bit from year to year. Magazines and books can only approximate these dates, because they are not set in stone. And this means that if you were born at the traditional start or end of a birth sign, you must get the degree of your Sun calculated to find out what sign you actually were born under. This is easy enough to do with internet access since many astrological sites offer free birth chart calculations, but it does mean pinning down the exact moment of birth.

What I love about the Sun signs is that each one is so brilliantly individual, clearly defined and accurate. And the more I study them, the more I learn about each one. People may forever debate why they are so wonderfully specific and true, and anyone who really learns about them will discover that knowing someone's Sun sign opens up an invaluable window of insight into his or her actions and antics.

It also has the helpful effect of making people more tolerant of each other. Gemini parents will be more accepting and understanding of their Cancer child's sensitivity and shyness—which contrasts so sharply with their own buoyant sociability—if they're aware that their child is born under the emotional sign of the Moon. A Libra and Aquarius couple will have a better chance of getting along if the Libra realizes that the Aquarius' need for freedom and space isn't a personal rejection but an inborn trait, just as the Aquarius will be more sympathetic to the Libra's urge for lots of couple time because it has everything to do with being born under the sign that rules partnership.

It's important to remember, though, that each person is really as unique as a snowflake. Our Sun signs are simply the costume we're wearing and the form we use to express ourselves. If "All the world's a stage," our Sun signs describe the part we're playing

in life, and the better we understand that part, the better we'll perform. And of course, all of the members of one Sun sign aren't identical, just as two actors won't play the same role in the same way.

In working on this book, I've delved into my experiences with people I've known over the years and have tried to delineate the characteristics of each of the twelve signs by showing how they come through in real-life situations. And, along the way, I found that I kept making eye-opening discoveries about the Sun signs. The more I think about them and try to locate the little pearl of meaning within each one, the more they seem to come alive and reveal themselves to me.

I hope that you will have the same experience, and that when you're reading about your own Sun sign or that of someone you know, you'll feel a thrill of recognition when something rings true. I also hope that you'll enjoy yourself and laugh now and then, as I did when trying to describe the various signs' idiosyncrasies. Each of the twelve signs has a unique and fascinating character, and each is a classic. I promise that the more you learn about the Sun signs and the more you put that information to use, the more impressed you'll be by its accuracy.

I

Aries

21 MARCH – 20 APRIL

O°

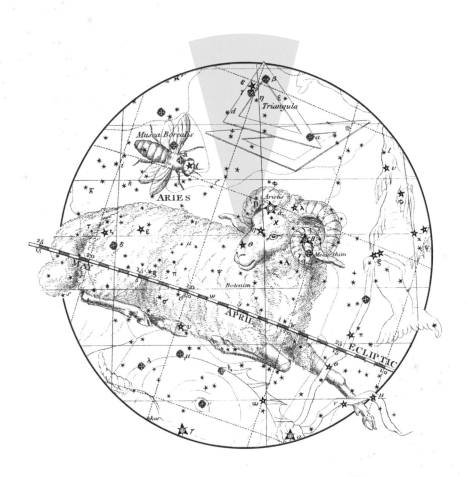

Being alive is the meaning.
—JOSEPH CAMPBELL

I used to find Aries a bit intimidating because they seemed to me—a shy Libra—to be both supremely confident and unnervingly direct. Luckily I've gotten over that, and now it's my Aries friends' directness that's one of their traits I admire the most. I can always count on my friend Rachel (April 14) to tell me the unvarnished truth about anything I ask her. Even when she's trying to be diplomatic, it doesn't quite work, and I can see her struggling, when she has something difficult to say, to put it into words that won't hurt my feelings.

When it comes down to it, though, she absolutely will not compromise on what she believes is right and honest in an effort to make things pretty on the surface. The effect can be disconcerting, but what's wonderful about Aries people is that what you see is what you get. Aries' emotions are right up front, and Rams are not trying to disguise their motives or manipulate others by subtle means. What's more, they don't believe they need to. Hiding behind some sort of false façade goes so entirely against their grain that they're incapable of doing so.

When I've been out to dinner with my friend, Liz, an April 9 Aries, if there's anything amiss with our orders—or with the food itself—it's always she (and rarely me, the overly diplomatic Libra) who will call the waiter over and delineate the problem in no uncertain terms: "Look, there's a worm on my friend's salad leaf. Could you please substitute another entrée?" No matter if all around us heads are turning to see the cause of the commotion; she's never embarrassed to air her grievances if they're justified, and she never questions her right to tell people what she thinks.

The way to recognize an Aries is by this "take me as I am" self-presentation. It's actually quite refreshing, and it doesn't leave you in the awkward position of trying to ferret out information or second-guess anything. As the first sign of the Zodiac, Aries represents birth, and as Linda Goodman points out in her wonderful book on the sun signs, Rams are really the infants of the zodiac, possessing both the self-absorption and the touching naïveté of a newborn. Aries will often venture where angels fear to tread, and in their innocence they may sometimes inadvertently offend people by speaking too impulsively and too frankly.

This is not to say that Aries are rude, nor do they tend to suffer from foot-in-mouth disease, like their fiery cousin, Sagittarius. Most of the Aries I know are surprisingly gracious—surprisingly so because they also manage to be unnervingly honest and never beat around the bush. The confidence they radiate comes across as a kind of glow which is very appealing and which magnetically draws others in. When you are in an Aries' presence, you sense that you are with someone special, if not important. It's not that Aries are conceited, but rather that they have an undeniable sense of who they are.

There are those Aries who are actually so hotheaded, though, that you need to be careful not to get too close to the fire. I've met a few of these types along the way—people who strutted around as if they owned the world, who had explosive tempers and were openly contemptuous of those less talented and savvy than they. One of these Aries was a friend's boss—a highly successful record producer—who kept his staff in such a state of anxiety that some of them ended up in psychotherapy. And my friend had such a huge blowout with him that she quit a job she truly loved, foregoing even severance pay. Not long after, though, she rose so meteorically in the ranks of a rival company that she became as powerful as her former boss. (She was an Aries, too.)

This kind of behavior represents a rare extreme, and most Aries aren't the least bit like this. I do think that many Aries struggle with their occasional feelings of superiority, though (they often really are more high-functioning than most), and make a huge effort to just not go there. I'm sometimes aware when I'm with one of my Aries friends that—in fact—they do a lot more in one day than I do in three; but even though it's clear that they're faster, more efficient and probably better at everything than most everyone they know, they're trying not to rub it in. Which, when you consider it, is actually quite nice of them.

Carole (April 9), a typical super-achieving Aries I know, for example, is simultaneously a writer (she freelances for magazines), a professional pianist (she teaches at a college, concertizes and performs regularly in a jazz band), a psychotherapist (she's been working on her degree on the side for years, during which time she's been seeing a number of patients) and the mother of two growing girls. She also appears to have a very successful marriage to another high achiever, is always there for her family and friends, and still manages to be almost continually gracious and smiley.

Why she isn't panting with exhaustion and complaining about how impossible it is to cram all her activities into one short day is, I believe, all part of the secret of being an Aries. Actually, it's obvious that she loves her life, delights in her ability to juggle so many different roles, and feels great. To be born with the sun in Aries is to possess what could be described as a healthy ego (unless the sun is horribly aspected at birth, but that's another story). In astrology, the sun is said to be 'exalted' in this fiery sign, which means that Aries is the best possible place for it to be of all the other signs of the zodiac.

Lucky Aries! These people were born to be doers, to have an innate sense of amour-propre and to live at full throttle. Probably the most difficult aspect of being an Aries, though, is that they just don't know how—or when—to stop. And most of the Aries I know will only take a break from their endless and killing round of activities if they're absolutely forced to do so by some injury, illness or other circumstance beyond their control.

Again, my dear friend Rachel—who is so constantly booked that it's nearly impossible to make a lunch date with her—comes to mind because twice in the last two years she's had minor but difficult accidents that simply stopped her in her tracks. Last summer, for instance, while she was rushing to move her horses to a new pasture and not—in her haste—taking care to take her most rambunctious horse in hand and walk him to his new destination, the horse became so excited on seeing all the new, untouched grass that he galloped right over her foot (she was wearing sandals).

Rachel, being a typical Aries, tried to ignore the nasty wound she sustained (even though it must have hurt horribly); she kept right up with her hectic life. But within a day or so, her foot became so swollen and infected that her doctor put her on antibiotics and ordered her to stay off the foot and keep it propped up on a chair for a period of six weeks. And while Rachel tried to accept this verdict gracefully and even, being the well-examined person she is, recognize that she'd been on such a crazy course that something had to at least momentarily force her to stop and smell the roses, she hated every minute of her leisurely convalescence. She was like a chastened child being kept away from a box of melt-in-the mouth chocolates, and you could almost hear her plaintively thinking, "When am I going to be able to get back to all my projects, my teaching, my ecological campaigns, my gardening…my hiking?"

Living on an adrenaline high is the way Aries likes to go. Most of the Aries I've met seem to live to be challenged and to use whatever is challenging them as a kind of proving ground. It's not as much about being better than other people (though it sometimes is) as it is about living up to their own expectations. What's horrible to see is an Aries who feels that he or she has failed at something. They don't seem to cut themselves any slack. None of the Aries I know ever seem to say things like, "Oh, but I had a headache that day, and I really hadn't slept well the night before." Excuses don't seem to cut it with Aries—at least not where their own behavior is concerned. And this is probably due to the fact that Aries is ruled by the planet Mars, which is all about survival of the fittest. Rams feel compelled to remain on top of things and to constantly strive because doing so insures that they will not fall by the wayside.

Competition excites and stimulates those born under this fiery sign, and their desire to win is not something that they feel a need to deny—as many people do. When Aries enter contests you'll see them snap to attention; their eyes will light up, and they

will become visibly gleeful at the prospect of pitting their skills against other worthy opponents. Any kind of challenge can get an Aries going, and Rams delight in leading the charge. Steve, an April 1 Aries and long-term client of mine, works as a consultant for those involved in business start-ups, and he is brilliant at what he does because it so perfectly taps into his natural abilities. Starting—or initiating—things is what Aries is all about. It is the zodiacal sign that ushers in spring, the beginning of a new and fresh cycle of growth.

Think of those first brave daffodils or the new shoots of grass that push their way through the seemingly barren earth at winter's end, and you'll understand what the sign of Aries is all about. Aries are moved by a desire to break new ground, take on challenges and make a difference. You'll often find Aries at the helm of community projects or fund-raising drives, and it's usually their passion and leadership that galvanizes others into action. I've seen any number of Aries getting out and stirring the pot to arouse interest in various causes, from my friend, Rachel, who has organized many consciousness-raising health fairs in a nearby town as well as a protest against the building of a chain supermarket, to Alice, who's always rushing out to set up emergency drives for flood or disaster victims or to arrange rallies to draw attention to cutbacks at the local school.

Aries are the quintessential crusaders of the zodiac, and more than any other sign they seem interested in performing great feats and proving themselves. In fact, Rams are often quite idealistic; they are highly intolerant of miscarriages of justice or any other behavior they consider unfair. "I have to do something about it!" is their characteristic response to any situation that strikes them as wrong. Those born under this hot-blooded sign do not sit passively back and let life happen to them. They will always rise to the occasion—no matter what it demands—and they will do so with verve.

What's more, nearly lost causes and seemingly impossible challenges are what seem to stir them up the most. I have seen Alice absolutely come alive when confronted by a situation that would have anyone else throwing up their hands and silently slinking away. A social worker who deals with errant teenagers, Alice revels in turning around rebellious, antisocial adolescents that the system has come to consider irredeemably lost. What others can't accomplish calls up the "I can do this!" spirit that fuels Aries. And it's impossible not to find their optimism inspiring.

Because they always have so much on the boil, Aries are generally in a hurry, although they are also quite capable of sitting down and enjoying a leisurely lunch with a friend. Lingering too long over that lunch, though, simply isn't their style, and they will tend to suddenly leap up and take off, probably dashing off to some important meeting or pressing appointment while glancing nervously at their watch. Rams also tend to

walk quickly, almost as if being chased, and those who aren't inclined to speed along will be left hopelessly in the dust.

Struggling to keep pace with my long-legged Aries friend Carole as we've strode along London's streets, I've sometimes had the sense that she was actually enjoying her prowess in being able to outwalk me, even though she wasn't aware of it. This continual proving of their fitness and (symbolic) rise to the top of the food chain is such an inherent part of the Aries nature that it's silly to take it personally. Aries can also appear less emotional—or, more accurately, less vulnerable—than they actually are, and for exactly the same reason—because their inborn character requires them to come across as tough survivors.

I've found, quite to the contrary, that Aries may be cut to the quick by an unkind remark or rejecting gesture, but in many instances, they will make a speedy exit in order to lick their wounds in private. Aries are far from insensitive, although to the less discerning eye they may appear to be diamond-hard; actually, both their almost childlike tendency to trust and their inborn idealism leave them open to all kinds of emotional wounds that the more self-protective signs escape.

Actually, I'm always somewhat surprised when an Aries friend of mine reveals upset or insecurity about something they've experienced, because I too am usually taken in by Aries' ability to appear so strong and in control. And there is generally something touchingly uncomplicated about the way they express their emotions, as when Rachel told me how hurt she'd felt when a number of people she'd invited to a New Year's party cancelled or didn't show up.

"I felt as if my friends didn't love me," she said, not something many would admit so candidly or with so little self-pity. Nor did Rachel dwell on her negative feelings for long; the whole episode was quickly forgotten because in fact she is someone who is very well loved, although she's also perceived as being so fiercely self-sufficient that people are probably less careful in their treatment of her than they should be.

It's easy to get the impression that Aries are emotionally tougher than they actually are, and they do recover more quickly from hurts and slights than most. They are highly confident, and Rams also generally seem to be quite preoccupied by their own concerns. Aries' famous self-involvement is evident in the way those born under this fiery sign love to talk about all their projects, plans and causes. What interests them, though, is what they're doing; they don't tend to drone on about private matters. And while they generally have a very healthy amount of self-esteem and are proud of their accomplishments, hardly any of the Aries I've known have struck me as being classic egotists.

Not that all those born under this particular sign escape this definition, though, because it can go with the territory, especially in the more afflicted or unevolved types. I've met a few Aries who just couldn't seem to see beyond their own interests, like Lucy

(March 28), the sister of a friend of mine, who is so focused on her own needs that she's unbearably demanding and unattuned to the feelings and needs of the people around her. But most of the Aries I know, while confident, are also somewhat self-critical, and they're also too genuinely interested in others to become self-obsessed.

Aries, in fact, seem always to be aspiring and pushing themselves to exceed their own expectations. They don't give themselves a break. But if they're intolerant of weakness and faintheartedness in themselves, they tend to be just as intolerant of these traits in others. I have seen my Aries friends' lips curl with contempt at blatant signs of laziness and self-indulgence in others. And they really aren't going to accept excuses for such behavior, because they don't accept excuses for their own shortcomings.

If Aries can be judgmental, though, they're also often generous, and they're definitely not just fair-weather friends. At those times when I've been felled by some life-altering event—a minor accident, illness or emotional crisis—my Aries friends have been notably on the scene, calling, stopping by and offering whatever help I might need. Crisis actually brings out the very best in their nature, and they love to rush to the rescue and pitch in. What's more, their eager-to-help attitude and optimism are a wonderful tonic. Aries are not depressive types, and their bright spirits resist any attempts to deflate or bring them down. They also resist any attempts others make to control them, and it's the rare Aries who hasn't clashed with more than one authority figure at some point during his or her life.

It's very difficult for Aries to take orders from anyone they consider inferior to themselves, and they will fight back by dragging their feet or even outright refusing to go along. It's also quite a challenge for those born under this creative, high-energy sign to stick to a routine. Where work is concerned, Rams tend to seek out situations which allow them a certain amount of freedom, and they tend more than any other sign except Capricorn to head up their own companies, work as consultants or pursue a number of work-related activities simultaneously.

Job stability generally isn't all that high on Aries' priority list, because what Rams really crave is success and acclaim, and they'll willingly take risks to achieve them. Aries also don't thrive in situations where they're stuck behind a desk. Mixing with other people and being in the thick of the action is what gets their blood pumping, and when an Aries is inspired he or she will outperform everyone. Rams particularly excel in situations where they can lead the way and take charge. And they tend to lose interest when they're thrust into an environment where they are expected to follow orders and aren't free to follow their own hunches and ideas.

"Do you want to know who you are? Don't ask. Act! Action will delineate and define you," said Thomas Jefferson (April 13, 1743), a true-to-type Aries who questioned authority in all its forms and was one of the most inspiring firebrands in America's

history. Aries can't stand to hang around endlessly discussing or theorizing. They are the doers of the zodiac, and the old chestnut "Actions speak louder than words" was probably coined by a Ram.

When their rebellion against authority and their passion for action go unchecked, these qualities can get them into trouble, as they did the well-known Wild Bunch outlaw Butch Cassidy, also an April 13 Aries (1866). That same fiery intensity might be channeled into a cause or ideal, as with Booker T. Washington (April 5, 1856), the brilliant educator and civil-rights activist, who though born into slavery raised himself up to be a prominent politician and leader.

Highly idealistic yet also pragmatic, Clarence Darrow (April 18, 1857) is a perfect example of the Aries crusader who as one of the most successful litigation lawyers of all time won an unprecedented number of battles in the courtroom defending society's underdogs. Another larger-than-life character, Charlie Chaplin (April 16, 1889), described by George Bernard Shaw as "the only genius to come out of the film industry," also displayed typical Aries courage and idealism in his first talking movie, *The Great Dictator* (1940) in which he took on Nazism and ridiculed Hitler before much of the world realized just how evil Hitler actually was.

Curiously, it was another Aries, Marlon Brando (April 3, 1924), who was one of only three professional actors, including Charlie Chaplin and Marilyn Monroe, to be named by Time magazine as one of its 100 Persons of the Century in 1999. Aries have a penchant for rising to unprecedented heights and standing head and shoulders above the rest; Brando was described as "unchallenged as the most important actor in modern American cinema" by the *St. James Encyclopedia of Popular Culture*. Brando was also a crusader for the underdog and an activist for both African-America civil rights and various American Indian movements.

Being first is what Aries aspires to—and, of course, the first female member of the Supreme Court of the United States, Sandra Day O'Connor (March 26, 1930) was born under the sign of the Ram. Prominent women's rights activist Gloria Steinem (March 25, 1934) is another true-to-type Aries—a charismatic crusader who's made her mark by standing up for her beliefs. And pioneer of the sexual revolution Erica Jong (March 26, 1942) has in typical Aries fashion led the way by doing, daring and speaking frankly.

Courage is also a quality Aries have something of a corner on, and the steel nerves of escape artist Harry Houdini (March 24, 1874), who was often buried alive in shackles or suspended in chains amid pools of rising water could only have belonged to someone born under the fearless sign of the Ram. The contained, fiery intensity of this sign is also evident in actors like Omar Sharif (April 10, 1932), Peter Ustinov (April 16, 1921) and actor and film director Quentin Tarantino (March 27, 1963) to name a few.

A very Aries-like brand of passion and daring also comes through the voice of poet Maya Angelou (April 4, 1928), who has been described as "America's most visible black female autobiographer." And Aries often have so much presence that they can hold others' attention even without speaking a word—like the brilliant mime Marcel Marceau (March 22, 1923).

THE CARE AND FEEDING OF AN ARIES

If there's an important Aries in your life, the first thing you need to understand is that the image embedded in their astrological DNA is of the hero. This is the role those born under the sign of Aries were born to play on the world stage no matter what form it might take. They can never be satisfied if they aren't caught up in some kind of activity that gives them a sense of purpose.

Aries need to feel inspired to be at their best, and you've probably noticed that when your Aries isn't caught up in an exciting project or plan, he or she noticeably wilts or becomes restless and dissatisfied. You must never take it as a personal rejection that your Aries needs to be constantly on the go, because Aries literally can't remain snuggled up at home playing the part of the perfect companion or partner without becoming frustrated. This has absolutely nothing to do with you and everything to do with the way your Aries is wired. Aries are born doers.

Try to remember that the sense of drive that makes your Aries such an upbeat, high-functioning type is what can also cause him or her the most grief. The fear of not being on the right path and involved in some brilliant, ambitious activity can put Aries into a panic. Having so much energy to burn, Aries tend to go haywire when they don't have an outlet—and not just any outlet, like mowing the lawn or doing the housework (an activity the majority of Aries women dislike), but a grand and truly worthy cause on par with saving the world.

You probably admire your Aries or were drawn in the first place by the lit-up, passionate way he or she approaches life. Your Aries is driven not by a need to feel important or attract attention but by an ingrained urge to take the ball and run with it. You can always count on the fact that your Aries will rise to the occasion when a genuine need or problem comes up—particularly if it involves taking the initiative or dealing with an emergency.

The adrenaline that courses through an Aries' system when under pressure is what he or she lives for. Understanding this is the key to your relationship with your Aries and should help you sympathize with his or her need for stimulation and action. It's not

always easy to cope with Aries' intense preoccupation with whatever their current interests have led them to, especially because they have a tendency to ignore everything else. This, quite naturally, can give you a feeling of being left out and delegated to the background. And if this bothers you, you really should be prepared to speak up, even if your protests or indignation aren't at all welcome.

If you don't, your Aries probably won't realize that you're discontent, because he or she isn't constantly scrutinizing your behavior to pick up clues about what you're feeling. Aries are naturally direct, and subtle hints or sulks aren't an effective way to communicate with them. Be honest and tell it like it is, even if you prefer to hide your hurt and irritation and pretend all is well. Otherwise negative emotions will fester under the surface of this relationship and will drive you and your Aries apart.

Aries may in turn be hurt, chagrined and completely taken by surprise by your criticism of their actions, but with Aries, it's essential to get everything out in the open. It's also essential to keep the doors of communication open and to keep your Aries up to date about what's going on with you. Aries' tendency to go off on their own tangents is an ever-present challenge in their relationships with others. You may have to make an effort to keep them engaged with your own feelings and pursuits, but doing so will prove to be well worth it. Your relationship with your Aries—whether he or she is your lover, friend, child or a family member—will thrive if you're clear, open, honest and not afraid to make demands.

Not that there's any guarantee that they'll meet your demands. The point is to make them known. But just as you shouldn't expect your Aries to be a mind-reader, you also shouldn't expect one born under this independent sign to want to share all his or her interests with you. Aries possess an innate urge to make their own way. The last thing they want to do is try to cling to others, and they don't enjoy having others cling to them.

Give your Aries plenty of space and don't force artificial forms of togetherness on this relationship. If your Aries loves to ski, and skiing doesn't interest you, it's a deal breaker to the Aries if you insist on tagging along just to stick by his or her side. On the other hand, if you love to ski, by all means go out and conquer the slopes ensemble. Don't be surprised, though, if your Aries quite blatantly and without a hint or self-consciousness begins testing his or her skills against your own.

Being competitive is an inborn aspect of Aries' drive to be the best. And your Aries isn't above trying to outski you, outrun you, or even show how much better he or she can be at cooking a gourmet meal. To an Aries, a bit of competition adds a delightful spice to whatever they're doing. And again, this is something that you just shouldn't take personally. It is not an indication that your Aries doesn't think that you're good at whatever you do—just that he or she always feels driven to do everything better.

Not all Aries are as over the top as others when it comes to needing to exhibit their superiority, and some will hold this urge in check—especially if they have any major planetary placements in their opposite sign of Libra. But all Aries love to win, hate to lose and are fueled by their inborn drive to lead the pack. They are high on life and thrill to challenges, and because they always aim to exceed their own limits, they find it difficult—if not impossible—to resist the urge to test them.

Keep reminding yourself that striving to be superman (or -woman) is Aries' inborn nature and not an offshoot of having a big ego or needing to show off. Aries is ruled by Mars, the hottest and most aggressive planet of the zodiac, and this makes him or her either courageous and driven or, as the case may be, brash and impatient when dealing with delays, others' carelessness and all those myriad details of life that from time to time are bound to go wrong.

You need to bear in mind, too, that it's difficult for Aries to keep still since they feel a burning, urgent need to be on the move; it's also, as you've doubtless discovered, a huge challenge to get Aries to cut him- or herself some slack and simply sit back and relax. You may at times feel the urge to forcibly grab your Aries and sit him or her down in a big easy chair—not that this tactic will work. Your Aries is likely to bounce up within a few minutes and resume whatever activity they were caught up in. But you really do need to tell Aries to stop, even if you feel as if your admonitions are falling on deaf ears. During those times when they're caught up in some engrossing project or plan, Aries really don't seem capable of putting on the brakes unless something forces them to. Once that adrenaline starts pumping, it fuels them with an enormous charge that keeps pushing them and pushing them beyond all limits.

You're obviously not responsible for getting your Aries to listen to reason. All you can do is tell them what you think. And Aries do know when they're overdoing it, but they take a certain, secret pride in relentlessly driving themselves and outperforming everyone else. It's all part of the superman complex those born under this fiery sign are prone to harbor, and it can be frustrating to watch. Too many Aries end up having accidents or otherwise doing themselves in because they refused to slow down when clearly they should.

But that goes with the territory where Aries is concerned, and it's a byproduct of the adventurous and bold character that identifies this Sun sign. The bright side of knowing an Aries is that no one can be more inspiring or more willing to come through in a pinch. Your Aries is capable of enormous generosity, genuine heartfelt warmth and—like the hero he or she inwardly aspires to be—can at the best of times behave in a way that can only be defined as "noble."

ARIES IN LOVE

In love, Aries are often impulsive, idealistic and intensely romantic. And since they're not inclined to be half-hearted about anything, when it comes to amour this fiery sign is either in it or not. Rams are also daring enough to go out on a limb and try to win a reluctant lover's affections, and many actually thrive on this kind of challenge.

Aries are direct, pure and entirely undefended when they fall in love. They will give their whole heart, and they will keep on trying once they've committed themselves, even when conditions become rocky. They are playful companions, are generally cheerful and upbeat and far more inclined to say "yes" than "no" to new suggestions and ideas. Aries are also quite willing to give the one they cherish plenty of space. They demand, in fact, that their partners hold their own, and if they can't or don't, they will tend to lose respect for them, if not interest. And because they require a certain amount of freedom, they need to partner up with someone who can get on with his or her life independently.

<p align="center">★ ★ ★</p>

With their own Sun sign, **ARIES,** Rams may feel a spark of interest and passion, but finding two Aries in a lasting relationship is a bit uncommon. The problem is that two fiery, Mars-ruled characters would find it difficult to find and maintain common ground, and after that grand moment of coming together both would tend to go their separate ways. Almost inevitably, competition is likely to spring up between two Rams. Like children, they're likely to get involved in silly contests and to place an undue amount of importance on the outcome. What these two do have going for them is mutual respect and the ability to give each other the space and freedom they each require. Ali MacGraw and Steve McQueen are an example of this pairing, and so are Sarah Jessica Parker and Mathew Broderick—two Aries who seem to have stuck it out together, despite some highly publicized problems.

Aries quite easily form friendships with each other, and it's often common interests that draw them together. What's tricky, though, is that these two can't resist the temptation to compete with each other, sometimes in a playful way but occasionally in a more testy fashion that can trigger outbursts. Aries like to lead, and if both try to lead—which they will—a tug of war is bound to ensue. This is a bond that is going to require a certain amount of maturity on the part of both partners in order to maintain a happy feeling of harmony and of rapport.

Aries parents with an Aries child are going to be—at least initially—quite proud of their little Ram's fierce spirit and independence. Inevitably, though, some problems are going to arise between them, since the headstrong little Aries is not going to be particularly responsive to parental guidance. The Aries parent and child will tend to get along wonderfully when they're caught up in an adventure or purpose together.

Aries can find **TAURUS'** steady, calm manner soothing and mysterious. Rams are ruled by Mars, and Bulls are ruled by Venus—a difference which holds a primal and heady magnetism—and in fact, Charlie Chaplin (Aries) and Oona O'Neil (Taurus) were a particularly happy example of this combination. But while the Taurus will help to anchor the Aries, many Rams are likely to have trouble with exactly what seemed so intriguing at first—that typical Taurean slowness of pace. Aries like to take life at full tilt, and Taureans' cautiousness can get on their nerves. The most difficult Taurean trait for the Ram, though, is this sign's possessiveness. Aries like to go their own way and to feel free to do so. When the Taurus gets threatened by such a show of independence and tries to pull the reins in—which they inevitably will do—the Aries is bound to rebel.

Aries and Taureans move at such a different speed that their friendships tend to put their patience to the test. Aries do admire Bulls' strength and stubborn will, though, and they also appreciate Taurus' calm manner and ability to sit still and listen. What the Ram responds to the most is Taurus' willingness to make an effort and to be available when needed. Friendships between these two can be quite enduring, but they will tend to occasionally clash because their style, or way of going about anything and everything, is so strikingly dissimilar. In any situation in which their roles are clearly defined, though, they can be highly complementary.

Aries parents with a Taurus child will be quite charmed by their little Bull's strong and sturdy character, although the Ram may find their Taurus child's tendency to take his or her time and to refuse to be rushed frustrating, if not annoying. Still, Taurus' gentle nature and earthy practicality will tend to have a calming effect on the Aries parent.

With **GEMINI** the Ram feels him or herself to be in the presence of a kindred spirit—but at the same time one who is quite delightfully different. A natural affinity exists between these two signs, and Aries also loves—and admires—Gemini's versatility. Geminis never bore Aries by doing the same thing the same way over and over, and they can match the Ram's adventuresome spirit and optimistic life view. Mary Pickford (Aries) and Douglas Fairbanks (Gemini) were a brilliant example of this complementary pairing, and I've known quite a few Aries/Gemini couples along the way who seemed quite perfectly suited. The one burning issue that can arise—and it may even be a deal breaker—is that Gemini's duality, which may come through in a tendency to say one thing and then do the exact opposite, can strike a straight-shooter like Aries as dishonest and misleading.

Since Aries and Geminis so enjoy each other's company, friendships spring up quite spontaneously between these two. Aries will be delighted by Gemini's quick wit and naturally high spirits and will tend to gravitate towards Gemini in social situations, even if they haven't yet met. Gemini's element, air, fans Aries' fire, and Aries feel excited and stimulated by being in Gemini's presence.

Aries parents with a Gemini child will form a strong bond with their little Twin that will endure through their shared lifetimes. Aries will particularly treasure their Gemini child's quick-witted responses and desire to communicate, and will very much enjoy spending time with him or her. A natural sympathy will exist within this relationship.

Aries often find **CANCERS** to be a little too touchy and defensive for comfort. "What's her (his) problem?" is what a Ram will probably think during the initial meeting, when the Ram's friendly and direct overtures are countered by what appears to be a marked lack of warmth. The watery energy of a Cancer tends to put out Aries' fire, and the result is that Aries feels weakened by this contact. Only if a Cancer has a great many astrological placements (other than the Sun sign) in more congenial signs will an Aries feel comfortable enough to pursue a relationship with a Crab. The volatile relationship of Claire Danes (Aries) and Billy Crudup (Cancer) was an example of this combination, and it was quite short-lived. The Aries finds it extremely difficult to understand Cancer's defensiveness, which will tend to crop up in response to the Ram's straight-on approach.

Friendships between Crabs and Rams work when the two are thrown together by a common cause or pursuit, but Aries will immediately become aware that the Cancer has to be treated with a great deal of care and consideration, or problems will ensue. The effort involved may be more than the Ram wants to make, and he or she will tend to limit the time spent in Cancer's company. This is not to say that this won't be an enduring bond, but it will not be an easy one.

Aries parents with a Cancer child will tend to be very protective of the sensitive little Crab. They may also find it difficult to interact with this child as he or she begins to mature, because the Ram's direct way of approaching touchy matters will tend to cause the Cancer to withdraw, which, in turn, will tend to make the Ram defensive.

Aries' awareness that **LEO** is more than capable of holding his or her own is a complete turn-on, and as a playmate, Aries finds Leo quite delightfully on the same wavelength. In fact, the sense of equality and compatibility an Aries feels in Leo's presence is a powerful aphrodisiac that tends to keep the Aries coming back for more. On the other hand, Leo's need to dominate and be the center of focus is a quality that will irritate all but the most docile and untypical Aries. The passion and romantic feelings the Leo ignites in an Aries' heart can induce the Aries to hide his or her critical response to Leo's controlling manner a good deal of the time, but this feeling can create a kind of distance

that corrodes this often enjoyable bond. Debbie Reynolds (Aries) and Eddie Fisher (Leo) were an example of this combination.

Aries and Leo's friendships are warm and companionable as long as these two aren't competing for attention in a group situation. A certain mutual respect can crop up between the two, and as two fire signs they are basically harmonious. Creatively, they tend to inspire each other, and if they find themselves working together, or engaged in a common pursuit, their engagement and competitive way of interacting will egg them on.

An Aries parent with a Leo child will quickly bond with his or her fiery little Lion and will delight in the child's innate confidence and sunny nature. The Leo child's demand for attention, though, is not one a Ram is likely to respond to with continual patience and understanding.

Aries aren't immediately magnetized by **VIRGOS,** but they are generally intrigued by their air of self-sufficiency. They also like Virgo's logical approach and quick wit. Their impression that, like themselves, Virgos are resourceful and can think on their feet can create a feeling of connection. Passion and excitement, though, can be hard to sustain in this pairing, because Aries will not feel that the Virgo is on his or her wavelength. And what a Ram will find hard to take in this relationship will be the uneasy feeling that the Virgo is making critical judgments about the Ram's ideas or plans. Virgo's practicality may seem admirable to Aries, but it can also have the effect of puncturing balloons and deflating high hopes. Heath Ledger (Aries) and Michelle Williams (Virgo) were an example of this combination.

In friendships, Virgos and Aries get along and for the most part admire each other, but Aries will sense that Virgo is not entirely sympathetic with the Ram's sometimes impulsive behavior and more aggressive manner. Rams will tend to see Virgos as resourceful and helpful and may tend to seek out those born under the sign of the Virgin for support and advice. Virgo's analytical approach may intrigue Aries, but Rams are also prone to become impatient with those born under this sign and to feel frustrated in their company.

Aries parents with a Virgo child will be quite impressed by their little Virgo's self-sufficient air as well as by the very sensible way in which he or she responds to challenging situations. Friction isn't likely to arise between them, and a very comfortable bond is likely to develop. The Ram parent may even come to rely on the Virgo child, who is aways ready to step in and help.

LIBRA is Aries' opposite sign, and a kind of tension immediately springs up in the initial meeting and interaction that puts the Aries on his or her toes. What the Ram senses is that this Venus-ruled sign needs to be treated with particular care, and that a direct approach—which is Aries' natural way—might rub the Libra the wrong way. Rams usually find Libras to be good companions and quite magnetizing but there is likely to

be a kind of push/pull quality to the relationship that can feel baffling and frustrating as well. Anne Miller (Aries) and Michael Gambon (Libra), whose marriage did not endure, are an example of this pairing; Aries can also become impatient with Libra's indecisiveness and tendency to speculate rather than take direct action.

Aries and Libras do tend to form friendships with apparent ease, and as long as they aren't thrust together for long periods of time, these two signs really can be quite complementary. Aries appreciates Libra's obvious efforts to please and provide companionship and usually makes a particular effort as well to meet the Libra's needs. Aries also appreciates the Libra's ability to communicate about personal matters that Rams are less likely to air and discuss with members of other zodiacal signs. In this sense, the two can share a special bond, one that can also be quite enduring.

An Aries parent generally find his or her Libra child to be delightfully charming and appealing. The parent may, though, also tend to be a bit judgmental about the Libra's reluctance to meet life head on, as Rams are inclined to do. The Aries parent will need to develop more awareness and appreciation of why the Libra child needs and wants to be so diplomatic.

The power and intensity of a **SCORPIO** can work a spell of fascination over a Ram. Sensing a challenge, Aries can be irresistibly drawn to members of this Sun sign. Some kind of primal excitement is stirred up by Scorpio's Plutonian depths that is above and beyond the Ram's usual experience. And more often than not, the Aries will take the chance and take the plunge. It's also important to the Aries that he or she will not find a relationship with a Scorpio the least bit boring. This alone can ensure this bond's longevity. Ethel Kennedy (Aries) and Robert Kennedy (Scorpio) were an example of these two signs in a long if somewhat volatile relationship. Scorpio's drive and intensity are qualities that Aries identifies with and admires, and Scorpio's sensuality is a wonderful revelation to Rams, and often quite an eye-opener.

Aries appreciates Scorpio's intensity and company in general as well, so friendships between these two signs can spring up quite spontaneously. What can be difficult for the Ram, though, is Scorpio's tendency towards concealment and secrecy, which runs counter to Aries' instincts. Aries might feel as if a Scorpio friend is shutting him or her out at times, and as a result withdraw. An emotional charge is likely to run through this connection which can trigger sudden fallings-out or confrontations.

Rams will tend to feel a powerful emotional connection to their Scorpio child from the start. The little Scorpio's passionate responses to life will resonate with the Aries' own fiery intensity, but the Scorpio child's tendency to hold back and not reveal his or her feelings is likely to be a source of frustration to the Aries parents.

SAGITTARIUS' optimistic outlook appeals to the Ram, and Aries experiences few doubts when entering into a connection with this fiery sign. Sagittarius' inclination to

say yes to new experiences is music to Aries' ears. Rams also sense that they aren't going to run out of things to do and say in this relationship; entertainment doesn't have to be sought after, because it's already there. On the dark side, though, Aries may not be as emotionally expressive as he or she sometimes feels with Sagittarius, because the Ram doesn't pick up the kinds of signals from the Archer that draw out sentiments. This can mean that this delightful pairing gets sabotaged and doesn't achieve the depth it needs to take root and endure. Serge Gainsbourg (Aries) and Jane Birkin (Sagittarius) were a brilliant example of this pairing.

Friendships happen almost instantly between fiery Aries and equally fiery Sagittarius, because Archers are as adventuresome and spontaneous as Rams, a perfect formula for having fun. Sagittarius is also the only sign of the zodiac that is as unapologetically direct as Aries—in short, a kindred spirit. These two like to be active together—and probably need to be—engaging in outdoorsy pursuits or any endeavor that involves moving about and doing. Aries is particularly impressed by Sagittarius' optimism and sense of humor, and this is a friendship that is full of shared good feeling.

An Aries parent finds a lot to connect with and enjoy in his or her Sagittarius child and will be delighted by the little Archer's sense of fun. What might be more difficult for the Aries is to discipline this child, because the Ram wants to make a pal out of the Sagittarius. The easy camaraderie between these two signs facilitates good communication.

What a Ram senses in the initial stage of acquaintanceship with **CAPRICORN** is that although they may be a bit difficult and judgmental, their discipline is awe-inspiring. And if a relationship does spring up between these two, the Aries will make an effort to accommodate the Capricorn's needs and demands, at least at first. Somehow, Aries senses that he or she has something to learn from this earthy and reality-oriented sign and will often try quite hard to make things work. Of course, the Ram will sometimes rebel and pull back, but normally only for brief intervals. Respect really is a good basis for a relationship as far as Aries is concerned. What's missing in this tie—and it can create a huge hole—is the kind of playfulness that Aries exalts in. The pressure to constantly live up to someone's expectations can also get to be a strain for the Ram, but the challenge inherent in this can actually give this relationship its spice. Patricia Arquette (Aries) and Nicholas Cage (Capricorn) are an example of this combination.

When it comes to friendship, Aries and Capricorn can interact quite enjoyably, especially if they have a common purpose they are working toward. Aries likes and respects Capricorn's organized approach and draws inspiration from being in the company of such an earthy, ambitious type. A friendly kind of competitiveness can spring up between the two that actually motivates Aries to do more and to be more disciplined. On

the down side, Aries may sense that Capricorn judges him or her a bit too harshly for being in too much of a rush.

An Aries with a Capricorn child will generally find the little Goat to be quite a paragon—a child who tries hard, is strong-minded yet cautious, and who is always motived to progress. There's a basic compatibility between these two signs, because Mars—Aries' ruling planet—is in what is described as "exaltation" in Capricorn.

Passions may flare up quite quickly between **AQUARIUS** and Aries, because Aries is drawn by Aquarius' distinct individuality, a wayward quality that the Ram can identify with. Waterbearers can also be quite direct—in their own quirky way—and Aries will feel as if he or she has connected up with a true equal, another lone wolf with whom he or she can form a brilliant pact. Aquarius' tendency to espouse causes and to follow their principles is another trait that creates a sympathetic chord between these two. What tends to sabotage this pairing, though, is that Aquarians, while open and honest, are not especially comfortable when it comes to their emotions, and their façade of detachment can lead to a breakdown of communications that pushes the Ram away. Vince Vaughn (Aries) and Jennifer Aniston (Aquarius) were an example of this combination, which does not seem to stand up in long-term relationships.

Aquarius and Aries can be great friends, though, and they intuitively respect each other's strongly stated individuality. Common causes will unite these two signs, and when they're fighting for some ideal they both believe in, they will get along famously. Aquarius' tendency to go off on tangents, though, can rub Rams the wrong way. And because Aquarius tends to appear breezy and distant, even though they are quite vulnerable underneath, Aries sometimes feels rebuffed or even rejected, which results in rifts.

Little Waterbearers are highly independent and whimsical, and their antics swiftly win over their Aries parents' hearts. For the most part, the common thread of strong individuality and an adventuresome spirit creates a powerful bond between these two, but the Aquarian child's need to test the limits and rebel can sometimes clash with the Aries parent's equally strong need to be in charge.

Aries often find those born under the watery sign of **PISCES** to be a bit baffling, because they are so dissimilar—or even alien—to the fiery Ram. The opposite of direct, Fish operate in the realm of feeling and intuition, and their often dreamy or inattentive manner can rub Aries the wrong way. On the other hand, the obvious openness and vulnerability of the Fish may trigger a protective and affectionate response in the Ram.

Unfortunately, communication between these two signs is fraught with many hazards, and the kinds of misunderstandings that can crop up can cause irreparable rifts. What's more, the Aries will eventually learn that Pisces is not the lost child he or she may appear (at least to the Aries), but rather is happy to go about life in exactly the way he or she feels comfortable doing. The marked differences between these two makes it difficult for

them to understand each other, but can also be the glue that holds them together. The apparently happy marriage of Sarah Michelle Gellar (Aries) and Freddie Prinze (Pisces) is an example of this pairing.

Aries and Pisces friendships tend to develop when the two have a shared interest or pursuit, but Fish and Rams aren't easily drawn together. Aries tends to find Pisces difficult to approach and draw out and doesn't particularly resonate with those born under this Neptune-ruled sign. The Ram's need to focus and move swiftly towards goals is frustrated by the Fish's very different urge to explore all the possibilities and take their time. When they are caught up in activities that allow them to play different and distinct roles, though, they can be quite complementary.

An Aries parent with a Pisces child will be quite protective of this sensitive and responsive child. What the Ram will need to guard against, though, is his or her tendency to take charge and to try to run the dreamy little Fish's life. Allowing the Pisces child to take his or her time to figure out solutions is likely to be a challenge to the Ram parent.

COLORS, GEMS AND FRAGRANCES

Red is the color always correlated with Aries. But what does this mean? Should Rams wear red, buy a red car…is red somehow emblematic of their personalities? Mars, Aries' ruling planet, is actually called the red planet, and this color is, of course, the hottest and most intense hue in the spectrum. The zodiacal sign Aries, too, is considered fiery hot and intense, and for a Ram to actually wear red when he or she is feeling excited, angry or stressed is probably not the best choice. There's a danger of coming across as overwhelming or too hot to handle, and Rams will do better in many situations to consciously select colors that complement or soften their inborn intensity.

Whenever an Aries is trying to fit into a new environment, gain someone's confidence or simply calm down, choosing the colors of the signs that are the greatest distance from their own, like Libra, their opposite, helps them to achieve the effect they're striving for. Green is the color associated with Libra, and Scorpio, the sign following Libra, is associated with blue/green. These colors give Rams the greatest balance when they need it. Indigo, Capricorn's color, also modifies Aries' intensity, but in a more subtle way; whereas yellow, Gemini's color, tends both to complement them and to step up their voltage.

Red should be saved for those occasions when Aries really wants to make a splash, be the center of attention and go for broke. It's generally not Aries' best color, for the reason

that it's simply too much. The colors we wear have an effect on everyone, ourselves included, and Aries rarely needs more of the aggressive heat that emanates from this color.

The diamond, Aries' birthstone, is, in gem form, a brilliant symbol of their shining singularity. For Aries, it will always be a confidence booster, and suits this sign perfectly. Interestingly, in Hindu astrology—in which gems play a far more powerful and intriguing role than they do in Western astrology—the diamond is correlated to the planet Venus, which, of course, is the opposite planet of Mars, Aries' ruling planet. This might be why, too, this particular gem has a positive effect on Aries, because it both polarizes and balances their energy.

Mars' gems, the ruby and the semi-precious coral, generally clash with Aries—and, like the color, red, should be worn only when a Ram choses to step up his or her impact and come on very strong. The gems associated with Aries' most complementary fire sign, Sagittarius, the semiprecious turquoise and yellow sapphire, brighten and enhance the Ram's optimism, and the emerald is a very good gem for Aries who are going through a crisis. And because Aries is a solar-associated sign, gold jewelry usually seems to work better on them than silver.

There are several flowers associated with Aries: the cheerful, hearty and colorful geranium heads the list, followed by the tiger lily and impatiens. Daisies are also considered to be Aries' flowers, and so are hollyhocks. Aries' trees are said to be the fir and all thorn-bearing shrubs and trees, probably because thorns are sharp and fend off aggressors in the manner of Aries' ruling planet, Mars.

When it comes to herbs and medicinal plants in general, nettles are often mentioned in connection with Aries and are effectively used in teas to cleanse the mouth or on the skin to combat infections. Broom is also thought to be under Aries' providence and is reputed to be good for the headaches Aries are known to suffer. (As far as general health is concerned, Aries is connected to the head, sinuses, gums and eyes.) Blessed thistle is thought to be highly beneficial to Aries, helping to relieve headaches and cure stress.

The fragrances specifically designed for Aries usually blend citrusy and floral notes, basically those that are associated with the first breath of spring. Musk is the essential oil connected with Aries because while being sweet, it also comes on strong—just as this birth sign does.

A fragrance that is truly a signature one for Aries should ideally be both intense and light at the same time. One of the flowers associated with Aries, geranium, is very much a signature scent and can provide a perfect base note for any personalized blend. ♈

2

Taurus

21 APRIL – 21 MAY

30°

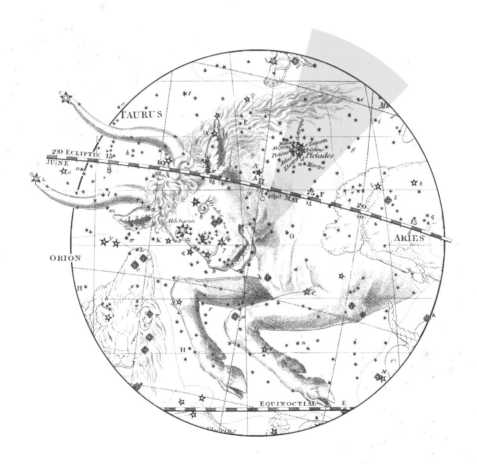

Most men pursue pleasure with such breathless haste that they hurry past it.
—SOREN KIERKEGAARD

Taurus is said to be all about acquisition and ownership, the idea of having something and holding on to it. Judging by the handful of Taureans I've known well, though, it doesn't seem to follow that those born under the sign of the Bull are materialistic.

Richard, a British mathematician (May 1) whom I dated when I was nineteen, was certainly down-to-earth and practical, but he also struck me as being more of a romantic than anything else. He was, in fact, a man who adored art and music and was prone to burst into song (opera was his great love, so this could be slightly embarrassing) while strolling along by my side. He enjoyed good food and life's many pleasures, and I'll always be grateful to him for taking me to see the incomparable French classic film *Les Enfants du Paradis*, which made such a lasting impression on me that the character of its heroine, the generous-hearted Garance, has been an inspiration to me throughout my life. (Interestingly enough, she had all the characteristics of a Taurus.)

Sylvia (April 26), another Taurus I've known for years, is also enraptured by music and art. Although she worked as a proofreader, she also played and taught piano when I first met her, then went on to paint, sculpt and write short stories. Then there's Carole—a long-term client—who while teaching yoga for a living also plays and teaches piano and lives for art and culture; and my former riding instructor, Sharon, as well, who aside from being a skilled dressage rider (an art in itself) paints and is a brilliant craftswoman.

Taurus is the first earth sign of the zodiac and like the other two earth signs, Virgo and Capricorn, is always described as being "practical". When I think of the Taureans I know, though, I think the word that describes them more accurately is "sensible"—not prone to flights of fancy, always aware of the possible ramifications of their actions and—how else to put it?—down-to-earth.

Sylvia has, like all the other members of this birth sign I've known over the years, always worked at a day job, even though her heartfelt desire in life was to make art. I can't imagine her ever chucking everything to live in a garret and paint, even though she possesses a great deal of talent. This also brings to mind another highly talented Taurus,

Josh, who I'm positive could have been a successful writer if he hadn't felt compelled to tenaciously hold on to his demanding, often twelve-hour-a-day job at a major magazine. Because the truth is that Taureans, as much as they adore music, art and all the cultural riches they can feast on, seem to need above all to feel secure.

The pursuit of wealth doesn't seem to be what it's about for the majority of Taureans, but comfort and enough to live on are usually at the top of their priority lists. And one way or another, most Taureans will give up a great deal to have the sense of safety that is found in a reliable income. What's more, you can always count on a Taurus' home to be replete with those accoutrements that make life nice: comfortable chairs and sofas, lots of handy kitchen implements…beautiful hand-thrown pottery mugs to hold your steaming cup of fresh-ground brew.

This is something I do love about Taureans. Being around them—especially in their personal environment—tunes you right into the sensual thrill of being alive. It's as if a heightened awareness of colors, textures and tastes steals over me when I'm in the company of my friend, Dora (May 4), who shivers with delight as she takes her first bite of the spicy chicken tikka she's prepared for our dinner—a feast that includes many colorful side dishes and tangy wine, laid out in all its splendor on an ancient oak table with a vase of purple, orange and gold zinnias in the center.

"How wondrous and how various are all the pleasures of this world, and how right that we should enjoy them," could easily be the Taurean motto. If you want to cheer up a Taurus friend, suggest taking them out to eat at a great restaurant or going to the ballet (or both). Taureans can't resist such temptations, no matter how out of sorts they might be feeling. And, in fact, resisting temptation is often a big theme in Taurean's lives. The urge to indulge—in delicious food, for example—or to acquire coveted and beautiful objects is one that those born under this Sun sign find difficult to say no to.

This is not to say that Taureans lack discipline, because they are quite firm, resolved people, and they will also always do what they promise to do, which is one reason why I so value my Taurus friends. If Sharon (May 4) tells me that she will meet me at 10:30 at a designated street corner, I know I won't be left standing there casting anxious glances at my watch, because I can count on her showing up precisely when she says she will. If she invites me over to dinner, I know she will prepare in advance an enjoyable meal that will be served in a timely fashion with all the trimmings.

Taureans possess a comforting solidity. They are the rocks you can cling to when the going gets tough. Not that they don't become unnerved or shaken themselves, but those born under this particular Sun sign somehow give the appearance of being more rooted and sturdy than most everyone else. And being ruled by the affectionate, other-directed planet Venus, Taureans like to make nice and comfort others—at least to some extent.

From my own observations, Taureans are also, perhaps, not as secure in themselves as you might expect them to be. As determined and unshakable as they may appear, most of the Taureans I know do suffer from self-doubt and become conflicted between their desire to get what they want and their innate need to maintain harmonious relationships and to be liked. In this sense, they are a bit like their astrological cousins, Libras, who are also Venus-ruled. Being aggressive is not really natural to them. They dislike making waves.

The children's story *Ferdinand the Bull* has always struck me as the quintessential story about the true nature of Taurus: the bull who didn't want to fight but preferred to sit beneath a tree and sniff the flowers. Ferdinand displays the Taurean love of the earth and its delightful sights and fragrances and has no interest in the rough antics of his less aesthetically inclined and aggressive peers.

When he happens to get stung by a bee, though, his reaction is so savage and intimidating that he appears far more threatening than any of the other bulls in his pasture. And it's for this reason—that he is perceived as terrifying due to his reaction to something rather than as a result of his real nature—that he is chosen by the matadors to travel to the capital and perform in the bull ring. Of course, when he gets there, even though he is provoked by the matadors, he refuses to fight.

In my experience, Taureans will go to great lengths to avoid confrontations—often to their own detriment. And in saying this, my friend Sylvia immediately springs to mind, because despite her strength and superior grip on life itself, she is easily played upon and pushed around by her tyrannical and demanding sister (an Aries). Unfortunately her sister suffers from a physical handicap, which clearly makes Sylvia, who is gifted, beautiful and able, feel guilty. But she is so unfailingly kind and so allergic to angry outbursts that she puts up with what would make anyone else stamp away in rage.

Taurus can explode, though, and when they do it can be devastating (witness Ferdinand). But they explode not because they want to fight but because they see absolutely no other solution. It is a last-resort reaction, and from what I've seen, it's far more common in Taurus men than in Taurus women. Even then, their rage is like the roar of a bull that's been stung by a bee, which is to say that it's triggered more by a sense of injury or pain than by pure anger.

While it's not the norm, there are a certain number of Taureans who develop into bullies. This is not an inborn behavior but tends to develop over time, when the basically gentle bull discovers how effective it is to throw his or her weight around. This discovery generally takes the Taurus individual by surprise, and he or she employs it only because it has turned out to have worked in the past. In fact, it's really nothing but an act, and if you call a bullying Taurus's bluff and refuse to be intimidated, you will see the person deflate before your eyes like a punctured balloon.

But if Taureans hate to fight, it's because they have another, far more formidable weapon at their disposal: their stubborn refusal to yield. Chloe (May 3), a sloe-eyed antique dealer I met in France, is sweet and gentle on the surface but is impossible—and I mean impossible—to budge once she's made up her mind about something. You can literally feel the impenetrable strength of her resolve when she sets her jaw and says, "No." Taureans are usually wonderful companions, because for the most part they are easy going and warm-hearted. But do not try to change their minds about any plan they've definitely decided upon, because you will run into a granite wall.

Arguing with a Taurus who's made up his or her mind is an exercise in futility. My advice is just don't go there—if you can't laugh about it, you'll probably get mad. But what good does it do to get mad at a stone wall? Whenever I've tried to deflect any of my Taurean friends from plans that for one reason or another I considered unwise, I've had the sense that basically I've just been talking to myself. Their ears might just as well have been sealed.

On the other hand, Taureans do seem to have the grace to admit that they've been wrong when their plans don't work out as they hoped. And what's positive about their determination is that it enables them to hold such a steady and consistent course through life. In fact, Taureans tend to be creatures of habit, like all those born under the influence of the fixed signs (Taurus, Leo, Scorpio, Aquarius), but perhaps because they are also earth signs, Taureans are the most attached to the familiar and known.

Judging by the Taureans I've connected with throughout my life, these people seem to stick to the same places, people and routines without becoming bored and restless. It may be because they are so particularly present in the moment and in their senses that they can perform the same acts day after day and still derive a great deal of pleasure from them. It may also be that disturbing the status quo makes them uneasy.

My friend, Josh, has worked at the same job for thirty years and has never shown the slightest interest in budging from his comfortable niche. He is able and gifted, but he doesn't choose to go any further or to seek outlets other than those he finds in his satisfying and well-regulated life. My friend Sharon has also pursued the same line of work since I first met her over thirty years ago and has lived in the same house for the duration. And while many people may stay rooted, Taureans seem to have a propensity for it. Change is not something they seek out and—actually—they appear to avoid it like the plague.

Staying put means dealing with life as it is, not as it could or might be. And this is another quality I admire in Taurus friends: their cheerful and resourceful way of coping. They try to make use of what's around them rather than casting about for something else—like my friend, Sharon, who needed a bedside table and created a lovely one from the driftwood she stumbled upon during a walk along the seashore. I've noticed that

Taureans revel in using natural materials to create art, and in using organic or home-grown produce when they cook. I have also encountered an inordinate number of Taureans who were potters, perhaps because this particular medium combines the earth and art in such a tactile fashion.

Many Taureans are brilliant gardeners as well; I've yet to meet one who didn't have a green thumb. These people seem to possess an almost magical link to the earth itself and to be able to wrest plump, juicy tomatoes or abundant heads of lettuce out of even the most unpromising soil. They also so revel in the wonder of putting seeds into the ground, tending them tenderly and then watching them sprout. This deeply felt love of the earth seems to be intrinsic to their natures and to be reflected in so much of what they do and think.

I also find Taureans to be quite private people who are not prone to blurt out their secrets on impulse. You must be a trusted friend before a Taurus will confide in you, and when they do, you will probably be surprised by the depth of their feeling. This is because Taureans tend to hide their emotions behind a pleasant and neutral façade. And they can remain quite calm and seemingly detached when they are describing some painful experience they've had. Don't be fooled into believing that they are as objective as they pretend to be, though. Taureans do not like to lose control, and this is one reason why it's difficult to fathom how passionate they really are.

The truth is that Taurus is one of the most romantic signs of the zodiac, as I've found when I've scratched beneath the surface of Taurean friends' or clients' stolid façades. Love is an ideal they truly believe in. Taureans are also highly sensual creatures who are not the least bit stuffy or reserved about the pleasures of the flesh. And while they are less likely to blatantly flaunt their charms than most, they are often potently magnetic.

They are also probably the most possessive Sun sign of the zodiac when they are in love. And this has a great deal to with a central aspect of the Taurean nature. The key words for Taurus are "I have." I remember a little Taurean playmate I had when I was a toddler (I know his birthday because our mothers remained friends for years) who, whenever I entered his bedroom during a visit, would snatch up his toys in his chubby little hands and exclaim, "This is Stevie's dump truck….This is Stevie's giraffe"...on and on as he gathered all his possessions around him in a circle, seemingly not wanting me to touch them.

My little friend's proprietary attitude towards his toys made a powerful impression on me and remains among one of my earliest memories. Ownership is what Taurus is supposedly all about, and while I haven't found my Taurean friends to be ungenerous or grasping, I have noticed that they treat objects with genuine respect and do not borrow or lend things very readily. They also tend to take quite good care of their possessions, especially their homes and cars, and are generally quite proud of them.

Not being rushed—and taking life at their own pace—is also something that the Taureans I've known feel strongly (even adamantly) about. These are not people who go dashing madly about, and if they must for any reason, they will hotly resent it. In fact, it can be frustrating to go shopping or on any sort of outing with a Taurus if you're not of the same stripe—that is to say, very laid back. I have been forced to cool my heels on various occasions when I've accompanied a Taurean friend out and about, and it always turns out to be an object lesson for me both in patience and in staying more completely in the moment.

If you try to rush a Taurus, you will encounter a very definite tug in the opposite direction: they will invariably slow down (probably without even realizing they're doing so). This can be maddening, but I think it's basically an instinctive reaction on their part. Resistance is always the first response you get from Taurus, when you try to push them or control them in any way. And the quality of this resistance isn't subtle. It makes you aware that they possess a formidable strength and that they're not going anywhere that they don't want to go.

At the same time, there's nothing hostile in their resistance, it's just an assertion of the Bull's powerful will. Taureans command respect not by being aggressive and domineering but by being steady, certain and solid.

Keeping calm, taking life as it comes, and not getting unnecessarily stirred up are highly important to those born under this earthy sign. Eric, the Taurean husband of my friend Veronique, continually uses the word "*tranquille*" (he's French) to describe how he's feeling, or a great holiday he's had…everything he considers positive and good. And this appears to be his major goal in life as well: to be peaceful and to smell the roses (a bit like Ferdinand, no?). The planet that rules Taurus is Venus, which is associated with romantic love and creativity. Beauty is Venus' realm, and its ideal is perfect harmony, which is what Taureans aspire to.

But the idealism of this sign can conflict with their innate practicality. I find that many of the Taureans I know can seem—and come across—as a bit cynical, even though underneath they're really just the opposite. Taureans are not foolish or credulous. They have their feet planted on terra firma, and I think that's part of their appeal. I've sometimes gotten the feeling that some of the Taureans I've known have felt torn between their idealistic, romantic side and their rationalistic mind-set, but the interplay between these two aspects of their natures make them interesting and sometimes even profound.

Teilhard de Chardin (May 1, 1881) the priest/paleontologist whose scientific research brought him into conflict with his own faith and with the Catholic church, is a fascinating example of this clash. So was Karl Marx (May 8, 1818), whose political theories seem to have been his attempt to bring his very down-to-earth attunement to economic realities into alignment with his humanist side. And what about Daniel Berrigan (May 9,

1921), the priest/activist who so clearly has felt the push and pull between his spiritual convictions and his revolutionary zeal?

The complexity of the Taurean nature really flies in the face of the hackneyed depiction of this birth sign as some kind of docile plodder. Machiavelli, considered the first political scientist, was a Taurus (May 11, 1469), and so was Sigmund Freud (May 6, 1856); these two great theorists came up with radical ways of looking at life and human nature that have had an enormous and lasting impact on the way we think.

The blend of the earthy and the idealistic is also apparent in the work of Taurean artists like Salvador Dalí, whose sense of irony makes an odd bedfellow with his visionary and transcendental dreaminess. On the other hand, Jasper Johns (May 15, 1930), whose influence led Abstract Expressionism toward a stronger emphasis on concrete images, seems to have been attracted—in typically Taurean fashion—to the solidity of form.

I've noticed that Taureans often fall into two categories—those who are clearly led by their hearts and those who seem to be led by their heads. I say "seem to be" because if you look a little more carefully, the determinedly realistic and rational types of Taureans usually turn out to be disillusioned romantics who are hiding behind a cool, worldly façade. Of those led unabashedly by their hearts, spiritual leader Muktananda (May 16, 1908) and mystical poet Rabindranath Tagore (May 7, 1861) head the list. The composer Erik Satie (May 17, 1865) also falls into this category, along with Stevie Wonder (May 13, 1950) and probably Florence Nightingale (May 12, 1820) as well.

As for the romantics manqués—those more dominated by pure logic—we have Orson Welles (May 6, 1915), Honoré de Balzac (May 20, 1799) and Vladimir Nabokov (April 22, 1899) among many others. Given that Taurus is ruled by Venus—the planet of love—it's also no surprise that quite a number of people regarded as sex symbols were born under this sensual sign, the most notable being Rudolph Valentino (May 6, 1895) often described as being "catnip to women." Penelope Cruz (April 28, 1974), George Clooney (May 6, 1961), Daniel Day-Lewis (April 29, 1957) and Uma Thurman (April 29, 1970) are also Taureans, not to mention Al Pacino (April 25, 1940).

As well as being magnetic and emanating an earthy appeal, Taureans are known for their common sense, so it seems logical that Dr. Benjamin Spock (May 2, 1903), whose famous book on child care became a bible of sound advice for anxious mothers, was born under this sign. What comes across in his lucid prose—the feeling that everything will be fine if you simply stay calm and know what you're about—is something that Taureans are able to convey almost automatically.

What's more, I can think of any number of Taurean actors or public figures whose appeal derives, in part at least, from the fact that they possess this reassuring sense of certainty and as a result exude a wonderful air of normality—James Stewart (May 20, 1908) for one, Henry Fonda (May 16, 1905), Jack Parr (May 1, 1918), Bing Crosby

(May 2, 1903) and Edward R. Murrow (April 25, 1908). Their easy, even peaceful qual-
ity of being completely at home in the here and now is above all a feel-good kind of
energy that I consider uniquely Taurean. It is also that sense of contentment implicit
in the belief that everything is exactly as it should be, or as Robert Browning (May
7, 1912), another Taurus, put it in these much quoted lines, "God's in his Heaven/All's
right with the world!"

THE CARE AND FEEDING OF A TAURUS

If there's an important Taurus in your life, you already know how kind, generous and
supportive someone born under this Venus-ruled sign can be. And you probably de-
pend on your Taurus to be there when needed—steady, sure and willing—without re-
alizing how much you've come to rely on his or her quiet strength. Taureans can be
unobtrusive while being fully present. They will put up with a great deal of frustra-
tion without making a fuss, because their inborn tendency is to remain in harmony
with everyone around them.

Perhaps the most important thing to remember about your Taurus is that a bit of
appreciation will go a long way towards setting his or her personal world to rights. Your
Taurus is genuinely motivated by an urge to be kind—and to be there—for those who
count, and this rare and wonderful quality is one that you should make every effort to
notice and to validate. Taureans don't tend to be demanding, and they'll put up with dif-
ficult situations and try to see them through. But their inner tensions can mount with-
out you or anyone else having a clue.

The truth is that Taureans are very passionate and full of feeling, but being ruled
by Venus—the lover of the zodiac—they don't like to make waves or upset the sta-
tus quo. You should never underestimate the intensity of emotion that lies be-
neath the surface of your Taurus' placid façade. Even though he or she is prone to
be soft-spoken and easy-going, Taureans are sensitive to all the nuances in their in-
teractions with others—especially if and when anyone tries to take advantage of
them or boss them around. And usually your Taurus will take everything in stride
and not react angrily, although as you've doubtless learned, it's not at all advisable to
push your Taurus too far.

A real difference does seem to exist between male and female Taureans in this
regard, though, probably because male Taureans feel that under certain circumstanc-
es they must display aggression or risk appearing unmanly, while female Taureans are
more comfortable being true to their inborn natures which are gentle, peace-loving and

placatory. But male or female, Taureans are capable of exploding if they've been prodded beyond endurance, and it's important to understand that anger isn't an easy emotion for them to express.

Which is why it may be exaggerated when it does erupt, and why you should be aware that something is very wrong if your Taurus feels pressured enough to explode. Taurus' first line of defense isn't to go into attack mode but to resist, and if you've ever been close to a Taurus you know that no one can be more impossible to budge than a Taurus who's just said no.

And isn't it ironic that what you most value about your Taurus—his or her solid strength and will power—is exactly what can be most infuriating when it's expressed in this way? Taureans can have very strong opinions and can stoically hold firm, which is why they're capable of being the rocks we cling to when the going gets tough. But as you most certainly have discovered, when they decide they don't want to go along with something, nothing you can do or say will change their minds. In fact, the more you try to pressure them, the more fiercely they will resist.

Which is why it's always best when dealing with a recalcitrant Taurus to let them see that you respect their point of view, and to stop pressuring them to see things your way. Taureans instinctively tense up and resist when pressure is coming their way, but once it stops, they will gradually relax and unclench their jaws. They are even capable—with time—of doing a complete about-face. And what you must do is to give them the time to come around, if and when they're ready to, which admittedly can be a bit difficult to do.

What you need to remember is that it's a point of pride to Taureans to show that they can hold their own and won't be pushed around. Taureans need to maintain their dignity, and it means a great deal to them to do so. If they somehow sense that they are being treated with a lack of respect or being forced into something, they will invariably react with an impressive display of passive resistance, which you'll find impossible to neutralize.

In fact, your wisest course is to avoid getting into power struggles with your Taurus in the first place. You should also be careful not to present him or her with non-negotiable demands. Taureans want to be reasonable, and their nature is to be loving. They do, though, have a very deliberate way of going about things. And as you doubtless know, Taureans do not like to be rushed into anything. It's their nature to take their time.

You probably appreciate how patient and consistent your Taurus can be, and how his or her approach yields tangible rewards. Taurus' dislike of being hurried along is another aspect of their measured way of going about things. If you try to get your Taurus to move a little faster when you're heading out together on some sort of errand, you'll run the risk of stirring up that ever-present pressure-resistant aspect of your

Taurus' strong-willed character if you say something like, "Can you hurry up a little? I'd like to get going..."

To your chagrin, you'll find that instead of moving more swiftly, your Taurus seems to be slowing down, dawdling in the kitchen for some obscure reason, or hanging about in the bathroom for an unreasonable period of time. He or she will appear to be totally preoccupied by something of immediate and pressing importance that creates an impenetrable barrier that you simply can't bypass.

Don't lose your cool. You're only going to stress yourself out and make things worse by putting even more pressure on your foot-dragging Taurus. Remind yourself that this inexplicably infuriating behavior is the dark side of your Taurus' cautious and purposeful voyage through life. You may arrive at various destinations on the late side when accompanied by your Taurus, but you'll always arrive in one piece, safely and surely.

The security your Taurus offers you is probably one of the reasons you value him or her so much. And your Taurus' predictability is also reassuring. You can pretty much guess how he or she will behave in certain situations, so you aren't in for any unwelcome surprises. Taureans are creatures of habit, as you doubtless know, and they tend to follow the same routines day after day. Your Taurus will tend to dig in his or her heels if you try to introduce changes, because the comfort of familiarity means a great deal to one born under this earthy sign.

Taureans value consistency because it's their key to success. They get where they want to go because they patiently keep moving (some would call it plodding) towards their goals. It's the one-foot-in-front-of-the-other approach, and it works for them wonderfully well. When you're involved with a Taurus, you can't help but become aware of how capable he or she is and how able to stick to what needs to be done with amazing determination.

Taureans are also inclined to hold on to what they have with great determination, and it's important to remember that this includes—especially if you're partners and lovers—you. Taureans tend to have a pronouncedly proprietary attitude towards their mates and lovers, and jealousy is a renowned Taurean trait. Even the most harmless flirtation can elicit anger from the normally gentle Bull, and you must bear in mind that this is not something that your Taurus can control. In these situations, you will get a startling glimpse of the passionate and feeling person your Taurus really is beneath that calm, daily mask. In fact, jealousy is one of the few emotions that can make a Taurus lose control and behave in a completely unacceptable manner.

Normally, though, your Taurus is easy-going and easy to get along with. Taureans aren't particularly moody people, but they can become glum if they feel lonely or unappreciated. The best way to cheer your Taurus up if he or she is feeling down is to treat him or her to a sensual or arty delight: a massage, a meal at a gourmet restaurant, a

classical concert—a trip to an art opening or museum. All of these experiences are ones that uplift and nourish Taureans and are guaranteed to put smiles on their faces.

But undoubtedly, feeling safe and secure in a loved one's affections is what matters most to Taureans, and even their love of comfort and beauty will come second to this.

TAURUS IN LOVE

Taureans are very much at home in the sphere of the emotions and of relating. Of course, Venus (Aphrodite) is their ruling planet, and their nature is to seek out companionship, and to connect, touch and share. What's more, great passion can lurk beneath the calm and often neutral façade Taureans present to the world. There may even be instances when the depths of their feeling can entirely overwhelm them. This sign is one of the most romantic of the zodiac, though in many cases, they are closet romantics who hide their true natures.

When they fall in love and have made a commitment, Taureans are willing to put a great deal of energy into their relationships, and they expect the same degree of attention and consideration in return. They are devoted partners who will stick by you through thick and thin and not spare themselves in their efforts to be on the spot and present for their loved one. Their expectations of love are high because they really are so idealistic beneath the surface. Yet Taureans can and sometimes do stray, as solid and trustworthy as they appear. This is because they so long for romance as a real presence in their lives, that if they're caught up in a connection that doesn't provide it, they will find temptation hard to resist.

What's more, those born under this earthy sign are often uninhibitedly erotic, and they place a great deal of importance on the physical side of love. Their intense level of involvement in the relationships they form also calls up a possessive aspect of their natures, and they see no reason why they should control their jealousy if it becomes aroused. They tend to keep a wary eye on their partners and to seethe inwardly if they sense that something amiss is going on. And jealousy can bring out the darker side of Taurus' character, which once aroused is like a force of nature.

<p style="text-align:center">* * *</p>

Taureans are generally quite stimulated and impressed by **ARIES'** fiery energy and spirited approach to life and find Aries to be quite exciting. What's positive about this connection is that Aries—adventuresome, fearless, impulsive—is different from Taurus in

ways that enter Taurus' life like a breath of fresh air and have the effect of springing Taurus free from ruts. Taureans are likely to admire Aries and look up to the Ram in a way that nurtures this bond. What is bound to be a bit difficult, though, will be Aries' tendency to move quickly versus Taurus' penchant for maintaining a slow, purposeful pace. Taurus is also likely to be frustrated by Aries' preoccupation with outside matters and projects that don't appear to contribute to some kind of mutual goal. And Taurus' sensitive nature can also be wounded by Aries' brusque manner from time to time. Still, these two can be wonderfully compatible, as were Katharine Hepburn (Taurus) and Spencer Tracy (Aries).

In friendships, Taurus, again, is likely to admire Aries' verve and energy and to be able to consciously act as a kind of ballast for their impulsive and excitable pals. On the other hand, Bulls can tend to feel a bit out of their element with members of this fiery birth sign, sensing the Aries' impatience with their own more measured approach and feeling a bit unappreciated, which can create a wedge that slowly drives the two apart.

A Taurus parent with an Aries child is likely to be quite impressed with their offspring's courageous approach to life and will also be able to encourage their little Aries to be more grounded and aware of his or her surroundings. What they need to be careful about, though, will be a tendency to be too controlling—a result of their own fears and concerns about speeding full steam ahead.

With another **TAURUS**, those born under this earthy sign may be at ease and appreciative, but sparks probably won't fly. What will exist between these two, though, is a mutual understanding that goes very deep. If two Taureans do get together, their love of security and comfort will encourage them to build a satisfying life together, but they're bound to get into ruts that become imprisoning to at least one member of the couple if not both. Examples of this pairing are impossible to find, and I've only known one Taurus/Taurus couple in my life who, while sharing a love of art and embarking on a pottery-making enterprise together, were unable to sustain a gripping romantic connection.

In friendship with one another, two Taureans will experience a powerful sense of recognition that will make both feel more confident and secure. There will be companionship in this relationship, but what will sometimes create disharmony are those moments when their strong wills clash and neither is prepared to give way. Still, their desire to maintain their connection will generally be strong enough that this tug-of-war will be resolved.

The intrinsic understanding a Taurus parent will have for his or her Taurus child will lay the basis for a powerful and very loving bond. Both will enjoy being together and doing things together and for the most part will make a major effort to avoid

falling out with each other. What is potentially tricky in this situation will be if and when the parent sees his or her own faults in the child and reacts in a way that is too critical and severe.

GEMINI and Taurus are not natural allies and are not wildly attracted to each other unless their other planetary placements create a magnetic bond. Taureans will certainly tend to find Geminis entertaining, but, on the other hand, may become a bit disenchanted by what they perceive of as Gemini's breeziness and tendency to spread themselves too thin. And because Taureans long for security, Gemini's love of variety and change are not reassuring and may drive them away. Queen Elizabeth (Taurus) and Prince Phillip (Gemini) are an example of this coupling, and so were Natasha Richardson (Taurus) and Liam Neeson (Gemini). This combination seems to work best with a male Gemini and female Taurus.

In friendship, a Taurus may not be initially drawn to a Gemini, because those born under the sign of the Twins often lack the steadiness and reliability Taureans look for in their companions. The Taurus will appreciate Gemini's wit, though, as well as their light-hearted approach to matters that cause Taurus some amount of consternation. In this sense, Gemini may provide a certain balance for Taurus, but is not a soul mate.

A Taurus with a Gemini child will delight in their offspring's verbal skills and quick-witted responses, but may be nonplussed by what he or she may view as Gemini's scatterbrained way of going about things, since Twins are not nearly as methodical as Bulls. The Taurean parent and Gemini child can be fairly compatible, though, since Twins are fluid enough to go along with the Bull's preferences and procedures.

What **CANCER** and Taurus have in common is a love of both security and a re-assuringly comfortable life. Taureans may not be particularly magnetized by watery Cancers, though, perhaps because these two signs don't tend to stimulate each other, and passion may be slow to develop. If it does, though, this can be a durable match, and Taurus will tend to become quite protective of a Cancer partner, making every effort to smooth the way for him or her. Cancer's devotion to family and home affairs will also strike a chord in Taurus' heart. The big deal breaker in this pairing, though, will be Taurus' inability to handle Cancer's moodiness and tendency to retreat into his or her shell. Barbra Streisand (Taurus) and James Brolin (Cancer) are examples of this combination.

In friendship, Taureans are likely to find Cancers to be companionable, but unless they are strongly bound to them by shared interests, they will tend to feel that the Cancer puts his or her own interests first or isn't particularly interested in what they have to offer or say. The Taurus will find that this bond doesn't thrive unless he or she puts a certain amount of effort into it, even though these two signs are basically quite compatible.

A Taurus with a Cancer child is an emotionally smooth combination, and the Taurus parent will enjoy sympathetic bond with his or her moonchild. The typical Cancerian moodiness displayed by the child, though, will likely sometimes throw the Taurus parent off balance, because it's difficult for the Taurus to tolerate any display of negative emotion.

Taurus and **LEO** are not considered to be at all compatible, because these two signs clash by forming a ninety-degree angle. But what Taurus will sometimes find quite irresistible in a Leo is their *joie de vivre* and self-confidence. In short, Leos shine—and Taureans are drawn by their glow. Taureans also—at least initially—feel secure with Leo who moves through the world as if he or she owns it. Leo's tendency to become self-absorbed, though, can deeply upset the Taurus, who will become increasingly frustrated and dissatisfied. And almost inevitably, the Taurean will get into battles of will with the Leo that poison the air with rancor and antagonism. Bianca Jagger (Taurus) and Mick Jagger (Leo) are an example of this pairing.

In friendship, Taurus is sometimes drawn to Leo for the same reason: because the Leo is so confident. Connections between these two can get off to quite a good start, but problems will develop because power struggles are prone to crop up between these two strong-willed signs. The Taurus will increasingly feel that the Leo is controlling and bossy; unless the Taurus is willing to make concessions (and often Taurus will), this bond won't thrive.

With a Leo child, a Taurean parent will appreciate the little lion's inherent magnetism, but will sometimes balk at his or her demands and need for attention. Again, clashes of will are inevitable, but a grudging but mutual respect can often come out of this. Taurus is more conciliatory than Leo, though, and may feel at a disadvantage.

As a love match, Taurus with **VIRGO** can be quite magical, and these two signs are essentially complementary. Taurus is quite intrigued by Virgo's versatility as well as their subtle sensuality. Taureans also appreciate Virgo's practicality and down-to-earth mind-set, and as a team these two can work together toward common goals with a genuine feeling of camaraderie and good humor. Taureans may prickle under Virgo's critical gaze, though, and may also find Virgo's changeability a bit unsettling. The stability that Taurus seeks may prove more elusive with Virgo than he or she expected. Roberto Rossellini (Taurus) and Ingrid Bergman (Virgo) are an example of this bond.

In friendship, the Taurus is likely to appreciate Virgo's efficient and sensible way of approaching life and find their sense of humor to be a source of delight. Taureans will also particularly enjoy working side by side with Virgos and undertaking anything that involves following a plan. On the downside, though, the Taurus may not feel as emotionally connected to those born under this Mercury-ruled sign as they long to be.

A Taurean parent with a Virgo child is generally intrigued and impressed by their offspring's resourcefulness and practicality. The Taurus will instinctively feel attuned to their Virgo child and find it easy to support their positive qualities. Not feeling needed enough may be the one fly in the ointment for the Taurus in this otherwise positive connection.

Because Taurus and **LIBRA** are ruled by the same planet, Venus, they are particularly sympathetic to each other. Taurus finds Libra to be almost ideally gentle and good-natured and also is drawn by that sign's love of culture and beauty. Taurus also feels calmed by Libra, who doesn't try to take control and call the shots but instead makes an effort to please. Since Taurus and Libra so dislike making waves, though, they may find it difficult to air their grievances with each other, which can result in an a build-up of unexpressed emotions. The greatest challenge in this relationship is to communicate openly at all times. Judy Davis (Taurus) and Colin Friels (Libra) are an example of this generally harmonious bond.

Conversely, in friendship, because Taurus finds Libra to be a kindred spirit, the Bull will feel safe enough to air his or her most secret emotions with members of this birth sign. Taurus also appreciates Libra's natural poise and optimism and will tend to pursue and maintain this connection wholeheartedly and without reservation. Friendships between these two are usually full of affection and long-lasting.

A Taurus with a Libra child has little difficulty tuning into his or her offspring's emotional states and sensitivity, but may become overprotective as a result. The Taurean parent will bond very easily with his or her Libra child and will also tend to identify with the little one's highs and lows to a marked extent.

Taurus will often find **SCORPIO** to be highly magnetic, which is entirely natural since these two signs are opposites. Scorpio's intensity is actually a wonderful match for the hidden passion behind a Taurus' façade, and Taurus can tumble quite hard for one born under this Pluto-ruled sign. On the other hand, the Taurus doesn't find it easy to trust the Scorpio, because Scorpios tend to be secretive by nature. And who is in control is also likely to be a major issue between these two and may well drive them apart. Lawrence Olivier (Taurus) and Vivien Leigh (Scorpio) were clearly two star-crossed lovers who found each other impossible to resist.

As far as friendships go, Taurus will either bond with Scorpio or feel instantly antagonistic. Often Taurus will tend to see Scorpio as possessing hidden motives or trying to gain the upper hand. When this combination works, though, it's when the Taurus identifies with the Scorpio as being equally strong and stable. And in this instance, Bulls will see Scorpios as valuable allies.

A Taurus parent with a Scorpio child will be highly sympathetic to his or her offspring's powerful emotionality. What will be difficult, though, will be the challenge of

not prying when the Scorpio child clams up (which he or she inevitably will); if the Taurus takes this behavior as a personal affront, a tug-of-war will usually result.

SAGITTARIUS is a sign that Taurus neither clashes with nor feels magically drawn to. Taurus may admire Sagittarius' high spirits and playfulness but may also see the Archer's optimism as foolishly overblown. Taureans' penchant for stability and comfort makes adventuresome, travel-oriented Sagittarius an unlikely recipient of Taurus' romantic but cautious heart. I can't think of any couples who have this astrological connection, and as far as well-known figures go, the brief romance of Taurus actress Kirsten Dunst and Sagittarius Jake Gyllenhaal is the only one that springs to mind.

As far as friendships go, Taurus is prone to feel that the Sagittarius is far too breezy and careless to be a real pal. The Taurus is also likely to be somewhat annoyed by Sagittarius' restless impatience, since Taureans hate to be rushed. If a Taurus does befriend a Sagittarius, though, the Bull is likely to feel compelled to try to have a stabilizing or calming effect on this fiery sign.

Taurus parents will have some difficulty coping with their Sagittarius child's happy-go-lucky attitude towards life. And because of this, they will usually make an enormous effort to acquaint the Sagittarius with the necessity of being more practical and deliberate. They will also tend to worry, often unduly, but they will delight in their Sagittarius' sense of humor and innate good-nature.

There's no question that Taurus and **CAPRICORN** make a good team, and the appeal Capricorn holds for a Taurus is that sign's reliability and cocky courage. The Taurus will initially tend to idealize the Capricorn and to see him or her as someone who is savvy and worldly-wise in a way that the Taurus is not. Emotionally, Bulls do not quite find Goats to be on their romantic wavelength, though, since while sometimes quite passionate, Capricorns also tend to be a bit insular and controlled. This can result in an increasing distance between the two, which both find difficult to bridge; they can, quite helplessly at times, drift apart. Renée Zellweger (Taurus) and Jim Carrey (Capricorn) are an example of this match.

Friendships between Taureans and Goats are pleasant enough, but while Taurus will admire Capricorn's ambition and strength, they may be prone to be too self-protective and careful with this Saturn-ruled sign to really open up and connect. Still, Taurus will find Capricorn a natural ally, and complementary in the sense that any projects and ventures that a Bull undertakes with a Goat will tend to work out well. Taurus will also sense that Capricorns are people they can count on.

A Taurus with a Capricorn child is likely to find a great deal of satisfaction in her little Goat's determined and clear-minded way of going about things. The Taurus parent will also tend to instinctively do everything right with a Saturn-ruled child, providing the kind of nurturance and environment that launches the young Capricorn on a successful life path.

Taurus is usually thought to be incompatible with the quirky, fixed sign of **AQUARIUS,** but when the two famously stubborn signs do hit it off, they seem to fascinate each other. Taurus enjoys Aquarius' individual style and admires the depth of Waterbearer's convictions, but Bulls do not find it easy to grant Aquarians the total freedom they require. The Taurus will usually become frustrated, and his or her response will be to withdraw in order to force the Aquarius to change and give in. These battles of will can be long and drawn out and will ultimately lead to a hopeless stalemate. Ryan O'Neal (Taurus) and Farrah Fawcett (Aquarius) are an example of this combination.

Friendships between Bulls and Waterbearers are often a bit tempestuous, but Taurus genuinely likes Aquarius' whimsical ways and independent spirit. The respect Taureans tend to feel for those born under this airy, intellectual sign makes it easier for Bulls to cope with the inevitable tugs-of-war that ensue. But because Aquarius can be inflexible and opinionated and Taurus tends to be the same, occasional clashes are impossible to avoid.

With an Aquarius child, a Taurus parent will cherish their little Waterbearer's strength of character, but will find it difficult to tolerate the rebellious behavior an Aquarius is bound to display. And for this reason, the Taurus parent will repeatedly try to lay down the law with the Aquarius child in a way that will tend to have difficult repercussions.

Taurus often finds **PISCES** a bit enigmatic and difficult to pin down and may eventually conclude that people born under this Neptune-ruled sign do not have their feet on the ground. Still, a sympathetic current can run between the two, and Taurus can be pulled into a relationship with a Fish by a strong impulse to protect and lend support as well as by the feeling of well-being they experience in Pisces' presence. There is little stress or strain in this pairing, and quite a lot of warm emotionality and sharing, and this can develop into a deep and enduring love. Rande Gerber (Taurus) and Cindy Crawford (Pisces) are an example of this particular combination, which can turn out to be quite a fulfilling connection.

Bulls may form friendships with Pisces on the strength of an emotional ease that exists between these two signs, but Bulls will tend to find Fish a bit impractical or unfocused. Shared interests, especially those of the artistic and creative kind, will often draw Taureans to Pisceans. Pisces' emotionality also sounds a chord with Taurus, and close, strong bonds can spring up between these essentially compatible signs.

A Taurean parent with a Pisces child will tend to dote on their sensitive, gentle little Fish and to find him or her very easy to get along with. The Pisces child's dreaminess is likely to become a source of concern to the reality-oriented Taurean parent, though, and they will almost inevitably endeavor to teach their Pisces offspring how to pay attention and to be more methodical.

COLORS, FRAGRANCES AND GEMS

The color associated with the sign of Taurus is deep russet or orange—an earthy, warm hue. And although there is sometimes disagreement about which tones go with which signs, actually the colors follow sequentially, starting with Aries (which is red) and working on down through the rainbow.

Russet is generally a flattering color for those born under the sign of Taurus, as are all orangey tones. This color seems to enhance and play up the warm glow that emanates from the Taurean nature and has an uplifting effect on those born under this fixed sign's moods. Yellow is also often a particularly good color for Taurus, since what needs to be balanced in the Taurean character is a tendency to become heavy and morose. And since yellow is associated with the solar-plexus chakra and represents clarity and self-esteem, it's the perfect color for Taurus to call upon when a dose of greater confidence is required.

Venus—Taurus' ruling planet—is generally associated with the color green, which is connected with the heart chakra. And green is a color that is enhancing for Taureans, particularly in its ability to both vitalize and soothe. The tone that would be best for Taurus would tend to be a verdant green with a strong undercurrent of yellow, rather than a forest green. When Taureans need to calm and center themselves, this is the color they should wear (or surround themselves with). Blue/green, the color of Scorpio, Taurus' opposite sign, is also very centering and anxiety-relieving for those born under the sign of the Bull.

The emerald, Taurus' birthstone, was the sacred stone of Venus/Aphrodite and is a wonderful gem for Taureans to wear. It represents fecundity and growth and has the potential to connect those who see it with the source of creation in its feminine form. There is something joyous about the color of a good emerald that is entirely life-enhancing and mood-lifting as well.

Rose quartz is one of the semiprecious stones considered to belong with the sign of Taurus, and this type of crystal is also known as the "stone of gentle love," since it's thought to have a positive and calming effect while being associated with romance. It is also reputed to promote receptivity to the beauty of art and music, which is also consonant with Taurus' nature.

Amber—which is a both earthy and magical—is also associated with Taurus, and its properties are said to be ones that lift the heart and promote courage. Tiger's eye is yet another semiprecious stone that is thought to be good for Taurus and it is, among other things, associated with the solar-plexus chakra and said to promote self-confidence.

Coral is also sometimes associated with Taurus, and copper is the metal that belongs to those born under the sign of the Bull (it's connected with Venus, Taurus' ruling planet).

One of the chief flowers associated with Taurus is the red rose, which is Venus' talisman. The lily is also a match for those born under this romantic yet earthy sign, as are the violet, hyacinth and the peach flower. The trees that accord with Taurus are the sacred ash (Venus' tree) as well as the apple and maple, and the herbs considered to be under Taurus' jurisdiction are sage, coltsfoot and goldenrod as well as thyme—which can be taken as an infusion for respiratory infections. Seaweed, particularly spirulina, is considered to be an important addition to Taurus' diet.

Violet can be the perfect fragrance for Taurus, but woodsy tones and spicy scents like sandalwood also capture the contrasts in the Taurean character. Rose is also a wonderful fragrance for Taurus and is naturally suitable because the rose is associated with Taurus' ruling planet, Venus—the planet of romance. Geranium, as well, is considered to be particularly good for Taurus's nervous system and is also said to be a mood enhancer. ♉

3

Gemini

22 MAY – 21 JUNE

60°

Change is the only constant.

—HERACLITUS

What has always struck me about Geminis is how spontaneous, engaging and upbeat they are. A Gemini's smile is infectious, and those born under this zodiacal sign quite frequently have a glinting look of amusement, or perhaps mischief, in their eyes. And this may be because they are so eager to observe and figure out what's going on around them that, in a sense, they view life and all of the changes it involves as a form of entertainment.

One of my closest friends, Pam (June 16), is possessed of an enormous sense of curiosity. She's always asking questions, and wherever she goes is always drawn into animated conversations. Geminis love to talk, and to converse with a Gemini is to hop excitedly from topic to topic and to laugh delightedly. Gemini's amusement at human behavior and life's little ironies translates into a kind of wit that is irresistibly fun.

Fast-moving conversation and entertaining repartee are Gemini hallmarks. And one of the reasons I love spending time with my Gemini friends is that they are never—and I mean never—boring. Perpetual motion is their modus operandi, and they do not let any grass grow under their mental landscapes. You can always count on a Gemini to be clued in to the latest trends in every sphere—from technology to weight-reducing diets. And if they stumble upon anything they don't know about, they will seize upon it with alacrity and add it to their repertoire.

My friend, Claudia (May 26), is always an amazing cornucopia of tantalizing informational tidbits. This is not to say that her knowledge of various topics is superficial, but that she has an enormous range. She often seems to be watching the news, reading e-mails and talking on the phone simultaneously. This is another fascinating aspect of Gemini's speedy, adroit way of handling things; those born under this mutable air sign are brilliant multitaskers.

Geminis are sometimes described as chameleons, because they seem to adjust and adapt to whatever environment or situation they find themselves in. And this is such a part of their character and make-up that they are hardly aware of their behavior. My friend Darby (May 22) has confessed rather abashedly that she often unconsciously starts imitating the accent of anyone with whom she holds a lengthy conversation, and there

have been those (including one woman from the Deep South) who were convinced she was purposely mocking them.

Maybe this kind of adaptability is actually Gemini's version of a survival technique. I've noticed that people born under this particular birth sign are generally quick studies and that they are able to thrive in completely new and unfamiliar surroundings due to their innate ability to pick up clues and act accordingly. In fact, fitting in and almost immediately making him- or herself indispensable is the kind of challenge a Gemini enjoys. Change is an aphrodisiac to Twins, and anything new and different gives them a wonderful charge.

This is why Geminis are known to move frequently and to change jobs—and partners—frequently as well. Usually a Gemini will chose one of the above to satisfy that inborn urge for the new and the untried, like my friend Pam who, while remaining married since 1971 and living in the same lovely country house for about that amount of time, has moved from position to high-level position in different arenas of the same profession on an average of every three-and-one-half-years.

Jane, a lively June 4 Gemini, instead lives out the dream of constantly changing places by spending several months of her year in Spain, several in France, one or two in England and the rest visiting exotic spots. (Her partner, also a Gemini, is an antique dealer who is always on the move.)

If they don't actually make some kind of career shift or physical move more often than most, Geminis will either belong to a profession that involves much travel (that desirable change of scene) and/or one that involves meeting new people and adapting to different situations at a rapid pace.

Dina, for instance, is an astrologer by profession, and she sees as many as ten new clients every week. She also globe-trots (to Bali, Hawaii and many other delicious spots) on and off during the year to various conferences to speak and teach. And Linda, a June 13 Gemini friend, is a real-estate agent who is always meeting new people and is constantly in her car, zipping around to various house showings, which she clearly enjoys.

Because their time is usually all booked up, the majority of the Geminis I know are also quite difficult to pin down in any way, shape or form. I manage to maintain fairly close contact with my two Gemini best friends, Pam and Claudia, but it often takes time and effort to have even a phone conversation with them, because both are always on the go. But Dina, who's a double Gemini, is simply impossible to track, as is Jane, who is always on her way somewhere, about to arrive or already off to the next destination.

Perhaps because her partner Don is also a Gemini, the confusion generated by their constant comings and goings and last-minute changes of plan is doubled—it certainly seems that way. In addition to craving variety, Geminis also love to have lots of different options in the air at the same time. Whenever I arrive at my friend Pam's home in

Massachusetts for a stay, she greets me with the same cheery announcement, "We have lots of different choices as to what we can do…" and then goes on to list the possible—and always inviting—outings, day trips, restaurant and menu choices she's thought up for our entertainment.

Geminis always love to have an enticing array of possibilities on the go and to be on the move, even if it's just in their cars. Sometimes described as "butterflies," twins have the same propensity to flit from experience to experience, extracting the essence (the nectar) from whatever they've touched down on and then moving on. The idea that, because of this, they are surface skimmers—i.e., shallow—is, in my opinion, way off base.

In fact, Geminis are usually quite emotionally deep, but they make an effort not to show it. They are so clever, mercurial and easily distracted, though, that they can lose touch with their feelings—they often deliberately keep them at bay. They also try to protect themselves by constantly analyzing what they're feeling, and they have a tendency to talk about their emotional states in a very cool, detached way.

Of course, this creates the illusion that they're in control, which is exactly what they are attempting to be. I view this as a smoke screen—one that leads to a lot of misunderstandings in their lives, because others don't really "get" them. A Gemini can be quite distressed, and yet appear so on top of things that no one reaches out and offers the support they really need. And their wit and charm are gifts that can work against them when people fail to see the deeply feeling person beneath their clever façade.

A Twin's inborn sense of fun also makes it quite difficult for him or her to be "heavy," so Geminis tend to make light of their troubles and to hide them away. Their ability to detach and step back works wonderfully well for them in many situations, though, because they are usually cool in a crisis, can think on their feet and can talk their way out of even the most awkward situations.

I've witnessed quite a few of my Gemini friends coping with pressing situations that were quickly turned around by their ability to persuade, charm and/or overwhelm the opposition with the right well-chosen words. And Geminis also have an inborn ability to get people to open up and speak their minds. In fact, I've never met a Gemini who didn't possess brilliant communication skills, or who didn't delight in using them.

This is probably why Geminis so love the written word, are often good writers and also often have a wonderful repertoire of witty sayings, poetry and anecdotes up their sleeves, which they will trot out at the first opportunity. Having been raised by a double Gemini (my mother), I was treated to a terrific array of aphorisms—"If it's important, it will come back to you"; "Anything worth doing is worth doing properly"; "He who hesitates is lost." My mother seemed to have sayings for every occasion (learned from her Gemini grandmother), as well as a rich assortment of poetry and endless stories about her family and forebears.

My childhood, in fact, was completely informed by the wealth of information that poured from my mother's lips. She had a powerful urge to impart her wisdom to her children, and she so enjoyed talking and recounting what she'd heard that being in her company could be quite a lot of fun. If I made a remark, she'd come up with a clever rejoinder, usually delivered with a little smile; for instance, during summer hot spells, when I complained that I was sweating, my mother would purse her lips primly and declare, "Ladies don't sweat, they perspire."

Mercury—the planet that rules Gemini—was known as "the messenger" in Greek mythology, and my mother's urge to tell and inform was entirely consistent with her inborn nature. I feel lucky to have been raised by someone who gave me such an appreciation of literature (she loved to read) and of words themselves, because my mother used them well and loved the sound of them.

After she'd been diagnosed with cancer, the year she was dying, my mother began recording all her favorite poems on cassettes so that she could play them back to herself when she was lying in bed. Just hearing the words of the poems she loved so pleased and comforted her as recording them had delighted her. Words fascinated and thrilled her (as they do me) and I'll never forget the little tile plaque (for hot drinks) which bore an aphorism in French—*Tout passe, tout casse, tout lasse, tout se remplace*, "Everything passes, everything breaks, everything wears out, everything is replaced"—a very Gemini-like sentiment, which she kept on her bedside table throughout her life.

I don't think it's surprising that I've sought out Geminis as friends throughout my own life, not only because they possess a wonderfully familiar kind of energy, but because they so enjoy talking. I can literally spend hours on the phone with my Gemini friends, and we never run out of things to say. One thought leads to another, and it's all a pleasurable and effortless glide through time until the moment when we must reluctantly say goodbye. I also spent hours—usually leisurely Saturday afternoons after my chores were done—talking and talking with my mother. All I had to do was ask her a question, and we were off. She knew something about almost everything, and she always had a great deal to say.

Being the messenger and making connections is a Gemini's purpose. For the past five years, Lionel (May 27), a long-time client of mine, has been manning an abuse hotline that provides callers with counseling and an extensive network of services, and in a line of work that has a high burnout rate, he seems to be thriving and feeling fulfilled. An enormous number of Geminis seem to enter communications, sales and the teaching professions, and they are also very much at home in this age of computer technology, like my friend, Claudia, who has worked for many years as an IT consultant.

Being born under the sign of the Twins, Geminis do seem to possess an innate duality and are quite capable of seeing both sides of a situation simultaneously. In fact, they seem to delight in playing devil's advocate at times, like my friend, Pam, who will occasionally

take the opposite point of view to someone's firmly stated opinion just to indulge in the kind of verbal badinage she so enjoys. She can sound so sure of herself, too, that unless you happen to notice the slightly amused look in her eye, you would never guess that for her it's all just a form of entertainment.

Geminis love wordplay and are famously adept at using words to weave a spell, to persuade and/or seduce. The term "silver-tongued devil" was probably coined to describe a Gemini, and whether the Twin in question really means what they say or is just playing a game is sometimes difficult to discern. Not that those born under this particular birth sign are insincere—though they can be—but they are capable of using words in a particularly clever and powerful way. And perhaps the negative stereotype of the con man—associated with Gemini—is the dark side of this brilliantly verbal sign.

All of the Geminis I've known have had very strong consciences and seem incapable of telling a lie, so it really does seem that the unfortunate penchant to deception only happens when the Twin in question has a particularly weak character. Most Geminis know, though, that they possess the power to win others over with their wit and charm, and they don't hesitate to do so. Why should they? Geminis liven up any situation that they enter, and I've found that people actually tend to smile more readily if a Gemini is in their midst.

Patience isn't a Geminian trait, though, and Twins don't like to hang around and wait: if they find themselves with time on their hands, they tend to go out looking for action. Even in conversation, some Geminis can hardly wait for others to finish their sentences but jump in and finish them themselves. Their attraction to movement and speed keeps most Geminis constantly on the go, and this is why Gemini is sometimes described as a "nervy" sign (Mercury, Gemini's ruling planet, holds sway over the nervous system) and why many Geminis find it difficult to relax.

The twinship aspect of the Gemini nature is a fascinating one; whether Geminis actually experience themselves as being somehow "two in one" or as possessing an other half that is both part of them yet somehow different is difficult to figure out. Whenever I consider this question, I'm reminded of the time my niece, Laura, who, ten at the time (and who has a Gemini Moon), was sequestered in her bedroom and carrying on a lengthy conversation with a friend (there really did seem to be two different voices). When she opened the door a few minutes later, I realized that, in fact, she was entirely alone. My mother occasionally talked to herself in this conversational way as well, and it seems to me that the self and "other" implicit in such conversations are actually two different aspects of the same self—the Twins in action.

All the air signs are dual, because they function on the mental plane, and to think is to become aware that you (the thinker) are separate from what you're thinking about. Gemini, being the first of the air signs (the others being Libra and Aquarius) is actually defined by the words "I think" and is symbolized by the Twins precisely because they do

represent duality. Gemini's powers of observation and ability to clearly describe what he or she sees is this sign's greatest gift.

But since thinking is abstract—not physical and material—Geminis can come across as a bit ungrounded, and they may also tend to build castles in the air—to think about and plan activities that never become real. Since Geminis find just imagining and visualizing something so satisfying in itself, people born under this birth sign are sometimes seen as big talkers who don't follow through.

Geminis are also reputed to be adept at many things without quite mastering them—the jack of all trades of the zodiac. I haven't found this to be true, but I have noticed that because they're so articulate they can appear to know more about various matters than they actually do. Picking up clues and making instant connections, Geminis quickly grasp the salient facts more swiftly than most, and they don't tend to linger over details.

Still, it was Gemini Alexander Pope (May 21, 1688) who warned that "A little knowledge is a dangerous thing…" although in making this observation he may well have been thinking of himself. A brilliant poet and satirist, Pope—not particularly well-educated—was able to make his living solely by writing, which during the early eighteenth century was an impressive feat. He was also known for having translated Homer and clearly possessed the wit and linguistic skill that typifies those born under his birth sign.

Many brilliant writers have been born under the sign of the Twins, including Saul Bellow (June 10, 1915), Michael Chabon (May 24, 1963), Thomas Hardy (June 2, 1840), Larry McMurtry (June 3, 1936) and William Styron (June 11, 1925) to name a few. Being wordsmiths by nature, Geminis excel at expressing themselves through language—and of course the list of Gemini poets is staggering, including, for instance, Federico García Lorca (June 5, 1898), Walt Whitman (May 31, 1819), Allen Ginsberg (June 3, 1926) and William Butler Yeats (June 13, 1865).

Anne Frank (June 12, 1929) was a Gemini, and her wonderful, confiding voice has touched hearts around the world and will always do so. The very clever Sir Arthur Conan Doyle (May 22, 1859) was also born under the sign of the Twins, and it's quite fascinating to see how the action of his novels plays off two very different twinlike characters (the classic twins of mythology, Castor and Pollux, were opposites)—the erratic and brilliant Sherlock Homes and plodding and logical Dr. John Watson.

Paul McCartney, known as the most commercially successful songwriter in history, is a Gemini (June 18, 1942), and so is Bob Dylan (May 24, 1941), many of whose lyrics are sheer poetry. What's more, Cole Porter (June 9, 1893) was a Twin, and his catchy, clever lyrics still capture attention today.

From Thomas Mann (June 6, 1875) to Joan Collins (May 23, 1933), Gemini writers range from the profound to the profane. Fast-paced, sharp dialogue often plays a major

role in fiction penned by Twins like Dashiell Hammett (May 27, 1894), and so do twisty, action-packed plots (Ian Fleming May 28, 1908). Geminis are also brilliant storytellers—take, for instance, Harriet Beecher Stowe (June 14, 1811) and Gail Godwin (June 18, 1937)—because they are born raconteurs.

Geminis are also renowned for being able to think on their feet, and not surprisingly, fast-talking comedienne Joan Rivers (June 8, 1933) was a Gemini, as is Sandra Bernhard (June 6, 1955), considered one of the great stand-up comediennes of all time. Another Gemini comedian, Bob Hope (May 29, 1903), perfected the slightly self-deprecating humor that is so typical of those born under this birth sign, and he also always seemed to have that unmistakable Geminian glint of amusement in his bright, intelligent eyes, as does the charming Drew Carey (May 23, 1958).

Geminis also often possess the gift of mimicry, which is why so many actors seem to have been born under this sign, including the truly brilliant Lawrence Oliver (May 22, 1907), Clint Eastwood (May 31, 1930), Johnny Depp (June 9, 1963), Nicole Kidman (June 20, 1967) and Angelina Jolie (June 4, 1975) to touch just the tip of the iceberg.

Twins often seem to know intuitively how to market themselves and capture all the right kind of attention, and in this sense, Marilyn Monroe (June 1, 1926) fits the mold, having had her finger so brilliantly on the public pulse that she became—even in her lifetime—an icon. Another Gemini who was intimately linked with her, John F. Kennedy (May 29, 1917), also achieved an extraordinary level of fame—not only due to his position and untimely death but because he was, as those born under this birth sign so often can be, so amazingly charismatic.

Geminis love variety and detest sameness, so it's not surprising that they're apt to change their minds frequently. Who other than a Gemini could have been responsible for the statement "A foolish consistency is the hobgoblin of little minds"? Ralph Waldo Emerson (May 25, 1803) is a classic example of the Thinker in action—and the depth and breadth of his ideas revolutionized the mind-set of his time.

THE CARE AND FEEDING OF A GEMINI

If you have a close connection with a Gemini, you probably don't feel pressured to hover over them or worry about how they're doing, because Geminis aren't needy people. To the contrary, they're usually quite independent and self-reliant, and they possess a wonderful kind of flexibility that enables them to quickly adapt to whatever comes along. Geminis, in fact, are low-maintenance types who don't require a lot of hands-on attention.

They do, though, thrive on lively conversation and wit. Probably the first rule to having a great relationship with a Gemini is to share ideas and thoughts with them, and if you're particularly close to a Gemini, it's probably because this is what you naturally do. Varied, interesting conversation is what Geminis crave as much as good food. And your Gemini also loves to tell you all kinds of things—recounting anecdotes, sharing information—or just cluing you in to what's going on in his or her busy mind.

Boredom is intolerable to Geminis, and if you've been chosen as a companion by a Gemini, it's unlikely that you're boring in any way. What Geminis find most stultifying is constant sameness—the deadening and repetitive side of habitual routines and behaviors. And if your Gemini ever seems a bit down or discouraged at any time, a fleeting, impromptu getaway to some unfamiliar locale will do wonders to raise his or her spirits. Geminis can stick to their own chosen routines with great consistency, but unlike Taurus, for instance, they welcome change, and you can easily introduce new plans or ideas to them without worrying about their reactions.

Your Gemini was born with a hunger for new and varied experiences, and the more you're willing to foray with him or her into unknown territory—both mental and physical—the better. Don't ever try to hold your Gemini back when it comes to sallying forth in whatever direction may beckon, because one of the worst things you can do to Geminis is to try to clip their wings. Geminis can become extremely enthusiastic about new and unexplored possibilities, and they need to have the freedom to suss them out in their own playful and curious way.

Have faith in your Gemini's ability to learn as he or she goes, because that's what Geminis need and love to do: learn. And always be ready to give your Gemini as much freedom and space as he or she seems to crave. If you try to control or in any way dominate Geminis, they may appear to acquiesce (or not), but you can be sure that they will find a way to do what they want to do in their own time and when they feel the urge.

What your Gemini does have a problem with—as you may have noticed—is getting overbooked. The urge to move off in any number of directions at the same time is one that Geminis find extremely difficult to resist. As a result, they tend to end up rushing around a great deal and stressing themselves out. But try as you might, this is not going to be an aspect of your Gemini's behavior that you'll be able to change. It actually does Geminis good to hear and be advised that they should rein themselves in a bit. It's just that they don't really seem to be able to stop getting excited and intrigued by untried options. They also sometimes find it difficult to say no.

This is one reason why Geminis tend to take on too much. As brilliant as they are at multitasking, they are inclined to overestimate their ability to cover numerous bases at the same time and also be willing to lend their talents and services to others if they're needed. Again, there's no point in criticizing them for this tendency, and in a way you

have to admire their optimism and goodwill. You'll rarely find your Gemini difficult or cantankerous, because those born under the sign of the Twins seem to be blessed with a happy disposition. And unless your relationship with your Gemini is a familial one, this is doubtless one reason that you were drawn to him or her in the first place.

Geminis tend to focus on the positive side of situations, and they almost always see the glass as half-full. They have a capacity to go with the flow and to adapt, and if you know a Gemini well, you're bound to have observed his or her chameleonlike ability to take on the colors and general feeling of whatever environment they find themselves in. Disconcerting as it may be to find your Gemini apparently chumming up to (for instance) a group of loudly dressed and—to your mind—overly boisterous tourists in a bar in the far-flung Hebrides where you're vacationing together, don't be surprised. Geminis' ability to blend in and appear at home is an inborn survival tool that helps them to get along swimmingly wherever they go. It's also something so intrinsic to their natures that it happens inadvertently.

It would be easy to get the impression that your Gemini is a bit glib or superficial in such instances, but you know in your heart that this simply isn't true, just as you realize that your Gemini's ability to switch sides during an argument doesn't mean that he or she doesn't harbor deep convictions. Gemini's duality—their twinness, so to speak—makes it possible for them to see both sides and to want to see them clearly as a kind of mental exercise or game.

In fact, Geminis are naturally playful, and you need to know your Gemini very well indeed to understand how deeply they actually feel and how much they instinctively step back and contain beneath their lighthearted and cheerful demeanors. All the air signs (Libra and Aquarius are the others) have a tendency to appear less intense and emotional than they actually are. It's an aspect of being an air sign that's hard to understand; Geminis, for instance, almost always appear to be in control and okay even when they're actually feeling stirred-up and upset. Don't make the mistake of thinking that your Gemini doesn't hurt inside at those times when he or she walks quietly and bravely away from some obviously painful situation or experience.

Geminis can be very hard to read emotionally. They can talk calmly and rationally about matters that are actually killing them inside, because air signs naturally take two steps back and observe everything that happens to them and around them with an air of cool detachment. This apparent detachment can lead to all kinds of misunderstandings, because others will think they are unfeeling when it's not the case. What it is actually about is that air signs need to mentally process what they're experiencing as a way of translating it into terms they can deal with and understand. And it's especially at those times when they're gripped by emotion that their instinct to step back and gain control kicks in.

Remember, too, that your Gemini may behave defensively and try to shrug you off if you try to comfort or console him or her; this is partly out of a need to reassure you and partly a way of not appearing needy. This doesn't, however, mean that he or she doesn't need to be comforted or consoled. Your obvious concern will mean a lot to them, even if they appear to be backing off. Don't be fooled into thinking that your Gemini is as emotionally in control as he or she tries to appear.

Some Geminis even have difficulty admitting to themselves how strongly they feel about something—or someone—and male Geminis are particularly prone to this. Geminis' tendency to live in their heads and to try to keep their hearts from running away with them can lead to all kinds of problems in the form of misunderstandings and crossed signals. It can also cause a lot of wear and tear on their health and welfare, leading to a built-up of tension that they find difficult to release.

Encourage your Gemini to get plenty of exercise, because this is one of the best ways for those born under this abstract sign to unstress. The happiest and most balanced Geminis are those who regularly go to the gym, dance class or yoga class, and who become tuned in to their bodies rather than living completely in their heads. Ruled by Mercury—which controls the nervous system, Geminis are more vulnerable to nervous exhaustion that all the other signs except Virgo (which is also Mercury-ruled).

Geminis are gems. They sparkle and make life more enjoyable for everyone around them. And while—again—they really don't demand a great deal or appear to require a lot of attention, they will sparkle even more brightly if you give them a bit more TLC than they appear to need.

GEMINI IN LOVE

Geminis may be cool, airy and objective, but they are perfectly capable of experiencing great passion. Pairing up appeals to the Gemini nature, and being a twin, those born under this birth sign crave the presence of an "other" to feel complete—and, of course, to have someone they can always talk to.

While they can experience passion, Geminis do have a tendency to overanalyze their feelings, and while this is most true of male Twins, female Geminis can also fall into this trap. I call it a trap because the tendency to question their emotions and toy with their options can have the effect of confusing them quite unnecessarily. Some Geminis do this in order to not feel overwhelmed by their feelings, but they may also do it because they have a restless tendency to keep their eye trained on the far horizon.

Geminis are mesmerized by possibilities, and they can lose themselves—and also lose touch with what they really want—by not focusing fully on the present moment. As Gemini Bob Dylan put it in in his famous lyrics "I must have been mad. I never knew what I had, until I threw it all away," the greatest danger for a Gemini in love is not realizing how deeply he or she loves until it's too late.

On the other hand, the majority of Geminis I've known have highly successful relationships to which they are totally committed. And they seem not only devoted but are ideal mates and companions to their beloveds.

* * *

The energy and upbeat attitude of **ARIES** appeals to Gemini, and Twins love the fact that Rams can keep up with them and are equally—if not more—adventurous. There can be a kind of thrilling sexual magnetism between these two, because they set each other off, the combination of air and fire fueling a real blaze of passion. Moving at a similar, speedy pace and ever curious about what lies beyond that far horizon, these two can enjoy a wonderful compatibility that also keeps them constantly amused. What's more, Geminis have the ability to keep Aries' occasional over-the-top bursts of grandiosity in check by finding their behavior more amusing than off-putting. Annette Bening (Gemini) and Warren Beatty (Aries) are an example of the essential compatibility of these two signs.

Friendships between Geminis and Aries spring up quickly and spontaneously and, again, these two seem to fuel each other and to generally delight in each other's company. Aries may try to run the show, though, and this won't go over at all well with a Twin, who will cleverly and quickly make it clear that no one can get away with bossing him or her around. However, serious fallings out don't tend to occur very easily between these two, because both are positive thinkers, both are optimists and both enjoy being on the move and taking risks—all qualities that are enhanced when they are together.

A Gemini parent with an Aries child is likely to form a very warm and supportive bond with the little Ram, and to admire his or her spirit and courage. The child's forthright manner will generally delight them, and their tendency will be to be very encouraging of their little Aries' pursuits. Very little is likely to go wrong in this particular parent/child relationship, although occasionally the Gemini will tend to get into minor power struggles with their young Ram.

The combination of Gemini and **TAURUS**, on the other hand, is harmonious enough, but these two do tend to move through life at a very different pace, which causes a certain amount of friction. Gemini enjoys Taurus' warmth and gentle approach

but is not willing to stay put when Taurus wants a cozy night in and Gemini wants to get out and party. Gemini is also likely to balk at Taurus' possessiveness, which will tend to have the effect of driving the Twin away and bringing out his or her rebellious side. A great deal of mutual tolerance is necessary for these two to stay connected. Dave Navarro (Gemini) and Carmen Electra (Taurus) are an example of this pairing; while they were strongly drawn to each other, their marriage was sadly short-lived.

When it comes to friendships, Geminis and Taureans do not have any major conflicts with each other but, again, their different energy patterns aren't especially conducive to the formation of close bonds. Geminis are bound to find Taureans a bit too poky and to become impatient with their stubborn refusal to be rushed. Still, affection can crop up between these two because they are emotionally sympathetic even though they go about doing things quite differently.

A Gemini parent with a Taurus child will find the little Bull's essentially gentle and kind nature very lovable, but will become somewhat frustrated by his or her slowness of pace. The Gemini must learn to be especially patient with Taurus offspring or their personalities will tend to clash, leaving the Gemini feeling a bit guilty.

GEMINI and Gemini together are a volatile but sometimes happy combination and have been described by astrologer Molly Hall as "a bit like two (four) kids together without a chaperone," which judging by the Gemini couple I know, Jane and Don, is an apt description. These two certainly enjoy each other and are very well matched, although they may become a bit competitive as to which is the wittier or more outrageous of the pair. They will simultaneously intrigue and frustrate each other, but an enormous amount of affection will be felt on both sides, because they understand each other so well. George H. W. Bush and Barbara Bush are an example of two Geminis who formed a lasting bond.

In friendship, Geminis are highly harmonious and compatible, though they may find it difficult to make plans and stay current, since both are constantly rushing about. Geminis do enjoy each other enormously, though, and their friendship is one of mutual appreciation. Twins are quite naturally drawn to each other, and when they team up, they tend to light up and lighten up the atmosphere around them.

A Gemini parent with a Gemini child is, of course, in his or her own element with the little Twin. They will delight in their ability to communicate with the child and in their offspring's quick-witted reactions to everything going on around them. They may also be prone to identify so strongly with their young Gemini that the bond will be an unusually intense one.

CANCER and Gemini are so dissimilar that they may complement each other, though they must work hard to understand how the other operates. Geminis have a propensity to tone down their behavior in the presence of Moonchildren, possibly

because they realize how sensitive this sign can be. And Cancer's emotionality is appealing to Geminis, who are uncomfortable when it comes to exposing their feelings and try to protect their vulnerability behind a witty façade. Nicole Kidman (Gemini) and Tom Cruise (Cancer), who were together for eleven years, are an example of this pairing, as were Wallis Simpson (Gemini) and the Duke of Windsor (Cancer).

Geminis don't find many people difficult to get along with, and they will make an effort to accommodate Cancer's changing moods up to a point. They aren't likely to particularly seek out a Cancer friend, because they often feel as if the pressure is on them to conform to Cancer's expectations, and this is not something they're apt to accept. They will, though, appreciate Cancer's often zany humor, and this in itself may provide the foundation for a bond.

A Gemini parent with a Cancer child will usually be aware from the first that the little Crab is a highly emotional being. In response, the parent will try to be particularly kind and caring but, at times, will feel put to the test. Cancer's tendency to overreact or to withdraw when hurt will be particularly difficult for a Gemini parent.

Geminis enjoy **LEO'S** confidence and sparkle and have no difficulty harmonizing with this fiery sign. Leo's tendency to dominate the scene and to demand attention doesn't rub those born under the sign of the Twins the wrong way, and they will generally play along, although they may not be as acquiescent as the Leo might hope. Gemini is also magnetized by Leo's fiery energy, but sometimes finds the Lion to be too self-absorbed and will also not hesitate to poke fun at Leo when this happens. In fact, it's Gemini's ability not to take Leo too seriously that can make this connection work. John F. Kennedy (Gemini) and Jacqueline Kennedy (Leo) are an example of this pairing.

Friendships between Leos and Geminis spring up quite spontaneously, and Geminis generally find those born under the sign of the Lion to be energizing and inspiring. The Gemini will probably put up some resistance to Leo's need to control or call the shots, but not to the extent that any real problems will arise. Twins will also very much enjoy and share Leo's playfulness and general love of fun.

Gemini parents will have no difficulty bonding with their fiery little Lion and will delight in his or her antics and confidence. They, may, though, not be entirely receptive to the Lion's need for witnessing and attention, although they will try to be responsive, and this may trigger a certain underlying tension or unease in the relationship.

Because **VIRGO** is also ruled by the same planet which rules Gemini—Mercury—Twins are quite drawn to those born under this mutable, earthy sign. They are intrigued by Virgo's wit and practicality and tend to identify with their nervy sensitivity. Twins also admire Virgo's ability to discriminate and to cut through to the core of problems and solve them. Virgo's reaction to stress, though, which is often quite exaggerated, has a way of getting under the Gemini's skin and creating disharmony, and too often, pairings

between these two become increasingly acrimonious as a result. A couple that illustrated this combination were Elizabeth Hurley (Gemini) and Hugh Grant (Virgo).

Geminis tend to find Virgos to be both on their wavelength and not at the same time, and friendships between these two can be somewhat volatile. They will enjoy a definite sense of companionship with those born under this sign, but are sometimes put off by what they perceive of as Virgo's pessimism and passivity. Geminis generally find much to admire about their Mercury-ruled cousins, though, and also usually harbor quite positive feelings about them.

Gemini parents with a Virgo child will be delighted by the cool thinking and down-to-earth attitude of their offspring and will be inclined to take him or her into their confidence. Twins are particularly in harmony with those as mentally astute and fast moving as they, and they will enjoy spending time with their little Virgo.

LIBRAS are air signs just as Geminis are, and Twins are naturally drawn to them because they share the same delight in conversing and relating. Geminis also find Libras to be soothing to be around, sensing perhaps that they are in safe company and can relax their guard. A great deal of mutual appreciation seems to spring up between these two, but the danger—in a romantic pairing—will be that the Gemini will not always clue in to the Libra's unspoken needs, since Libras aren't that comfortable about expressing them. Paul McCartney (Gemini) and Linda McCartney (Libra) were an example of this generally harmonious combination.

In friendship Geminis are drawn to Libras for the same reasons. Part of the attraction is that Libras are so relationship-oriented that they are always happy to connect and communicate, which is also what Geminis seek. The natural affinity of these two signs lies in their positive approach to life and in their desire to share. Friendships between these two will often be full of affection and will tend to stand the test of time.

A Gemini finds a Libra child to be wonderfully responsive and related and immediately feels very connected to this gentle being. Communicative and generally eager to please, the Libra child reaches out to the Gemini parent in a way that insures that the two will form a very strong bond, and they will often become close friends.

Geminis are intrigued by **SCORPIO'S** enigmatic air of self-containment. And since solving puzzles is something Geminis delight in, they are drawn to this fixed, Pluto-ruled sign because they feel compelled to penetrate Scorpio's façade to figure out what's going on in their mysterious depths. Prince Rainier (Gemini) and Grace Kelly (Scorpio) epitomized this somewhat unlikely pairing, and the spell Grace Kelly wove was obviously one that Rainier couldn't resist. The fundamental differences between these two are likely to become more evident with the passing of time, and communication break-downs can drive a wedge between them.

Friendships between Geminis and Scorpions happen for the same reason, and Geminis consider Scorpios to be worthy of their interest because they exude an aura of certainty and of being in control. The kind of rapport Gemini seeks in friendship, though, may not be consistent enough to satisfy Gemini's craving for companionship, and the Gemini is also likely to be put off by the fact that he or she tends to be the one who must make the effort to keep this connection afloat.

Gemini parents with a Scorpio child will admire their little one's aura of self-reliance and inner strength, but will at times be a bit nonplussed by their intensity. The Gemini's need to talk problems out will also be somewhat frustrated by the little Scorpio's tendency to hold back and conceal his or her motives.

SAGITTARIUS is Gemini's opposite sign, and in this case (though not in many others) opposites really do attract. Geminis are drawn by Sagittarius' fiery, spirited energy and also by its spontaneity, and this pairing often thrives because Gemini both enjoys and admires the Archer's upbeat attitude and sense of purpose. Twins are also inspired by the visionary zeal that so often fuels Sagittarius, and this can be the glue that cements this bond. The only real threat to this connection is both signs' tendencies to go off on tangents that result in their somehow losing touch. Angelia Jolie (Gemini) and Brad Pitt (Sagittarius) are a wonderful example of this combination.

Geminis often form friendships with Sagittarius for many of the same reasons. Sagittarius' optimistic take on just about everything delights Gemini, and Twins feel very much at home with their Sagittarius friends. Because Geminis tend to speed through life in rocketlike fashion, though, they often find it a challenge to synchronize plans with the equally engaged and busy Sagittarius. The feeling that Twins foster for their Archer friends, though, is almost always one of great affection.

Gemini parents generally find their Sagittarian child to be delightful in every way. The inborn exuberance of their little Archer is a quality that the Gemini treasures, and the Gemini will tend to bond very strongly with this child.

Gemini may be impressed by **CAPRICORN'S** drive, but often the chemistry between them isn't particularly compelling. Gemini can find Capricorn to be a bit too unbending and focused on his or her own ends to enter into the spirit of play that Gemini so enjoys or to engage in the constant communication that Gemini seeks. What's more, Geminis will sense Capricorn's coolly critical gaze settling on them when they rush off in pursuit of yet another new and fascinating idea or interest—and this can be a genuine deal breaker. Paul McCartney (Gemini) and Heather Mills (Aquarius) are an example of this combination; their relationship eventually ended on a particularly bitter note.

In friendship, Gemini will tend to be discouraged by Capricorn's more serious, goal-oriented approach to shared endeavors and will not initially be drawn to bond with those born under this Saturn-ruled sign. Gemini will, though, find Capricorns to be

excellent organizers and will respect Goats and even consider them to be role models in sticking to their goals and agendas. Of course, friendships may spring up between these two due to other planetary placements in their charts.

Geminis with a Capricorn child will tend to be quite impressed by their little Goat's maturity and determination. And because Capricorns like to learn, the Gemini's natural tendency to teach and inform will find fulfillment. In fact, considering that these two signs aren't particularly compatible, the Gemini parent/Capricorn child connection can turn out to be a surprisingly successful one.

AQUARIUS and Geminis are natural allies, and Twins find Waterbearers' individual way of living their lives to be admirable and often endearing. Intellectually, at least, Gemini also finds it easy to connect to and communicate with those born under this airy sign who appear to be very much on the same wavelength. Emotionally, though, Gemini is often not forthcoming enough to bridge the gap with the cool, seemingly distant Aquarius, and due to both signs' self-protective façades, misunderstandings can arise. Still, this combination can be successful. Dixie Carter (Gemini) and Hal Holbrook (Aquarius) were an example of this pairing, and their marriage lasted twenty-six years, until Dixie Carter's death.

Friendships between Geminis and Aquarians spring up very spontaneously, due to the fact that the two feel an immediate sense of commonality and understanding. Geminis are drawn to Aquarians' sense of fun and to their eagerness to communicate and share. Twins also find that they think faster and better in the company of Waterbearers, which tends to keep them coming back for more.

Gemini parents finds their Aquarius child easy to communicate with, which helps to form a warm and affectionate bond. Gemini tends to perceive of the little Waterbearer as a kindred spirit and will be enormously supportive except when the young Aquarius behaves rebelliously and becomes antagonistic, a stage which rarely lasts.

Although a natural bond of sympathy exists between Gemini and **PISCES**, Geminis often find those born under this watery sign a bit difficult to understand. As a result, they will tend to be critical of the Fish or to see them as a bit fuzzy-minded and unclear. An attraction can spring up, though, because Gemini also finds the fluid, gentle Pisces to be sensually alluring. Donald Trump (Gemini) and Ivana Trump (Pisces) are an example of this combination, which often founders on the characteristic differences between these two signs.

Friendships between Twins and Fish can be volatile, because Twins don't find it easy to mesh with the contradictory Fish. And while Geminis tend to find Pisceans quite likable, they also often feel that Pisces aren't particularly reliable or interested in the same matters. Still, Twins often find Fish to be enjoyable companions, especially in social situations when the sometimes retiring Pisces is inclined to lighten up and loosen up.

Gemini parents may find their Pisces child a bit baffling, but will have no difficulty feeling close and bonding. The Twin, though, is apt to become impatient with the little Fish's tendency to dawdle or not pay attention and will also have difficulty understanding the Pisces child's need to fantasize and daydream.

COLORS, GEMS AND FRAGRANCES

Gemini's color, following sequentially through the rainbow of the signs, is a clear orange, though yellow has also been traditionally associated with the sign of the Twins. The lightness and buoyancy of the Gemini personality definitely has a bright, sunlit quality, as though it picks up the light or transmits it, and orange and yellow do seem to fit those born under this sign particularly well.

These colors actually enhance the Gemini character and traits, and orange or yellow are good choices for those times when a bit of extra energy is needed to make an impression or begin some new endeavor. Paler shades of these tones are also helpful and soothing for Twins, like a creamy orange-sherbet shade or a very pale yellow. The color of our opposite birth sign is usually a very important one as well, because it balances our natures, and since Gemini's opposite sign is Sagittarius, a rich sky blue or purple-tinged blue can be the best prescription for soothing nerves and tension. For Geminis, it is a color that is actually calming when worn.

Most Geminis also look smashing in a very clear shade of red, perhaps because Aries (which is associated with red) is such a compatible sign, and because Mars—Aries' ruler—energizes Mercury, Gemini's ruler. For those times when a Twin really wants to bowl people over, this shade of red is bound to help them make a wonderful impression.

The only precious stone associated with Gemini is the white sapphire, although I have seen the emerald also designated, because in Vedic astrology (though not in Western) it's connected with Gemini's ruler, Mercury. The white sapphire is an excellent gem for Gemini, because it picks up the light and transmits it, which is consonant with Gemini's nature.

The agate is universally held to be Gemini's stone, because it has so many colors running through it. In fact, no other gemstone is more magically striped than agate, being a type of quartz that forms in concentric layers in a great variety of color tones and textures. For this reason, it suits Gemini's nature quite perfectly and is entirely enhancing.

The citrine and topaz—yellow/orange-colored stones—are also associated with Gemini, and so is the turquoise, which is the stone of Sagittarius (Gemini's opposite sign)

and can have a calming influence on Gemini's nature. I have also observed that many Geminis love jade, which seems to be soothing as well.

Various flowers are associated with the sign of the Twins, the most accepted being the lilac, lily of the valley and lavender. I have also found that the daffodil is sometimes connected to Gemini, probably for its particularly bright yellow color. Lavender is a wonderful scent for helping Gemini's' nervous system to unstress, and sleeping with a lavender sachet under the pillow can ensure Gemini a calmer night.

Many Geminis seem to crave the fragrance of gardenia as well. Eucalyptus, too, seems to have a particularly positive effect on Gemini's general well-being.

Other herbs associated with Gemini are skullcap, said to soothe this birth sign's excitability; flaxseed and linseed, which are reputed, when drunk as a tea, to help to heal coughs and afflictions of the lungs (which Gemini rules); parsley, also considered soothing to Geminis; and meadow sweet, caraway and dill. The trees connected to Gemini are said to be those of the nut-bearing kind, such as hazelnut and almond trees.

The fragrances that enhance the Gemini personality generally have a light, effervescent quality. Vetiver is probably the true signature scent for Gemini, and it is entirely harmonious with that sign's nature. Citrusy fragrances are also wonderful for those born under the sign of the Twins, as are scents with nutty, dry undertones, such as those of hazelnut. Musk—which is heavier and more sensual—also seems to suit Geminis particularly well. ♊

4
Cancer

22 JUNE – 22 JULY

90°

Self-preservation is the first law of nature.
—SAMUEL BUTLER

The symbol for Cancer is the crab, and this sea creature—with its tough shell and soft insides—is the perfect representation of what it's like to be born under this zodiacal sign. The truth is that Cancers are probably the most vulnerable and tender of all the signs, but they protect themselves so fiercely that they can appear to be the exact opposite: hard. All that's evident is that impenetrable shell.

Not all of them, of course. I know any number of friendly, outgoing Cancers, like my friend Pam's husband, Bob, whose warmth and openness immediately put people at ease. But like the other two water signs, Scorpio and Pisces, the real key to Cancers is that they are governed by their emotions. And what intense and volatile emotions they have! Ruled by the moon, Cancers are also as changeable as the moon—or, in a word, moody.

If one day a Crab seems to be amazingly gregarious, sparkly and upbeat, the next day he or she might mysteriously withdraw, refuse to communicate and project a general air of gloom. In fact, a Cancer's moods are very like the changing phases of that lunar sphere. And judging by the Cancers I've known—and I was married to one for quite a number of years—Crabs find their own shifting emotions as baffling as everyone else does.

Crabs also seem to unquestioningly accept the constant flux and flow of their feelings in a way that most of us are incapable of doing. And perhaps because they are so much at the mercy of their own emotional ups and downs, they are highly sympathetic and responsive to others' feelings and needs. All the Cancer women I've known are the kinds of people who tend to put their arm around a friend who's in distress or at least reach out and somehow touch someone who clearly feels upset, and their swift and caring reactions are always wonderfully reassuring.

Marie, a July 14 Cancer and the wife of a dear friend, is someone who guards her privacy with great care. On the other hand, at those times when I've gone through some sort of crisis or difficulty, she has also made it very clear to me—often in a demonstratively physical fashion—that she is entirely aware of and sympathetic to what I'm experiencing. In fact, I've never known anyone who could more expressively say hello—French style, with a heartfelt kiss on both cheeks, accompanied by a fierce hug—in a way that left me in no doubt that she loved and cherished me deeply.

In my own experience, Cancers are often great huggers—really top of the line—bestowing the most tender, loving embraces on those they care about. And I firmly believe that Cancers' penchant for this kind of physical expressiveness is a direct manifestation of their very special brand of emotional sensitivity. That which is too strongly felt and perhaps too revealing to be put in to words comes through, and its sincerity simply can't be doubted. In this sense, I really think that Cancers possess a kind of emotional talent—perhaps even genius—which is nonverbal and particular to this watery birth sign.

Crabs are easy to misread, though, because their sensitivity often makes them defensive. And if a Cancer is in the presence of someone who seems to be behaving aggressively—even if only by speaking more loudly and assertively than usual—the majority of Cancers will overreact. This is instinctive on their part, I believe, but it's also often quite bewildering. Suddenly, your gentle, amiable companion seems to turn into a hissing snake. This has happened to me with various Cancers I've known, and my reaction was to immediately back down and try to diffuse the situation, which often proved not so easy to do.

Once such an adrenaline (flight/fight) syndrome has been triggered in a Cancer, it doesn't seem as though it can be quickly shut off. It's important to remember though, that Crabs behave so ferociously because they are actually so vulnerable. But if Cancers are self-protective—and this truly is one of their defining characteristics—they are also extremely protective of others. This is why those born under this sign are sometimes described as the caregivers of the zodiac. The maternal instinct flows strongly through the Cancer character, whether the Crab is male or female. And to Cancers nothing is more sacred than family ties.

Marie, for instance, the mother of four, is undoubtedly one of the most devoted parents I've ever met—although several other Cancers I know run a close second. She is also so protective of her children that criticism of them from any quarter is completely unacceptable to her. I remember one time when another friend said something slightly derogatory about Marie's then-teenage daughter—that she was a drama queen or some similar remark—and word got back to Marie. As a result, it became clear that Marie no longer considered this woman to be her friend—an extreme reaction, perhaps, but one that was consistent with Marie's deep-seated need to keep her child safe from all harm.

Oddly, though, despite the way that she defends and protects them so fiercely, her children are not at all spoiled. And they seem to adore her as wholeheartedly as she does them. Cancers generally turn out to be exemplary parents because they want, above all else, to ensure that their children emerge from the family nest well equipped for survival in the outside world. For this reason, they may be quite strict in the sense that they make sure their children learn the skills they will need to cope. Nothing is too much to ask of a Cancer when it comes to his or her children because nothing is more important to

them. And if they're parents, male Cancers are deeply driven to being good providers. In fact, it's usually their highest priority.

Not that Crabs are all work and no play, because those born under this watery sign are often quite sensual and very much enjoy life's pleasures. Cancers can be gregarious, and if they're in the mood, they may even be the life of the party although they aren't usually attention-seeking in an obvious way. Their laughter comes easily, and they possess a particularly warm, engaging sense of humor that draws others in. They also delight in the experience of being amongst a group of people who are enjoying themselves, literally basking in the shared fun.

Most of the Cancers I know also love to entertain, particularly if food is involved. And most of those born under this nurturing sign are very good cooks. It's not just the obvious pleasure of making and presenting something delicious that thrills the Crab, though, but also simply that they like to provide meals for others. In fact, one of the most marked characteristics of Cancers is how deeply tuned in they are to basic life skills—especially everything having to do with food and shelter.

Stocking up on supplies for a rainy day is something Cancers do so instinctively they're hardly aware of it. My friend Lucy (July 2) has a pantry so full of canned goods that it reminds me of a supermarket aisle. She has accumulated enough to get herself and her family through any possible emergency, choosing highly practical items like cans of beans and tins of fish that would fill protein requirements if they were needed. And she doesn't find anything unusual in her urge to pile up food. To her, it's just normal.

It's not only food that Crabs like to keep in reserve but anything that might at some moment in time prove useful—which includes just about everything. And if you ask a Cancer why, for instance, he or she hasn't taken the broken and rusted-out manual lawnmower (long replaced) to the dump but left it with a pile of other apparently useless junk in a corner of the garage, the answer you'll get will be something like "But maybe it could be fixed," accompanied by an inscrutable stare.

In fact, Cancers really don't like to throw anything away, and they are doubtless the most prodigious hoarders of the zodiac, with attics full of old books, tattered clothes and outmoded utensils. Anything old holds an attraction to those born under this sentimental sign, and every single Cancer I've known has adored spending hours in antique stores and vintage clothing shops. What has gone before has a hallowed—even sacred—quality to Cancers, and they often like to immerse themselves in histories of long-ago eras like my Cancer friend Bob (July 17), who has also become quite an expert on the British royal family and its evolution through the centuries.

History and family are two Cancer obsessions, and my cousin RoseLynn (July 7) also shares Bob's fascination with the lineage of the British royal family and like him is partial to reading about the lives they lived in the fifteenth and sixteenth centuries.

Of course, during these periods tradition was so deeply entrenched that it was simply not questioned, and tradition holds an enormous appeal to those born under the sign of the Crab, because it's all about rituals that both uphold and honor the structures that are in place.

Following a trusted and well-trodden path gives Cancers a wonderful and reassuring feeling of security, which is what they crave. And honoring tradition upholds those family values that they sense—from deep within—are so necessary for survival. What's more Cancers don't just give lip service to these ideas and ideals, they live them with total conviction.

My friend Nadine, a mother of three, has during the last several years seen her husband, Michel, suffer a near-fatal heart attack, which resulted in his being kept in an induced coma for more than two weeks. She supported and stood by him during his ensuing year-long depression and recuperation and then, not two years later, when he was just beginning to bounce back, went through another and possibly worse scenario involving his health and welfare.

Eight months ago, Michel fell from a ladder, hit his head on the cement floor and was on the critical list for days. This was followed by another two-week period during which he was again kept in an induced coma. He has emerged with a changed and very aggressive personality—not unusual with brain injury victims. In fact he can be, at times, verbally abusive and difficult to deal with, but Nadine—who does express her feelings and reactions to this without any inhibitions—is at the same time unfailingly loyal to her mate. She remembers how he was before all this happened—warm, funny and a devoted family man—and this memory fuels her fierce determination to stick by his side. It's clear that she will do anything possible to help him, as he struggles with the various medications he's being given to ameliorate his wild mood swings.

Her depth of commitment and loyalty is impressive, and what's also impressive is that she doesn't pretend to be an angel. She vents, and she shakes her fists at cruel fate, but she hangs in there. Cancers are such emotional types that they can't—and don't—hide behind a façade of false good humor and optimism. They can, in fact, be the most pessimistic and depressing people in the world to be around when they are in one of their miserable, blue moods. It's best to try to steer clear of Cancers when they're in such a state, because nothing you can do or say is going to cheer them up, and actually is likely to antagonize them.

Leave them alone, though, and they will, soon enough, emerge with a sunny smile. All the people I know who've been married to Cancers have concurred with me about this simple truth. It's really a matter of respecting the fact that Cancers feel what they do, when they do, and there's nothing that can be done about it. They appreciate being given space when they need it, and love to be close and connected when they're in

the mood. And no one can be more considerate, gentle and sensitive companions than Cancers. Nothing escapes them, and they will pick up on your worries and concerns with their extraordinary psychic antennae and sympathize in a way that no others (except perhaps Pisces) are capable of doing.

Cancers' immense practicality also shows up in their attitude towards money, and a Crab will go to a great deal of trouble to avoid spending one cent more than necessary, even if this means walking a mile out of their way. If this sounds miserly, the truth is that Cancers are not ungenerous. Their hearts will open up to others who are in real need or distress, and they are also generally willing—even eager—to reciprocate when they are given to.

Money also represents security, though, which is why Cancers are so careful with their funds. It's extremely rare to find a Cancer who does not have a rainy-day cache that's been judiciously set aside, not to be touched except in the most dire of emergencies. Cancers also delight in comparison shopping and will always check out all the possible options before doling out their precious cash. Impulse buying is simply unimaginable to those born under this sensible sign, and if they see anyone else engaging in such behavior, they feel genuinely shocked.

Cancer's cautiousness is another aspect of this sign's inborn instinct to protect and preserve. Before undertaking any new endeavor, Crabs will investigate every angle, and they also prefer to take the tried and true approach rather than chance a risk. In business, Cancers are often startlingly successful and shrewd, playing their hand close to their vest and strategizing with extraordinary finesse. Impulsive behavior strikes Cancers as foolish behavior. They play to win and are often brilliant card players and crossword-puzzle enthusiasts.

Not being pushovers in any sense of the word, Cancers are also canny negotiators and will drive a very hard bargain. It's easy, initially, to be fooled by their gentle and affable demeanors, and this undoubtedly contributes to the success of Cancers in business situations. Competitors are all too likely to underestimate their ability not only to stand their ground but to outmaneuver their opponents—and in these instances, the element of surprise also works in their favor.

If you want a good deal on a used car—or any article you're looking to buy—you're well advised to take a Cancer friend along on your search, because you'll not only end up with a vehicle that runs like a dream but you're going to get it at a brilliant price as well. When I first arrived in France, my friend Cecile (June 29) accompanied me to several car lots, and despite her disarming femininity and charm—which lulled the salesmen into false hopes of a quick and easy sale—she managed to subtly take such control over these interactions that each and every one of them ended up falling all over themselves in their attempts to close the deal. Her detailed questions, her careful and clearly expert

scrutiny of every car we looked at and her relentless bargaining netted me (at an absurdly low price) an entirely reliable little Renault that has proved impeccable in every way.

What's more, Cecile thoroughly enjoyed our expedition. She delighted in the whole process of picking each proffered vehicle apart and driving the price down. Cancers love to get good value for their purchases, and if you've ever gone shopping with a Crab you probably haven't failed to notice how they, for instance, tend to rub the fabric of a dress between their fingers, turn it inside out and examine the stitching, hold it up to themselves, frowning in concentration, and then finally take it to the dressing room where it will undergo the next level of scrutiny.

Such patience is unquestionably a virtue, and on those occasions when my Cancer husband and I went grocery shopping together, I was forced to slow down and comparison shop even small items like dish-washing sponges, which, I discovered, varied vastly in price and yet were really very similar. I was embarrassed by my own inclination to grab what I needed and recklessly toss it into my cart, and his patience and the care he took in selecting each and every article were an object lesson to me in the value of being more practical and focused.

Cancers are also highly territorial, and their instinct to protect their turf is easy to understand if you can appreciate how attached they are to their homes and families. "Home is where the heart is" is a phrase probably coined by a Crab. Home and all that it represents—protection from the storm and the comfort of security—are what matter most to one born under this vulnerable, emotional sign. Cancers aren't necessarily house-proud, though they can be. But they don't tend to accrue possession to show them off; their purpose is to use them. And comfort and utility will generally take precedence over appearance and décor.

Not that those born under the sign of the Crab lack the artistic touch or an appreciation of beauty. Their connection to their emotions often makes them extremely receptive to music and all forms of artistic expression. Cancers also generally love the sea and are sometimes enamored of boats—to an often obsessive degree. A boat, of course, is a home on the water, so this fascination on their part isn't difficult to understand. Everything involved in preparing a boat for a voyage—making sure it's sea-worthy, outfitting it and stocking up on provisions—is the perfect metaphor for the Crab's search for a sturdy refuge from the stormy seas of life.

Clinging to what's safe and known, Cancers retain impressions and experiences with greater tenacity than any other sign of the zodiac. The past remains present to a Cancer, because it's always somehow with them, and Crabs are as retentive of memories as they are of objects.

"When from a long-distant past nothing subsists...the smell and taste of things remain poised a long time, like souls, waiting to remind us," wrote Marcel Proust (July

10, 1871) in his celebrated *In Search of Lost Time*. This sentiment is a testament to those sensations that trigger the remembrance to which Cancers are so exquisitely tuned. And Proust, who was so wrapped up in the past and the emotions it evoked, was expressing an aspect of his nature that all those born under this birth sign seem to share.

Nostalgia for a disappearing world is also evident in the work of artist Andrew Wyeth (July 12, 1917), whose depiction of the familiar, reassuring landscapes of his rural home-town struck such a chord in the American psyche. Home and family, typically Cancerian themes, also play a major role in the novels of Pearl S. Buck (June 26, 1892), who wrote so feelingly about family life in a Chinese village before World War II that her book *The Good Earth* became a best seller and won the Pulitzer prize. She also founded a wel-come house for the care of the children of Asian women and American soldiers—a truly Cancerian undertaking and a testament to her nurturing nature.

What all Cancers share is an emotionality that makes them both vulnerable and self-protective, and Ernest Hemingway (July 21, 1899), who wrote about tough guys who were so obviously fueled by intense and overwhelming feeling, brilliantly explored this dynamic in his novels. Hunter S. Thompson (July 18, 1937) was another Cancer writer whose emotionally charged—and often comic—reactions to his experiences were what made them so entertaining.

Interestingly, the two most celebrated advice columnists of all time—Ann Landers (July 4, 1918) and Abigail Van Buren (July 4, 1918) were both Cancers—and they were, in fact, twins. Direct, emotionally astute and full of home truths, these two women were able to evoke the archetype of the all-knowing mother (Cancer, of course, is the sign of the mother) in a way that the public found quite irresistible.

John D. Rockefeller (July 8, 1839) was a Cancer who displayed another aspect of this sign's character: shrewd, self-preserving and tenacious. He was, in fact, such an intuitive-ly gifted businessman that he went on to become quite literally the richest man in the world. Rockefeller also firmly believed in family values and was entirely devoted to his wife and children, as Cancers almost always are. John Wanamaker (July 11, 1838), con-sidered the "father of marketing," was another enormously successful businessman born under this sensible, survival-oriented sign.

Any number of unusually gifted actors are Cancers, and they are often renowned specifically for their extraordinary emotional range, like Meryl Streep (June 22, 1949), widely regarded as one of the most talented actresses of our time. Jane Russell (June 21, 1921) was a Cancer, and so are Harrison Ford (July 13, 1942), Diana Rigg (July 20, 1938) and Donald Sutherland (July 17, 1935), not to mention Tom Cruise (July 7, 1962).

The comedic side of the Cancerian personality has a way of stirring emotions while tickling people's funny bone, and no better example comes to mind than Robin Williams (July 21, 1952), whose performances seemed often to be both moving and

hysterically amusing. Bill Cosby (July 12, 1937) is also a Cancer, and his brand of humor has what might be described as a folksy or even homey touch (very crablike, and also parallel to the tone Red Skeleton, July 18, 1913, so skillfully struck); while the two famous comediennes Gilda Radner (June 28, 1946) and Phyllis Diller (July 17, 1917) were similarly satirical and self-mocking.

Lady Diana Spencer (July 1, 1961) was another Cancer who managed to touch hearts and stir emotions, perhaps because she herself was so ruled by her feelings. Her response to people in need was spontaneous, direct and emotionally charged. She understood that the best medicine can be to simply reach out and touch someone in distress—as she put it, "Hugs can do a great amount of good."

THE CARE AND FEEDING OF A CANCER

Probably one of the reasons why you so treasure your connection to the Cancers you're close to is that they can be so emotionally responsive and caring. If they see that you're upset about something, they try to help you, and if you're not feeling well, they hover over you and take care of you. You have the sense—even the conviction—that if your car breaks down, they'll come to your rescue. You know that their feeling for you is a real and palpable thing. It translates into action. It's worth the world.

On the other hand, what you may sometimes find difficult to deal with in your Cancer are his or her moods—especially when it's one of those heavy, nothing-is-right-with-the-world kinds. It's hard not to feel enveloped in the cloud of gloom that seems to descend over everything and engulf you. And you've long ago made the discovery that no matter how brightly you smile or how peppy you act, your Cancer is not going to cheer up. In fact, he or she will more likely eye you sullenly and leave the room.

What you've learned, of course, is that the best way to counteract your Cancer's dark moods is to leave him or her alone and go your own way. And you've probably been surprised by how quickly your Cancer bounces back from the far side of the moon, as if nothing ever was amiss. This tells you quite clearly that as bleak and cast down as your Cancer may sometimes appear, it's probably not as dire nor serious as it looks. Which is not to say that Cancers don't feel deeply. Cancer is the zodiac's first water sign—characterized by pure, unadulterated emotion that overwhelms everything in its path. This is what makes your Cancer so self-protective and touchy. Cancers possess an intense emotional responsiveness to everything they experience, which is why, like the crab, they need to grow a hard shell to keep themselves safe from being swept away.

Your Cancer picks up on your emotions too—every fleeting little shift in your tone of voice and expression is taken in and responded to, and your Cancer often has to step back inwardly to keep from being overwhelmed by *your* feelings. You may have noticed that when you're angry and upset about something that has nothing to do with your Cancer, he or she may take your raised voice and annoyed expression personally and become riled up. You always need to remind yourself how emotionally open your Cancer actually is, although he or she can seem—at times—the exact opposite: indifferent, stoical and tough-minded.

Which doesn't mean you can't be openly expressive with your Cancer. Just be aware that he or she has what might be described as a heightened quality of feeling that he or she has learned to cope with somehow. On the plus side, your Cancer isn't prone to miss the clues you send out, or to tune you out and not respond to your needs. Your relationship with your Cancer is special because of this ever-present current of feeling and connection that's going on, and it's one of Cancer's gifts to be present in this way.

You can probably see, though, that it's not always easy to be as responsive to everything as your Cancer is, although in some situations it gives him or her an edge. You can't fail to notice that your Cancer is quick to pick up on other people's hidden agendas and suss out what they're really about beneath whatever façade they may present to the general public. Your Cancer has wonderful instincts that help him or her to survive as well as to thrive. So many of his or her responses are based on avoiding danger and staying in a certain safety zone, and that's a very important clue as to how your Cancer navigates through the world.

Cancers really are quite canny, although they can develop a certain cynicism about people and life that comes out of their ability to see—or, more accurately, to feel—their way though false fronts and pretenses. Remember, though, that if Cancers sometimes appear negative and critical, it's because they have been disappointed when others have not lived up to their high ideals, have shattered their hopes and abused their trust. The imprint of painful emotional experiences remains a living presence in Cancer's inner world. This can make it difficult for Cancers to give people and situations that have wounded them a second chance. Sometimes they just can't go there. And it can put you in an awkward position if the situation involves a mutual friend or acquaintance.

Cancer's self-protectiveness is so deeply instinctive that it's not subject to conscious control. Once burnt is enough; Cancers will not repeat the same mistake twice. You must admit that there's a definite logic to this, even if it strikes you as extreme. Always remember that feeling safe is of primary importance to your Cancer. And the plus side is that being with your Cancer makes you feel safe too. The self-preserving instinct that guides your Cancer envelops you in a protective force field which can be a very cosy and comforting place to be.

You can also count on your Cancer to turn up when you expect him or her to, because Cancers are reliable. Being sensitive and vulnerable under their capable façades, Cancers understand too well how unpleasant it is to be placed in an insecure position, and they don't like to impose such experiences on other people. It's easy to take a Cancer's empathetic generosity for granted, but it's another of their qualities that make them worth seeking out and knowing. Your Cancer has the ability to identify with you and what you're going through at any given time, and this has the wonderful effect of bolstering you up and keeping you from feeling alone.

Your Cancer's loyalty to you is also something you can count on. Cancers are innately cautious when entering into new relationships and go through a process of advancing and retreating during the initial phases that can be a little baffling to anyone on the receiving end. Once they've determined that you are someone they can respect and trust—and those are all-important matters to them—you can be sure that they will stick with you through all manner of trials and tribulations and stand up for you when they sense that you're being mistreated in any way.

What's important to understand about your Cancer is that he or she takes your relationship deeply to heart and expects you to respond in kind. Always treat your Cancer with the tender consideration that he or she deserves, because even inadvertent hurts and slights will be felt and recorded and will have a damaging effect on your connection. Your ability to be kind and considerate, on the other hand, will be noted and appreciated in a way that is a reward in itself.

Another matter of signal importance is your understanding of the significance of family ties to your Cancer. Even if your Cancer is alienated from a close relative, they do not dismiss these bonds lightly and never will. Your Cancer will feel impelled to spend time with family members and to remain consistently in touch with them. And while Cancers may occasionally criticize someone from their own clan, they will not take kindly to anyone else doing the same.

To them, these ties are sacred, which tells you a lot about your Cancer's most important priorities. Cancers will take the roles that they have been assigned in their lives—son, sister, parent, friend or employee—completely to heart and will not hold back in their efforts to live up to the expectations involved. What's more, they take the assumption of such responsibilities for granted and are shocked when others don't do the same.

To sum up, what your Cancer needs most from you is understanding, appreciation and the same support you unfailingly receive from them. And while your Cancer may at times be unpredictably moody and difficult to read, you won't doubt—deep down—that the bond between you is full of affection, substance and enduring strength.

CANCERS IN LOVE

Cancers in love are tender, caring and committed, but they don't give their hearts easily. In typical crab fashion, they will approach a possible lover obliquely, never revealing their deep and passionate feelings until they are absolutely convinced that they are on safe ground. No doubt they are so careful because hurt and rejection so devastate them. And when they do lose in love, they are so completely destroyed that they will withdraw into their shells for a long period of sadness and mourning. They will tend to keep their hurts private, though, so that even the object of their affection may never realize how much they've suffered or how deeply they've been wounded.

Of all the signs of the zodiac, Cancers are also the most inclined to be faithful and, if they marry, to take their vows to heart. Their belief in the value of family and the ties that bind are fueled by their inborn desire for security, which is probably why they so firmly uphold them. This is also why they are so careful about entering into a close relationship to begin with, and why they must be certain in their heart that the object of their affection is an admirable and worthy recipient. Cancers take love seriously, are highly sentimental and give their chosen other the very best of which they possess.

When it comes to the fiery sign of **ARIES**, Cancers often find the very direct and sometimes aggressive manner of those born under the sign of the Ram to be a bit abrasive and threatening. Traditionally, these two signs are considered to be incompatible because they "square" each other, which is to say that they quite simply clash. Aries' boldness can strike Crabs as being unnecessarily rude, and they will tend to pull back on first encountering a Ram or to give them a wide berth. Secretly, though, they might admire the Ram's confidence, and this can form the basis of a connection given time. Whether it will last, though, is the real question, because these two invariably seem to rub each other the wrong way. The volatile relationship of Billy Crudup (Cancer) and Claire Danes (Aries) is an example of this combination.

Cancers don't bond with Aries on first meeting, and usually not even the second time around. The friendships that spring up between these two generally take time to form and will happen because they are thrown together or share common interests. The problem for the Crab is that Rams aren't particularly tuned in to their brand of sensitivity and will tend to be too challenging and forceful for the Cancer to feel comfortable and safe. Aries' "tell it like it is" manner tends to put the Cancer, who prefers to skirt difficult subjects, on the spot.

A Cancer parent with an Aries child, on the other hand, will generally be quite proud of their little Ram's fierce will and fearless approach. And even though the Crab may tend to be overprotective and to feel a bit anxious about some of their Aries child's antics, they will be, particularly when the Ram is quite young, highly supportive and loving.

TAURUS and Cancer are immediately at ease with each other, and Crabs like the way those born under this Venus-ruled sign make such an effort to be gentle and pleasant to everyone they encounter but are down to earth enough to be honest. In fact, Bulls can draw Cancers out more readily than almost any other sign can, because they are so reassuringly practical and normal. And what creates the glue between these two is their mutual longing for security. What's better than finding someone who not only understands you, but who's prepared to give you what you need? James Brolin (Cancer) and Barbra Streisand (Taurus) are an example of this combination and long shared an enduring and happy bond.

Friendships between Cancers and Bulls spring up quite spontaneously because these two are intrinsically in harmony with each other. Cancers don't feel intimidated by Bulls, and they sense that they can open up and trust the steady and kind-hearted Taurus, which is not something they do very readily. Cancers particularly appreciate the fact that, when they're feeling overwhelmed and upset, their Taurean friends are patient and not inclined to pass judgment. Bonds between these two tend to last lifetimes.

A Cancer parent delights in the calm, sweet character of a Taurus child and finds much in his or her personality to reassure the Crab that the little one will thrive. The little Bull's patience and determination are traits the Cancer parent especially treasures, and little disharmony will erupt to undermine the strength and warmth of this parent/child bond.

Cancers aren't particularly drawn to GEMINIS, but they often find their liveliness quite enchanting. Geminis are communicative and playful, which Crabs enjoy, and those born under the sign of the Twins are rarely aggressive, another aspect of their natures that Cancers appreciate. Bonds between these two often thrive because Venus, which travels close to the Sun, is often in the other one's birth sign—a placement that is quite mutually magnetic. And while their natures are different, Cancers don't feel at odds with Geminis; they may even perceive them as being complementary to themselves. The Duke of Windsor (Cancer) was even willing to give up a kingdom to seal his bond with Gemini Wallis Simpson.

Although Cancers may make friends with Geminis, they don't immediately experience a feeling of comfort and trust with those born under this airy sign. It's usually common interests that bring these two together, and Crabs are often prone to feel a bit let down by their Gemini friends. The reason for this is that Cancer's sensitivity makes it difficult for the Crab not to feel slighted by Gemini's typical behavior: overbooked, a bit distracted and always on the move. Cancers often drift apart from their Gemini friends for this reason.

Cancer parents will initially be stimulated and pleased by their little Twin's desire to reach out and communicate. A happy connection will spring up between them, but

once the Twin reaches adolescence, the Cancer parents are likely to feel emotionally out of sync with their cool, independent child.

Cancers do find other **CANCERS** sympathetic and appealing, but at best, their relationships are destined to be volatile. If they tumble for each other, they may initially believe that they've truly found their soul mate, but the truth is that they're too alike in their tendencies to establish a workable balance. Their moodiness can cause them to overreact to each other, and when one pulls back, the other is likely to distance him- or herself even more. As a result, they often wound each other unintentionally and then expect the other one to make amends—something like a Mexican stand-off. What can bind them together, though, is their intense emotionality and their love of home. Dan Ackroyd (Cancer) and Donna Dixon (Cancer) are two Crabs who've made this combination work.

Cancers do make good friends, and they seem to experience a wonderful sense of coming home when in the company of other Crabs. Their shared sensitivity means that they understand each other deeply and in each other's company they can relax, let down their guard and express even their most pessimistic feelings without fear of being judged. They also share a particularly zany kind of humor, and when two Cancers are together, laughter is bound to erupt. These friendships also endure because two Crabs treat each other exactly as they hope and expect others will treat them.

Cancer parents tune into their little Crab offspring with enormous tenderness, which is what their tiny duplicate needs and craves. The little Cancer's sensitivity and mood changes won't disturb the Cancer parent unduly, and he or she will have the wisdom to leave the child alone when privacy and a bit of time to come around are needed.

Water and Fire don't make the best mix, so when it comes to fiery **LEO**, while Cancers enjoy Lions' playful banter and jaunty manner, they also tend to resent their need to dominate the scene. The Cancer, though, does respond to Leo's sunny warmth, and this can be enough to draw him or her out. Leo's confidence also appeals to Cancer, who sometimes suffers from a lack of it. What will determine if this combination works is whether or not the Cancer feels that he or she is getting enough attention from the Lion. The positive side of this astrological bond is that these two can make each other feel secure; Sylvester Stallone (Cancer) and Jennifer Flavin (Leo) seem to be a pair who have managed to get the equation right.

Leos and Cancers can easily form friendships and seem to bring out each other's childlike, playful side. But though initially these two may hit it off, the Leo's demand for attention can get on the Crab's nerves. And though normally the Cancer will defer to the Lion's bids to take control, resentment will build up, and the Crab will, in characteristic fashion, retreat without saying or doing anything to explain his or her actions. And if and when this occurs, the Cancer isn't likely to give the Leo a second chance.

Cancer parents with a Leo child will generally be very supportive and loving to the little Lion, but won't always accede to his or her demands for acknowledgment and attention. Raised voices and showy behavior tend to rub Crabs the wrong way, and the Cancer parents will make efforts to tone down their Leo child's behavior, but always in a gentle, caring way.

Cancers tend to like **VIRGO'S** unassuming manner and practicality and to feel very much at ease with those born under this earthy sign. A real bargain sealer is often Virgo's ability to stretch a dollar, and Cancers have no difficulty identifying with Virgos and accepting them into their charmed circle. Cancers also admire Virgo's discerning and analytical mind-set, which they seek to emulate in their own way, and the only deal breaker for the Crab is Virgo's tendency to criticize, which can cut the sensitive Cancer to the core. Celebrity examples of this bond are hard to find, but I have met a number of Cancer/Virgo couples who seem to have found lasting happiness together.

Cancers and Virgos bond easily, so friendships between these two are natural and common. Cancers find Virgos sympathetic in many ways and admire the way they think. If the Crab senses that the Virgo is taking a critical stance toward him or her, though, this friendship can quickly go awry. What the Crab will appreciate, though, will be the lengths a Virgo friend will go to in order to make amends. And the Cancer's feeling that the Virgo is capable of being sensitive and caring can make this a connection that endures.

A Virgo child will appeal to Cancer parents in many ways, and he or she will very much enjoy their interactions. Best of all, the Crab will find the Virgo child to be quite receptive to instruction and to picking up on all the messages the Cancer parent feels it is his or her responsibility to convey. The bond the Cancer forms with the Virgo child will be a caring and supportive one that promotes lasting closeness.

Cancers and **LIBRAS** are both gentle, sensitive signs, and Cancers may be drawn to Libras for this reason. Crabs appreciate Libra's diplomacy and their willingness to pay attention and really relate. What's tricky about this combination, though, is that these two signs actually square each other; as a result, they can—at times—jarringly clash. The Crab may become critical of the Libra's far less cautious attitude towards spending and can also find Libra's characteristically cool and objective way of thinking to be distancing and unsympathetic, which leads to the Crab's feeling highly ambivalent and torn. Pamela Anderson (Cancer) and Tommy Lee (Libra), who have married and divorced twice, are an example of this volatile pairing.

Friendships between Cancers and Libra are often uncomfortable and difficult to sustain. Cancers often suspect Libras of harboring ulterior motives or just generally don't trust this airy sign because—to the emotional and sensitive Crab—Libras seem too calm and cool, or somehow facile. Connections can spring up between the two, though, when

the Libra makes a deliberate effort to reach out. But because of the difference in their natures, Crabs aren't generally inclined to extend themselves in the same way.

When the Crab is landed with a Libra child, though, the result is very different. Cancer parents will tend to admire their little Libra's ability to reach out and relate and will delight in their child's desire to please. Adolescence may present a bit of a challenge because separation will tend to be difficult between the two, and the Cancer parents may feel slighted or hurt by their Libra child's defection to other people and situations.

Cancers are attracted to **SCORPIO'S** intensity and will sense that this watery sign operates on a similar wavelength. Sparks can fly when these two meet and passions may be aroused. The Crab will revel in the feeling that the Scorpio is equally emotional and can meet him or her halfway. Cancers are also magnetized by Scorpio's palpable sensuality. But Cancer's sensitive antennae will also detect Scorpio's colder, darker side, and this causes alarm signals to go off that may drive the Cancer away. Princess Diana (Cancer) and Prince Charles (Scorpio) epitomized this connection, but, curiously, Camilla Parker Bowles is a Cancer as well.

In friendship, Cancers will find themselves drawn to Scorpios for the same reason: because they feel so strongly and exude such passion and intensity. Because Cancers identify with Scorpions, they will extend their trust more willingly than usual and will expose their hidden fears and emotions. Powerful pacts may form between the two which will be broken only if the Cancer becomes wary of the Scorpio's motives and suspects that he or she is less than honest or sincere.

A Cancer parent will tune into his or her little Scorpion so easily that an instant bond will be formed. Cancer's tenderness and warmth will provide a safe environment for the emotional Scorpio and the Cancer parents will also have the wisdom to allow their Scorpion child to keep whatever secrets he or she wishes to keep.

SAGITTARIANS are so jovial and optimistic that Cancers tend to be drawn in. Intense attraction between these two, though, isn't probable unless the couple shares some other astrological connections. The fiery Sagittarius isn't emotionally engaging enough for the Cancer to connect with deeply. On the plus side, Cancers do feel buoyed up by Archers' good spirits and sociability, which has the effect of brightening their own spirits. Tom Cruise (Cancer) and Katie Holmes (Sagittarius) are a Cancer/Sagittarius couple who seem to have found lasting happiness.

Cancers and Sagittarians may form friendships, but generally this happens when common interests draw them together. Cancers sometimes find Sagittarians a bit too sharp and direct or too carelessly caught up in their own pursuits to be the sensitive presence Crabs seek in a close personal connection. What Crabs will appreciate in their Sagittarius acquaintances, though, are their blithe spirits and good intentions.

Cancer parents will particularly treasure their little Archer's *joie de vivre* and sense of humor. The Crab is likely to feel that this child is a bit too impulsive or happy-go-lucky for his or her own good, though, and to respond by being a bit disapproving and admonishing. Still, a very warm bond will exist between the two.

Cancer and **CAPRICORN** are opposite each other in the zodiac (180 degrees apart), but this is one of the rare astrological oppositions that seems to magnetize more than it repels. Cancers are attracted to Capricorn's sensible and sometimes stern manner, which strikes a sympathetic note with the similarly cautious Crab. And since Cancers long for security, they are drawn to Goats because they appear stable and certain (even when they're not). Together, these two play out clear-cut roles and cleave to traditional values that keep them connected. Capricorn's lone-wolf quality, though, can seem cold and distancing and can drive the Moonchild away from this otherwise very workable bond. Egon von Furstenberg (Cancer) and Diane von Furstenberg were an example of this pairing.

Cancers and Capricorn can be good friends, and they work well together, too. Cancers get a kick out of Capricorn's gallows humor and aren't put off by Goat's pessimism, because it matches their own. Crabs also feel secure with Capricorn, who is steady, reliable and responsive to demands. A certain balance can be struck between these two that is mutually strengthening and supportive, and they can form satisfying connections that also stand the test of time.

Cancer parents will have no difficulty bonding with their little Goat, who seems to strike a special chord with them and to be an ideal child. The Capricorn's strong sense of duty is exactly what the Crab parent admires most, and for this reason, Cancers tend to shower this child with affection and to be quite proud of him or her. Very positive emotions tend to permeate this parent/child bond.

Amazing attractions crop up between Cancers and **AQUARIUS**, because as completely unalike as the two signs are, they fascinate each other. Cancers seem to be drawn to Aquarius' zany humor, as well as to Waterbearers' highly individualistic way of going, which strikes the Moonchild as a form of strength. Aquarius' ability to respect the Crab's need to occasionally withdraw and regroup may also make the Moonchild feel safe with those born under this airy, intellectual sign. Enormous misunderstandings can crop up between these two, though, that are very difficult to resolve. Nancy Reagan (Cancer) and Ronald Reagan (Aquarius) seemed to find a wonderful kind of balance in their bond; another example of the combination was Natalie Wood (Cancer) and Robert Wagner (Aquarius).

Friendships between Cancer and Aquarius can thrive for the same reason: these two signs are so unalike that they can be complementary. Cancer's emotionality finds solace in the clear, objective reason of the Waterbearer, who is also so humane that the Crab

feels reassured even if the Aquarius seems a bit distant. What tends to happen is that these two will either intrigue each other or fail to connect at all.

Cancer parents will find many of their Aquarian child's traits admirable and noteworthy. What's bound to be a bit tricky, though, will be the Crab's instinct to protect the little Waterbearer when he or she craves the freedom to test the limits. Emotionally, the Cancer won't have difficulty connecting to the gentle Aquarius until, as an adolescent, the Waterbearer pulls away rather sharply.

PISCES is traditionally considered highly compatible with Cancer, because it's also one of the three water signs (Scorpio is the other). And Crabs do often find Fish sympathetic and easy to be with. Lots of tenderness, sensuality and emotion can arise when these two signs come together, but one or the other must take the initiative, and because they are both so self-protective and receptive, this may not happen. Once bonded, Cancer and Pisces will treat each other well, but there's a danger that they will be too hypersensitive with each other to communicate effectively, which may very well have been the case with Elizabeth Taylor (Pisces) and Michael Todd (Cancer).

Cancers usually warm to Pisces because Fish are sensitive and emotional like themselves, and these two can become fast friends. Problems tend to crop up, though, that involve hurt feelings on both sides, because these two signs have a tendency to wait for the other to make moves or issue invitations. Crabs are also likely to become critical of what strikes them as Pisces' spacey way of not paying attention (usually to what they themselves are feeling). And for these reason, their bond can go sadly awry.

Cancers are prone to be very protective of their Pisces child, because they so quickly tune in to his or her sensitivity and lack of boundaries. In their eagerness to help equip their young Fish to cope with the real world, the Crab may tend to become a bit too controlling and anxious, but this won't noticeably undermine the warmth of the connection between these two.

COLORS, GEMS AND FRAGRANCES

The lightest possible shade of orange is Cancer's primary color, but because this emotional and changeable sign is ruled by the Moon, lunar tones also accord with Cancer: silver, white, or even a yellow-tinged white. In fact, from sunset to early dawn the Moon does take on many shades ranging from orange to white, and all of these are expressive colors for Crabs.

When a Cancer wants to attract attention and make an impression, orange actually is a very appropriate color to wear. The Moon is orange when it reflects the Sun when

full and rising, and Crabs can enhance their magnetism and project an aura of power, warmth and radiance with this tone. Being receptive by nature, Cancers can also raise their spirits by donning the right colors. Bright red is often too intense for Crabs, but as red begins to blend with yellow in the color spectrum, all the tones ranging from deep orange to a very pale shade of orange are wonderfully enhancing for Moon children.

The right shade of purple is quite calming for Cancers because it is the opposite, balancing tone (Capricorn's color). Indigo, violet and also maroon fall into this range, and cranberry is also an uplifting color for Crabs. Blues, on the other hand, can be a bit too cold for Cancer, although green, especially when it contains enough yellow, can be an upbeat, positive tone. White, although it is one of Cancer's colors, can make a Crab feel practically invisible.

The glowing, reflective pearl is Cancer's primary stone, and it is a lovely one for Cancers to wear because it is so expressive of Cancer's nature. Moonstones are also associated with the sign of the Crab, although this changeable gem isn't necessarily best for Cancers, who are so changeable themselves. In fact, the bright red ruby is often described as Cancer's lucky gem, because its color is so strong and definite that it charges up the Crab's energy.

The semiprecious orange chalcedony, a lovely opaque stone, is both flattering and beneficial to Cancer, as are the peach aventurine and the red jasper (which is more orange than red). A true blue/green turquoise is a semiprecious stone that is particularly positive for those born under the sign of the Moon. And silver is the metal considered to belong to Cancer.

The flowers associated with Cancer are the lily, the white rose and the gardenia. This is very much due to the fact that these flowers are so pale in tone and for this reason considered to be connected to the Moon, Cancer's ruler. Other flowers said to be related to Cancer are the iris, the white poppy and the southern magnolia. The sensitive and lovely acanthus is another flower that belongs to the Crab, and jasmine is often cited as well.

Ferns, hydrangea and water lilies appear to be sympathetic for Cancers, too, and the herbs that commonly seem to be connected to the sign of the Moon are sage, eucalyptus, fenugreek and bay. Aloe is also associated with Cancer and is soothing to Moonchildren in all its forms—as a skin cream, as a balm for burns and as a stomach-healing drink. The trees connected with Cancer are the alder, willow, acanthus and all sap-bearing trees.

As for fragrances, lily-based perfumes are wonderful for Cancers, and so are deep, musky scents. Another fragrance particularly expressive of Cancer's sensual side is gardenia, and sandalwood can also be appropriate for this subtle and sensitive sign. The Bach flower remedy that seems to be tailor-made for those born under the Moon is honeysuckle, which is prescribed for those who live in the past, but honeysuckle is an especially enhancing scent for Cancers, as is any fragrance that contains watermelon. ♋

5
Leo

23 JULY – 22 AUGUST

120°

*Great is the human who has not
lost his childlike heart.*

—MENCIUS (MING-TSE)

I grew up with a Leo—my sister Debbie, who was two years older than me—and from the beginning she dazzled me, as she did most everyone who met her. It wasn't just that she was adorable, with her wavy auburn hair and thickly lashed brown eyes. Debbie glowed. When she entered a room, heads turned. And she demanded attention in a way that I, a shy Libra, would never have dreamed of doing.

My two sisters and I each had chores to do in the house every Saturday before we were allowed to go out and play, and as soon as Debbie finished hers—cleaning the bathroom or the kitchen floor—she'd call in my mother and demand, "Didn't I do a good job? See how clean everything is?" which it always was, and to which my mother could have no other response than, "Yes, Debbie, you did a great job!"

Leos, I've noticed time and time again, crave this kind of feedback, and this is the real key to their natures. Their need to be witnessed could be interpreted as a kind of egotism, which it actually can be, but this is missing the point. Leos are driven by the urge to trigger responses from others that attest to their own special qualities. Their natural role is that of the leading character in life's ongoing drama because, after all, the Sun is their ruler—and what else is the Sun but the Earth's primary source of energy?

If you want to win over a Leo, give him or her a genuine compliment. Leos live for this kind of reaction. They can't help it; it's written in their astrological DNA. And there's no sadder sight than a Leo who doesn't get the hoped-for attention or response he or she is seeking, because despite their normally upbeat attitude and fiery vitality, Leos are tremendously vulnerable in this respect. Going unnoticed cuts them to the core.

Richard (July 31), the husband of a friend of mine, is so obvious in his bids for attention that it would actually be annoying if he weren't so likable and warmhearted. He isn't aggressive, exactly, but somehow whenever I've seen him in a group of people, the conversation always seems to get around to his quite glorious career in publishing, or his hobby as a watercolorist (probably because his wife steers it that way), and you can practically see him waiting for the murmurs of admiration and awe that, once they arrive, leave him purring like a big, contented cat.

On the other hand, on those rare occasions when Richard has somehow ended up being overlooked and uncelebrated, it's been very clear that, although he continues to behave normally, he is not a happy camper. He seems to become increasingly introverted and restless, finding his chair uncomfortable, or distractedly staring out windows. He is unfailingly polite, but he appears deflated. And he is.

Most of the Leos I know are creative. A few are artists, several are musicians and two are writers. Self-expression is what Leo is all about—whatever form that expression takes. And Leos are expressive in general, broadcasting their opinions and ideas, effusively emotional and prone to dramatics. Almost all the Leos I've ever encountered also exude warmth, although, in my opinion there are two kinds of Leos, the more outgoing and animated ones and those who are more contained and inward but who nonetheless are still driven by the same hunger for attention and applause.

The contained types of Leos seem more conscious of their need to maintain their dignity than the eager, notice-me-everyone kind, who often dress in very bright, dramatic clothes or attempt to make themselves eye-catching in other ways. The quieter, contained Leos have a more subtle way of drawing glances, and they often fulfill their need to be center stage by actually stepping into the spotlight and performing.

Alan (July 25), a Leo jazz guitarist I know, is an appealing person with a laid-back demeanor and a gentle smile. He has that characteristic Leo glow, but he tends to merge into a group rather than dominating it. His greatest pleasure and love, though, is to play his music in public, and when he picks up his guitar and gets going he is so brilliantly gifted that he is totally riveting. The pure joy on his face when he's performing also announces that playing and having all eyes upon him totally blisses him out. It's what he lives for, and it seems to feed his very soul.

Recently, I attended the solo concert of an American harpist who performs ancient and sacred music, practices a form of sound healing and also leads tour groups to French sites associated with Mary Magdalene. It was quite a casual setting, with the audience seated around her, occasionally making requests. What struck me was how gracefully Ani handled everyone, accommodating her public, continuing to play and play, and how despite the fact that some people were making endless demands, she seemed to be in her element and blooming, rather than wilting away (as I would have done).

Surrounded by a group of followers who obviously adored her, she resembled a kind and dignified queen holding court, and she turned out to be—no surprise—a Leo. Ani also seems to be one of those particularly evolved Leos who fulfill the role of light-giver and to whom people turn for guidance and insight.

I think the most highly developed Leos are those who live out the role of being sources of inspiration and energy, like the Sun. At the other end of the spectrum are those attention-hungry Leos who become peevish and distressed if they aren't constantly

being noticed and stroked. The average Leo probably falls somewhere between the two, sometimes amazingly generous and giving, sometimes discontent if the right kind of validation isn't forthcoming. Leos actually place quite a few expectations and demands on themselves which are probably not that easy to live up to.

On the surface, though, none of this is evident. Leos seem to need to project an image of self-certainty even if they're struggling with insecurity and lack of self-confidence like everyone else. They find it hard to admit it if they're quaking inside, and this is due to the famous Leo pride. The bright side of being born under the sign of the Lion is the magnetism and golden glow that goes with the territory. The down side is that when a Leo isn't living up to what seems to be his or her heritage of specialness, or even royalty, the result is depression, or at least a painful sense of lack.

Willpower, though, is another Leonian characteristic, and Lions can be formidable when they set their sights on a goal. Born under one of the four fixed signs (the others are Taurus, Scorpio and Aquarius), Leos possess a special kind of staying power, and they are very, very stubborn. Lions can be true miracle workers when they direct their will, like my amazing friend Susan (July 26), whose first-born child turned out to have cerebral palsy. Whatever dismay Susan may have felt—and she was bound to have been deeply upset—her reaction was to immediately start searching for solutions, even though all the experts told her there weren't any.

The upshot was that she ended up exploring and using a whole array of alternative therapies from Feldenkrais and biofeedback to yoga, never surrendering her conviction that somehow her daughter was going to triumph in the end. And after endless visits to various practitioners and years and years of exploring and following up on every potentially viable option, her daughter overcame the majority of her disabilities, eventually graduating cum laude from one of the Seven Sisters and entering the field of journalism.

What drove Susan, aside from her obvious love of her daughter, was her identification with her child as her own creation and part of her. She found her daughter's disability as unacceptable as if it had been her own problem, and this galvanized her into action and kept her moving ever forward. Her determination was so great, in fact, that she could—and did—move mountains to triumph over quite incredible odds.

What I love about Leos is the way they lead from the heart. They are wonderfully engaged with life and they are—in my opinion—the most emotional of the three fire signs. I don't think Leos are neutral in any way. I've met a few sad, discouraged Leos, but the majority of Lions who've crossed my path have been optimistic, full of fiery intensity and vividly—even cinematically—alive.

Leos usually have strong opinions, too, and they don't take kindly to contradiction. They are very sure of what they know and what they think. And when a Leo has a plan of action, it's generally impossible to override him; he will just ignore you and continue

to do whatever he has in mind. The Sun is at the center of the solar system, and Leos don't reflect what's going on around them. Their instinct is to take control, which is exactly why Leos often find it difficult to submit to authority. They will play along in an effort to be politically correct, but taking orders goes entirely against their grain.

Quite a number of my Leo friends are self-employed, or if they're not, they are department heads or chiefs-of-staff wherever they work. Even then, they tend to run into difficulties with higher-ups unless their bosses have the wisdom to let them run their own show. Pete, an August 7 Leo I know, quickly rose to the high level of chief superintendent in the police force, but was so unwilling—or unable—to bow and scrape as his commander expected that he was eventually forced to quit. (He became a private detective.)

Being servile, even in small, token ways, is practically impossible for a Leo. And this, I believe, is because Lions instinctively feel that they were born to rule. How can they be expected to go down on their knees when they should be sitting on the throne? You can generally recognize a Leo by his or her posture: the shoulders will be slightly thrust back, the head held high, and the Lion will move with a certain unmistakable majesty that instantly commands respect. This dignified, even royal way of carrying themselves seems to come quite naturally to those born under this sign. I've yet to see a Leo slouching.

Leos are sometimes quite dramatic, too, and they can get so caught up in their own theatrics that they get carried away. Strangely, this seems to be a form of play for them; I know one particular Leo, Neil (August 16), who falls in and out of love quite regularly, just because he so enjoys playing the role of passionate lover that he momentarily convinces himself that it's all true. Leos are often natural actors, not only because they adore the feeling of being onstage (with all eyes upon them) but also because they just love to play.

In short, the inner child is alive and well in all happy and healthy Leos, and is always ready to throw caution to the wind. It's not difficult to coax a Leo to join you for a night on the town or to dine at a five-star restaurant (Leos love luxury). And Lions will generously insist on paying for you and all of your guests and are rarely tightfisted— though they can be. Another thing I love about Leos is that they know how to entertain in style and excel at it, so it's always a joy to accept an invitation to their home. You will be feted and stroked and made to feel like royalty, because you have entered into their special circle.

I have known Leos who were austere, thrifty and self-denying, but they have been few and far between. Of the three Lions of this kind I've known, one had suffered extreme poverty in childhood and was still struggling, raising two children on a tiny budget and hardly making ends meet; one had joined a religious order that demanded relinquishment of worldly matters and goods; and the last was a student working her way through college.

Life-loving and spontaneous, Leos often have difficulty resisting temptation, especially when they're children; my sister Debbie would always find a way to climb on a stool and raid the cookie jar when she was a toddler, or, well before Christmas arrived, suss out where the presents had been hidden and try to sneak a peek at them, often leaving tell-tale signs in her wake. Of the three of us, she was the one who most often got into trouble and got caught (I was far more careful and surreptitious), because her excitement made her reckless, and because there was an almost royal disregard of common sense in her headstrong pursuit of whatever caught her eye.

The problem was that she had to pay the consequences—and Lions' sense of entitlement can get them in trouble when it doesn't work to their advantage. There's nothing more mortifying to a Leo than appearing foolish. The experience is soul-destroying and may even leave scars. It's hard to really fathom how fragile a Leo may be just beneath that shining, self-assured surface. And it's nearly impossible to reconcile the outward buoyancy with the inner sensitivity. I've known many stable, well-centered Leos, but I've also known several who self-destructed because they were so completely crushed by their inability to live up to their own ideals, or because they were so disappointed by life itself.

This is really the paradox of being a Leo, and I've noticed that most people are totally taken in by Leos' bravado and just don't get it that those born under this fiery sign are not actually tough and invulnerable in the least. Some Leos may act in the most brazen, outrageously arrogant fashion, but they sometimes stumble, and they may even break. And it's not easy for a Lion to reach out for help in such situations, because asking for help is an admission of failure. In many respects, Leos are loners, and they prefer to stay self-sufficient and to be in charge. Lions are more comfortable taking on responsibility and running the show, although they can and do like to delegate.

They also like to teach, and quite a number of Leos enter the teaching profession (when they're not creative artists, performers or entrepreneurs) because they so enjoy being in front of an audience whom it's their job to advise and inform. Entertaining is also Leo's forte, and Leos revel in their ability to not only capture others' attention but to inspire, excite and make them laugh. In fact, other people's laughter at their jokes and antics is truly music to their ears, and they will go to great lengths to elicit this response, even (within this context) behaving like fools with endearing abandon.

Leos are, in fact, often endearing, because they will expose themselves to ridicule (though not knowingly) and take chances that most of us wouldn't dare try. The Sun represents the ego in astrology; most everyone struggles with the desire for attention and love, often awkwardly and with a certain amount of consternation. But Leos are really forced to get out there and strut their stuff, because it's their birthright and their job. They show us all how it's done (when it works) and how embarrassing it can be when it isn't.

My sister Debbie was a terrific role model for me in various ways, and one was that her behavior could be an object lesson in how not to act with my mother. Sometimes her demands for attention worked, sometimes they didn't; and sometimes her obvious desire for something seemed to annoy my mother, which prompted me to be a bit less direct and self-revealing. Debbie was so transparent that it could be painful to observe. Everything about her was genuine, and her emotions could be read on her face in an instant. It was impossible for her to lie without giving herself away.

She was also a hard act to follow because she was such a scene-stealer—somehow more vivid, magnetic and riveting than everyone else. I felt pale and almost invisible in comparison (although I totally adored her), and I know of others with older Leo sisters who've felt very much the same. Debbie seemed to be a law unto herself—like a cat— following her own sure instincts and doing as she pleased. It struck me as an enviable way to be, and I've noticed that many Leos seem to have this catlike quality, possessing an air of independence and an inborn awareness of their dignity.

Leo's magnetism propels those born under this fiery sign into the spotlight more frequently than the norm, and what's particularly noteworthy about many famous Leos is how personality cults seem to spontaneously spring up around them. Take for instance the artist Andy Warhol (August 5, 1927), whose fascination with celebrity ("In the future everyone will have their fifteen minutes of fame") was a typically Leo-like preoccupation.

And then there's Jacqueline Kennedy (July 28, 1929), whose dignity and charm cast her quite fittingly into the role of America's most royal public figure and who excited so much curiosity, fascination and adoration that people still talk about her in hushed tones. The legendary Mata Hari (August 7, 1876) was another Leo whose charisma guaranteed her a permanent place in the public's imagination, and the same could be said of Magic Johnson (August 14, 1969), the fascinating T.E. Lawrence (August 16, 1888), Amelia Earhart (July 24, 1897), Dorothy Hamill (July 26, 1956) and Neil Armstrong (August 5, 1930).

Leo actress Lucile Ball (August 6, 1911) endeared herself to her public by being such a loud and lovably attention-grabbing dizzy dame, and it should come as no surprise that the seductive, riveting and adorably self-mocking Mae West was also a Leo (August 7, 1888). Robert Mitchum (August 6, 1917), who exuded masculinity, also possessed a particularly feline, tongue-in-cheek brand of charm; and Arnold Schwarzenegger (July 30, 1947) is another Leo who originally caught the public eye because he was such an exaggerated example of the muscle-man, tough-guy archetype—comedic and yet somehow also deadly serious.

Self-parody is a common thread that runs through many Leos' performance or creations, with Alfred Hitchcock (August 13, 1899) being a wonderful example of someone

who often poked fun at his own over-the-top sense of drama while still exploiting it, and Steve Martin (August 14, 1945) being another master of the art of comedically playing off one's own oddities.

Since Leo's are born to rule, it's not surprising that a staggering number of powerful world leaders, some of whom possessed particularly forceful personalities and all of whom were or are notably charismatic, were born under the sign of the Lion: Napoleon Bonaparte (August 15, 1769), Benito Mussolini (July 29, 1888), Menachem Begin (August 15, 1913), Fidel Castro (August 13, 1926), Yasser Arafat (August 4, 1929), Hugo Chavez (July 28, 1954), Bill Clinton (August 19, 1946) and Barack Obama (August 4, 1961).

And it's fascinating to observe how certain Leo writers are drawn to create larger-than-life anti-heroes (who might epitomize the overly inflated ego), like Herman Melville (August 1, 1819) who dreamt up the unforgettable monomaniac Captain Ahab in *Moby Dick,* and Emily Brontë (July 30, 1818), whose Heathcliff in *Wuthering Heights* is a character of such brooding power that his name is sometimes used to describe a certain type of character (as in "Heathcliffian").

Alexander Dumas (July 24, 1892) was a Leo author of another stripe; despite the fact that he made a great deal of money from writing, he was apparently often broke because—as Lions are prone to do—he lived in the moment, lavishly squandering his money on women and high living and entertaining in style at the Château de Monte-Cristo (named after his celebrated novel). He is best known, though, for *The Three Musketeers,* that wonderfully adventurous tale of heroic men, camaraderie and romantic love which reverberates with that life-loving spark that fuels the Leonian spirit. In his writing, Dumas, in fact, lends life itself a kind of magic, meaning and sense of worth, which is always the best novelists' gift.

Romantic, heart-stirring poets Percy Shelly (August 4, 1792) and Alfred Tennyson (August 6, 1809) were both Leos, and so was Sir Walter Scott (August 15, 1771) and George Bernard Shaw (July 26, 1856). And it was Shaw who remarked, "Life isn't about finding yourself. Life is about creating yourself"—possibly the quintessential Leo statement.

THE CARE AND FEEDING OF A LEO

If you live with or are close friends with a Leo, you're probably aware that he or she thrives when feeling appreciated and noticed. Like the great big cats they are, Leos love to be stroked, and those born under this sunny sign also exude an air of independence and self-containment that is characteristic of felines great and small. If you want to hear your Leo purr, all you need to do is give him or her a compliment. It should be sincere

and true, but even if it's a small one, like "You look really great in that sweater," it will brighten your Leo's spirits and perhaps bring a smile to his or her face.

It's not that your Leo is all that vain (though he or she might be), it's just that Leos live to be witnessed. It's their job description, and they are caught in the grip of an undeniable urge to get out there and shine in whatever way they're equipped to. Understanding this is essential if you're going to maintain a close, caring relationship with one born under the sign of the Lion. Your Leo can't deny this aspect of his or her nature (although, of course, each Leo handles it a bit differently), because it is emblazoned in his or her astrological DNA. You obviously don't need to go around pumping up his or her ego at every opportunity, but you do need to accept that getting positive feedback is all-important to your Leo and is one of his or her basic needs.

Precisely because your Leo appears strong and sturdy, it's easy to not cotton onto his or her vulnerability in this respect. And Leos are strong. If you're connected to a Leo by family ties and/or emotional ones, you're bound to be aware of how powerful your Leo's will can be. Your Leo will get out there and do what he or she has decided to do with a consistency and certainty that's quite impressive. Leos can be quite unstoppable when they have their eye on a goal or prize, and like the other three fixed signs—Taurus, Scorpio and Aquarius—they have an ability to stick it out and endure through even difficult situations. You can count on them to be there and—most of the time—to do what they say.

Aside from your acknowledgement of his or her abilities and contributions, your Leo also needs reminders about taking good care of him- or herself. Leos can be quite health-conscious, but they also tend to drive themselves too hard and to turn a blind eye to their body's messages and protests. Leos' famous pride—and this is a very real aspect of their natures—makes it difficult for them to (ever) admit defeat or stop trying. They are capable of pushing themselves beyond their endurance, and they really do need for those who care for them to urge them—when necessary—to put on the brakes.

The first part of Leos' body to show signs of stress when they are in one of their driven, "must do this" states is their backs—and the other huge stress point for Leos is their hearts. But of course you can't take responsibility for your Leo's health all by yourself, and Leos aren't generally daredevils or reckless types. They just must remember (or be reminded) to pay more attention to their body's signals and to stop when they've exhausted themselves.

You've doubtless noticed how your Leo's pride can sometimes prevent him or her from behaving sensibly or not overreacting and their pride tends to kick up most fiercely when their dignity is offended—again, very like a cat who will stalk off if treated disrespectfully or caught in an embarrassing situation. What you must remember, always, is that your Leo really is royal; not only is the Lion the king of the jungle, but the Sun,

Leo's ruler, is the monarch of our solar system. It may sound silly, but Leos do possess a certain, innate sense of their importance in the scheme of things—it is basic to their natures. This may appear to be pure egotism, but if it is, it is egotism in the best sense of the word: a consciousness of the self and the designated role the self must play on life's stage.

If your Leo feels belittled, he or she is bound to react even more strongly than you (if you're not a Leo) will do. And he or she will go to great lengths to make sure that whoever was responsible for placing him or her in such a position becomes aware of the error of their ways. Leos are not particularly revengeful, but if their pride is offended, they will roar—or rebel. They find an experience of this kind intolerable, and their only other option is to pretend that the unacceptable situation never happened and to refuse to acknowledge it.

Have you ever seen a cat accidentally tumble off a chair or table (possibly during a nap), then adeptly leap to its feet, glancing quickly around to make sure that its undignified landing escaped notice? Cats recover and right themselves so swiftly that the awkward situation seems never to have happened. And Leos will behave in exactly the same way under similar circumstances. Understanding and respecting your Leo's innate sense of dignity is essential to the health and welfare of your relationship. And remember, you can only tease a Lion up to a certain point before you risk offending and distancing him or her. Leos will sometimes decide to play the buffoon themselves because they love to entertain others, but they cannot stand to be made into a buffoon by other people.

What will rarely fail to delight your Leo and raise his or her spirits is hieing off to a five-star restaurant or plush resort. Few Leos can resist luxury and opulence. Most Leos will also revel in seeing and being seen at hot spots frequented by celebrities or other notables. If your Leo is one of the rare few who frowns on displays of wealth and excess, though (and this unusual type does exist), he or she will still be perked up by being the recipient of your complete and devoted attention. Even if you just make a bit of a fuss by preparing a tasty meal and mark the occasion by putting a vase of flowers in the center of the table, you will see your Leo light up and come out of whatever spin he or she might have been in.

Leos are not prone to push everyone away and go off on their own for any prolonged period of time, even when depressed. When a Lion behaves in this way, you can be certain that something is seriously wrong. A very depressed Leo is—in a sense—a contradiction in terms, because those born under this sign are Sun-ruled, light-emitting types. You will know that a Leo has taken a very debilitating blow if he or she slinks off and seems to drop from sight. And unlike with a moody and emotional Cancer, you should not hesitate—at least after a short interval—to intervene. It's so easy to think that Lions have tougher skins than they do, because they seem so sure and capable. But Leos

can actually get hurt to the point of devastation, and when they do, they need to be bailed out, although this is a role they can't bear to be cast in.

Instead, as you've certainly noticed, your Leo likes to take responsibility and to feel that it's others who depend on him or her. Your Leo also likes to be the one who calls the shots, and you will have to negotiate and stand tall if you're not willing to constantly go along with his or her plans. Of course, not all Leos are bossy, but those born under this sign do need to feel as if they are in control. You must be a strong, centered person to maintain the right balance with your Leo, but he or she wouldn't be your friend, lover or partner if you weren't. And if you have a Leo child, you've learned that you need to draw certain lines with him or her and to assert your authority and control.

Leo's take-over energy is just another aspect of this sign's urge to play the leading role. And Leos will back down if they're made to see that they're being overbearing and unfair. Your Leo's urge to take control is linked up with his or her desire to be noble, kind and just—in short, a benevolent ruler, not a tyrant. If you prove yourself equal to your Leo by asserting your own will, you will find that he or she will then respect you for your strength and self-confidence, and you will be rewarded by a royal portion of geniality and goodwill. You will also be treated to bursts of radiant generosity and affection which are guaranteed to be as delicious as basking in the warmth of the summer sun.

LEOS IN LOVE

When they fall in love, Leos light up like Christmas trees, and their joy is contagious. Leos are romantic to the core, and they believe in happy endings. Possessing an enormous reservoir of passion and intensity, Lions will be totally focused on their chosen one as long as they're getting the attention they need and live for. Leos can also be quite possessive in love and will not put up with disloyalty of any kind in their mates. If the romance dies down and there is little passion left, those born under this fire-ruled sign will tend to pine away.

Ruled by their hearts, Leos can be carried away by their emotions—but they generally are very careful about who they commit to and why. Their expectations run quite high when it comes to love; they don't hide their feelings and can communicate their needs without inhibition. Their openness and generosity can make them delightful companions, but Lions do not hesitate to make demands (unless their Suns are afflicted in their natal charts) and their tendency to dominate can trigger power struggles in their most intimate relationships.

On the other hand, Leos' warmth and spontaneity is a constant gift to their beloved. No one is more ready to rush to the aid of their one and only, or openly show their love, than a Sun-ruled Lion.

Leos can find **ARIES** riveting, because their fiery twins are as charismatic and powerful as they are, but Rams' tendency to compete rather than harmonize isn't conducive to smooth relations. Leos don't feel particularly noticed or acknowledged by Aries, who seem to be too busy pursuing their own ends to be satisfying companions, but the flip side is that Lions really do delight in the high energy charge of connecting with someone who is so clearly an equal, and this combination can be delightful when it works. The uneasy partnership of Robin Wright Penn (Aries) and Sean Penn (Leo) is a perfect example of this pairing in action (two splits and then divorce after fourteen years of marriage).

Leos and Aries can get along famously as long as their egos don't clash, and as far as friendships go, these two can have a lot of fun playing together and spending time in each other's company. Rams and Lions can set each other off and egg each other on in a way that is amazingly enjoyable for them both. Lions, though, really want—and often require—a more receptive audience than Aries is inclined to provide, and this can rub those born under the Sun-ruled sign of Leo the wrong way and lead to fallings out.

A Leo parent raising an Aries child will have his or her hands full, because the little Ram will not be particularly amenable to following orders or submitting to authority. Lion parents will admire their child's spirit and independence even while trying to control and direct their fiery Ram's actions, often unsuccessfully.

What Leos will find most appealing about **TAURUS** is the obvious strength and pleasant manner of those born under this Venus-ruled sign. Taureans are quite giving, and Lions usually find their presence soothing and reassuring and can also feel quite attracted to the sensuality Taurus can exude. What's tricky, though, is that Leos will eventually find Bull's stubborn streak a challenge. Strong-willed themselves, Lions tend to get involved in power struggles with those born under the earthy and determined sign of Taurus, and these may undermine the good feeling that originally triggered the attraction. Aside from Bianca Jagger (Taurus) and Mick Jagger (Leo), Gina Torres (Taurus) and Laurence Fishburne (Leo) epitomize this combination.

As friends, Bulls and Lions can stabilize each other and find each other's presence to be highly reassuring. The normally calm Taurus has the ability to relax the Leo, and the Leo can lend the Taurus the feeling of confidence that he or she longs for. Lions appreciate Taurus' steadiness, too; but just as a love match between these two can founder when the Leo tries to call the shots and the Bull resists, their friendship can also be undermined by battles of will.

Leo parents will be delighted by their little Bull's solid character and down-to-earth manner and will bond very easily with this child. Because Taureans are generally easygoing and amenable, the Lion parent will be able to harmonize with this child as well. Few conflicts are likely to mar this connection except when—occasionally—the Taurus child resists direction.

Leos are attracted to **GEMINI'S** outgoing friendliness and sparkle, and these two signs are traditionally considered to be highly complementary. Gemini's playful manner and attunement to cutting-edge trends appeals to Lions, and irresistible attractions can spring up. But what can defeat this love match is exactly those qualities that trigger the attraction: Gemini's changeability and love of living fully. Lions can come to feel that Twins lack the steadiness and reliability that they require, and they may come to suspect their loyalty. John F. Kennedy (Gemini) and Jacqueline Kennedy (Leo) were a Gemini/Leo pair, and so were Angelina Jolie (Gemini) and Billy Bob Thornton (Leo), whose marriage turned out to be short-lived.

Leos and Geminis get along famously, and friendships between these two spring up spontaneously and often last. Leos find Twins to be stimulating companions and perfect playmates, and they will also seek out Geminis because they so delight in the verbal sparring they can engage in with this witty air sign. These two signs' high spirits and optimism ensure that they will greatly enjoy each other's company, and Leos also appreciate that they can talk their problems out with their interested and articulate Gemini friends.

Leo parents with a Gemini child will be over the moon about their little Twin's charm, verve and wit. Leos make very proud parents, and with a Gemini child, the Lions usually feel particularly fulfilled in seeing how quickly their little one adjusts to new situations, wins others over and excels. And when the Gemini child of a Leo parent reaches adulthood, these two are likely to remain good friends.

Leo and **CANCER** are ruled by the Sun (Leo) and the Moon (Cancer), and when this match works it can be a classic. For Lions, Crabs' love of tradition, loyalty and tendency to coddle loved ones is a huge turn-on. On the other hand, Cancer's lunar moodiness can bewilder sunny Leo, Cancer's sensitivity can pass unnoticed by the thicker-skinned Leo, and when Leo is not in the mood to play the rescuing hero, Cancer's insecurity in certain situations can be a turn-off. Jennifer Flavin (Leo) and Sylvester Stallone (Cancer) are one such pairing who've made it work, and Marie Louise Parker (Leo) and Billy Crudup (Cancer) are an example of a couple who didn't.

Friendships between Leos and Cancers can thrive because, being next to each other on the zodiacal wheel, these two signs may share many planetary connections. A complementary interaction can spring up between these two, with the Leo tending to be the leader and instigator and the Cancer tending to look to the Leo for inspiration (which

the Leo likes). Lions appreciate that Moonchildren are there for them when needed as well, and friendships between these signs often stand the test of time.

A Leo parent is likely to find his or her little Cancer somewhat puzzling, since a Moonchild will swiftly transition from being outgoing and happy to withdrawing or dissolving in tears. And for this reason Lions may tend to be somewhat overprotective of their Cancer child, although emotionally this tie is usually particularly deep and strong.

The royal pairing of a Leo with another **LEO** can be amazing and highly passionate. The sparks that fly when these two meet can ignite a fire, but how long it blazes depends on whether the two Lions can remain mutually enamored and try not to dominate each other. Extravagant gestures, huge fights and dramatic reconciliations are typical between these two (especially if they are extroverted types), and yet they can make a brilliant team when they put their strengths together and identify with each other's interests. Two Lions can be destructive to each other, too, especially if one overpowers the other. Madonna (Leo) and Sean Penn (Leo) were two Lions who didn't manage to get it right, but Antonio Banderas (Leo) and Melanie Griffith (Leo) seemed to have formed a supportive and lasting bond, although have recently parted ways.

Friendships between two Lions may spring up quite spontaneously, but for these to last, both will need to be willing to share the limelight, which is difficult for Leos to do. Even working together will be challenging, because Leos like to be in charge and do not take orders easily if at all. Only in those rare cases where two Leos have a common cause that they feel passionately about, and which enables them to put their own needs aside, are they likely to successfully harmonize with a member of their own Sun sign.

Leo parents are capable of being truly nourishing of and supportive of their own little Lion, but everything depends on how developed and aware the Leo in question is. Some Leo parents are likely to clash with their willful Leo child and to be too severe in their response. Others, though, instead of taking their little one's behavior personally, will deeply connect to this child.

VIRGO'S sensible, down-to-earth approach to life may impress Leo, and those born under the Sign of the Virgin also seem to have a calming effect on fiery Lions. In fact, these two signs are so different that they may either complement each other or not connect at all. Lions do appreciate the clarity of Virgo's minds, their willingness to stay in the background and let Leos shine, and their independence. Virgo's cautious approach toward spending sometimes clashes with Leo's more lavish style, though, and this—along with Virgo's tendency toward fault-finding—can sabotage this often harmonious match. Madonna (Leo) and Guy Ritchie (Virgo) are quite a clear-cut example of an unsuccessful pairing, while Jacqueline Kennedy (Leo) and Aristotle Onassis (Virgo) were a couple who seemed to find contentment in this bond.

As friends, Leos and Virgos can be quite compatible, and if these two team up to accomplish something together, they're capable of playing off each other in a wonderful way. Their inborn differences can be complementary as long as they don't end up rubbing each other the wrong way. Leos appreciate Virgo's organization skills, but may rebel against what they see as Virgo's narrow vision. On the other hand, Virgos can be wonderful foils for Leos in that they can help the Lion to hone his or her approach. Leos also delight in Virgo's wit and powers of observation.

Leo parents are generally quite impressed with their little Virgo's common sense and adaptability. Everything about this child tends to please the Lion and to reinforce his or her sense that their little one is a credit to him or her and is capable of thriving. The positive feelings generated by this connection are often strong enough to ensure an affectionate and lasting bond.

Leos are often attracted to **LIBRAS** because people born under the Sign of the Scales seem particularly receptive to their charms. Libras try to please everyone, and of course Lions enjoy having so much attention showered on them; they also appreciate Libra's gracious sociability and ability to charm everyone they meet. Initially, this match may work, but the intrinsic danger is that the Leo will find Libra's constant attempt to strike a balance, and not overdo, restrictive and irritating. Lions may also fail to pick up on Libra's cues for more reciprocity in their interactions, which can lead to a breakdown in communications. When this bond does work, though, it can be quite a brilliant match, as it seems to be for Rosalynn Carter (Leo) and Jimmy Carter (Libra) and for Patti Scialfa (Leo) and Bruce Springsteen (Libra).

Leos and Libras tend to get along quite well, and friendships easily crop up between these two. The Leo may be unaware of how hard the Libra is trying to please and get along with him or her, but will enjoy the results—how easy and comfortable it is to be with this Venus-ruled sign. The Leo will also tend to take the more controlling role, though, which may lead to fallings out that are difficult to identify and repair. The basic inequality of these signs is that while the Sun rules Leo, it is "in fall" or poorly placed in Libras, who have much less confidence as a result.

Leo parents tend to delight in their Libra child, who is responsible, loving and outgoing. What's tricky about this situation, though, is that the Lion will have difficulty understanding that the little Libra possesses a less sure sense of self than his or her own and can feel more quickly discouraged and more vulnerable as a result. The Leos may also unintentionally overpower their Libra child and will need to tread carefully to avoid doing this.

Although **SCORPIO** and Leo are not considered compatible (because these signs are ninety degrees apart and therefore square each other), surprisingly often they are. Both are strong-willed and dynamic, and this alone can set up a magnetism between them. Leo is challenged and stirred by Scorpio's power and depth and feels steadied by

Scorpio's obvious self-confidence. Lions also sense that Scorpio will help them realize their ambitions and enhance their lives. If the Leo feels harshly judged by the Scorpio in any way, though (and Scorpio can be quite scarily judgmental), the Lion will tend to pull away and maintain a watchful distance for some time. Bill Clinton (Leo) and Hilary Clinton (Scorpio) are a fascinating illustration of the dynamics of this pairing, as are Arnold Schwarzenegger (Leo) and Maria Shriver (Scorpio).

Friendships form between Leos and Scorpios when these two somehow come together for a purpose. Initially, Lions are a bit wary of Scorpions, because they sense that those born under this fixed, watery sign are watching them and passing judgment (which they are). If the Scorpio begins to open up and become more forthcoming, the Leo will reveal his or her generous, giving side, and a real connection will be formed. Although volatile, friendships between Leos and Scorpios will be quite long lasting because both are quite loyal and steady in their affections.

Leo parents will immediately sense that they've met their match in their Scorpio child and will often fall quite passionately in love with the fascinating and strong-willed little Scorpion. Dramatic and stormy moments may occur between the two, but the Leo parent will be inclined to be particularly lenient.

On paper, Leos harmonize with **SAGITTARIUS,** and these two do tend to bring out each other's passions. Lions and Archers love to romp and play together and can enjoy a delightful feeling of camaraderie. The difference in the way their fires burn, though, can trigger issues that are impossible to ignore. Lions seek stability and certainty in their close relationships, and because Sagittarians tend to shoot their arrows in many directions at once and to be possessed of a kind of emotional wanderlust, Leo is prone to feel increasingly overlooked and neglected. Sagittarius' independence and need for freedom can also feel like a personal rejection. Melanie Griffith (Leo) and Don Johnson (Sagittarius) are an example of this pairing, as are Bridgid Coulter (Leo) and Don Cheadle (Sagittarius), who have managed to build a lasting bond.

Leos and Sagittarians do connect brilliantly in the less pressured arena of friendship, though, because fire does feed fire—and for the most part they revel in egging each other on and behaving rambunctiously. For the Leo, though, the Sagittarius' reluctance to really play along with the Leo's plans, or even to cooperate fully, can be irritating and upsetting, leading to fallings out. In work-related situations, the Leo will tend to see the Sagittarius as less focused or hardworking than he or she.

A Leo parent is generally a steady and consistent influence on Sagittarius, and Lions appreciate their little Archer's spirit and optimism. A warm bond will spring up between these two, but the Leo parents are likely to be dismayed by their Sagittarius child's tendency to ignore wise advice and to be angered when he or she gets into difficulties as a result.

Leos and **CAPRICORNS** can be drawn together by their ambitions and values, and Lions are impressed by Goats' firm grip over their affairs. For a Leo, Capricorn is a steady and reassuring influence, and though this bond may take time to grow, it's no less significant than one that springs up spontaneously. Leos are turned on by Capricorn's high standards and unrelenting drive to reach the top. Leos can become disheartened, though, by Capricorn's criticism and fault-finding, and if they feel that they are no longer being viewed in a positive fashion, they will increasingly withdraw. Iman (Leo) and David Bowie (Capricorn) are a well-matched example of this pairing, and so are Barack Obama (Leo) and Michelle Obama (Capricorn).

Friendships between Leos and Capricorns spring up when these two are drawn together by mutual interests and pursuits. Because they function differently but are equally drawn to achieve, Lions and Goats make a brilliant team. Lions also find Capricorns to be sage advisors and trusted allies and will seek out those born under this earthy sign for support. A certain mutual dependence that happens between these two also ensures that once a friendship is formed it will be a particularly lasting one.

Leo parents with a Capricorn child tend to be quite in tune with their little Goat's needs and feelings and highly sympathetic as well. The Lion will be delighted by this child's poise and strength of character and will encourage him or her to pursue his or her ambitions. The Saturn-ruled child's willingness to follow rules will ensure smooth relations between these two.

AQUARIUS intrigues Leo because this fixed, airy sign is so cool and objective— the completely opposite of the fiery and passionate Lion. Aquarius can expand Leo's view of the world, and the magnetism between these two can be a powerful aphrodisiac. Aquarius' zany, rebellious side also appeals to the Lion, and what these two also have in common is that both are very in touch with their inner child. On the other hand, Aquarius' tendency to lead by the head and maintain a cool distance can feel like an outright rejection to Leo, and since both are equally opinionated and stubborn, Lions and Waterbearers also tend to square off and clash quite frequently. Loni Anderson (Leo) and Burt Reynolds (Aquarius), one example of this coupling, were divorced after five years of marriage; another is Whitney Houston (Leo) and Bobby Brown (Aquarius), who ended up divorcing after fourteen turbulent years.

Leos and Aquarians can be great friends, but this is likely to be a relationship that has an on again/off again quality. Lions like Waterbearers for their independence and clear way of communicating, but emotionally these two may be on such different wavelengths that they just don't read each other's signals right. Leo is likely to feel distanced by Aquarius' apparently cool manner and to take offense or feel put-off. What can bond a Leo with an Aquarius, though, is the Waterbearer's willingness to give and share, which quickly melts the Lion's heart.

Leo parents relate warmly and well to their Aquarian child, whose intelligence is usually immediately apparent. The Lion will not take kindly to their little Waterbearer's proclivity to march to the beat of his or her own drum, though, especially if it leads to a direct challenge to the Lion's authority.

What attracts Leo to **PISCES**—when it happens—is this malleable sign's responsiveness and sensitivity. Lions often feel flattered by Pisces' willingness to listen, and they may bond with a Fish because of his or her playfulness and openness to life itself. Still, the tendency to drift and dream—so typical of Pisces—can perplex and sometimes anger the fixed Lion, who usually has some specific aim in mind. And Pisces' moodiness and occasional negativity can be difficult for Leo to handle. Water can put out Fire, and the most sabotaging effect of this combination is the way in which a discouraged or depressed Pisces can effectively douse a Leo's optimism and good spirits. Lucille Ball (Leo) and Desi Arnaz (Pisces) were one celebrated example of this pairing, and Steve Martin (Leo) and Bernadette Peters (Pisces) were another.

Friendships between Leos and Pisces tend to be volatile, though the two are drawn together by their mutual playfulness. Lions sometimes interpret Pisces' behavior as flighty or undisciplined, and they may become quite critical of their Fish friends. Leos do admire Pisces' creative side, though, and these two are often thrown (or drawn) together by mutual interests and pursuits. When this happens, they can work wonderfully well together, because each has a completely different contribution to make.

Leo parents are likely to find their Pisces child simultaneously adorable, baffling and worrisome. The difficulty is that fixed fire (Leo) operates so differently from mutable water (Pisces) that the Lion does not easily clue in to the changeable emotions that fuel their little Fish. This relationship will only flourish if the Leo parent can accept this child for who he or she is.

COLORS, GEMS AND FRAGRANCES

Leo's colors are, of course, sunny ones, the primary hue being yellow. But all the colors that the Sun can be, ranging from an almost white yellow to a hot orange, accord with the sign of the Lion. Gold is especially appropriate and is the color of the Lion itself—that tawny, rich gold that holds an inner glow. Leos do well to wear these warm tones when they are in situations that demand that they hold center stage, and red also resonates with this fixed fiery sign and is a very good color for important social occasions.

Because most Leos are inclined to get overexcited and overheated, though, sunny colors aren't always the best choice. White can be a very soothing choice for Leo,

because it is the color of the Moon and allows the Leo to be more reflective, to cool down and calm down. Indigo—the color of Leo's opposite sign, Aquarius—is balancing and soothing as well; wearing this tone makes it easier for the Lion to blend in when situations demand that he or she play—for whatever reason—a more low-key role.

Leos are lucky in the sense that all the colors of the rainbow are suitable for them— perhaps because they are Sun-ruled and capable of carrying them off. There don't seem to be any colors they need to avoid, although dreary ones like gray are very incompatible with their upbeat natures.

The ruby is generally agreed to be Leo's birthstone, and the ruby's rich color does express the heart-centered warmth that Lions emanate. Diamonds are also occasionally accorded to Leo as well (although most agree that this is Aries' gem), and diamonds are appropriate for Leos in the sense that they sparkle and catch the Sun in a way that reflects Leo's nature. There are also quite a number of semiprecious stones associated with the Sign of the Lion, first and foremost being the tiger's-eye, whose golden color is brilliantly in sync with Leo's glowing nature.

Citrine, amber and onyx are other semiprecious stones for Leo, and some sources also cite the garnet, which is red like a ruby, and rose quartz, a stone associated with the heart. And of course the metal most harmonious with Leo is gold, which always seems to suit Lions wonderfully. In fact, it's difficult to imagine a Leo wearing silver; usually this reflective metal does not work on Lions at all, though copper can.

What else would Leo's most important flower be but the sunflower, which so wonderfully expresses Leo's direct, vivid nature? Marigolds, probably due to their golden color and fluffy, full faces, are also considered to belong primarily with Leo, and so are passionflowers, celandine, heliotrope and the yellow lily. Poppies also seem to be associated with Leo, as are mistletoe, the bay tree and the walnut tree.

Walnuts are said to be particularly beneficial to Leos, who are advised to put them in their salads frequently (walnuts are reputed to be good for the heart). Saffron is also associated with Leo and is also considered to be medicinal. The herbs calendula, eyebright and St.-John's-wort are purported to be particularly beneficial to Leos.

The orange flower—neroli—is one fragrance which is very sympathetic for Lions, and blends of amber, peach, apricot and musk are extremely harmonious for this Sun-ruled sign. Olive blossoms, citrus and frankincense are also associated with Leo. Juniper, in particular, is cited as a wonderful aromatherapy remedy to calm and uplift a stressed-out Lion. ♌

6

Virgo

23 AUGUST – 23 SEPTEMBER

150°

Success is the sum of details.
—HARVEY S. FIRESTONE

I don't think that it's any coincidence that the two most charming women I've met in my life have both been Virgos. Rosemary (September 14) and Melanie (August 24)—the former an elderly woman I knew years ago in Connecticut, and the latter a woman in her forties I met in France—are the kinds of people who are so extraordinarily gracious, affectionate, witty and effervescent that everyone adores them and wants to be in their company. Whenever Melanie comes for a visit—which she normally does every Monday afternoon, to go horseback riding—within minutes of her arrival I feel my spirits lifting, and a wonderful sense of well-being washes over me. It's not just her own personal brand of optimism or her evident interest in me and what I'm up to that's responsible for this. I remember experiencing the same kind of heady good feeling whenever I encountered Rosemary, too.

When I've tried to define what it is about Rosemary and Melanie that produces this effect, I find it difficult to pin down. Perhaps the closest I can come is to say that both women are unusually giving, in a way that does not draw attention to them and seems amazingly effortless. The dictionary defines charm as, among other things, "to delight or please greatly," and these two Virgo women—and a few other Virgos I can think of—also inject such humor and warmth into their generous way of treating others that being in their company is addictive.

Not all Virgos are such terrific company, of course, and those with severe afflictions in their charts can often be quite tense and tiresome. But it's my belief that of all the signs of the zodiac, Virgo is the most maligned and misunderstood. This may be due to the fact that Virgos can become quite nervous and obsessive under certain circumstances. But at core what underlies the nature of this earthy and sensitive sign is a deeply felt desire to make a difference or, to put it succinctly, "to serve."

If you watch Virgos in action, you will see that—unobtrusively, and with a honed efficiency that smacks of long practice—Virgo people make themselves useful in whatever situation they find themselves, doing whatever needs to be done before anyone else even thinks of it. And, in fact, most people don't seem to notice how much their Virgo friends

or relatives are contributing, because not only is their service rendered without fanfare, they are not looking for or expecting rewards.

My father was a Virgo (August 24), and he was a very hands-on parent, making breakfast for us girls, driving us—after a long day's work—to piano lessons or a friend's house and attending school plays and other events with patient good grace. He also read to us at night and helped to tend us when we fell ill. I remember his way of lightly kissing my forehead to check my temperature (he could always tell if I had one), and I also remember that I never felt any resentment from him about how much time and care I might have demanded. He gave without thinking about it.

Because they like to be of service, Virgos often choose professions in health care or teaching and are also attracted to work that's down-to-earth and practical. The urge to help others is generally a strongly motivating force in their natures, and my father, for instance, who was an economist and could have made a great deal more money if he'd done otherwise, always chose to work in the public sector, spending the last years of his life at the U.N. My great-grandfather, a physician, was also a Virgo (September 15), and he chose to open a clinic for the needy and poured most of his energy into this endeavor.

Not all Virgos are altruistic, of course, though a surprising number are. What Virgos share, though, is a down-to-earth practicality that keeps them grounded in day-to-day reality. Virgos are completely tuned in to all those small but significant details that keep life running smoothly, and they are also very aware that to drop one stitch is to mess up the entire fabric. This is one of the reasons why Virgos are known for their "fussiness," as it's often described. It seems to be their thankless task in life to keep everyone focused on the importance of routines and diligence, and they know perfectly well that if they can't get the people around them to pay attention and do their part, that they themselves will inevitably be forced to pick up the slack.

Virgos are terrific organizers, and even when they're capable of far greater or more creative contributions they often find themselves forced into the role of manager and overseer of details, because they do it so well. I can think of any number of talented Virgos I've encountered who've struggled with this issue and have felt deeply frustrated by their continual assignation to this role when they longed for more freedom to use their many other talents. Not all Virgos succumb to the pressure to keep everyone else's lives running efficiently, but many do. The need to be useful, and their inescapable attunement to all the bits and pieces, exert such a powerful hold over them that they can't shake it off.

Which is not to say that Virgos can't break the mold and succeed in the arts; I've known quite a few extraordinarily talented people born under this sign who have done just that. One of the first Virgo women I ever knew was (and still is) an actress and singer, not only unusually gifted but beautiful and charming. Above all, what I remember best

about BJ (September 16) was her quick wit, which—like Geminis, also ruled by the articulate planet Mercury—Virgos possess in great measure. BJ's sharp observations and humorous interpretations were a delight, and she could lighten up even the most difficult situation by seeing—and cleverly exposing—its funny and laughable side.

BJ went on to achieve recognition with what she dubbed "Stand-Up Opera," a wonderful mélange of her vocal talent and comedic side, combining high art and humor. Satire, is, unquestionably, Virgo's natural territory. It requires brilliant powers of observation, an ability to cut through to the core and the wit to hold up folly to ridicule. Virgos see everything that's going on around them with stark clarity. They don't miss a trick, and they can have an uncompromisingly sharp awareness of their own and others' faults. The most evolved Virgos I know see others' faults and immediately forgive them (although they don't forgive their own). But most Virgos are highly critical. This also goes with the territory because discernment—discrimination—is really Virgo's baseline characteristic. What this sign is all about is the ability to test quality and detect flaws.

That wonderful old fable "The Princess and the Pea" is an archetypically Virgo story—the princess displaying her royal or highly refined nature by being able to detect the presence of one single pea beneath a towering stack of fluffy mattresses. And, tellingly, this flaw—the presence of something that altered the quality of the mattresses—was so irritating to her that she tossed and turned all night. Which is precisely how Virgos react to anything that isn't pure, correct or up to par. Imperfection makes them fret. It goes against the very grain of their nature and is for them as grating as the sound of chalk scraping a blackboard.

Virgo is sometimes described in old-fashioned astrology books as a "nervy" sign, and this is precisely why. The jarring imperfection of so many aspects of life can continually rub them the wrong way and drive them up the wall. Obviously, Virgos handle the particular stresses they're prone to with varying degrees of grace; I've known those who have become proficient at rising above it all and those who, on the other hand, seem continually jumpy and tense—often to the extent that they keep losing their tempers or even turn to drink.

One particular person—who will remain nameless—springs to mind when I think of this type of Virgo which might be dubbed "the uptight version," and he was someone I got to know well, since he became—for a period—a member of my family. I can say in all honesty that I have never known anyone who was so wired, reactive and uncomfortable in his own skin as this individual. It was painful to watch. Virgos of this type seem unable to handle the stresses that day-to-day life is inevitably full of, and something as trivial as spilled spots of tea on a white tablecloth, or the way a particular clock keeps running two minutes slow, can seem so unbearably jarring to the nervy type of Virgo that he or she practically loses the plot.

I think it's people like this who have tended to give Virgo such a dubious reputation. But the truth is that this mutable, earthy sign encompasses great extremes, which is why it might easily be dubbed the sign of "saints and sinners." At their best, Virgos can be so kind, so good and so giving that they seem to transcend ordinary human limits; at their worst, Virgos can be shockingly dissolute and self-destructive. Most of the Virgos I've known have fallen somewhere in the middle of these extremes, being people who were so multifaceted and complex that they were difficult even to describe.

Theosophist Alice Bailey described Virgo as a "triple" sign—as opposed to the others that are either double (dual) or single. This accords with Virgo's glyph, which has three parts, and may also be reflected in the fact that Virgo really does seem to be more variegated and complex than the other zodiacal signs (except Scorpio, also a triple sign). Despite all these nuances and dissimilarities, though, the common thread that runs through Virgo's nature is an ability to make fine distinctions, and Virgos all seem to possess a kind of radar that enables them to separate the wheat from the chaff.

Impurities—the addition of additives to foods, the chemical component in synthetic fibers—really do have a more abrasive effect on many Virgos than on most of us. And those born under this refined and sensitive sign may become quite obsessed about health-related matters and diet. Just the idea of adulterating any substance—like putting sugar and preservatives into applesauce for commercial use, for instance—can strike a typical Virgo as intrinsically wrong, because the effect is to compromise the applesauce's original and authentic form.

In fact, the idea of contamination absolutely appalls Virgos. And Virgos can become concerned about remaining germ-free to the point of obsession. Compulsive hand washing and anal-retentive habits like arranging objects in a certain rigidly maintained order are all by-products of Virgo's inborn attunement to the importance of purity and authenticity. This is really what the Virgin—Virgo's logo—is all about, not straitlaced sexuality, as so many people imagine. And actually, most Virgos are anything but prudish. They may have high standards regarding their partners' character or appearance, but this earthy sign is also both uninhibited and highly sensual. Virgos seem to revel in the realm of the senses. They are lovers of good food and are often great cooks—epicurean and full of delight in their engagement with the pleasures life has to offer.

Virgos also always like to be prepared, and you can always count on them to have aspirins and Band-Aids and an astounding number of other useful objects in their handbags or glove compartments. I remember going on a picnic with a Virgo friend and being impressed by her foresight in bringing along every possible utensil and accoutrement we might need, including a little packet of peppermint-flavored tooth-picks (a very Virgo-like addition) for use after the meal. Another friend, Nicki, is renowned for never failing to have—or somehow immediately lay hands on—anything that might be needed

in an emergency, from a needle and thread to reattach a fallen button to an elastic bandage to wrap a turned ankle.

Which is precisely why everyone tends to turn to their Virgo friends in a crisis. They seem so effortlessly efficient and on the spot. Virgo friends are a boon and a blessing, because they never fail to rise to the occasion when you need them, and they're so adept at everything, from unblocking frozen pipes to figuring out why your computer's suddenly crashed, that order is quickly restored. My friend Melanie (August 24) is exactly the person I want to have around when something goes wrong, because nothing seems to faze her and she actually seems to enjoy having a problem to solve.

Virgos aren't good at sitting still, and if seated for any period of time, they will suddenly jump out of their chair as if they've been suppressing the desire to do so for some time—which they probably have. Their energy tends to be more frenetic than forceful, though, because it's fueled by their nervous systems and active minds. Virgos like to move—swiftly—from one activity to the next and to have a variety of things to do. Ruled by Mercury (the mind planet), Virgos are thinkers, but they are also doers. Unlike their Mercury-ruled cousin, Gemini, Virgos aren't inclined to build castles in the air; they want to bring their ideas quickly down to earth. They are result seekers, and they derive tremendous satisfaction from executing their plans and making the bits and pieces fall neatly into place.

The fictional character Dr. Spock, of *Star Trek* fame, is, many astrologers agree, an uncannily perfect representation of the classic Virgo type—a being on whom everyone depends for his sane and logical approach and superior problem-solving skills. Spock is also from Vulcan—a mythical (or, as some claim, undiscovered) planet that has always been associated with the zodiacal sign of Virgo. Astrologer Linda Goodman believed—as others have—that Virgo is actually ruled by Vulcan, not Mercury. Mythologically, Vulcan was the son of Jupiter, and intriguingly, his feast day was August 23—Virgo's traditional starting point on the zodiacal wheel.

Logical thinking comes naturally to Virgos, as it did to Spock—but emotions are a bit more difficult to handle for those born under this earthy sign (as they were for Spock, who claimed not to possess them). Virgos don't easily reveal their feelings, but when they do, they're apt to suddenly erupt (curiously, Vulcan is associated with volcanos) and then just as suddenly to draw back into themselves. Being in control is clearly one of Virgo's biggest priorities, and those born under this sign seem to feel the need to analyze or make sense of their emotions instead of just allowing them.

Once they've subjected their emotions to logic, though, they'll have managed to censor those aspects of themselves that they can't comfortably accept. If Virgos tend to be faultfinders, and critical of others, they also tend to be fiercely hard on themselves. None of their flaws escapes them. I've never met a Virgo who suffered from a swollen ego

(though they must exist) but, to the contrary, have known quite a few who underestimated their own worth and were relentlessly harsh in their depiction of their shortcomings and imperfections.

Virgos seem to shrink away from any form of self-aggrandizement, and they aren't very comfortable receiving compliments, either. I've found that when I've told a Virgo friend something particularly nice that I've noticed about them, he or she will often either deny it or otherwise try to dispel any illusions I might have about his or her attributes or character. This isn't false pride. It may be modesty, though, and a reflection of the fact that Virgos are hyperaware of their own flaws.

I can think of no one who exemplifies the high end of the spectrum of the Virgo nature more perfectly than Mother Teresa (August 26, 1910), whose purity of character manifested itself in her selfless devotion to the alleviation of suffering and who believed that "A life not lived for others is not a life." In typical Virgo fashion, Mother Teresa put her inspiring ideals to work by finding entirely practical ways to help the neediest and most desperate sector of India's population.

Jane Addams (September 6, 1860), known as the most prominent reformer of the Progressive Era, was another Virgo doer who put her ideals into action in a form of "social" work that established that activity as an actual profession. Then there was Margaret Sanger (September 14, 1879) who, having watched her Catholic mother go through eighteen pregnancies (with eleven live births) in twenty-two years and then die at the age of fifty, and who later, as a nurse in New York City, continually witnessed the horrifying after-effects of illegal abortion, went on to risk prison and censure by fighting and winning the battle to legalize birth control.

Many famous Virgos have also been activists and fighters for the causes they believed in, from Upton Sinclair (September 20, 1878), who exposed the unsanitary conditions in the meatpacking industry (what could be a more Virgo-like activity?) in his muckraking novel *The Jungle* and was a founding member of the American Civil Liberties Union, to River Phoenix (August 23, 1970), who was a prominent spokesperson for People for the Ethical Treatment of Animals and a fervid environmentalist.

Quite strikingly, some of the greatest writers of all time have been Virgos, from the extraordinary and brilliant Leo Tolstoy (September 9, 1828), whose humanitarianism and spirituality is so evident in his unequalled *War and Peace* and *Anna Karenina*, to subtle, gifted, Jorge Luis Borges (August 24, 1899) and Johann V. Goethe (August 28, 1749), the "supreme genius of German literature."

In stark contradiction to the falsely prudish public image Virgo has attracted, D.H. Lawrence (September 11, 1885), whose frankly erotic *Lady Chatterley's Lover* became the scandal of the day, was born under this earthy sign; and the sexually explicit potboiler

Peyton Place (which also caused a furor) was written by a Virgo—Grace Metalious (September 8, 1924).

The perfect puzzles that Agatha Christie (September 15, 1880) constructed in her celebrated mysteries are distinctly Virgo-like, with all the bits and pieces falling neatly into place; so is the artwork of Grandma Moses (September 7, 1850) with her talent for depicting scenes of day-to-day country life in meticulous and stunning detail. O. Henry (September 11, 1862), renowned for his wit and wordplay as well as his clever surprise endings, was a Virgo, as was the brilliant science-fiction writer and satirist H.G. Wells (September 21, 1866).

A number of outstandingly glamorous women have been born under the sign of the Virgin, including Greta Garbo (September 18, 1905), Sophia Loren (September 20, 1934), Ingrid Bergman (August 29, 1915), Raquel Welch (September 5, 1940) and Lauren Bacall (September 12, 1924), who somehow managed to be at the same time witty, sultry, refined and self-mocking. Various Virgo actors are also utter charmers, like Maurice Chevalier (September 12, 1888), Sean Connery (August 25, 1930) and Richard Gere (August 31, 1949), while others are brilliantly comedic, like Peter Sellers (September 8, 1925), Bill Murray (September 21, 1950) and Buddy Hackett (August 31, 1924). But all possess a considerable range that reflects the complexity of this triple earth sign.

The most defining characteristic of the Virgo nature, though, is the ability to distinguish the real from the false and to clearly perceive the essence of things. As the Virgo Leo Tolstoy once put it, "Truth, like gold is to be obtained...by washing away from it all that is not gold."

THE CARE AND FEEDING OF A VIRGO

Whatever your relationship with a Virgo, you have to admit that he or she is quite useful to have around. Who else would fold the laundry right after the dryer stops so that it doesn't have a chance to wrinkle, or can figure out how to fix the dishwasher when it goes on the blink, or always scrubs the yellow water mark out of the bathtub? Who else, when you have guests, would pitch in without being asked, or knows how to change a fuse, or does your shopping when you're stuck in bed with the flu?

It's all too easy to start taking for granted all the small but helpful things your Virgo does for you, because he or she does them so efficiently and quietly. Besides, Virgos don't demand or even expect thanks. They are there on the spot when needed and seamlessly fit themselves into situations so that it's difficult to really notice how much they

contribute. And rather than seeking appreciation or acknowledgment, what those born under this high-functioning sign really care about is keeping the ship running smoothly.

The most important consideration in relating to a Virgo is to value them as highly as they deserve. Virgos tend to be the kind of people who are overlooked until—for whatever reason—they aren't on the scene. And though your Virgo really doesn't need you to fall all over yourself thanking and applauding him or her, what tends to happen to Virgos is that their own needs become obscured and ignored because they are so intent on doing what needs to be done for others.

Staying tuned in to your Virgo's underlying feelings, and to the pressures he or she might be under, will take a conscious effort on your part. There will be times, of course, when his or her problems will be glaringly evident. But much of the time they won't. Virgos don't want or demand that anyone direct a huge amount of attention their way because those born under this sign tend to be both private and modest. It's up to you to say tuned in and to read the signs right.

Your Virgo will, of course, be appreciative if you pitch in when he or she needs help or support, but, remember, it's up to you to take the initiative in such situations. Virgos are very unlikely to go around making demands of other people, even when they really require aid of some kind. It's not their pride that's responsible for their reticence but their discomfort with the whole notion of bothering others and taking up their time.

Virgos aren't particularly inclined to self-pity, either, unless they were born with severe afflictions to their natal Suns. If you're close to a Virgo, though, you're bound to realize that although they don't tend to carry on or draw attention to themselves, they are prone to get stressed-out when the pressure is on, for whatever reason. And their inner tension will come through in various ways—jumpiness, irritability, a way of nervously drumming their fingers on the table or not being able to sit still.

Virgo's stress may also show up in physical forms, like skin rashes or digestive upsets—both sure signs that for some reason, your Virgo is feeling off-kilter and not coping well. When they're feeling seriously under the gun, quite a few Virgos are prone to employ the technique of displacement, which takes the form of focusing on some obscure detail to the point of obsession.

Take note if your Virgo suddenly becomes intent on straightening all the pictures on the wall or getting every speck of lint off his or her jacket, because this is a clear indication that something is really bothering them. Virgos' apparent fussiness is really a result of their tendency to focus on some external—and perhaps annoying—detail in order to avoid becoming overwhelmed by an unwelcome emotion. And it's easy to find their behavior disagreeable rather than cluing into where it's actually coming from.

Just remember that when Virgos become stressed and anxious they often develop a kind of tunnel vision that obstructs their ability to maintain their perspective. Their

tendency to use displacement is a way of taking the pressure off, but it avoids the real is-sue of what's causing so much upset and worry. It can be difficult getting a Virgo to talk about feelings he or she is trying to avoid. Instead, what can be helpful to your Virgo is a physical exercise regime or a relaxation technique like yoga or meditation. Virgos also do very well with the gentler forms of the martial arts like tai chi. Because they're ruled by the planet Mercury, which holds sway over the nervous system, it's their nervous systems that show their stress.

Helping your Virgo wind down and relax is one of the ways you can be a good friend, partner or parent to this sensitive, finely tuned person. Virgos are very responsive to sound, so music can be an important element in soothing their rattled spirits. And, as long as you don't actually pounce on them and aggressively demand what's wrong, so will talking and gently drawing them out. Virgos are communicators, because Mercury is the planet that rules communication. They can be extremely articulate and witty, and putting their emotions into words is healing and helpful to them even though they often resist doing so.

You'll notice that your Virgo will generally try to make light of upsets when he or she does verbalize them—even to the point of making them into a big joke. This is an-other kind of deflection—just another sign that Virgos hate to be heavy and dramatic about their feelings. They are more comfortable with satire. But Virgos can display anger when they've been pushed too far and are frazzled to the core, and when this happens they are capable of being direct and utterly scathing.

Another important point to bear in mind about your Virgo is that his or her way of reacting to—for instance—being offered a drink in a glass that doesn't look quite clean, or the idea of undesirable additives in his or her food, isn't a matter of being prissy and over the top. Virgos are so tuned in to the importance of purity and quality that they're forced to pay attention to anything that throws it into question. This is a basic, built-in characteristic of Virgo's nature. It may come across as a form of fastidiousness that bor-ders on obnoxiousness, but one of Virgo's designated roles in life—no matter how diffi-cult this is to deal with—is to find flaws (so that they can be corrected).

This can make a Virgo quite unpopular in certain situations, but it's also a useful ability. Discernment is a trait that Virgos display in a way that distinguishes them from all the other zodiacal signs. Their talent for assessing situations accurately enables them to be efficient and to zero in on what needs to be done. This is why Virgos are so good at fixing things, from a malfunctioning garbage disposal to your grandmother's ancient sewing machine. It's more than just a matter of being knowledgeable and resourceful, Virgos possess a particularly analytical mind-set, an ability to see all the details and then to figure out exactly how they fit together so that everything works.

If at times your Virgo's tendency to critique you and everyone else rubs you the wrong way, remember that he or she is also highly self-critical. Your Virgo isn't likely to give him- or herself grand airs, because Virgos are just too practical and down-to-earth to nourish illusions about their talents and prowess. They are, though, aware of their own best qualities, and they try to optimize them in a consistent and logical fashion. Being with your Virgo helps to keep you on track, because Virgos are such superior reality-testers. They are completely aware of what's going on around them, and as a result they know how to cope with the prevailing conditions in the most efficacious fashion.

Whether your Virgo is emotionally expressive or not (of course, female Virgos are better at showing their emotions than males, but that's more related to gender issues than astrological ones), you will always find proof of your Virgo's affection for you in all the helpful things he or she does for you. And you're not likely to ever really doubt your luck in having a Virgo by your side, because, as you've doubtless learned, your Virgo is one hundred percent present and there for you, and at all times a loyal and brilliantly reliable friend and companion.

VIRGOS IN LOVE

Virgos aren't given to dramatic displays or gushy sentimentality, but that doesn't mean that they don't love with great passion. In their practical, down-to-earth way, they tend to express their passion by being on the spot, useful and always ready to render their services. Virgos are genuinely romantic, too, and they tend to very much idealize their beloved. They don't fall in love easily, since their discerning natures demand that their beloved meet some very high standards, but when they give their hearts, they don't hold back.

Virgos can be sensual, loving, companionable and giving, and they will try their best to adapt to their loved ones ways and needs. No other sign is capable of being so totally practical and blissfully romantic at the same time; a Virgo who has found a love that's true in his or her own terms will stop at nothing to make the relationship work. Virgos are also deeply loyal and will stick out a difficult relationship with a dedication that few are capable of matching. Their earthy practicality enables them to accept the good with the bad while continuing to hold onto their ideals about what love means and should be.

★ ★ ★

Virgo may be impressed by **ARIES'** energy and enthusiasm, but is likely to be put off by what those born under this refined and fastidious sign perceive of as the Ram's brash—or even uncouth—manner. Aries' tendency to speed ahead and not pay close attention to details also strikes Virgo as reckless. Even if there's an initial attraction, the Virgo is likely to become increasingly critical of the way the Aries behaves, and as a result flare-ups and increasing distance will follow. Virgos tend to want a far more settled and consistent lifestyle than Aries seeks, and this is not conducive to a durable and long-term commitment. Ryan Phillippe (Virgo) and Reese Witherspoon (Aries), whose marriage lasted seven apparently effortful years, are an example of this challenging bond.

As friends, Virgos and Aries aren't especially compatible either since, again, Virgos are likely to find Aries' way of going about things a bit slapdash and unsatisfactory. What Virgo does like about Aries, though, is the Ram's confidence and high spirits, and this may kindle a certain—grudging—admiration in Virgo's heart for this fiery, life-loving sign. For this reason, Virgo may enjoy spending time with Aries, but won't tend to bond with a Ram all that closely.

A Virgo parent is likely to find an Aries child to be a bit of a challenge, because Virgos like to do things carefully and well, and the little Ram is always in a rush to speed forward. In this sense, the Virgo can be helpful to their child in teaching him or her how to pay closer attention and to make more of an effort to master tasks before moving on, but if the Virgo becomes too critical in the process, this relationship is bound to suffer.

Virgo tends to find **TAURUS'** earthy and unpretentious manner very appealing. A natural affinity exists between these two earth signs, since they are of the same element and intrinsically understand each other in some basic, nonverbal way. Taurus is full of common sense and seeks a secure and stable life, and this, too, has a reassuring effect on Virgo. What will grate on Virgo's sensibilities, though, is Taurus' inflexibility.

Subtle power struggles can ensue between these two that undermine their otherwise cozy bond. This is a harmonious connection, though, and one that may also be quite erotic, as was the long-term liaison between Ingrid Bergman (Virgo) and Roberto Rossellini (Taurus).

Virgos tend to find Tauruses comfortable and agreeable companions and a warm friendship can crop up between the two. Virgos will appreciate Taurus' love of food and the good things in life and will be encouraged to enjoy life more fully in the company of a Bull. The difference between the way a Virgo operates (swiftly and efficiently) and the way Taurus tends to approach things (slowly and laboriously) may at times tend to rub the Virgo the wrong way, but not to the extent that it causes him or her to pull away from this pleasant association.

The Virgo parent will have no difficulty relating to his or her little Bull's grounded way of perceiving the world. Virgos are also likely to find this child's placid and friendly

nature a delight, although they are likely to become somewhat impatient with their Taurus child's occasional stubborn resistance and plodding way of going about things.

Virgo and **GEMINI** seem to have an almost fatal attraction to each other, probably because they share so many traits associated with their mutual ruler Mercury—quick wit, sharp powers of observation and a love of language and communication. Virgos find Geminis to be exhilarating companions and great company, but Geminis' inconsistency and inability to stick to routines can begin to rub Virgo—who is so carefully consistent—very much the wrong way. Virgos sometimes feel undermined by Gemini's light and breezy attitude, and this leads to a growing tension between the two that can result in petty bickering and ill-will. The unconventional relationship between Tim Burton (Virgo) and Helena Bonham Carter (Gemini) is an example of this bond.

Friendships between Virgos and Geminis tend to be a mixed bag, because Virgos find Gemini's mental acuity and clever repartee a delight but are put off by Gemini's airy nonchalance. And while Virgos genuinely enjoy talking with Geminis and find their company stimulating, friendships between the two will tend to have an on-again/off-again quality, because Virgos won't be tolerant of Geminis' changeability and although feeling attracted will also feel a need to step back and maintain a certain distance.

Virgo parents will be able to strongly identity with their Gemini child and will be thrilled by their little Twin's quick mind and cheerful attitude. Virgos are actually great teachers for Geminis, helping this airy sign become a bit more grounded; Virgo parents will for the most part enjoy playing this role, but will sometimes feel a bit concerned about their Gemini child's tendency to scatter his or her energy.

CANCER is a sign that is quite compatible with Virgo, who is drawn by Crab's practicality and emotional availability. Virgos tend to find Cancers to be comfortable and soothing to be around, not only because they are reliable but because these two signs see eye-to-eye on many matters. Cancer's frugality pleases Virgo immensely, and Virgo also appreciates Cancer's shrewd business sense and dry sense of humor. What tends to create difficulties between these two, though, is Cancer's moodiness, which Virgo has a great deal of trouble understanding and accepting. Cancer's emotionality is also quite alien to Virgo, and Virgo's critical response can trigger real rifts. The only available example of this pairing—Rupert Grint (Virgo) and Hannah Stewart (Cancer)—doesn't reflect the fact that this bond is often quite long-lasting.

Friendships are not uncommon between Virgos and Cancers, because Virgos do tend to feel at ease and very much in their element with Crabs. Shared pastimes may bring these two together; they enjoy puttering around with each other and engaging in various hands-on activities like building or gardening which reinforce their cozy bond. Neither finds the other threatening, which is also a reason why this friendship springs up and tends to last.

A Virgo parent will quickly tune into his or her Cancer child's sensitivity and will generally be quite respectful and careful in response. Emotionally, Virgo is more detached than Cancer, and Virgo parents can help their little Crab to learn how to handle his or her volatile mood changes with greater ease, and to articulate his or her wants as well. The bond between these two will be warm and affectionate.

Initially Virgo is not particularly at ease with **LEO** and may feel a bit overshadowed while also feeling drawn. Virgos tend to play the role of helper or supporter with Leo, which sets the stage for later problems and misunderstandings about who is in control. What Virgo admires about Leo is the Lion's immense self-confidence—not a trait that Virgo shares. Virgo may bask in Leo's popularity and sunny warmth, but in the long run, those born under the sign of the Virgo tend to become critical about what they perceive of as Leo's self-indulgence and penchant for indulging in theatrics. And in the end, this is not an especially comfortable relationship for Virgo, Guy Ritchie (Virgo) and Madonna (Leo) being the prime example.

In friendship, Virgos and Leos may simultaneously appreciate and irritate each other— not the best formula for a close bond. When the two are drawn together in work-related situations, the Leo comes to rely on the Virgo for his or her attention to detail and follow-through, and the Virgo tends to relish this role and play it well. Some kind of inequality between the two—felt by both—also makes this combination a bit uneasy.

Virgos with a Leo child tend to feel proud of their little Lion's confidence and glowing good spirits, which seem to reflect well on them. They won't, though, be especially tolerant of Leo's need for witnessing and attention, which will sometimes elicit a critical response from them. But, while volatile, this relationship will be an affectionate one.

Virgos do get along well with other **VIRGOS,** and they can bond on the basis of the "two peas in a pod" feeling their similarities generate. They share obsessions about cleanliness, health and—often—ecology, and they also share an ability to enjoy life fully. Complementary and brilliantly efficient when they team up together, they're also prone to elicit the dark side of their relationship through a tendency to sharply critique each other. This may happen because they so clearly see their own faults reflected back to them—like looking in a mirror they can't step away from. Claudia Schiffer (August 25, 1970) and David Copperfield (September 16, 1956), who dated for five years, are an example of this interesting pairing, and Leonard Cohen (September 21, 1934) and Rebecca De Mornay (August 29, 1959) are another.

Virgos can become great friends with each other, especially when they meet due to mutual interests or in a work-related situation where their special organizational skills sparkle. Mutually appreciative, they are thrilled to find themselves with someone who is so much on the same wavelength and upon whom they know they could—if the need

arose—count in a crisis. Virgo friends tend to stay in touch with each other and to give each other quite a lot of mutual support.

Virgos with Virgo children are wonderfully pleased to have such a helpful and self-reliant offspring. Virgos make great parents for their own kind, because their modus operandi is so similar that the (often) shy little Virgo feels enormously reassured. It often happens, though, that the Virgo parent comes to rely quite heavily on this child.

Virgos and **LIBRAS** do often find each other to be charming and intriguing and can form quite durable bonds. Virgos are attracted to Libra's clear mind and poise and are also impressed by Libra's obvious refinement, a quality that they consider to be of the utmost importance. Libra's innate aesthetic sense is also a quality that Virgo appreciates. On the downside, though, Libra's tendency to mentally glide along and think abstractly is out of sync with Virgo's distinctly analytical approach, and Virgo is often dismayed by how little attention Libra sometimes pays to detail—not to mention this Venus-ruled sign's extravagant streak. Tensions can mount that are difficult to disperse, and Virgo may grow increasingly disillusioned. Prince Harry (Virgo) and Chelsy Davy (Libra), who dated for seven years, are an example of this combination.

Virgos and Libras do form firm friendships, though, and often relish each other's company. Virgos enjoy Libra's responsiveness and eagerness to relate, and they also admire Libra's style and taste. Probably the real glue in these friendships, though—from the Virgo's side—is the lack of competitiveness and the feeling of harmony that tends to characterize these signs' interactions. Both are highly communicative, too, and mutually supportive of each other.

Virgos have quite a bit of rapport with their Libra children and bond quite closely with them. If there's going to be a problem between the two, for the Virgo it will stem from what the Virgo sees as Libra's carelessness and inattention to the practical aspects of life that are very important to the Virgo. Virgo parents with Libra children do tend to find themselves trying to bring their little Libra more down to earth.

A mutual fascination can spring up between Virgo and **SCORPIO,** but because both tend to be somewhat guarded, a romantic relationship isn't likely to take off like a rocket. Virgo may tend to see Scorpio as a kindred spirit, since Scorpio is both a realist and a very discriminating judge of character; this sets the stage for a feeling of complicity between the two. Virgo is also prone to admire Scorpio's strong will and ability to persevere in difficult times. Emotionally, though, Virgo is inclined to tread almost too carefully with Scorpio, and the warmth that fuels close bonds between these two can be tamped down or even lost. On the other hand, in the realm of the senses Virgo is very much at ease with this water-ruled and notoriously passionate sign, so that a powerful physical connection can develop between the two even if they aren't entirely open and comfortable with each other in other ways. Elvis Costello (Virgo) and Diana Krall (Scorpio), though, seem to have forged a bond that lasts.

Friendships between Virgos and Scorpios are full of nuances and an underlying feeling of connection because these two signs are—in quite distinct ways—very much on the same wavelength. Virgos sense that, like they themselves, Scorpios are observing and taking notes behind their apparently neutral façade, and Scorpios tend to strike Virgos as inherently interesting and worth getting to know. Traditionally, signs that are sextile to each other (sixty degrees apart), as these two are, enter a kind of comfort zone in each others' company, and these friendships are often the kind that last.

Virgos find their Scorpio children to be compelling and sometimes mysterious, and they may also be somewhat in awe of the depth of emotion they sense in this particular child. Virgos also are generally particularly good parents for Scorpios, because they can respect their little Scorpion's need for privacy and adeptly deflect power struggles with this inherently willful sign.

Virgos and **SAGITTARIUS** find it difficult to understand each other and may even rub each other the wrong way. Which is not to say that Virgo isn't drawn to Sagittarius, whose fiery and adventuresome spirit strikes those born under the sign of the Virgin as admirable, if a bit misdirected. For a Virgo, a relationship with a Sagittarius is a walk on the wild side, because Archers' impulsive reactions and galloping pace are so alien to Virgo's analytical and highly discriminating style. What jars Virgo the most is Sagittarius' way of ignoring details and leaping into the fray. Still, what Virgo does like about members of this mutable fire sign is the excitement they generate, with the tempestuous relationship between Aristotle Onassis (Virgo) and Maria Callas (Sagittarius) being the perfect example.

Virgos and Sagittarius may form friendships, but there's usually a certain tension inherent in the way they experience each other's energy. Virgo finds Sagittarius just a bit too slapdash for his or her taste, and if these two attempt to work together, the Virgo is likely to become annoyed and disgruntled. On the zodiacal wheel these two signs are ninety degrees apart, forming a sharp angle or square—an aspect that is typified by clashes. What may attract Virgos to Sagittarius also repels them. For instance, they might find Sagittarius' enthusiasm contagious, but will be put off by the lack of definition behind their ideas and plans.

Virgo parents who have little Archers tend to feel that they have their work cut out for them with this particular child. They sense that their little Sag is all over the place, and their instinct is to rein him or her in. Sagittarius tendency to see the big picture conflicts with Virgo's penchant for zeroing in on details, and these different ways of approaching life can lead to conflicts which are difficult to resolve.

CAPRICORNS are as grounded and precise as Virgos, and these two signs experience a sense of homecoming when they meet. Virgos tend to find Capricorn's self-certainty very reassuring and are drawn by the Goat's drive and ability to set goals. Most important, Virgo feels understood by those born under this disciplined and health-conscious sign. Together, Virgo senses, the two form a team that is mutually enhancing,

although Virgos do tend to be the partner who makes more of an effort to please. Erotically, a great deal of magnetism can spark up between these two. Cameron Diaz (Virgo) and Jared Leto (Capricorn) are an example of this combination, and so are Lauren Bacall (Virgo) and Humphrey Bogart (Capricorn).

Great friendships can spring up between Virgo and Capricorn because they operate in a similar way and identify with each other. Virgo is thrilled with Capricorn's organizational skills since they're on par with his or her own, and delights in the Goat's somewhat caustic sense of humor. The two can fall out when they hold different opinions or inadvertently offend each other, but they will reconcile without rancor because they complement each other so well.

A Virgo parent feels very much in harmony with his or her little Goat and is usually quite proud to be the parent of such a well-put-together and sensible child. Few problems are likely to crop up, and a warm bond will spring up based on an instinctive understanding. Virgo parents will encourage their little Capricorn's ambitions and delight in his or her successes, which will only serve to strengthen this already positive connection.

Virgo and **AQUARIANS** are both cool, calm and collected, and this in itself can create a special frisson between them. Virgo is particularly drawn to Aquarius' humanitarian sensibilities, which those born under the sign of the Virgin tend to share. Virgos also find themselves lightening up in the presence of Waterbearers, who are less concerned with details and yet don't seem to lose the ability to be precise. A relationship between these two may never take off, though, because Virgo can find Aquarians a bit too breezy and distant to approach. On the other hand, if a strong connection does spring up, Virgo will find him- or herself surprisingly riveted by this airy sign, whose ruler Uranus is so complementary to Virgo's ruler, Mercury. Richard Gere (Virgo) and Carey Lowell (Aquarius) are a happy illustration of this particular bond.

Virgos and Aquarians often become friends because they find much to admire in each other. Virgo is impressed by Aquarius' objectivity and clear-mindedness and feels stimulated in the presence of this dissimilar yet complementary sign. Community work and mutual causes may bring these two together initially, and they make a great team because Virgo efficiently homes in on the details while Aquarius focuses on the broad view. A feeling of mutual respect and shared interests is the glue which will make this friendship hold up over time.

Virgos tend to get along well with their Aquarian children, who they find communicative and delightfully playful. They may tend to find their little Waterbearer's rebelliousness a challenge, though, especially when it comes to following the routines and rules the Virgo parent tries to impose. For these reasons, this is a relationship that will go through difficult phases.

PISCES is Virgo's opposite sign, which means that it exerts a magnetic pull but also repels. Virgo feels comfortable with Pisces' easygoing and sociable manner, and, as with many opposites, a certain magnetism may flare up, tugging the very practical and down-to-earth Virgo toward Pisces, sometimes against his or her better judgment. What almost immediately unnerves Virgos is the Fish's emotionally driven approach to matters that—as far as Virgos are concerned—must be dealt with by cool logic. They also feel dismayed by Pisces' tendency to drift along rather than taking control and to gloss over details which are discounted as unimportant. The result is that Virgos end up feeling irritated and at sea with Pisces a great deal of the time. Richard Gere (Virgo) and Cindy Crawford (Pisces) were an example of this pair-up.

Virgos and Pisces can sometimes connect quite strongly on an emotional level, so friendships between these two are not rare. The Virgo, though, is often drawn into the role of counselor or helper with the Fish, who he or she tends to view as confused or disorganized in one way or another. And because playing this part (whether Pisces really wants or demands it) is something Virgo enjoys, this relationship can endure and even thrive. As work associates, though, Virgos find Pisces' meandering approach jarringly out of sync with their own and tend to feel quite critical toward their Pisces colleagues.

A Virgo with a Pisces child is often overcome with a very strong feeling of protectiveness. A particular source of concern to the Virgo will be their little Fish's often spacey and emotional mind-set, and the Virgo's reaction will be to make a continual effort to get this child's feet more firmly planted on terra firma. Warmth and affection, though, will not be lacking from this connection.

COLORS, GEMS AND FRAGRANCES

On the astrological wheel, Virgo's color is a yellowish shade of green that holds a warm glow, yet is—at the same time—somewhat cool. It's the color of sunlight on the grass, and it suggests growth and abundance. Virgo, of course, is also connected to the harvest, and all the tones and hues associated with this period in the natural order of the seasons—brownish gold or bronze and tan—are Virgo's colors too.

Green is generally a very harmonious color for Virgo, and it tends to suit those born under this earthy sign. It's soothing to the nerves (a benefit for high-strung Virgos) and allows the wearer to blend in without any fuss. But when Virgos do want to be noticed, they may tend to be attracted to fuchsia—a color which isn't as attention-grabbing as red, which most Virgos would shy away from, nor as moody as purple. Normally, though, Virgos don't seem to go for hot colors or those that loudly announce themselves. Yellow,

on the other hand, is a color that Virgos often like, because it is bright and cheerful without—unless it's a very strong yellow, which Virgo would avoid—being overbearing.

Silver can also be quite wonderful on Virgo, associated as it is with the Moon (which the Virgin is also associated with). And silver is subtle, which Virgos appreciate. A particularly verdant shade of green (Libra's color) is also one that Virgo finds harmonious and soothing, since it holds a Venusian influence, and this color usually suits Virgo brilliantly.

The sapphire is considered Virgo's birthstone by most, and this lovely, light-catching gem (which is generally, if of good quality, blue) is enhancing for Virgo. Its cool color and sparkle are a perfect metaphor for the Virgoan nature, and its elegance is completely in harmony with Virgo's intrinsic refinement.

Jade is a semiprecious stone considered to belong to the sign of Virgo, and it does accord strongly with Virgo's colors, possessing a surprisingly warm quality while being a cool shade of green. The deliciousness of this particular green is also enhancing for Virgo, somehow amplifying the sign's positive qualities. Malachite is another green stone that is very much in harmony with this mutable earth sign, as is moss agate. Carnelian—which is generally a rich reddish brown—is another semiprecious stone associated with Virgo, and so is the citrine.

The morning glory is the flower primarily associated with Virgo, and its message, opening as it does with the light, is "I bring clarity," which is powerfully synonymous with Virgo's mission. Some say the buttercup is also Virgo's flower, and also the yellow archangel. The aster is another flower that falls under Virgo's rulership, and so is forget-me-not, which grows in small clusters and strikes a sweet, old-fashioned note evocative of Virgo's nature.

The cedar and elder tree are considered to belong to Virgo, as do—in general—all nut-bearing trees. And the plants most commonly associated with Virgo are ivy and ferns (it's considered favorable for Virgos to plant either or both in their gardens). As for herbs, fennel heads the list for Virgo, but valerian runs a close second. A natural tranquilizer of some renown, valerian taken as an infusion makes a brilliant tonic for stressed-out Virgos. Liquorish root is said to be particularly helpful for Virgo's digestion, and the endive is a vegetable reputed to be favorable for Virgos as well.

Fragrances that somehow evoke growing plants and greenery, like vetiver, are especially appropriate for those born under the sign of the Virgin, and for daytime use so are scents that are somewhat stimulating and fresh, like citrus. Lavender is also said to accord with this sign. Virgos are highly complex, and so they tend to need to vary their use of fragrances quite radically depending on the moment and their mind-set. For nights out, they often seem attracted to sultry scents that contain undertones of gardenia and/or vanilla, but perhaps the fragrance that expresses their earthy yet sensual natures best is sandalwood. ♍

7
Libra

24 SEPTEMBER – 23 OCTOBER

180°

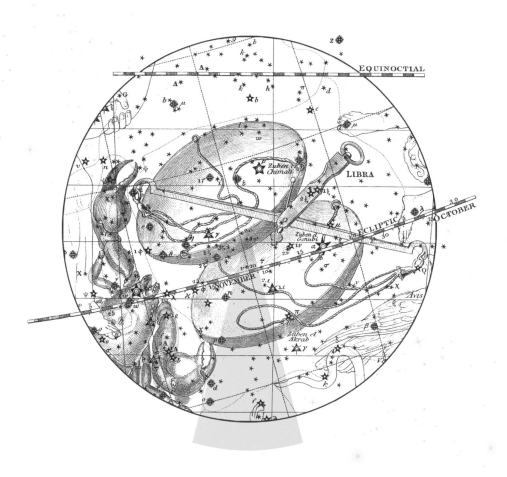

Do unto others as you would have them do unto you.
—THE GOLDEN RULE

I'm always impressed by how easily Libras engage with people and how adept they are at making others feel comfortable. My friend Betty (October 5), a seventy-six-year-old British ex-pat, is a past mistress at this; to enter her cozy home is to be drawn into such a cossetting environment—a fire burning brightly in the stone hearth, a cup of tea appearing instantly, along with various delectable treats—that my spirits invariably start to rise.

She's always eager to find out exactly how I am and what is going on in my life—the perfect companion, genuinely interested in me and ready to confide and let me into her own private thoughts and world. And it really does seem to me that Libras (with the exception of those with badly afflicted charts) are born with an unusual array of social skills that enable them to strike the right note and get along with others.

Libra children are invariably full of smiles and charming ways that have adults cooing over them, like my friend Pam's one-year-old granddaughter Annabel (October 16), who is so genuinely sweet and nice that even the grumpiest adults can't help but fall in love with her. And that's it in a nutshell: Libras are just so nice that it's very difficult not to succumb. Their job in life seems to be about winning others over and keeping them happy—even, at times, at their own expense.

Which is not to say that those born under the sign of the Scales are selfless, because they're sometimes quite the opposite. Being a Libra myself (October 1), I'm always aware of my compulsive desire to please everyone around me and give them what they want, versus my need to maintain my own comfort zone and not give away too much. And I think that this is exactly what the Scales that represent Libra are all about: finding that right balance between self and others.

Good manners are important to Libras, because this sign is ruled by Venus—the planet of beauty and harmony—and it goes against the aesthetic grain of the Libran personality to behave ungraciously. Even when upset or angry, Libras try to control their reactions, having a horror of grotesquely contorting their features and causing a disturbance. In her description of Libra, Linda Goodman comments that they "always wear a markedly pleasant expression" and that "in fact, the typical Libra face reminds you of nothing so

much as a box of bonbons, or a sugar cookie," a remark that I must admit I found a bit insulting, detecting the typically Arian (her Sun sign's) contempt for Libra's nice-making (the opposite of Aries' pot-stirring) style.

It took me a long time—until I was well into adulthood—to become comfortable about asserting myself, and for most Libras, I think, being aggressive is a learned skill. Not that they can't develop the ability to become very good at it; I know any number of Libras who are capable of being fierce and intimidating when they choose. Julie (October 2), a divorce lawyer and a client of mine, is known by her colleagues as "the Rottweiler," because when she goes on attack she goes for the jugular. And actually, those born under the sign of the Scales are sometimes quite clumsy about the way they handle anger—holding it in and then overdoing it and blasting everyone away, because they are, deep down, so conflicted about getting mad in the first place.

All the Librans I know are distinctively even-tempered, at least when in company. And most of the Libras I know are also instinctively charming and fun to be around. This is because they make a supreme effort to fit seamlessly together with whoever they're with. My first best friend, Jeannie (October 14), whom I met in kindergarten was, I remember, so irresistibly compatible with me that we never clashed about anything. And because I'm a Libra too, we bonded so completely that we become inseparable.

Libras are fascinated by relationships, and this is because this sign of the zodiac is all about relating. I would bet that the typical Libra spends more time thinking about and analyzing their (close) connections with others than any of the other birth signs. All the Libras I know constantly talk about their interactions with others, and this is nothing compared to what's going on in their heads. Every nuance and subtle exchange, the way and degree to which two people affect or influence each other, registers in the Libran mind as vital information.

What's more, the give-and-take aspect of relationships is of the utmost importance to Libras. If you take a Libra to lunch, you can be sure you will receive a similar invite back. Reciprocity is a burning issue to those born under the sign of the Scales. Many Libras feel more comfortable being the giver in general, and few can bear the burden of being "in debt"—having been given to and not returning the favor.

This is also about balance, of course, and Libras tend to feel out of control when the balance falls in the wrong direction and they are left owing. On the other hand, Libras become extremely miffed when they do something nice for someone—or give a great deal—and then feel as if they aren't getting enough of a return to balance the scales.

Fairness is a concept that Libras passionately embrace, and if they think that something isn't just, they generally won't be able to accept or live with it. I've seen quite a few Libras make the difficult decision to end a relationship (and Libras hate to end relationships) because, in the final analysis, they decided that the scales were too out

of balance: what they were giving simply wasn't being matched, and the situation was unacceptably unfair.

Libra is known as the sign of justice, because it's all about weighing and measuring and what is equitable and what is not. And if something strikes one born under the sign of the Scales as patently unjust, even the most laid-back and accommodating Libra will suddenly metamorphose into a warrior.

A client of mine, Susie, who is one of the nicest people you could hope to meet, recently found herself being slyly maneuvered out of her long-term job (where she'd excelled) just a crucial month before she would become vested for a pension. I can just imagine the chagrin of her scheming bosses when this apparently docile woman (who I'm sure they'd imagined would be a complete pushover) firmly put her foot down, engaged a tough employment lawyer and forced them to keep her on.

Harmony, though, is what all Libras long for and actively seek. And this isn't just what they try to create in their relationships but in their physical environment as well. Many of the Libras I know have an outstandingly strong aesthetic sense that expresses itself in their decorating skill, in their appreciation of art and in their good taste. I love visiting my friend, Barbara (October 17), for instance, not just because I enjoy her company but because her home is a treat for the senses—beautiful in the most refined and elegant fashion imaginable.

Being entertained by a Libra is also a delight; those born under this sign will not stint in their efforts to provide their guests with whatever they might enjoy or need. Reveling in giving others a pleasurable experience, Libras are often great cooks, and they will not only knock themselves out preparing a wonderful meal for you, they'll also try to provide all those touches that will make the ambience special—candles, cloth napkins and lovely tableware.

A party hosted by a Libra will typically be luxurious, lavish and carefully planned. Enticing appetizers will arrive in a timely fashion, food will be tastefully presented, and your Libra hostess will be keeping a watchful eye on all of the guests, keeping glasses filled and making sure that no one is sitting off in a corner feeling left out.

Another of my Libra friends (September 24) who also possesses an enviable sense of style, color and form is an editor at *House Beautiful,* and a number of others are artists, dancers, poets or filmmakers. In fact, an inordinate number of people in the creative arts are either Libras or have this sign strongly accented in their birth charts. Venus—Libra's ruling planet—represents the creative impulse, and Libras seem to have an innate urge to manifest beauty in whatever way they can, because it is their ideal.

In fact, Libras generally are idealists, and this is particularly apparent in their starry-eyed view of romantic love, no matter how much they try to hide behind a veil of indifference or cynicism. Libras dream of finding their soul mates and of happy endings, because the perfect balance between self and other is their dharma, or life path. This is

the reason why so many Libras are disappointed in love and why some have a tendency toward a distinct serial-relationship pattern.

Probably the greatest Achilles' heel for those born under the sign of partnership is their often fruitless search for the *perfect* partner. In their hearts they truly believe that this is their sacred quest, and it's probably why Libras are sometimes described as "fickle" and why—even though they will try and try—they find it soul-destroyingly impossible to remain in what feels to them to be a dead or hopeless relationship.

Many Libras look for too much in their relationships, as if bonding with another were the solution to all life's problems. Their expectations can be so over the top that they're continually disappointed, like Jeff, a client of mine who falls in and out of love with such regularity that it's hard to watch. But sometimes the problem is that conquest—finding a sense of validation in winning someone's love—lies at the root of the less evolved Libra's romantic quest.

The truth is that Libra is—in a certain sense—the most insecure of all the zodiacal signs. To be a birth-sign Libra is to have the Sun—which symbolizes the ego—in "fall," its worst possible placement. How does the ego learn to thrive in the sign of "others"? This is the dilemma Libras live with and solve in various ways, but the first step often involves claiming the self back in a certain sense—learning how to stop continually viewing oneself through others' eyes.

Libras who constantly look for that spark of admiration in a new conquest's eyes, and the validation of being the target of someone's affection, are the most insecure types, who are still stuck at the stage of projecting their center into others—or, to put it another way, lacking a core sense of self and always trying to find it outside of themselves.

I know a few Libras of this type; even those who are more developed really do love to flirt and are highly accomplished at it, like my friend Bea, who has a way of fluttering her eyelashes when she encounters anyone of the opposite sex that is both blatantly obvious and totally disarming. She is at the same time, though, a strong and independent woman with a clear sense of who she is. I find myself behaving a bit coquettishly at times—much to my chagrin—even when I don't want or mean to, as if it's an unconscious and instinctive aspect of my nature I simply can't control.

Being charming is simply Venus' territory, and Libras have a natural inclination to want to attract others toward them, although they may learn to fight this urge, since it can come to seem like a kind of self-betrayal. I have known various Libras like my friend Judith, who, in her determination not to act like the fluttery female she secretly saw herself to be, took to dressing in an overly severe fashion and assumed a brusque and intimidating manner that was actually quite off-putting.

Such are the desperate lengths to which some Libras will go in order to wrest back their identities and stop basing their actions on others' response to them. This is a perfect example of the Scales swinging disastrously in one direction. The flirty, man-magnet

type of Libra female you're bound to encounter at some point in your life—or her male equivalent, the suave seducer—are in stark contrast to a completely different type of Libra woman you'll also come across—the ferociously independent professional woman (or the contained and slightly distancing man with a cause).

As Linda Goodman put it, "There's a frustrating inconsistency to this Sun sign," and it's all about Libras' varying reaction to the greatest challenge they face: the search for their self. The inborn desire to please can be uncomfortable to live with, and it's a source of conflict to everyone born under the sign of the Scales. Even in their day-to-day actions, Libras struggle with the tug-of-war that the need to please confronts them with. One minute outgoing and sweet, the next recalcitrant and withdrawn, Libra is trying to get it right: to keep everyone happy, but at the same time not to betray him- or herself.

Libras can be hard to read for this reason, although they don't generally realize what mixed signals they are sending out. Peacemakers who are always attempting to step in and sort out others' conflicts (they can't stand it when people don't get along), Libras also love to argue and can be impossible to cajole or win over if they think they're right—which they usually do.

In fact their ingrained desire to please sits uneasily beside the cool, intellectual thinking aspect of the Libran nature. Sometimes one side wins, sometimes the other, but since the mentally active element air is actually Libra's element, everything a Libra feels must filter through his or her highly active mind. Like Gemini and Aquarius, Libras have a way of appearing slightly detached, even when they aren't. The element air is all about thinking (unlike water, for instance, which is the emotional element), and Libras aren't at all inclined to impulsive action. They will always think through everything they do.

Libras think quickly because they are air signs. And they're also constantly comparing, which is probably why they're so often dubbed "indecisive." Actually, I don't find the Libras I know to have difficulty reaching a decision, but they will go through a definite process before they make a choice. Judith, for example, will sometimes talk through with me an issue she's grappling with. She'll ask my opinion, and I'll almost see the wheels spinning in her head. She analyzes all the aspects of what's she's considering in a careful, logical fashion. But when she decides, that's it. There's no wavering or mind-changing.

Libras are slow to make a decision because they know that their snap judgments are sometimes way off target, and that until they're able to see both—or all—sides of a situation, they're liable to make a mistake. And because changing their mind might involve letting someone down, they'll do everything they can to avoid making such a mistake. The fear of hurting people's feelings (or making people dislike them) is one reason why Libras often end up behaving in ways that create dilemmas they can't figure out how to solve—like saying "yes" when they really want to say "no."

The instant gratification of arousing someone's positive feelings towards them can contrast sharply with the simultaneous regret of wishing they could somehow wiggle

out of this new obligation. My friend Amy (October 19), a typically charming and accommodating Libra, is prone to get herself into this kind of situation; she's even done it with me, agreeing to some plan or favor that I can immediately see she's reluctant to take on.

"Never mind," I'll say, typically Libran myself. "It's okay…I'll figure something else out."

"Oh no," she'll assure me. "It's fine…"

"Really, you don't need to. I can take care of it myself…"

"No, I want to, don't worry," she'll tell me—and we'll actually go on and on like this until we both run out of steam.

Generally, if you ask a Libra what he or she wants to do when you're planning a shared outing, you can almost count on the reply "What do *you* want to do?" even though, in the end, you may well find yourself at a destination that your friend (not you) actually prefers. This inquiry about your preferences is a testing of the waters, which doesn't necessarily mean that they're willing to accede to your wishes (although they might).

Libras are known as the diplomats of the zodiac, because negotiating is their forte, and they know how, without revealing their hand, to tip the balance in their own favor. In my opinion, Libras develop these skills because they don't actually feel comfortable about making demands and being assertive. Their need to take other people's emotional temperature before making a move is designed to keep the peace—and keep others in a good mood.

Libra's innate tendency to tune into the needs of others often propels them into professions like social work, counseling, and law (their love of comparing, and arguing, finds a perfect outlet here) and many Libras are also found in the political arena, like Desmond Tutu (October 7, 1931), Juan Perón (October 8, 1895), Jimmy Carter (October 1, 1924), Jimmy Breslin (October 17, 1931, David Ben-Gurion, (October 16, 1886), and Dwight Eisenhower (October 14, 1890) to name a few.

Mahatma Gandhi (October 2, 1869) was also a Libra, and he managed to tip world opinion in his country's favor through his passive resistance to British rule. His inspired pacifism was a perfect expression of Libra's desire to choose harmony over violence. It was also Gandhi who said, "The greatness of a nation can be judged by the way its animals are treated," and various well-known Libras have been active in the animal-rights movement, like Brigitte Bardot (September 28, 1934), Alicia Silverstone (October 4, 1976) and Linda McCartney (September 24, 1942); the majority of Libras are animal lovers and often pet owners too. The desire to defend all creatures great and small attests to Libras' penchant

for considering others' feelings and putting themselves in their shoes—an empathy that's an inborn trait.

Since fairness is such a burning issue to Libras, many tend to get involved in human-rights movements too, like Philip Berrigan (October 5, 1923), Jesse Jackson (October 8, 1941) and Lech Walesa (September 29, 1943), not to mention Bobby Seale (October 20, 1936), the Black Panther Party cofounder whose belief in "Freedom by any means necessary" hardly makes him a poster boy for the supposedly harmony-loving Libra personality. But injustice can be so intolerable to those born under this Venus-ruled sign that even the mildest Libra can become radicalized by the urge to fight against it.

Ruled by their ideals and principles, Libras can sometimes become overbearing and overwhelming because they're so convinced that they're right. Margaret Thatcher (October 13, 1925), who became known as "The Iron Lady," was not the example of the sweetness and light traditionally associated with the sign of the Scales; but as aggressive and unyielding as she appeared, there's much to suggest that her behavior was fueled by a need to please—in this case, to please her politically ambitious and conservative father, whose influence seems to have shaped her beliefs and personality.

Libras are also great observers of human behavior, which fascinates them—especially (since Libra is the sign of relationships) the ways in which people interact. Think of F. Scott Fitzgerald's (September 24, 1896) *Tender is the Night*, his moving novel about the convoluted and ultimately doomed bond between an unhappily married couple; or of Eugene O'Neill's *Long Day's Journey into Night*, his four-act play about the members of a dysfunctional family and their impact on each other's lives.

An inordinate number of talented writers seem to have been born under the sign of Libra, including, William Conrad (September 27, 1920), Truman Capote (September 30, 1924), Thomas Wolfe (October 3, 1900), Gore Vidal (October 3, 1925), Arthur Miller (October 17, 1915), Katherine Mansfield (October 14, 1888) and Oscar Wilde (October 16, 1854), as well as Elmore Leonard (October 11, 1925), John le Carré (October 19, 1931) and James Clavell (October 10, 1924).

The creativity of this sign, coupled with its aesthetic and intellectual powers, has also produced many notable poets like Samuel Taylor Coleridge (October 21, 1772), Arthur Rimbaud (October 20, 1854), T.S. Eliot (September 26, 1888), E.E. Cummings (October 14, 1894), Wallace Stevens (October 2, 1879) and W.S. Merwin (September 30, 1927).

Acting is a profession that seems to draw an enormous number of Libras, perhaps because their innate tendency to want to charm and attract others makes this a natural choice for them. Among the many Libra film stars who've made their mark, Yves Montand (October 13, 1921), Helen Hayes (October 10, 1900), Lillian Gish (October 14, 1896), Richard Harris (October 1, 1930), Montgomery Clift (October 17, 1915) and

Marcello Mastroianni (September 26, 1924) are some standouts. And it's quite fascinating how Deborah Kerr (September 30, 1921) and Julie Andrews (October 1, 1935) epitomize the gracious, ladylike aspects of Libra, while Brigitte Bardot (October 28, 1934) represents a completely different but also classic Libran type.

THE CARE AND FEEDING OF A LIBRA

If there's an important Libra in your life, count yourself lucky, because as long as you treat Libras kindly and well, they'll knock themselves out trying to make you feel cared for and comfortable. And the real key to understanding your Libra is that those born under the sign of the Scales always try to treat other people the way they want to be treated themselves.

You're likely to notice that this is particularly true of the way your Libra behaves with the people he or she deals with in public situations, like sales clerks, servers or the plumber. Libras will go to great lengths to be friendly and nice, because they have such a need to create harmony and good feeling (not to mention getting people to like them) that being polite and considerate is the way they really want and need to be.

This can lead to certain kinds of problems and issues, though. For instance, if you sometimes feel irked that your Libra isn't directly confronting difficult or abusive people who have caused them trouble, but instead is doing everything humanly possible not to rock the boat, try not to be openly critical. Your Libra may need some encouragement, but making him or her feel defensive—or worse, weak—isn't going to help.

In fact, being seen as weak—or spineless—is what a Libra fears and detests the most. Most people born under this sign can't control their urge to act sweet and nice; they often find themselves in situations in which they know they should be acting tougher and more aggressive, but somehow they just can't. Later, though, they're apt to castigate themselves and feel inadequate because they didn't come on stronger. And remember, what they need is your understanding and support to do what needs to be done.

If you can help them to see that they're actually entitled to be forceful or even angry in a situation where they're being treated unfairly, you'll be giving them the boost they need to deal with whatever issue they're having. You might need to really let them talk the situation out, and this will probably demand a bit of patience on your part as they examine all the bits and pieces from every angle; but you'll be surprised what a difference it makes to your Libra when you tell them they can go ahead and get mad! It's something they have to actually give themselves permission to do, because it goes against the grain of their Venus-ruled, harmonizing nature.

Your Libra is likely to have the same problem showing any negative feelings or reactions in dealing with you unless he or she knows you very well and is entirely comfortable with you, and even then there will be lapses. You need to remember that Libras will always tend to try to keep the peace, even if something you've done has rubbed them the wrong way or upset them. And this, of course, can lead to problems further down the road. But how do you get a Libra to admit that he or she is angry at you when he or she is hell-bent on concealing it? In fact, how can you even know whether Libras are angry if they say they're not?

Don't get the idea that your Libra isn't a strong and sturdy person. Most of them really do have a healthy dose of self-esteem. It's just the Libra's inborn reluctance to create disharmony that can sometimes make him or her appear to be a pushover. If you sense that your Libra isn't happy with something you've done or said, you'll contribute to the strength and longevity of your bond if you bring it up. Even if your Libra won't admit it, the fact that you weren't fooled into thinking everything was all right (when it really wasn't to your Libra) will make an enormous difference.

Later he or she will often come to you and calmly explain what was upsetting about the situation or your behavior. As long as you show that you're aware and open, the flow of real—authentic—communication won't be disrupted. But by now, you're probably wondering if you need to be a mind-reader to have a relationship with someone born under this complex birth sign. Why don't they just say what they think? Why do they hold back and then, much further along—and sometimes when it's too late—explode and storm out the door?

While at times you may feel that there's something oblique—or perhaps Oriental—in the Libra's overly polite and indirect manner (Libra is the sign that's actually situated at the far east of the zodiacal wheel), just remember what Libra really wants is to connect with you. If your Libra seems downcast or upset, nothing will cheer him or her up more than a chance to share time with you, preferably over a meal at an elegant restaurant. You'll be amazed at how quickly the idea of going out and being with others in aesthetically pleasing surroundings will restore your Libra's normally upbeat spirits.

A Libra's physical environment is extremely important to this sign's sense of well-being. Ugliness and disorder can drag Libras into a state of despair almost instantaneously, whereas surroundings that are tasteful and refined are profoundly uplifting to them. Your Libra will take a deep breath, relax and be assailed by a feeling that all's right in the world when he or she is in a particularly beautiful setting. Beauty is a shining ideal to Libra. And the urge to make their home a place that's visually pleasing is not a trivial matter to those born under this sign.

In fact, the Libra views it as a basic need to nourish his or her aesthetic sense, which may be lavish or understatedly minimalistic but is always about harmony and balance.

Remember that the outer world—Libra's surroundings—will always have a profound effect on their moods. You may feel that your Libra is a bit obsessed about decorating, or is houseproud, but it's really not what others think that matters the most to the Libra. Instead it's that to be in the right—visually pleasing—environment is what he or she requires in order to feel happy.

What your Libra wants most, though, is to be the partner or friend of your dreams, even if he or she can't always live up to this shining ideal. Fulfilling your expectations is something your Libra thinks about—and often worries about—and your Libra is also probably trying to juggle his or her own wishes and needs in relation to yours, always trying to achieve the perfect balance. If you fail to be considerate of your Libra, he or she might not protest right away, but you'll sense a subtle withdrawal—a kind of pulling away that signals distress. Libras don't want to put this kind of emotional distance between themselves and those they care about, but if something strikes them as unfair, they will inadvertently recoil.

Their concept of fairness can be quite rigid, in fact, and if you're not tuned into this, you may find that you and your Libra become estranged. So if you sense that you've somehow run afoul of your Libra's highly calibrated sense of justice, a bit of negotiating will be in order. Libras are skilled negotiators, though, so watch out—or make sure that you can back your arguments up with facts. But the truth is that communicating and trying to analyze what's gone on is the real key to getting your relationship with your Libra back on track—even if he or she seems to resist at first. And remember, too, that Libras will see reason if it's there. Their minds are usually highly logical, and they love to discuss and compare.

For the most part, you will find that having a Libra in your life is a plus—even if he or she isn't always as direct or forthcoming as you might wish. No one else tries as hard as a Libra to make others feel good, and if you respond in kind and are appreciative, you'll reap some wonderful rewards. And remember that even if your Libra has some special needs they really are secondary to his or her greater need to partner you perfectly.

LIBRAS IN LOVE

Libras are lovers. Being in love is the bliss they long for. And even if later in life they become disillusioned (which they may), those born under the sign of the Scales are the quintessential romantics of the zodiac. What makes their world go round? Finding that special someone to become an "us" with, as opposed to pining away as a "me." And once

they do find that person who makes their heart beat faster and brings out the stars in their eyes, no one will try harder to make their relationship work.

Your Libra lover will buy all your favorite foods when he or she goes to the grocery store, will never forget your birthday or that of your parents, siblings or close friends. He or she will revel in romantic dinners on the town and shared adventures and vacations and will contribute more than his or her fair share in every possible way. This is because what fuels the Libra native is the desire to be an active partner in a perfect relationship.

Libras tend to fall in love passionately, deeply—and, especially when they're young, unformed or immature, regularly. Once a Libra's imagination has been snagged by a potential amour's special qualities, he or she will begin to toy with the notion that here at last is the true soul mate he or she has always been searching for. Libra's idealism can make those born under this birth sign blind and impulsive in love, and it also makes them reluctant to admit it when they've made a mistake. Hating to hurt anyone's feelings, Libras will sometimes fail to tell the unsatisfying partner about their change of heart, prolonging the agony of break-up.

When a Libra feels and believes in his or her heart that this is the right person, though, no one is capable of being more committed, giving and companionable. The joy Libras feel when in a close and generally happy relationship simply means the world to them.

* * *

Libras and **ARIES** are opposites who may either clash or click. Romance may spark up between these two, but whether it will last is another question. Libras are attracted to the Ram's upbeat, confident style but at the same time may be put off by Aries' tendency to get passionately caught up in their own affairs, interpreting this behavior as selfish. And because Libras crave a powerful one-on-one connection and Rams prefer to be lone wolves, the Libra may end up feeling left out or overlooked. When this combination works it can be brilliant, but it's more likely to falter. Bonnie Parker (Libra) and Clyde Barrow (Aries) are an unfortunate example of this bond.

Libra and Aries often do strike up wonderful friendships, and when this happens they enjoy a real sense of camaraderie. As opposites, they may either complement each other or clash, and Libra sometimes can find Aries overbearing. What's difficult for Libra with Aries is the Ram's tendency to tune everything out except his or her own projects and concerns. Libra also sometimes senses that Aries judges him or her for not being as courageous as the Ram. This is not to say that Libra/Aries friendships can't thrive, though,

because Libra genuinely admires Aries' bold spirit, and if the Aries reaches out to him or her in a sincere effort to connect, this is a friendship that will endure.

A Libra parent with an Aries child will be awed by this child's self-assurance and will tend to be quite proud of the way the little Ram conducts himself, whatever the setting. For the most part, Libra (air) is apt to fan Aries (fire) by encouraging this child to go after his or her dreams. The challenge will be for the Libra parents to hold their own when the little Rams show their horns.

On paper, Libra and **TAURUS** are a great match, since both are ruled by Venus, the planet of harmony and beauty. And Libras really do appreciate Taurus' steady warmth and affability. The exciting frisson of attraction, though, is not a given with this combination. Libra may be drawn to Taurus, but is not particularly stimulated by the Bull's down-to-earth approach and slow-paced style. Taurus' romantic and loyal nature strikes a powerful chord for Libras, though, because finding a partner capable of living up to their expectations is their constant dream. No doubt there are any number of Libra/Taurus couples who've found happiness together, but famous examples are hard to find.

Libras find Taureans to be pleasant companions though they may also sense that those born under the birth sign aren't exactly on their wavelength. What will draw a Libra into a friendship with a Bull will be this steady sign's gentle manner, steadiness and reliability. Libras also appreciate Taurus' taste and strongly developed aesthetic sense. What can keep this friendship going more than anything else, though, is Taurus' talent for making their Libra friend feel valued.

Libra parents with a Taurus child will find their little Bull's gentle demeanor highly endearing and will bond with him or her very easily. Taurus' famously strong will—or stubborn streak—will not tend to arouse anger in the Libra parent, who's more likely to find this behavior amusing and will not lock horns or feel a need to prove that he or she is in control. Probably the one challenge will be Libra's impatience with their little Bull's plodding style.

Libras are often immediately drawn to **GEMINIS,** and attraction may flare up quite quickly between these two. The basis of this magnetic pull—for the Libra—is the feeling of meeting a kindred spirit, which Gemini, being an air sign like Libra, genuinely is. Libra's urge to connect is quickly met by Gemini's eagerness to communicate, and Libra feels simulated, balanced and admired all at once—a potent blend that doesn't fail to work its magic on romantic Libra. Those born under the sign of the Scales also love the Twin's wit and sparkle and never find those born under this sign dull or boring. Gemini's chameleonlike changeability, though, can strike the wrong note with Libra, who may see this behavior as evidence of superficiality. Paul McCartney (Gemini) and Linda McCartney (Libra) are one example of this combination, and Marilyn Monroe (Gemini) and Arthur Miller (Libra) are another.

Libras form friendships with Geminis because they find them to be such delightful companions. Libras almost always "click" with Twins, and this immediate feeling of rapport becomes the basis for an often long-continued bond, which endures because those born under the sign of the scales so enjoy Gemini's spontaneity, playfulness and sense of adventure. Gemini's need to communicate is exactly what Libra craves. Libra also identifies with Gemini, who is similarly quick-thinking and observant, and finds his or her long, laughter-punctuated conversations with Gemini friends to be highly addictive.

Libra parents with a Gemini child will revel in their little Twin's bright mind and responsiveness. They will also find this child particularly easy to be with—a natural companion whose signals are never difficult to interpret. Libra will also be beguiled by Gemini's amiability, and a genuine friendship will often evolve between these two when the Twin matures.

Libra and **CANCER** take time to warm up to each other, but there is a genuine sympathy between these two that can evolve into romance. Libra is drawn by Cancer's sensitive emotionality and by the Crab's desire for security, which in itself makes the Libra feel more secure. Libra also appreciates Cancer's tenderness as well as his or her nurturing side, but lasting intimacy may prove difficult to sustain due to Libra's tendency to find Cancer's moodiness upsetting and distancing. Libra may also judge Cancer's (highly emotional) thinking as being somewhat illogical or unclear, finding it harder and harder to communicate and connect. The brief pairing of Carrie Fischer (Libra) and Dan Ackroyd (Cancer) is an example of this uncertain combination.

Libras often feel uneasy with Cancers, and this can get any possible friendship between the two off to a difficult start. Those born under the sign of the Scales tend to interpret Cancer's self-protective behavior as aloofness and are quickly stung by what they think is a rejecting or critical response. If these issues don't result in the Libra backing off, though, a bond can spring up between these two that is genuine and heartfelt. And Libras love the way Cancers open up when they do drop their guard, although the resulting connection may prove difficult to sustain.

The Libra parent will quickly realize how sensitive the little Crab actually is and feel an urge to take special care of this responsive child. A very warm bond can spring up that the Libra is eager to maintain, but those born under the sign of the Scales are likely to find their little Cancer's moodiness and emotionally charged reactions somewhat baffling.

Libras and **LEOS** can sparkle together and create a truly romantic magic between them. Leo's confidence and very centered sense of self draws Libra in, and Libras have a talent for giving Lions the kind of admiring gazes and attention they crave. As long as a feeling of mutual admiration persists, Libra glows in the warmth of Leo's affection. What can go wrong as time passes, though, is that the Libra may begin to feel that the Lion is too self-involved and not as attentive as he or she seemed at first. As the Sun seems

to drift behind the clouds of other pressures and concerns, the Libra may begin to feel quite disillusioned. There's a basic compatibility here, but the danger is that this relationship begins to seem lopsided to the Libra, who feels that he or she is doing more of the giving. Bruce Springsteen (Libra) and Patti Scialfa (Leo) are a happy example of this pairing, and F. Scott Fitzgerald (Libra) and Zelda Fitzgerald (Leo) a less contented one.

Friendships do spring up between Libra and Leo, because Libras are drawn by Lions' warmth and self-sufficiency. As with the Libra/Leo couples, though, Libra can be put off by what is seen as too much self-absorption on the Leo's part. Since Libra is all about give and take, and Leo—by nature—is the Sun around which all else revolves, those born under the sign of the Scales may find it hard to actually engage with Lions except—as far as the Libra sees it—on Leo's own terms. Libras do appreciate Leo's loyalty, though, and will reciprocate in kind, so the friendships forged between these two tend to endure.

Libra parents with a Leo child, on the other hand, are likely to delight in this child's sunny nature and find no fault with their little Lion. Leo's self-certainty will reassure the Libra that this child can thrive in many situations, and Libra parents will take great pride in his or her accomplishments. The bond between these two will be a warm and generally harmonious one, though the Libra parents will sometimes fear that their Lion doesn't fully respect their authority.

Libras often instantly like **VIRGOS**, although they don't tend to be bowled over by them, so the romantic feelings that may develop are likely to take Libra by surprise. Passion doesn't generally erupt but rather grows and prospers on the admiration Libra feels for Virgo's refinement, character and good sense. Libra is also reassured by Virgo's down-to-earth approach to life, which has the effect of making airy, abstract Libra feel secure and safe. Most important, Virgos generally maintain the balance of give and take in their relationships that is so crucial to Libra's sense of well-being—and this is also what will ensure that this bond endures. Will Smith (Libra) and Jada Pinkett Smith (Virgo) are an example of this often successful combination.

When it comes to friendship, Libras find Virgos to be responsive companions who are sensitive to Libra's needs and feelings. Libra also finds much to admire in their Virgo friends because although they may be critical—even picky—they possess an essential kindness that never fails to come through if others are needy or upset. Those born under the sign of the Scales also feel drawn to their Virgo friends' clear rationality, and they sense that the Virgo has qualities that they themselves lack, or need to develop. And this propels the Libra to continually seek them out.

Libra parents with a Virgo child will be intrigued by their little one's sensible and analytical approach to life. The ways in which this child differs from them (Virgo is earth, Libra is air) will be a source of delight to the Libras, who will greatly enjoy interacting

with their little Virgo. As this child matures a particularly harmonious bond is likely to evolve between these two, and the Libras will often come to depend on the Virgo to help them in various ways.

What happens when one Libra encounters another **LIBRA** can be magical for both—a spark of recognition, a tug of attraction and the feeling of seeing their own best qualities reflected back to them in the partner's charming response. Sensitive to each other's feelings and doing their utmost to be and do what the other wants, with a fellow Libra there's a sense of coming home to safe territory: the other Libra is making the same effort and for once, the balance is completely right.

The bliss may not last, though, and some Libra couples fall seriously out of balance when one or the other begins to take the relationship for granted and stops trying. But for the most part, this is a combination that works wonderfully well—Catherine Zeta-Jones (Libra) and Michael Douglas (Libra) being a prime example.

Libras also befriend each other delightedly and often passionately, finding in their own sign the kind of responsiveness and eagerness to share that they themselves possess. Two Libras together can form an exclusive little club of "we," sharing secrets and feeling the satisfying sense of being witnessed and appreciated. What happens when two Libra spend time together usually pleases both, because each makes a genuine effort to give the other what they want. Few signs get along as well as Libras do with each other, and this is a bond that generally endures.

Libra parents with a Libra child will sense how eager their little one is to do—and be—what they require. Seeing their own qualities reflected back in their Libra child's behavior, the Libra parent will often feel moved and emotionally drawn in, but also disconcerted. Some Libra parents are unconsciously tougher on their Libra children because they are too much like them, and their relationships with their Libra children are prone to be highly complex.

SCORPIO'S intensity magnetizes Libra, who is drawn as much by Scorpio's powerful sensuality as by that sign's unreadable depths. What Libra experiences with Scorpio is a jolt of passion and excitement that can catapult him or her into the kind of bliss the Libra longs for. How well the relationship plays out, though, depends on the Libra's ability to actually deal with Scorpio's sometimes overpowering emotions and mysterious withdrawals. Libra also finds Scorpio's sometimes blatant displays of anger difficult to accept, but at the same time Scorpio's ability to feel so deeply, and to actually follow through on their feelings, come what may, acts as an aphrodisiac on Libra's more abstract and airy nature. Katy Perry (Scorpio) and John Mayer (Libra) are an example of this often volatile pairing.

Libra-and-Scorpio friendships generally thrive, because Libras never fail to admire Scorpios' definite sense of who they are and what they want. What Libra sees in Scorpio

are qualities that he or she wants to possess and hopes to acquire; at the same time, Libra also revels in the intensity of this friendship, which can be all-enveloping. Feeling special and singled out as the Scorpio's chosen companion, Libra will often go to great lengths to keep this connection afloat.

A Libra parent will feel somewhat awed by the passionate depths of her Scorpio child's nature and will tend to pick up on and respect little Scorpios' need to protect their inner selves and hide behind a veil of secrecy. As a result, Libra parents often have a tendency to handle their Scorpio children with kid gloves, which can sometimes be exactly what's needed but that also may, quite inadvertently, have a distancing effect that leads to misunderstandings.

Libras generally like and are attracted to **SAGITTARIUS,** but Sagittarius' breezy style isn't conducive to the romantic passion Libra longs for. What does draw Libra to Sagittarius is their cheerful nature and playfulness, and the feeling of companionship a Libra experiences with Sagittarius can lay the foundation for a successful relationship. Libra's inclination, though, is to hold back until certain that a possible love interest reciprocates his or her feelings, and Sagittarius doesn't easily commit or to offer the kind of assurances the Libra looks for. This bond may never take off at all; but if it does, it can work quite well, since an intrinsic harmony exists between these two signs. The enduring relationship of Woody Allen (Sagittarius) and Soon-Yi Previn (Libra) is a successful example of this combination.

Libras and Sagittarians almost always get along with each other, and friendships between the two spring up quite naturally. What Libra most appreciates about Sagittarians is their adventuresome spirit as well as their warmth and conviviality. As with the two other fire signs, Aries and Leo, Sagittarius may be so caught up in his or her own plans and concerns that the kind of one-on-one sharing the Libra seeks isn't all that available. Libras often have numerous Sagittarian acquaintances, but find long-lasting friendships with Sagittarians more difficult to sustain.

Libra parents with a Sagittarius child will delight in their little Archer's bubbly spirits and sense of humor. The good feeling the Sagittarius child engenders in the Libra makes this relationship a particularly happy and harmonious one. Few problems are likely to arise, and generally Libra will remain quite close with their Sagittarius child as he or she grows into maturity, although the Archer's urge for freedom and independence may strike some Libra parents as a rejection of themselves.

Libra initially finds **CAPRICORN** a bit cool and distancing, but Capricorn's evident strength and innate worldliness can impress those born under the sign of the Scales and draw them in. Libras sense that they need to work harder with a Goat to win his or her approval and admiration—a challenge they sometimes can't resist. What's more, the aura of power that Capricorn exudes is one that Libra can find quite tantalizing,

because Libras are often not entirely secure in themselves. The additional fillip of a stable relationship—which Capricorns, who take their responsibilities seriously, seem to offer, also holds enormous appeal for Libra. What can make this pairing tricky for the Libra, though, is his or her frustration at Capricorn's lack of spontaneity and the Goat's need to be in control, which strikes Libra as unfair. Jayne Meadows (Libra) and Steve Allen (Capricorn) are an example of a Libra and Capricorn who made this combination work.

Libra admires Capricorn's determination and grit enough to pursue friendships with those born under this sign, and will also make an effort to keep this relationship going. Capricorn's reliability is an attribute Libra appreciates—always being able to count on the fact that this friend will turn up at the appointed hour and behave in a highly dependable fashion. And although Libra doesn't generally find Capricorns to be on the same wavelength, Capricorn's many sterling qualities make this connection one that Libra values.

Libra parents tends to find their Capricorn child satisfactory in every way and to be quite charmed by their little Goat's pragmatic and competent way of coping. The Libra parent will also be very supportive of this child's ambitious efforts and thrilled by his or her accomplishments. Emotionally, though, Libra parents may sometimes have the sense that a certain distance exists between this very self-contained child and themselves.

With **AQUARIUS,** Libras are very much in their element, and a sense of ease and camaraderie is often instantaneous. Libra sees much to admire in the Waterbearer, but romantic attraction is more likely to happen over time than arrive like a bolt out of the blue. What draws and holds Libra in this relationship is the good feeling and playfulness that sparks up whenever he or she is in the Waterbearer's company. The sense of being with a kindred spirit who shares similar values and ideals is a kind of aphrodisiac that keeps this naturally harmonious bond afloat. Aquarius' need for space and freedom, though, can pose a huge problem for Libra, who wants constant closeness. The pairing of John Lennon (Libra) and Yoko Ono (Aquarius) attests to the power of this combination.

Libra and Aquarius may bond on first meeting, but Libra is somewhat discouraged from pursuing a close connection by Aquarius' highly independent, even lone-wolf stance. Nonetheless, Libra is drawn by Waterbearers' originality and idealism and always enjoys whatever time he or she spends in their company. The Libra ideal of the one-on-one connection is somewhat in conflict with Aquarius' group-oriented leanings, and the intensity that Libra looks for in his or her connections may not be that easy to find with Aquarius. Still, these two can be great friends under the right circumstances, and Libra will tend to hold his or her Waterbearer friends in high esteem.

A Libra parent with an Aquarius child has no difficulty communicating with his or her little Waterbearer and will be intrigued by this child's whimsical thoughts and original way of seeing the world. The young Aquarius' independence will normally strike the

Libra parent as admirable, although he or she won't necessarily allow as much freedom as the Waterbearer seeks. The Aquarius child's tendency to appear emotionally detached may also lead to misunderstandings between these two.

Libra and **PISCES** often have a special rapport, because their ruling planets, Venus and Neptune, are very much in harmony. Libras tend to trust Pisces and to open up with those born under the sign of the Fish, and the kind of romantic magic that can happen may have a very powerful effect. Whether this relationship can survive the crossed signals that inevitably crop up, though, is another story. Pisces' emotionally driven and intuitive approach is one that Libra may simultaneously admire and view as muddled and illogical. Libra also may feel frustrated by Pisces' unwillingness to analyze and discuss important issues. Still, the current of feeling that exists between these two signs can make this relationship work, as it seems to have done with Chris Martin (Pisces) and Gwyneth Paltrow (Libra).

Libra and Pisces friendships are generally forged when work or shared pursuits bring these two together. Libra appreciates Pisces' sensitivity and will make every effort to be a kind and supportive friend to the emotional—and often turbulent—Fish. And while Libra may not find the kind of light-hearted and playful companionship he or she looks for in this relationship, Pisces' confiding manner and emotional honesty weaves its own special spell. Friendships between these two may prove volatile, but they will also tend to endure.

Libra parents will have no trouble bonding with their little Fish and will delight in his or her responsiveness. Few issues are likely to cast a cloud on this relationship, but the Libra parent will tend to worry about the sensitive Fish's ability to deal with life's sterner side. This may result in a kind of overprotectiveness and a tendency to foster dependency.

COLORS, GEMS AND FRAGRANCES

No one seems to agree whether the color that accords with the sign of the Scales is blue or green, but it's interesting to note that Beta Librae—a prominent star in the constellation of Libra—is said to give off an unusually strong greenish tinge. Green is also the opposite of red, which is the color of Aries, Libra's opposite sign. And green undoubtedly enhances the soothing and harmonizing traits that characterize Libra's nature.

Blue, on the other hand, is said to be the color of Venus—Libra's ruling planet—and is generally a very flattering color for Libras to wear.

All shades of blue—from the palest hue to the richest, deepest tone—seem to be right for Libra, as does turquoise, which is, of course, a blend of blue and green. Purple is another color which Libras seem to like and one that, being a combination of blue and

Libra's opposite color, red, may help those born under this birth sign to strike a balance between being outgoing or more retiring.

Red, though, is a color many Libras seem to avoid—or to wear only under circumstances when it suits their mood. This is because red is traditionally an attention-grabbing color, and Libras are inclined to avoid being conspicuous or making an effort to stand out. Red can be very flattering to Libras, though, and should not be passed up at those times when a Libra feels a need to assert him- or herself and boldly step into the spotlight.

Silver and gray, though, are very natural colors for Libra to seek out, and wearing these tones can be reassuring to Libra, who feels at home in them.

The opal is a stone traditionally associated with Libra, and its reflective, multi-toned qualities seem to harmonize with Libra's character, but may not always be the best choice for those born under the sign of the Scales. Being innately receptive, Libra may be better off with another stone also associated with their birth sign, namely the sapphire—especially the blue variety, which is attuned with the color of Libra's ruling planet, Venus.

Diamonds are actually very strengthening to Libras, representing the centered self, which Libra seeks to achieve. Libras are often drawn to diamonds, and they should wear them to build their confidence and clarify their thoughts. Numerous semiprecious stones are said to be associated with the sign of the Scales, including lapis lazuli—which is very flattering to Libra—and agate, chrysolite and cornelian. The metal which accords with Libra is copper—also connected with Venus, Libra's ruler.

Violets are said to be one of Libra's primary flowers, and their color and fragrance are expressive of Libra's charming effect. The white rose is another flower that accords with this birth sign, and so are cosmos and hydrangeas. Pennyroyal, which sports purple flowers, is another plant that falls in Libra's domain, and the numerous trees associated with Libra include the almond, walnut, plum and myrtle.

The cleansing and toning herbs considered most healing for Libras are angelica, thyme, burdock, bearberry and uva ursi, purported to be good for the kidneys (which traditionally fall under Libra's jurisdiction). Anxious nerves, often suffered by Librans, are soothed by aromatherapy employing lavender or rose, and a sachet of one or the other, placed under the pillow, will ensure sweeter sleep.

Libra's fragrances run the gamut from the sweet scents of violet and neroli to the more complex geranium. Libras do not tend to wear strong or overpowering perfumes, preferring a light and barely discernible scent which doesn't impose itself, but leaves a lingering sweetness in the air. ♎

8

Scorpio

24 OCTOBER – 22 NOVEMBER

210°

What reason weaves, by passion is undone.
—ALEXANDER POPE

What I love the most about Scorpios is that they feel so deeply. The quality that makes those born under this sign stand out from all the rest is their intensity. I don't think any of the other birth signs experience their emotions in quite such a powerful way as Scorpios, and the key to understanding them is to clue into the gale-force feelings raging behind their usually cool and collected façades.

There's never anything trivial or lukewarm about a Scorpio's reactions. My friend Jane (November 4) is always bursting with enthusiasm about someone she's just met or obsessed with a creative project she's involved in. Just to be around her is to feel more alive. Even Scorpio's bad moods and upsets are so richly charged with emotion that they're invariably stirring. Scorpios don't float along on life's surface; they are the deep-sea divers of the emotional realm.

I think people sometimes find Scorpios intimidating because they seem to look right into you and know what's really going on beneath your carefully controlled surface. All those murderous or sexual thoughts that are teeming in our most primitive depths are no strangers to one born under the sign of the Scorpion. It's not that they choose to experience and know these subterranean levels; as Scorpios, they simply can't escape them.

I always found it so enjoyable to talk about and analyze people with my late husband, Anton (November 6), because he saw into them so well and didn't shy away from revealing what he observed. Scorpio's frank—uncensored—perceptions are generally so accurate that they're startling. And they're funny, too, in the way any opinion or observation that perfectly hits the nail on the head can provoke a delighted guffaw. It's as if Scorpios possess an inner radar that enables them to see right through pretensions and disguises. And that radar is fueled by their firsthand knowledge of the often embarrassing and hard-to-bear reality of being human.

Irony and gallows humor are very much up Scorpio's alley. Sometimes those born under this sign have a very dark vision of the world, but this is all because their consciousness seems to be pinned to what's going on in everyone's subconscious. As a result, many Scorpios are drawn to depth psychology. Mysteries fascinate them too, and they

can become positively driven by the urge to get to the bottom of situations and reveal what's hidden away deep below.

In fact, being driven is one of the common threads that runs through Scorpio's nature. All of the Scorpios I've known have been urgently alive and on the move—whether in pursuit of a high ideal, an ambition or sheer, unadulterated pleasure. You won't find a Scorpio lolling around doing nothing, because those born under this intriguing sign are too consumed by their own intensity to just lie fallow. And Scorpios are renowned for taking an experience to the limit and beyond. They are notorious extremists who will push on until they drop.

I think Scorpio's famous pride is one force that drives them beyond all reason; but Scorpios also seem to feel a need to test the limits to simply find out where they are. I've observed various Scorpios I've known indulge in such outrageous behavior that it's been hard to believe, and carry on until they either did themselves in or until something absolutely forced them to stop.

It's hard to understand what can make those born under this sign so crazily over the top that they have been known to self-destruct, but the key to this mystery lies in Pluto—the strange dwarf planet considered to be Scorpio's ruler. Pluto is said to be the planet of "transformation" in astrology, and it is also about the process of death and re-birth—the same process which so many Scorpios seem to replicate in their life stories.

One of my favorite Scorpio clients, whom I'll call James, was a classic example of this phenomenon—a talented musician who for years on end was hopelessly hooked on heroin, nearly destroying his career and all his relationships. James stayed stuck in this lethal pattern until well after everyone had given up on him. It's not really clear what finally turned him around—possibly a close brush with death—but he finally kicked his habit, never to relapse. And from the chaos of his past James emerged as an amazingly disciplined and powerful man who has gone on to help and support others who struggle with addiction.

It's worth noting that among the symbols associated with Scorpio are the classic Scorpion (the only creature with the ability to self-destruct by biting its own tail)—the Phoenix (the mythological bird that rises from its own ashes) and the Dove (the symbol of peace). And James really did manage to live these symbols—self-destructing like the Scorpion and then rising above his former self, like the Phoenix. And he now functions as a Dove, helping others to find peace as he seems to have done.

I've met all kinds of Scorpios, and they really do seem to fall into different categories, some obviously being of the Scorpion variety—moody, vengeful and controlling—while others seem to have their dark side well in hand and to have put their misspent years behind in true Phoenix fashion. Then there are the Scorpios who are so good it's

absolutely impressive, people who actually live for their ideals with the kind of passion only a Scorpio can muster.

What all Scorpios are highly attuned to, though, are the uses and abuses of power. I've never met a Scorpio who didn't have a very clear awareness of his or her ability to intimidate, control or overwhelm others. Not that they choose to use this ability in normal circumstances, but it's there, lurking behind that penetrating gaze. And Scorpios do not take kindly to anyone else's attempts to control or, worse still, dominate them. Nothing escapes their observant gaze, and no one is going to get away with treating them disrespectfully.

Scorpios' passion and intensity isn't something they wear on their sleeves. They feel so much that they probably imagine that it's obvious, and that everyone is equally as emotional as they are. I believe that Scorpios' enigmatic façade isn't a mask deliberately put on to hide their true intentions. Instead, acting in a cool and controlled manner is the only way they can manage to contain the bursting feelings that they're constantly experiencing.

It's actually a paradox: Scorpios are so hot that they're cool. Two of the people I've been closest to in my life have been Scorpios (my sister and my late husband), and my firsthand experience is that those born under this fascinating sign are incapable of wearing a false mask, because their emotions are too powerful. My sister Joan finds it impossible to behave in a deceptively friendly fashion with people she distrusts or dislikes and has actually embarrassed me—a diplomatic Libra—by acting rude or confrontational in such situations. My late husband, Anton, was the same way; he couldn't fake a pleasant manner to conceal his true feelings, even when it would simply make life easier.

Not that my ability to act nice when I don't feel it is anything to be proud of, but being an air sign (Libra), I accept that, for the most part, my emotions have to pass through the filter of my intellect or reason before they come out. For a water sign (emotion) like Scorpio, though, it's the feeling that dominates. My late husband sometimes accused me of trying to "censor" him when I objected to his emotionally charged reactions to people or situations that bothered him. What it was really about, though, was the difference in the way we operated. I still find it hard to understand when, for instance, my sister openly glares at a plumber who's done less than a good job on fixing something in her home and goes on to treat him with angry disdain, when my impulse—as a Libra—is to try to cajole him into doing what I want.

Scorpios can also be extremely vengeful. It's all part and parcel of their intense emotionality, not to mention their pride. Scorpios seem to think that it's their sacred duty to pay someone back if they've been wronged. What's more, there's no question that playing the avenging angel gives them quite a kick. This is particularly true of the Scorpion type of Scorpio, of course, and they are masters at the art of revenge. The idea that two

wrongs don't make a right doesn't hold any weight with a Scorpion because, in their minds, someone who has wronged them hasn't only gotten away with something, but done so at their expense.

I've known Scorpios who have concocted various "punishments" for those who have acted in a less than trustworthy or kind manner towards them, and their revenge can run the gamut from somehow embarrassing the guilty party to—in extreme cases involving very unevolved Scorpios—causing them harm. Whatever form their getting their own back takes, though, the Scorpion never doubts that the wrongdoer deserves to be punished.

This attests to how hurt the Scorpios can feel by an act perpetrated against them, and how deeply it penetrates into their vulnerable and fiercely protected inner selves. Their behavior may appear to be a ridiculous overreaction, but to them it's entirely justified because of the harm they've suffered.

"If someone somehow hurts me, and if I do in any way let them back into my life later," a Scorpio friend once told me, "I'll still never open myself up to them again." Scorpios are possibly the most emotionally retentive of all the birth signs, Cancer running a close second. Reputed to have "memories like elephants," as Linda Goodman put it in "Sun Signs," Scorpios seem to hold onto past hurts and past wounds almost as if they're reluctant to let them go.

Even if they do forgive, they will never forget. But this is not to say that they won't try to overcome their negative feelings, just that their scars are always there for them to see. The depth and breadth of a Scorpio's emotional range can also make them generous-hearted and deeply sympathetic. Feeling everything so strongly, they have little difficulty identifying with others' woes or mistakes, even if they don't condone them.

Another paradox—and Scorpio is full of them—is that those born under this richly emotional sign can be either highly moral or the worst of sinners. Most of the Scorpios I've known are of the former variety, and their awareness of the difference between right and wrong is as intensely felt as everything else they experience. As children, they will suffer inordinately if they do something they were told not to do, tormenting themselves until they confess or somehow right the wrong.

A friend of mine who has a Scorpio son remembers how when Alfie (November 11) was about five, he stole a friend's coveted toy dump truck and hid it in his closet. He then began to behave very peculiarly, averting his head and turning a violent shade of red whenever she looked directly at him, shutting himself in his room and suffering from nightmares that woke him up during the night.

Seriously concerned, my friend finally sat Alfie down and demanded to know what had happened to upset him so deeply. And without a word, Alfie led her to his closet, rummaged around and then handed her the stolen truck. Of course, she made Alfie

return the truck to his playmate, which, shamefaced, he did; but she didn't feel a need to reprimand him too severely, since he so clearly had suffered the pangs of remorse without anything being said.

On the other hand, those Scorpios who make a decision to go against their consciences and flout the moral code will tend to do so with such depraved abandon that they become the embodiment of evil. Scorpios are not inclined to do anything casually or halfheartedly, and once they direct their powerful wills, they can be unstoppable.

This quality can make Scorpios impressively effective and enormously successful. A great many of the Scorpios I've known have risen to real heights in their chosen professions, but once they've reached the pinnacle, I have also noticed that circumstances have conspired to bring them down a notch or two, forcing them to go through the constant "birth, death, rebirth" cycle that seems to be Scorpio's lot in life.

The numerous Scorpios I've known who've gone through this have included, among others, an art dealer who became one of the top names in the art world before descending down the slippery slope to far lesser status; the talented managing editor of a celebrated magazine, who was abruptly replaced long before his time, probably because—in true Scorpio fashion—he wasn't enough of a team player; and a soap-opera actress who had a pivotal part in an extremely popular soap, was suddenly phased out and was never able to recapture her former glory.

What's telling is that, to a greater or lesser extent, their brilliant success went to these people's heads, and they became so full of themselves that they abused their power by behaving arrogantly, throwing their weight around, indulging in over-the-top spending and other excesses. And it seems to be typical of this sign's fate that Scorpios who get above themselves just don't seem to be allowed to get away with it. They may even manage to somehow sabotage their success so that, in quite a humiliating fashion, they fall on their faces.

Scorpio's pride is often this sign's downfall (or its making, depending on how you look at it). It's important to remember that this complex, Pluto-ruled birth sign is all about transformation. Being humbled seems to be the way in which Scorpio is forced to make the leap from overweening pride to an admission of his or her own shortcomings and limitations. The result is not only that Scorpios become better and nicer people, but that often this death-and-rebirth cycle leads to a spiritual awakening that completely changes their lives.

Scorpios are often fascinated by religion, spiritualism and the unexplained. Whether they embark on a spiritual path or not—and the majority of the Scorpios I've known have done so—they can be as obsessed by the desire to pierce the veil of life's mysteries as they are by sex. This birth sign has always been associated with a kind of enhanced or rampant sexuality, and though I've met a few Scorpios who were a bit

prudish, most have been the opposite—unabashedly sensual and hotly interested in all aspects of sexuality.

This is yet another aspect of Scorpio's intensity, but it's interesting to note that the eighth house of the zodiacal wheel, which accords with Scorpio, is known as the house of "Sex, Death and Regeneration"—on the face of it a somewhat weird combination, but on closer examination, perhaps not. (Consider that the French have described orgasm as *"la petite mort"*—the little death—referring to the momentary loss of self which happens with orgasmic release.)

Sex and death are hardly light subjects, and Scorpio is without a doubt the most feared sign—or the one that, on mention, is most likely to cause people to step back or recoil. I've seen this kind of reaction when a Scorpio friend divulged his or her sign upon request, and I've gotten the impression that the Scorpio person got quite a kick out it. Scorpios are conscious of their power, and they like getting the respect that they feel that they're due. They're neither lightweights nor people that others can afford not to take seriously.

Scorpios are also strong-willed and courageous, and they can be wonderful in a crisis, because they will stay icy cool when everyone around them is losing the plot. Keeping their powerful emotions under control gives them a lot of practice at not succumbing, so that when adrenaline-triggered panic wells up, their ability to remain in control seems almost superhuman. So does their ability to direct their will, and Scorpios actually seem to thrive in adversity and to rise to greater heights when they're being challenged than when they're not.

And once they're focused on a goal, Scorpios will keep going and going, ignoring physical discomforts to the extent that they may even damage their health. Obsession, in fact, goes hand in hand with Scorpio's passionate nature. Scorpios' desire to have what they want will overpower every other matter or consideration, and once they're on the trail, like bloodhounds, nothing can throw them off the scent.

This is why Scorpios make such brilliant detectives and researchers, like Marie Curie (November 7, 1867), the first woman to win the Nobel prize for her research into radioactivity and, interestingly, *plutonium;* as well as the celebrated Jonas Salk (October 28, 1914), the discoverer of the polio vaccine.

The number of Scorpio writers who've explored the darker side of human nature is interesting to note, like Albert Camus (November 7, 1913), whose *L'Etranger* (The Stranger) tells of a man so alienated from society that he committed a murder and experienced no remorse; and Truman Capote (October 30, 1924), whose sobering *In Cold Blood* details the senseless killing of a rural family by two disturbed young men. And, of course, Fyodor Dostoevsky (November 11, 1821) wrote *Crime and Punishment*, the renowned novel that forays into the subterranean depths in its exploration of a desperate

young student's killing of a pawnbroker. In true Scorpio fashion, filmmaker Martin Scorsese (November 17, 1942) has also addressed modern crime, violence and issues involving guilt and redemption in such films as *Mean Streets, Taxi Driver* and *Goodfellas.*

The gallows humor and satire of novelist Kurt Vonnegut (November 11, 1922) is also distinctly Scorpionic, as are the macabre and side-splittingly absurd human behaviors depicted by comedian Jonathon Winters (November 11, 1925). Comedians Dick Smothers (November 20, 1939) and Goldie Hawn (November 21, 1946) have been known to venture into the same territory, and Scorpio's comedic gifts are also delightfully evident in the self-mocking style of actor and comedian John Cleese (October 28, 1939).

In fact, it's quite striking how skillful Scorpios are at making us laugh—particularly at ourselves—like talk-show host Johnny Carson (October 23, 1925), who was a master at the art of being enigmatic and could deliver the most hilarious lines with a completely straight face. Carson also had an enormously mesmerizing presence and the power to hold others' attention, as did the very magnetic newscasters Walter Cronkite (November 4, 1916) and Dan Rather (October 31, 1931).

"Magnetic" is also an apt description of actor Richard Burton (November 10, 1925), a classic Scorpio whose excesses were well chronicled throughout his life. The potent intensity that informed Burton's acting ability was also evident in talented actress Sarah Bernhardt (October 23, 1844), and it's no surprise that the passionate Vivian Leigh (November 5, 1913) was also a Scorpio. So is the evocative Tatum O'Neal (November 5, 1963) as well as Sally Field (November 6, 1946), not to mention Katharine Hepburn (November 8, 1907), Hedy Lamarr (November 8, 1914) and Demi Moore (November 11, 1962), among others.

The powerful personality of acerbic actress and comedian Roseanne Arnold (November 3, 1952) is as much a part of her appeal as her ability to convey emotion. And in true Scorpio fashion, she has experienced many tumultuous ups and downs in her widely publicized personal life. And what other sign could driven, courageous Hillary Clinton (October 26, 1947) have been born under but that of the Scorpion? Her ability to rise—Phoenix-like—from the ashes of her trials and defeats has enabled her to have a lasting impact on world affairs.

The emotional intensity of Scorpio poet Sylvia Plath's (October 27, 1932) work is what gives it such depth and appeal, and the dark themes she explored are typical of the preoccupations of those born under this birth sign. Poet Ezra Pound (October 30, 1885) was a Scorpio, as was riveting, alcoholic Dylan Thomas (October 27, 1914). So was the remarkable artist Pablo Picasso (October 25, 1881), also reputed to be brooding, intense and powerfully charismatic.

Encompassing such extremes as the difference between Charles Manson (November 12, 1934) and Billy Graham (November 7, 1918), Scorpio is a sign whose range seems

to span the distance between heaven and hell and back again. And the sign's constant underlying theme has everything to do with the danger of overweening pride, well illustrated by the fate of Scorpio Marie Antoinette (November 2, 1755) whose self-aggrandizement and excesses so tragically led to her downfall.

"Turn around, go back down," wrote singer/songwriter Hamilton Camp (October 30, 1934) in his haunting Sixties hit about the fall of Babylon (recorded by both the Byrds and Quicksilver Messenger Service). "The mighty men are beaten down, the kings are fallen in the ways….Oh God, the pride of man broken in the dust again…"

Camp, also a talented actor and lifelong follower of the Subud spiritual movement, was, of course, a Scorpio.

THE CARE AND FEEDING OF A SCORPIO

The first thing you need to understand about your Scorpio is that he or she really does need your love, attention and care, even if he or she doesn't like to show it. Scorpios don't parade their weakness and dependency out there for all to see. In fact, Scorpios usually try to give the impression that they are completely fine on their own. Don't be fooled. Scorpios are masters at the art of subterfuge.

On the other hand, Scorpios really don't want you to fuss over them or baby them. This is because they are always struggling not to acknowledge their need for you and to be little islands of self-sufficiency—an effort reflected in their tendency to pull away when you, for instance, try to place a Band-Aid on a cut they've accidentally sustained instead of letting them do it themselves.

This may strike you as a bit silly and childish, but Scorpios hate to be needy in any way, and they also hate to be reminded of their vulnerability (which sustaining any sort of injury forces them to do). I remember how my late husband, Anton, would recoil if I tried to play nurse when he got hurt in any way and his need not to display any weakness in such situations. With Scorpios it's extremely important to know when not to interfere and to make sure that you don't insult their dignity or invade their privacy.

If it drives you crazy when a veil seems to drop over your Scorpio's eyes and you know that he or she is concealing something from you, remember that it will only make matters worse if you try to pry. Letting your Scorpio see that you do respect his or her boundaries works wonders, because it allows them to open up in their own time and fashion, and it paves the way for the trust it takes to make this relationship work.

At the same time, because Scorpios are so aware of power and its uses, it's essential to let them know where your own boundaries are and to demand to be treated with the

respect you deserve. Scorpios are not impressed by wishy-washy behavior of any kind, although they may pity those who are clearly weaker than them. This is not to say that you shouldn't show them your own weakness, but it's never a good idea to let them walk all over you.

To have a strong and fulfilling bond with a Scorpio is to claim your own power and not be afraid to use it. When you display your own passion and intensity, your Scorpio feels closer to you. This is because your Scorpio is filled with emotion and needs to know that he or she is not alone out there. What's wonderful about being with a Scorpio is that you can show what you feel and express yourself without self-consciousness or fear. Even if your Scorpio is of the more controlled or inhibited type, he or she will understand if and when you lose control of your emotions.

What you should not try to do, though, is to pretend to be what you're not. Remember that Scorpios possess a kind of psychic radar than enables them to penetrate through façades and clue in to what's really going on. Falsity doesn't wash with them. Being open and honest is the only policy that works. And revealing your darkest and most guarded secrets is the currency of real connection and communication with your Scorpio. The darker, the better, in fact, because Scorpios are totally tuned into their own dark side and find it fascinating to find out about yours.

Remember, though, that while it's fine to share your secrets with your Scorpio, it should be taken for granted that the code of omertà applies to the secrets he or she shares with you. Your loyalty is extremely important to your Scorpio, and you'll completely undermine your bond if you reveal to others anything that's private between the two of you. In fact, this would be tantamount to an unforgivable betrayal to your Scorpio, and is likely to result in a permanent breach that's impossible to repair.

Truly understanding your Scorpio is to be aware of how deeply he or she feels everything. The intensity of your Scorpio's reactions may appear exaggerated or overplayed to you, but bear in mind that he or she experiences life in bold Technicolor. Remember, too, that your Scorpio doesn't reveal his or her feelings to anyone but those he or she deeply trusts—the exception being anger, which those born under this sign sometimes find difficult to contain.

If you're involved with a Scorpio, chances are that you're not afraid of real passion, and you don't feel a need to run for cover when someone loses their temper. Your Scorpio respects people who stand up for themselves and who know how to wield power gracefully. Scorpions will also appreciate—even if they don't show it—your ability to tell them to back off or cool down when they seem to be losing the plot, especially if you're capable of doing so in a calm and assured manner.

Scorpios generally try—and succeed—in keeping a lid on their emotions most of the time. When something that affects them very deeply blows that lid off, they can

become swept away by the hurricane-force winds of their emotions. If this happens to your Scorpio—and it probably will, more than once—your job is to do or say whatever will help to restore perspective and save him or her from the carnage.

Your Scorpio may be stubborn and willful at times, but being with someone who lives with such feeling and intensity is undeniably enlivening. Before I married my Scorpio husband, Anton, having chosen to hold the ceremony in an Episcopal church, we were required to attend three counseling sessions with a priest, who, fortunately, turned out to be a delightfully observant person whom we both liked.

During the second session I remember bringing up the issue of Anton's reactiveness to everything as well as his sometimes volatile temper. After hearing me out, the priest fixed me with an amused, wise look and said, "But isn't it great to have all that passion?" A perfect rejoinder, of course, because it was absolutely spot-on. Anton's passion really was evocative and wonderful, even if it sometimes had a dark side. Your Scorpio travels through the deep currents of life, and while the experiences you share will occasionally be turbulent, they will have a heightened intensity that is truly enriching.

When focused on a goal or ambition, your Scorpio will tend to drive him- or herself with a single-mindedness bordering on obsession. And you'll find that nothing you can do or say is going to convince your Scorpio to lighten up once he or she is set on a particular course of action. Of course, you'll have no choice except to step back and give your Scorpio the support and encouragement that's needed, and you may even have to temporarily take over some of the responsibilities of your shared lives—if you're living together—or, if not, to understand your friend's total preoccupation with whatever business is at hand.

Scorpios will sometimes get so wrapped up in their pursuits that they undermine their health; and while they may tend to fob off your attempts to steer them toward better habits, it's obviously important to at least try. The subtle balance between being unobtrusive and being caring and concerned may be difficult to achieve in your relationship with your Scorpio, and it's almost certain that this will be something you think about quite a lot if you're in any way entangled with someone born under this fascinating sign.

One of the most important things to remember about your Scorpio is that those born under this fixed sign are creatures of habit who tend to stick fanatically to their routines. And one of the greatest gifts you can give them is to help them to spring out of their ruts. This won't be easy; they'll usually resist. Still, the occasional spontaneous outing can work wonders in shifting their perspectives and bringing on the smiles.

Most of all, your Scorpio will appreciate your kindness, your strength and your honesty. In fact, your Scorpio will quite clearly see you exactly as you are—and this is probably why you value him or her so very much.

SCORPIO IN LOVE

Scorpios aren't prone to instant intimacy, nor do they flit around falling for every possible love interest they encounter. Attraction is another matter. Being powerfully tuned into their sexual impulses, those born under this mysterious sign are frequently drawn to people they meet—or even fleetingly see—and they won't fail to flirt or send out signals if their interest is aroused.

Love, though, is hardly a causal matter to Scorpio. When they do tumble, they tumble hard. But even when a Scorpio does fall under Cupid's spell, he or she is not going to reveal the tidal wave of emotions welling up inside until there's a clear indication that they'll be returned. Scorpios will test the waters carefully, even when the physical side of a new relationship is wildly fulfilling. Sex means a lot to those born under this sensual and magnetic sign; but Scorpios—especially the male variety—seem quite capable of separating lust from the romantic side of love, which to them is sacred.

When Scorpios give their hearts, though, they do so completely. There's nothing halfway or tentative in the way they love. And this is because they enter the experience with eyes open. The object of their true affection has been thoroughly analyzed and scrutinized. Romantic love is not an impulsive walk in the park for Scorpios. Those born under this strong-willed sign can be among the most committed and emotionally loyal mates of the zodiac.

Scorpios will stick with even difficult relationships and continue to try and try. Infidelity, though, will be a deal breaker. No sign is more possessive than Scorpio (with the exception of Taurus), and when a Scorpio's jealousy is aroused, it can be explosive and destructive. This, though, is really just the other—dark side—of Scorpio's deeply felt and passionate way of loving.

Scorpio and **ARIES** are both high-powered and passionate signs, and they're more likely to clash than to click. Scorpios may find Aries' self-assurance admirable and intriguing, but water (Scorpio) and fire (Aries) aren't usually compatible, and Scorpios tend not to feel as if they can emotionally connect with Rams with any ease. Attraction does definitely happen, though, since Scorpio finds Aries' energy quite exciting. Still, the course of a relationship between these two isn't going to be smooth, and Scorpio is more than likely to feel put off by Aries' intense self-involvement. Meg Ryan (Scorpio) and Dennis Quaid (Aries), whose relationship ended in a somewhat acrimonious divorce, are an example of this pairing.

As friends, Scorpios and Aries may have a stimulating effect on each other, but Scorpios don't generally feel all that comfortable with Rams. Ego clashes can occur, and Scorpios feel inexplicably riled up when spending much time in an Aries' company.

Sensing that Aries isn't especially receptive to his or her subtle overtures, Scorpio can become defensive and critical. These two may be most complementary when united by a common goal.

Scorpio parents with an Aries child will be quite impressed by their little Ram's bold spirit and independence and will tend to be encouraging and supportive of this child. However, the little Ram's tendency to ignore advice and to charge into questionable situations without looking is likely to trigger difficult power struggles between these two.

Scorpios and **TAURUS** are opposites, and a definite magnetism exists between the two. Scorpios sense the passion lurking behind Taurus' calm façade. and the earthy sensuality that this sign possesses is a powerful aphrodisiac for Scorpio. Scorpio also finds Taurus' company to be soothing and reassuring and is able to open up and unwind with the Bull. The issues that can crop up, though, will be battles of will in which Scorpio is aroused to anger by Taurus' passive but determined resistance. In these situations, Scorpio will tend to seethe and feel deeply frustrated rather than being able to let the situation go. The successful and long-lasting relationship between Bo Derek (Scorpio) and John Corbett (Taurus) is an example of this coupling.

Scorpios are quite at ease with Taureans, and this provides a good basis for a lasting friendship. Scorpios are drawn to the solid reliability of those born under the sign of the Bull as well as by their practical, down-to-earth attitude, and Scorpios also sense that Taurus' feelings run deep, which is a quality with which Scorpio identifies quite strongly. Taurus is also a good balance for Scorpio, being less aggressive and more conciliatory.

Scorpio parents will bond quite strongly with their Taurus child and will be quite protective of their little Bull. The Bull's gentle nature is one the Scorpio parent will both admire and feel concerned about, sometimes fearing that this Venus-ruled child isn't assertive enough to make his or her way in the world.

Scorpios are likely to appreciate **GEMINI'S** wit and charm while not being particularly magnetized by those born under the sign of the Twins. In fact, Scorpio may tend to dismiss Gemini as superficial and unfeeling, because Geminis, being Mercury-ruled air signs, tend to function on an intellectual rather than emotional wavelength, which Scorpios tend to misinterpret as being cold and uncaring. If a Scorpio enters into a relationship with a Gemini, there will be some difficulties due to the fact that these two are bound to misunderstand each other and drift apart as a result. Only if the Gemini has other powerful planetary places that complement Scorpio will this relationship take off at all. Grace Kelly (Scorpio) and Prince Rainier (Gemini) were an example of this pairing.

Scorpio doesn't feel a strong attraction to Gemini, but does enjoy the Twins' ability to communicate so entertainingly. What can draw these two together in friendship is likely to be circumstance rather than affinity, but once the connection is made, Scorpio may

seek Gemini out as a companion because Gemini is clever and analytical in a way that Scorpio admires. Still Scorpio isn't likely to feel especially at home with Gemini, and this friendship isn't likely to be a close one.

Scorpio parents with a Gemini child will be quite proud of their little Twin's ability to adapt to new situations and to charm everyone in his or her vicinity. This relationship is likely to be an easy one on both sides, although at times Scorpios will tend to misread their Gemini child's reactions and fail to clue into the emotions that the little Twin so skillfully evades.

Because Scorpio and **CANCERS** are both water signs, they are generally harmonious with each other, and Scorpio may be drawn by Cancer's evident sensitivity and emotional warmth. Attractions can flare up that draw Scorpio further in, but difficulties can quickly ensue when Cancer's insecurities trigger critical reactions in the Scorpio. In fact, Scorpio is likely to be quite put off by Cancer's tendency to withdraw and behave in a prickly fashion when the least bit threatened or upset. The emotional turbulence that can happen between these two may distance them from each other even though their bond is basically an affectionate one. Prince Charles (Scorpio) and Lady Diana Spencer (Cancer) were an example of this combination.

Scorpios and Cancers can strike up strong friendships, and Scorpios generally like being in Cancer's company, because they sense the well of emotion the Cancer harbors. A caring bond can develop that the Scorpio finds sustaining, and the Scorpio also appreciates Cancer's nurturing warmth. The two may fall out, though, when Scorpio misinterprets Cancer's sensitivity and insecurity as rejection and abruptly withdraws.

Scorpio parents with a Cancer child will very quickly tune into this child's depth of emotion, which will lay the foundation for a strong bond. What might be difficult for Scorpio parents, though, will be their awareness of the little Crab's vulnerability, and they might attempt, not always in the most effective way, to get him or her to toughen up.

Scorpio and **LEO** is not a combination that's supposed to work, but it can and sometimes does. Scorpio can be pulled in by Leo's sunny warmth and dramatic emotions. And with a Leo by his or her side, a Scorpio feels that uplift that comes from being with an equal. Passions flare up between these two that can be over the top in their intensity. Unfortunately, Scorpio doesn't want to play Leo's game of witnessing and supporting the Lion's brilliant qualities and applauding his or her triumphs. In fact, Scorpio can be a bit scornful of Leo's need for an audience, which does not promote harmony in this bonding. Sylvia Plath (Scorpio) and Ted Hughes (Leo) were an example of this coupling.

As friends, Scorpio and Leo are apt to have many ups and downs. Scorpio really does enjoy Leo's warmth and extroversion, but also tends to be quite critical of the Lion's need to draw attention to her- or himself. Refusing to get drawn in, the Scorpio will,

instead, often tease or goad the Lion, which doesn't create good feeling between them. Still, the Scorpio may feel a genuine affection for his or her Leo friends and admire their many talents.

Scorpio parents with a Leo child will both delight in and resist their little Lion's playful behavior, feeling a certain obligation to tone down the boisterous Leo. The Scorpios will also tend to be a bit stern with their young Lion when he or she acts demanding or willful. Beneath the surface, though, a very strong and loyal bond will be forged.

Scorpio can find **VIRGO** intriguing, admirable and somewhat exasperating all at the same time, which makes for a very mixed review. Virgo's sensible practicality strikes a positive note to Scorpio, and so does that sign's earthiness, which may evoke an erotic response. Scorpio is also drawn to Virgo's analytical intelligence and essential kindness— but emotionally, Scorpio doesn't always find it easy to engage with those born under the sign of the Virgin, finding their responses a bit cool, or even flat. Still, Virgos tend to have a calming effect on Scorpios, and what these two signs share—a highly discriminating mentality—can create a very sympathetic bond. Brad Paisley (Scorpio) and Kimberly Williams Paisley are an example of this pairing.

Scorpios and Virgos easily befriend each other and are generally comfortable in each other's presence. Scorpio loves Virgo's ability to articulate what he or she thinks and feels, and also appreciates Virgo's unobtrusive way of being helpful, which others easily overlook or miss. As a team, Scorpios and Virgos can accomplish a great deal together and enjoy working in tandem. Their friendships can be long lasting and durable—a source of strength to both.

A Scorpio with a Virgo child finds much to like and admire in this small person, especially his or her efficiency and general competence. Emotionally, the Scorpio parent may find it difficult to connect with this self-contained child, though, and not always know exactly how to address issues that arise which in extreme cases could result in a communications breakdown.

Scorpio and **LIBRA** isn't a classically great match, but because these two are different in a complementary way, they may end up in each other's arms. After initially experiencing doubts, Scorpio finds Libra to be surprisingly strong beneath his or her people-pleasing façade and is also impressed by this air sign's cool-mindedness and ability to strategize. What's more, Scorpio is often physically attracted to those born under this Venusian sign. On the other hand, Libra's tendency not to say what he or she feels, in order to avoid rocking the boat, can strike the Scorpio as dishonest and manipulative and can trigger issues between the two. This relationship rarely runs smoothly, but then few of Scorpio's relationships do. The tumultuous relationship of actor Ryan Gosling (Libra) and actress Rachel McAdams (Scorpio) is an example of this pairing.

Scorpios and Libras frequently form friendships, but they may not have much staying power since Scorpios are so intensely emotional while Libras are inclined to be far more abstract and intellectual. Libra's diplomacy also tends to strike Scorpio as a kind of guardedness, and Scorpio may become critical of Libra as a result. Not that these two don't get along and often enjoy each other's company. When common pursuits draw them together, they can be highly compatible.

Scorpio parents with a Libra child will have little difficulty bonding with this eager-to-please child and will delight in their little Libra's responsiveness and charming manners. The inherent danger in this relationship, though, will be that a Scorpio parent's more powerful personality may tend to have an inhibiting effect on the Libra child.

You might imagine that two intense, moody **SCORPIOS** would have difficulty getting along, but this is not the case. Because no one can understand a Scorpio as well as a fellow Scorpio, a special kind of complicity can occur between them that is irresistibly reassuring and heart-warming. I've known more than one Scorpio couple, and they've always seemed enviably well-matched. Their mutual ability to navigate the dark depths of their emotions and to wisely give each other space when it's required seems to keep their relationship on course. They also seem to become increasingly loyal to each other with each passing day. If anything's goes wrong between them, though, it's likely to be a power struggle of some kind, which ends in a deadlock. Lyle Lovett (Scorpio) and Julia Roberts (Scorpio) were an example of this pairing.

Scorpios often grow close, and their friendships have a sustaining quality that both parties seem to appreciate. Their similarities lay the foundation for a depth of understanding that's hard to find, and they will tend to be more tolerant of each other than they are of non-Scorpios, as if they belong to a special club. Once connected, they tend to stay connected, forming bonds that stretch over lifetimes.

Scorpio parents are likely to be amused and stirred by their little Scorpio, experiencing a powerful and sometimes disconcerting recognition of their shared qualities. The Scorpio parent will also tend to fluctuate between being too strict and cutting the little Scorpio too much slack. Battles of will can cause serious rifts.

Scorpio and **SAGITTARIUS** can click quite brilliantly, and attractions are not uncommon between these two. Scorpios are usually favorably impressed by Sagittarius' direct manner and fiery good spirits and are drawn to pursue a further connection. And since Sagittarius isn't inclined to cater to Scorpio and is constantly on the go, Scorpio is also thrust into the role of pursuer, which may add to the attraction. Sagittarius' ability to make Scorpio laugh is a gift that Scorpio will treasure, but Sagittarius' self-involvement and need for independence can trigger Scorpio's possessive side. The relationship of Marlo Thomas (Scorpio) and Phil Donahue (Sagittarius) is an example of this combination which has stood the test of time.

As friends, Scorpio and Sagittarius seem to hit it off, because Scorpio admires Sagittarius' optimism and good humor and is cheered when spending time in Sagittarius' company. Scorpio will particularly value Sagittarius' broad perspective and honesty and will tend to seek Sagittarius out when grappling with problems, because he or she values Sagittarius' point of view. Long and sturdy bonds can be forged between these two.

Scorpio parents with a Sagittarius child will delight in their little Archer's happy nature and adventuresome spirit, but will also feel a powerful urge to steady and slow down this impetuous child. For the most part, though, the Scorpio parents will simply enjoy their Sagittarius child's company.

Scorpios and **CAPRICORN** can connect deeply, and they seem to possess an inborn understanding of each other. Scorpio is drawn by Capricorn's strength and perseverance and admires the Goat's drive, which is similar to his or her own. Capricorn's earthy sensuality is another magnet, and powerful attractions can flare up between these two. Scorpio also shares a similar sense of humor, which feeds this connection and generates a kind of complicity that draws these signs even closer. The difficult side of this relationship, though, is that Scorpio may sometimes find Capricorn's pessimism depressing, especially when he or she is feeling moody and shut down. Mike Nichols (Scorpio) and Diane Sawyer (Capricorn) are one example of this durable combination.

Scorpio and Capricorn get on brilliantly and tend to feed off each other's dry wit and somewhat cynical views. Friendships between the two tend to spring up quickly, because Scorpio instinctively trusts someone born under the Goat and feels at ease with him or her. Scorpio also identifies with Capricorn's ambition and admires the way that Capricorn relentlessly pursues his or her goals. When working together Scorpio and Capricorn can be extremely successful, and friendships between these two are generally lasting.

Scorpio parents with a Capricorn child will find it easy to relate to this earthy and self-contained child and will have a great deal of confidence their little Goat's ability to make his or her way. As the Capricorn child matures, the Scorpio will be particularly proud of his or her abilities and talents.

Scorpio and **AQUARIUS** are two strong-willed signs who can be drawn together by mutual admiration. If their relationship is to flourish, though, they are going to need to be tolerant of their differences and respectful of each other's need for privacy and space. Scorpio tends to feel energized through contact with an Aquarius and attracted by Aquarius' individualistic style. Emotionally, though, Aquarius' cool detachment can strike Scorpio as indifference, and Aquarius' need to contradict everyone and everything can trigger Scorpio's famous temper. Tatum O'Neal (Scorpio) and John McEnroe (Aquarius) were a classic example of this combination.

As friends, Scorpio and Aquarius may clash over various matters and fall out seriously enough to make reconciliation difficult. Scorpio is as drawn by Aquarius' detachment as he or she is curious to find out what lies beneath the surface and may purposely stir Aquarius up in order to get a reaction. Aquarius' high principles can trigger a grudging admiration in Scorpio that evolves into a genuine liking and respect. Even at its best, though, a friendship between these two is likely to be volatile.

Scorpio parents with an Aquarian child will find their little Waterbearer to be both endearing and puzzling. And because the Aquarian child isn't overtly emotional, the Scorpio may not pick up on various issues that are happening beneath the surface, which can result in misunderstandings, rifts and crossed signals.

PISCES' evident emotionality draws Scorpio, who is often quite attracted to those born under this watery sign. The Fish's kind and sympathetic manner encourages the Scorpio to let down his or her guard and expose the hidden depths that are too often withheld. Scorpio has the sense that Pisces both supports and complements him or her and deeply appreciates Pisces' ability to read between the lines and pick up on unspoken feelings and thoughts. What can go wrong for the Scorpio is entangled with his or her reaction to Pisces' changeability and tendency to drift, which stands in stark contrast to his or her need to maintain a firm and controlling hand. Demi Moore (Scorpio) and Bruce Willis (Pisces) are an example of this pairing.

Scorpios and Pisces are capable of having rewarding friendships, because Scorpio feels quite at home with those born under this water-ruled sign. Scorpio senses that Pisces won't judge him or her and feels liberated enough to really open up. On the other hand, because Scorpios are strong-willed and driven, they may become critical of their less motivated and often dreamy Pisces friends. Bonds between these two may be strong, but they're not always durable.

Scorpio parents with a Pisces child will have no difficulty connecting to their little Fish emotionally. They will sometimes become overly protective, though, because they will tend to see their Pisces child as particularly sensitive and vulnerable. They will also tend to go out of their way to encourage and support their little Fish.

COLORS, GEMS AND FRAGRANCES

On the zodiacal wheel, following on Libra, which is green, Scorpio is accorded a color that falls between green and the blue of the sign after Scorpio, Sagittarius, and comes out as a kind of teal blue, or a green that is deepened by blue so that it's no longer green

nor is it blue. It is a color that's difficult to describe but very appealing—a bit mysterious, like Scorpio itself, and full of nuance like a very deep body of water.

This color can be very suitable for Scorpio to wear, and soothing, as it brings Scorpio back to his or her real nature. But there are other colors also associated with the sign of the Scorpion that are descriptive of this intense sign's passionate nature—namely, red and black. Scorpios do seem to favor these colors and wear them quite often—sometimes even together. The drama of red feels familiar and right to Scorpio, and the mysteriousness of black also holds a strong appeal.

Wearing red or/and black is the kind of statement Scorpio likes to make, but while these colors may be expressive of Scorpio's powerful emotions, they aren't balancing or soothing. When Scorpio feels a need to be more centered and contained, purple can be an excellent color choice, because it is evocative without being obvious or over the top. I have noticed that Scorpios seem to shun yellow and orange, but to sometimes favor green, which can also be calming and soothing.

Orange topaz—known as "precious topaz"—is Scorpio's traditional birthstone, and it may be strengthening and centering for a Scorpio to wear. The word "topaz" is related to a Sanskrit word that means heat or fire, and Pluto—the planetary ruler of Scorpio—has been called "the principle of frozen fire"—a complete contradiction reflecting the fact that Scorpios are so hot emotionally that they may seem or act cold in order to control or balance their overpowering feelings.

Coral is also associated with Scorpio, or with Mars (which ruled this sign before Pluto was discovered), and can be quite flattering to those born under the sign of the Scorpion. Coral with its varying shades of red comes from the sea and is therefore associated with water, Scorpio's element. Obsidian, volcanic glass, is also associated with Scorpio, and this is a very appropriate stone for Scorpio to wear—it's formed from cooled lava, which accords with Scorpio's true nature.

The ruby is said to be one of Scorpio's stones, probably because it is red and associated with Mars. And the amethyst—which in ancient times was worn to prevent intoxication—is sometimes accorded to Scorpio, possibly because it may have a soothing effect on Scorpio's emotional nature. Other semiprecious stones mentioned for Scorpio are malachite, tourmaline and aquamarine.

Chrysanthemums are traditionally considered Scorpio's flower, because in many European countries this flower is associated with death, which accords with Scorpio's house placement on the zodiacal wheel (the eighth house of death and regeneration). Bird-of-paradise is also sometimes associated with Scorpio, and so are the narcissus and amaryllis.

Flowers that bloom at night, like evening primrose and the Casablanca lily are said to have an affinity with Scorpio, and wild pink cyclamens are also mentioned as are mountain gentians and thorny gorse. The cypress tree as well as the hawthorne and ash are also connected with this birth sign.

The herbs that Scorpio particularly benefits from are basil, said to be good for the reproduction organs—traditionally associated with Scorpio—and coriander. Ginger is also considered healing for those born under the sign of Scorpio, particularly infusions of this herb, which are cleansing and therefore an important tonic.

The fragrances that match and enhance Scorpio are a blend of floral along with earthy notes, like moss and anise. Narcissus, one of the flowers connected with Scorpio, can be an appropriate fragrance; so can musk, which leaves a lingering and slightly haunting note in the air, which accords with Scorpio's effect. ♏

9

Sagittarius

23 NOVEMBER – 21 DECEMBER

240°

Exuberance is beauty.

—WILLIAM BLAKE

Why do the Sagittarians I know seem so hard to describe? They all share distinct characteristics, are likable and have a wonderful ability to make me laugh. But there's something elusive about them, and what it is, I think, is that they don't hold still long enough to give anyone a chance to pin them down.

That's because they are always, for various reasons, on the go—off to run in a marathon, attend a lecture, visit a psychic or lunch with other members of the Gourmand Society at some five-star restaurant. They're dashing to a poetry reading, making and distributing posters for their latest cause or jetting off on a world tour.

My friend Jennifer (December 8) is one of the most traveled people I know, always heading somewhere—London, Rome, Santa Fe—and she's lived in more countries than most people have a chance to even visit. Like most of the other Sagittarians I know, she also has wide-ranging interests and thrives on adventure, as does my intrepid Sagittarian brother-in-law Pat (December 4) who, despite a debilitating knee injury that has left him permanently incapacitated, is only really happy when he's planning his next challenging camping trek to the Grand Canyon or the wilds of Alaska.

Jupiter—the Roman king of the Gods—is Sagittarius' ruling planet, and it's funny how some of the Sagittarian men I've known have actually looked like the statues of Jupiter I've seen in photos or museums. Sidney (November 23), a successful poet I once knew in Cambridge, Massachusetts, resembled Jupiter right down to the full beard; and Alan (December 1), an alternative veterinarian, is, while smaller, bearded and commanding in exactly the same way.

But whether male or female, Sagittarians have a certain unmistakable presence—full of life, good spirits and a kind of bursting enthusiasm that lights fires all around. Their excitement and optimism are contagious, and they love to whip up others' interest and enthusiasm, enlisting them in their projects and causes. In a crowded room, you will always be able to pick out a Sagittarius: he or she will be the one addressing a small group and expressively waving his or her arms around while telling jokes or eagerly expounding upon a new pet theory.

Of course, there are extroverted Sagittarians and then there are those who are more private and introverted, the latter tending to have a quieter style. But there's nothing quiet about what's going on in their busy lives—or in their minds either, which are always spinning out new concepts and theories. Expansion is what Jupiter is all about. The quieter types are often brilliantly intellectual, their minds covering a staggering amount of territory. My brother-in-law, Pat, an astrophysicist by profession (stargazing being a very Sagittarian pursuit), can expound on Jungian theory, Nietzsche's philosophy, the history of the Mormons or the fate of the Anasazi, with a depth of understanding that is frankly breath-taking.

I know that when he becomes interested in an idea he finds out everything he can about it—reading, thinking, watching films, or, in other words, expanding and then further expanding his range of knowledge. Sagittarians are fueled by a burning curiosity about everything, and "why?" is one of the most frequently used words in their vocabulary. In fact, Sagittarian children have been known to drive their parents up the wall with their endless, often unanswerable questions.

Sagittarius is one of the true free spirits of the zodiac. Their minds are wide open and they will have no qualms about venturing into uncharted territory. When I run through the Sagittarians I know, I'm struck by how many are involved in so-called new age therapies and techniques, and how comfortable they are going off the beaten path and following whatever interests they feel drawn to.

Maybe this is because they have more confidence in themselves and in life than most. Jupiter—Sagittarius' ruling planet—is, after all the "planet of good fortune," and some say that those born under this sign are born lucky. Whether this is true or not, Sagittarians often act as if it is. Their belief that everything is going to turn out right is so strong that they can usually convince everyone else as well. In fact, they are so optimistic and full of confidence that they have a powerful ability to inspire others—a role they seem born to play.

In their heartfelt dedication to their ideals and causes, they sweep others along on a tide of enthusiasm and excitement. Sheila (December 12), a long-time client and friend of mine, heads a successful non-profit organization called Share the Care, which helps caregivers to cope. Sheila possesses a wonderful and very Sagittarian talent for getting others onto her bandwagon and uplifting their spirits and sense of purpose, as does Jennifer (December 8), a filmmaker whose visions (she both writes and directs) have the power to draw others into her highly creative and magical world.

Sagittarians live on faith, and they have such an abundance of it that they spread it all around. When Sagittarians are at their best, they are caught up in a consuming plan or undertaking which keeps them galloping full speed ahead toward their dreams.

And while such belief and confidence is uplifting, it also can be—at times—seriously over the top.

There are those Sagittarians who don't know how to rein themselves in and stop. Their optimism can turn into an overweening confidence that spurs them to take ill-considered risks. The truth is that Sagittarians don't like to accept limits, because doing so runs counter to their expansive, Jupiterian natures. Embracing life is what this fiery sign is all about. Saying "yes" feels right to a Sagittarius while being prudent and cautious goes against the grain.

But while less aware and evolved Sagittarians have a penchant for becoming carried away and getting in over their heads, those born under the sign of the Archer can also develop into wise men and women whose understanding is born of real experience. Some Sagittarians live out their expansive and adventuresome side by trekking all over the world; some are philosophical explorers whose fascination with concepts and ideas deepens and broadens their searching minds; some do both.

A love of nature and the outdoors is another trait that is shared by the majority of Sagittarians, and those born under this sign will suffer if confined in airless spaces for any period of time. Sagittarians don't like limits. They require fresh air and freedom. This is why—more than any other sign—you're likely to find them engaged in work that involves travel, being outdoors and above all, acting as their own boss.

When I think of the Sagittarians I know, not one has a desk-bound job. They all have managed to carve out a path that give them the autonomy and freedom they crave. When I run through the list, Jimmy (December 8), for instance, is an independent contractor, Sam (December 18) is a pilot for a major airline, Diana (November 29) is a violinist... and then there are those wild and wonderful Sagittarians who have completely defied tradition in their work choices, like Patricia (December 5), the only female farrier I've ever met, and Pea Horsely (December 9), who left a successful career in theatre management to become an equally successful animal communicator (pet psychic) because all of her instincts led her to this highly unusual work.

Laura Stinchfield (December 5) is another professional animal communicator I've known, and it's striking how many people in this controversial field have strong Sagittarian placements in their charts (if not the Sun, the Moon or various planets). It takes a special brand of self-trust and confidence to pursue such an unorthodox path, not to mention the ability to thumb one's nose at convention, which Archers love to do.

In fact, those born under this fiery sign get quite a kick out of people's reactions to their sometimes outlandish behavior and antics. Which is due, of course, to the famous Sagittarian sense of humor. Jupiter, Sagittarius' ruling planet—is known as "jovial Jupiter" for just this reason. Sagittarians love to laugh and often have a distinctive belly laugh that doesn't fail to bring smiles to everyone's faces. They also love to tell jokes and to

play them on others, and if you ever spend any period of time in a Sagittarian's com-
pany, you're bound to find yourself smiling and laughing more than usual (unless the
Sagittarius has heavy Capricorn influences in his or her chart).

Sagittarius' wit can be absurd and playful, and it can also be scathing and sarcastic.
Archers like to poke fun at matters they believe others take too seriously. Pretense of any
kind strikes them as intolerable and silly, because those born under this sign tend to be
honest to a fault. In fact, Sagittarians can be embarrassingly, in-your-face honest. They
will blurt out home truths without forethought or discretion.

Don't tell your Sagittarius friends any secrets, because it seems impossible for those
born under this truth-seeking sign to keep anything under wraps. I once made the mis-
take of asking a trusted Sagittarian friend (November 29), whom I'll call Mary, about
the character of a man a particularly vulnerable friend of mine was having an illicit affair
with (I assumed, of course, that the matter would remain strictly confidential). As soon as
Mary bumped into this man, who was hardly a close friend of hers, she couldn't control
her impulse to let him know she knew what was going on, citing me as her source.

I suppose I should have suspected that this would happen, but it never occurred
to me that even a tell-it-like-it-is Sagittarian like Mary would be quite that indiscreet.
It's almost as if secrets burn a hole in Archers' hearts, like money burns holes in some
people's pockets. They absolutely must speak up. You can see them bursting with their
knowledge, and the news seems to actually erupt out of them. And then, sometimes, they
will clap a hand over their mouth in horror, as if surprised by their own audacity. You'd
think they'd learn. But they never do. And there is something touchingly innocent about
them, maddening as their actions may be.

On the other hand, if you want an honest opinion, Sagittarius is the one to ask. Just
be prepared for the unvarnished truth because that's what you'll get. "Do you like my
new haircut?" might elicit an answer like: "Well, it's better shorter because, before, it
made you look old.... But it looks kind of chopped off, like a butcher cut it."

Probably not the answer you hoped for. But Sagittarians are not being hostile when
they say things like this. You asked, and they told you. Sagittarians are generally quite free
of malice, and they feel no need to dress up their speech or opinions with diplomatic
niceties. It seems to me that female Sagittarians are more inclined to this kind of no-
holds-barred directness than males, though I'm not sure why. In fact, there's a particular
type of Sagittarian female who adamantly refuses to kowtow to convention by acting
feminine and fluttery, and whose behavior can be so acerbic that she bears an uncanny
resemblance to the character Kate in Shakespeare's *The Taming of the Shrew*.

Sagittarian women—and men—can be perfectly charming and well-behaved, but
I've found that there can be something particularly appealing—and even admira-
ble—about the defiantly rude types that sometimes people this sign. Whenever I think

of January, a Sagittarius (December 12) woman who boarded her horse at the same barn where I boarded mine in Connecticut, I find myself smiling with genuine delight. She was so outrageously direct that it was sometimes hard to believe, but she was also so clearly trying to be honest and express her true feelings that being with her was like a blast of fresh air.

Sagittarians seem to share an enormous affection for animals, and the majority will not be without at least one dog or cat, while many have menageries. You may meet the occasional Archer who doesn't possess a passion for all creatures great and small, but he or she will be the exception to the rule. Sagittarians' hearts are also quickly engaged by the plight of lost and injured animals, and you will find many Sagittarian volunteers at animal-rescue organizations, and particularly in work or pursuits that involve horses— for whom Sagittarians seem to feel a special bond (probably because their symbol, the Centaur, depicts them as half-horse and half-man).

Wide-open spaces and all that is wild and untamed hold a magical appeal for Sagittarians. People born under this sign love to camp—to cook over an open fire and feel free of all the accoutrements of civilized life. Sometimes they will carry this to an extreme, liberating themselves, as they see it, from the complexities of life by becom- ing self-styled ascetics. At the other end of the spectrum, though, are those Sagittarians who worship the good life and are full-blown epicureans. I've known both types of Archers, and while different on the surface, they've all shared a huge enthusiasm for their chosen lifestyles.

I remember Sam (December 3), a graduate student and Zen practitioner I once knew, who would practically go into fits of excitement while preparing an austere meal of rice and adzuki beans in his monastic one-room apartment in Cambridge, as his gigantic Newfoundland (who was called, quite humorously, Puppy) cavorted at his feet. And at the other end of the spectrum was Henry (December 7), a robust entrepreneur who, im- peccably turned out in a bespoke three-piece suit, would be beaming and bursting with anticipatory pleasure as we tucked into an elaborately presented meal at one of New York's finest restaurants.

Despite their blatant dissimilarities, these two Sagittarius' exuberance was exactly the same—as was the hot flush of excitement that bathed their skin in a rosy glow as they sat down to their evening meal. Sagittarians really do glow. Full of *joie de vivre* and ruled by Jupiter—which is, after all, the largest planet in the solar system—they have great breadth of vision and are full of big plans. Sagittarius' eye is always on the far horizon. And this is why they are always on the go. They are born seekers on a quest for what they sense is a wonderful prize just beyond reach.

Hating to be pinned to one place or situation, Sagittarians thrive on change—like their opposite sign, Gemini—and love the feeling that their lives are full of untapped

possibilities. One longtime friend of mine, Judy (December 14), is a certified classi-fied-ads addict, and if she isn't on a quest for a new horse (like many Sagittarians, she's an accomplished equestrian), scouring the ads in *The Chronicle of the Horse* and other such publications for that wonderful new dressage horse she's been dreaming of, she's on a search for a new home in some other place than where she currently resides. She'll lit-erally spend hours perusing listings on the Internet, becoming an expert about real estate in Santa Fe, New Mexico, for instance, or some other place that suddenly seems utterly desirable and perfect and new to her.

The search is what it's all about for Sagittarians, and if they are caught up in a quest, they feel particularly stimulated, alert and alive. Frequent changes of location are the norm for many Sagittarians, and it seems that—for some of the Sagittarians I know—as soon as they've completely finished renovating and fixing up their newest home in that dreamy, far-flung spot, they begin to grow restless and antsy and eager for fresh sights and experiences.

Sagittarians enjoy being on their way somewhere. Movement satisfies some basic need in their searching natures. It brings a sparkle to their eye and a smile to their face. Stopping and replenishing their reserves, though, is something Archers seem to have dif-ficulty allowing themselves to do. I remember how one of my Sagittarius clients, Luke (December 15), a brilliant entrepreneur, was described by his psychiatrist as "rushing full speed ahead on empty." Archers always seem to be in a rush. Sprinting off in pursuit of their dreams, they will ignore their bodies' protests and sometimes even forget to say goodbye, so eager are they to get out the door and on their way.

They will also ignore their feelings and try to make light of their upsets. Being ruled by Jupiter is all about optimism, joy and laughter, which doesn't leave room for neg-ativity of any kind. Even introverted Sagittarians—who are often deep thinkers and profoundly aware—are not adept at handling their darker emotions. It's all too easy to underestimate the depth of what they actually feel and to imagine that they're coping better with stress than they are, because they don't tend to show it.

Instead, Sagittarians are more inclined to try to make a joke out of their woes. Woody Allen (December 1, 1935) tickles our funny bone by spoofing his own goofy behavior and others', and he has a wonderful way of making us see the ridiculous side of even tragic situations. And brilliant and controversial comedian Richard Pryor (December 1, 1940), as Bill Cosby reportedly put it, "drew the line between comedy and tragedy as thin as one could possibly paint it" in his sidesplittingly funny depictions of the insulting and cruel treatment of blacks.

Cartoonist James Thurber (December 8, 1984) was another witty and wise-cracking Sagittarius, and so was the brilliant Charles Schulz (November 26, 1922), the creator of *Peanuts*, whose characters, from Charlie Brown to Lucy van Pelt, so captured the public's

imagination that they became cultural icons. Pithy, wry Mark Twain (November 30, 1835), whose voice was so distinctively blunt and American, also bore the unmistakeable stamp of the Sagittarian character, as did Emily Dickinson (December 10, 1830), whose direct and often mocking style seemed to pierce through all pretense to the heart of matters great and small.

Following along in the same vein, we have Jane Austen (December 16, 1775), who displayed the typically acerbic Sagittarian wit; her scathing social commentary finds parallels in the similarly romantic yet realistic work of Gustave Flaubert (December 12, 1821). In fact, many Sagittarians seem inclined to observe and critique the ills of unjust social systems that so cruelly crush the human spirit; George Eliot (November 22, 1918) is another example as is the extraordinary Alexander Solzhenitsyn (December 11, 1918), whose dissidence singled him out for labor camps and deportation.

Social activist Abbie Hoffman (November 30, 1936) is a poster boy for the Sagittarian rebel and prankster, an archetype that resonates with a slew of Sagittarian rock-and-roll bad boys. The rambunctious and lovable Keith Richards (December 18, 1943) heads the list, followed by Jim Morrison (December 8, 1944), Jimi Hendrix (November 27, 1942) and Billy Idol (November 30, 1955).

Often the class clown in adolescence, Sagittarians draw attention to themselves by not playing by the rules—they just can't seem to sit down and behave themselves like everyone else. This can make them lawbreakers, like the infamous Lucky Luciano (November 24, 1897), who, according to Wikipedia, is considered the father of organized crime in the United States. Or they may become a rebel, like activist Tom Hayden (December 11, 1939), or a muckraker like journalist Drew Pearson (December 13, 1897).

Quite a number of popular politicians have been Sagittarians, including two recent mayors of New York City, John Lindsay (November 24, 1921) and Ed Koch (December 12, 1924). Both had a particularly likable public persona, and Koch was also something of a jokester, with a down-to-earth sense of humor that kept even serious issues in perspective. And two of the greatest statesmen of recent history have also been Sagittarians—Winston Churchill (November 30, 1874) and Charles de Gaulle (November 22, 1890).

Archers tend to think big, and Walt Disney (December 5, 1901), who started out with nothing but dreams and Laugh-O-Grams—his first animated cartoons—went on to create the iconic Mickey Mouse and to become the head of a sprawling, multibillion-dollar empire. Filmmaker Steven Spielberg (December 18, 1946) also ventured into animation with brilliant results, and Luke Skywalker of *Star Wars* is just one of the various heroes he invented who became household names.

Sagittarians do seem especially adept at creating characters who take up residence in the public imagination; C.S. Lewis' (November 29, 1898) wonderful talking lion, Aslan, in *The Chronicles of Narnia*, is another example. Lewis was also a highly

philosophical and spiritual man who exhibited the breadth of vision so characteristic of this astrological sign.

But perhaps the most shining example of what the sign of the Archer is all about was William Blake (November 28, 1757). An unparalleled poet, artist and visionary, Blake's ability to "see a world in a grain of sand" attests to his very Sagittarian belief that nature and spirit are one and inseparable and that "...Everything that lives is holy, Life delights in life."

THE CARE AND FEEDING OF A SAGITTARIUS

If there's a Sagittarian in your life with whom you have a close connection, you already know that you need to give him or her lots and lots of space. It's not that Archers are stubborn or resistant to influence; it's just that they will follow their own instincts religiously and without fanfare, no matter what anyone says or does. They zip through situations and experiences without a backwards glance, because their gaze is always riveted on the far horizon.

Sagittarians don't lack deep feeling or sentiment, but they're not prone to be sentimental. You aren't likely to doubt that your Sagittarius cares about you and always wants what's best for you, but actions—not words—are Sagittarians' way of expressing emotions, and your Archer's attention and presence say it all. In fact, if you can hold your Sagittarian's attention for any period of time, that is a very strong statement in itself. So many siren songs are sounding in Sagittarian's heads that they can scarcely find enough time to do and experience it all. What you really need to understand, in order to appreciate where your Sagittarian is coming from, is the nature of Sagittarius' ruling planet, mighty Jupiter.

What's tugging on your Sagittarian's attention all the time is a feeling of needing to reach out—to literally expand—in every direction at once. Quite simply, Jupiter is the planet whose energy is defined by the principle of expansion. And your Sagittarius is happiest and most fulfilled when his or her energy is on the move, whether in a physical way (walking, running, traveling) or in a mental or intellectual way (thinking, theorizing, exploring ideas).

By way of contrast, not being on the move isn't very comfortable for your Sagittarius. You've probably noticed how fidgety and discontent he or she will become when having to wait in a doctor's office or airport—or for guests to arrive. And telling your Sagittarius to relax isn't going to accomplish anything. He or she will want to jump up and *do* something—preferably involving a search.

Let your Sagittarius do whatever he or she needs to in order to cope with boredom or inactivity. If you're dealing with a bedridden Sagittarian, though, you're going to have a big problem keeping him or her from resuming normal activities too soon. The Sagittarians I know all tend to be terrible patients—and the despair of their doctors—because they are too eager to get back on the go.

Trying to help and support a Sagittarius who's recovering from an illness is a challenge and will require a great deal of understanding on your part. But at least appreciating how powerful and ingrained his or her urge for movement and adventure is can help you from losing your temper and lapsing into a boring, lecturing mode. The biggest lesson to learn in dealing with a Sagittarius is that you really can't tell them anything. They have to learn by themselves—and they will, painful as it may be to watch.

What you can count on in your Sagittarius, no matter what, is that he or she will strive, and succeed, at finding the positives in even the most daunting of situations. Your ability to appreciate this quality—your Sagittarius' optimism and faith in life itself—will go a long way to smooth out the wrinkles in your relationship. On the other hand, your keen awareness that your Sagittarius is sometimes overly confident that everything will work out is essential to your own sanity and well-being.

What you need to remember is that, as a Jupiterian (born under the sign ruled by the planet Jupiter), it's Sagittarius' job to hope for and expect the best. But, at the same time, it's your job as a non-Sagittarian to help determine when he or she isn't seeing reality for what it is. This can be an impossible call, and it also places you in the disagreeable role of naysayer and spoilsport. But you do need to understand, deep down, that sometimes Sagittarians will push their luck too far.

You won't fail to notice, though, that a Sagittarian's ability to believe in happy outcomes sometimes has the power to bring them about. Obviously some Sagittarians have better judgment than others (it all depends on aspects to their Sun and their Jupiter in their natal charts), but supporting your Sagittarius' visions and dreams is something you have to do as often as you can, or your relationship will not thrive. This is because it is their visions and goals that matter the most to Archers and keep the stars shining in their eyes.

And remember, you do need to be able to be spontaneous to really appreciate and enjoy your Sagittarius. You must be willing to embark on their outings and adventures with them, or else end up cooling your heels at home. Not that your Sagittarius will mind, because almost all Archers have a genuinely laissez-faire attitude when they're in a relationship. They may urge you to try something that delights them, because they're sure it will delight you too, but if you'd prefer curling up with a book when they're hot on going skiing, they will shrug, smile and be on their way with no regrets.

Again, this is not an indication that they don't care, or don't want your company; it's a testament to their respect for your ability to make your own choices. Sagittarians are rarely possessive, and they hate it when others are possessive of them. If you try to curtail their interests or activities in any way, you will only succeed in driving them away. And sometimes, when your Sagittarius is charging off on the newest adventure, you're bound to feel as if you've become an insignificant figure in the landscape, growing smaller and smaller as he or she rushes away toward that far horizon.

Don't cling. This is the best advice anyone could possibly give you, whether your Sagittarius is your best friend, your partner or your child. Even if your Sagittarius tries to console you, calm you and meet your needs as you hang on tight and refuse to let go, inside he or she will be cringing. And even the most tolerant and gentle Archer doesn't take kindly to anyone who strikes them as a wet sponge. Any effort on your part to clip your Sagittarius' wings, no matter what you're feeling, will be lethal to your relationship with this freedom-loving individual.

Truth and honesty are what Sagittarians understand and respond to, and that's what should guide you in approaching any issue you need to air. Tell it like it is. Don't accompany your delivery with guilt-inducing or manipulative ploys. Sagittarians are straight shooters. And when you say what you think and don't pull any punches, you'll get the best possible reaction. You'll also win your Sagittarius' respect, which you will find is worth a great deal. Having a connection with a Sagittarius is all about being equal partners. You will be perceived of as a separate individual with the right to do as you please, and you will be expected to carry your own weight.

Not that your Sagittarius won't help you or perform services for you, but the currency of your bond is companionship, not codependence. And having fun together is essential to keeping this relationship truly alive. You will find that your Sagittarius greatly appreciates your ability to arrange festive gatherings and to lighten up and live fully. Play will be an important ingredient in this relationship, and your willingness to enter into the spirit of the moment will keep both you and this connection young.

Your Sagittarius is, in fact, a child at heart, in the sense that the wonders of life and of nature in all its manifestations are always striking him or her anew. And if you find that your Sagittarius needs cheering up, get him or her to go on a hike with you to some particularly beautiful spot or treat your Archer to a getaway in a natural setting. Fresh air, the smell of wet earth in the spring and the sound of birdsong are the elixir that cures Sagittarius' ills, both emotional and physical, and will have a magical effect on his or her spirits.

Remember, too, that while Sagittarians are passionate and fiery, they don't tend to display emotion in a dramatic fashion. Water signs like Pisces, for instance, will weep in public, but while you won't find a Sagittarius doing this, it does not mean that he or she

doesn't experience deep and strong feelings. Not given to dramatics, Archers actually aren't adept at conveying their emotions even though they may verbally express what they feel in a misleadingly calm way. And for this reason, people often don't pick up the clues when Sagittarians really are suffering and in need, because they don't appear all that overwhelmed or upset.

Being sensitive enough to see what's going on beneath your Sagittarian's generally cheerful façade takes practice and experience. It's not Sagittarius' nature to broadcast depression or strain, even when it's being felt, which makes it easy to miss the signs. Keep reminding yourself that your Sagittarius is always in the grip of that Jupiterian urge to move outwards towards life, and count your blessings that you have such a generally optimistic and life-loving person in your private world. If your Sagittarius is typical of those born under the sign of the Archer, you will be treated to lots of sidesplitting jokes and humorous anecdotes on a daily basis, and you will have a companion with whom you can discuss any subject under the Sun.

SAGITTARIUS IN LOVE

Sagittarians are full of contradictions when it comes to love. Romance excites and thrills those born under this fiery sign, but Sagittarians are often pushed and pulled by their opposing desires for closeness and distance, which can result in their sending out mixed signals and blowing hot and cold. Not that they can't become so carried away by passion that they give their hearts. Once given, though, they don't always find it easy to sustain the level of intimacy that the other might demand.

On the other hand, Sagittarians can be wonderful partners and companions, who are willing to do everything in their power to make a relationship work. Idealists at heart, those born under the sign of the Archer can believe in the power of love so strongly that it will enable them to rise to harsh challenges or stick out unsatisfying situations.

What can destroy their faith and commitment, though, is the curtailment of their freedom. A possessive and controlling partner can put out the love-light in a Sagittarius' eyes so effectively that there's no turning back. Sagittarians can love deeply, but they will always need their space.

Those born under this adventuresome sign can also be commitment-shy or prone to sudden, fleeting attractions, especially in their youth. Loving wide-open landscapes and fresh air, Sagittarians often see marriage as a state that hems them in and closes off their options. What's more, the idea of "togetherness" is not a concept that particularly appeals to such an independent sign.

If and when love overcomes their reservations, and they do make a commitment, though, they won't tend to look back or to experience doubts or regrets. To Sagittarians, life is really a vision quest, and it is the future—and what they are moving towards—that grips their hearts and their imaginations.

<p style="text-align:center">⋆ ⋆ ⋆</p>

Sagittarius is drawn to **ARIES'** "take me as I am" manner, and this attraction can be very hot—especially on Sagittarius' side. Aries doesn't try to rein Sagittarius in, and Rams aren't inclined to hang around to see what Sagittarius might be up to. Their independence can act like an aphrodisiac for Sagittarius, who, instead of feeling pinned down and pulling away, must become the pursuer to keep this connection alive. In some cases, the Sagittarius will decide that he or she can't be bothered to have a relationship with someone who is just as—or even more—independent, but in others it can be the trigger for genuine passion. In the end, though, Sagittarius will probably grow tired of having to do so much to make this relationship work. Kevin Federline (Aries) and Britney Spears (Sagittarius) are an example of this combination; the relationship unfortunately ended in an ugly divorce.

Sagittarius likes Aries instinctively and will enjoy Ram friends' company tremendously when these two actually do find time to meet. The problem with this friendship combination is that Sagittarius isn't inclined to actually go after Aries because he or she is equally caught up in various projects, plans and activities. Sagittarius will find Aries to be the ideal hiking companion, though, as well as the perfect person to share adventures with.

Sagittarius parents with an Aries child will be delighted with their little Ram's fiery courage and forthright manner. And the Archer won't be threatened or concerned by Aries' need for independence but will tend to encourage his child to be and do whatever he or she wishes. For this reason, Sagittarius parents will usually have a wonderful connection with their Aries offspring.

Sagittarius is prone to admire **TAURUS'** calm and friendly demeanor and will find the Bull's company pleasantly restful. There may be an erotic spark as well, since Venus-ruled Taurus exudes an air of sensuality that Sagittarius will not fail to notice. Taurus' earthy practicality, though, can rub Sagittarius the wrong way, especially when the Taurus questions Sagittarius' ideas and plans and judges them as being unclear or unsound. Taurus' plodding style also contrasts sharply with Sagittarius' fast-paced way of going, and the relationship between these two will often founder on their basic and

irreconcilable differences. The short-term liaison between Kirsten Dunst (Taurus) and Jake Gyllenhaal (Sagittarius) is an example of this somewhat uncommon pairing.

Sagittarius can be drawn to Taurus as a friend, because he or she appreciates Taurus' unassuming style and down-to-earth nature. Sagittarius will have the sense that his or her Taurean friends can offer a safe harbor or sound advice when needed, but at the same time may feel out of sync with them precisely because of the Bulls' stolid and slow-moving approach. Still, Sagittarius will have an impulse to maintain this connection because he or she finds it valuable and reassuring.

A Sagittarius with a Taurus child will be thrilled by his or her little Bull's harmonious and gentle nature and will feel a great deal of affection for the child. On the other hand, Taurus' very deliberate way of moving through life will at times frustrate the Sagittarius, who goes at a much faster pace. Still, this relationship will be a compatible one.

Sagittarians are very drawn to **GEMINIS** and find them amusing, exciting and in-triguing. Gemini's air fans Sagittarius' fire, and this can be a real love match—although, given both signs' changeability, one that might not stand the test of time. Sagittarius finds Gemini playful and companionable in just the way he or she requires. Sagittarius also delights in Gemini's clever wit and spontaneity, and these two are opposites that really do attract—or, more precisely, magnetize—each other. Egging each other on, Sagittarius and Gemini may burn the candle at both ends together, each delighting in the other's ability to keep pace. Angelina Jolie (Gemini) and Brad Pitt (Sagittarius) are an example of this astrological connection.

Sagittarians often have numerous Gemini friends, because they are very much on the same wavelength and similarly inclined to seek adventure, new experiences and change. Sagittarius enjoys Gemini's company and feels neither bored nor hemmed in by them. Twins' light-spirited manner resonates with their own optimistic nature, and Archers will also appreciate Gemini's ability to laugh at a joke and rise to a dare. Friendships between these two tend to endure.

Sagittarius parents who are gifted with a Gemini child will experience genuine de-light in their little twin's buoyant nature and clever mind. There will be a great deal of ease between these two, although communications can break down occasionally when both are finding it difficult to articulate their emotions.

Sagittarians tend to find **CANCERS** a bit too touchy and moody to feel immedi-ately drawn to them, but the Crab's sense of humor can have an almost magic appeal. Fire signs like Sagittarius tend to be leery of water signs like Cancer for good reason, though: water can put out fire. Cancer's self-protective shell can strike Sagittarius as a wall of resistance or negativity pushing him or her away, and Sagittarius doesn't find Cancer's need for security particularly understandable either. If other factors in their charts attract these two to each other, the incompatibility between their Sun signs will

pose continual problems, as it may have done between Tom Cruise (Cancer) and Katie Holmes (Sagittarius), whose marriage foundered after five years.

Sagittarians may not take to Cancers when they first meet, but friendships can spring up between these two because they share a similar sense of humor. This may be due to the fact that Jupiter—Sagittarius' ruling planet—is "exalted," as astrologers describe it, or very well placed, in the sign of Cancer. Sagittarians can feel an implicit camaraderie with Crabs, because they can share laughter which lifts their spirits and they appreciate each other's jokes and asides. These friendships can be quite lasting as well, although Sagittarians may find that their tendency to blurt out home truths sometimes pushes their Cancer friends away.

Sagittarian parents with a Cancer child are likely to find their little Crab both endearing and baffling. The Cancer's extreme sensitivity can make the Sagittarian parent a bit uneasy, but he or she will be adept at reassuring this child and getting him or her to smile and lighten up. In later years, though, these two can drift apart because they are basically so dissimilar.

Sagittarius and **LEO** are both fire signs, and Archers can be drawn to Leos because they are as vitally alive and full of energy as they are. Their similarity makes them equal partners, and passions can flare up between the two and lay the foundation for a lasting bond. Sagittarians are particularly drawn by Leo's aura of strength and certainty, while Leo's playful, childlike side resonates with Sagittarius' own nature. If the Leo becomes too controlling, though, and insists on running the show, the Sagittarius will subtly withdraw while on the surface appearing to go along. And Leo's possessiveness may also pose problems, since Sagittarius does not like to account for his or her time to anyone. For this reason, issues can arise between these two that are potential deal breakers, and power struggles can weaken and threaten this bond. Bridgid Coulter (Leo) and Don Cheadle (Sagittarius) are an example of this often successful pairing.

Sagittarians will treasure their Leo friends and enjoy spending time with them, because they are so full of life and energy. Sagittarius tends to feel complemented by Leo in the best possible way; Leo's enthusiasm acts as a stimulant which encourages the Archer to go after his or her hopes and dreams. Leo's demands for attention can rub Sagittarians in the wrong way, but generally, they will not find it difficult to cope with Leo's powerful personality, because Archers are not afraid to say what they think. And this is why friendships between the two can be strong and enduring.

Sagittarian parents with a Leo child will respond to their little Lion's fiery nature and playful antics with heartfelt affection. The Archer will feel particularly bonded with the Leo child and will support his or her desires. Doling out discipline will not be easy for the Sagittarius with this strong-willed child, though, which can lead to problems between these two.

Sagittarians and **VIRGOS** are considered incompatible because their signs form a square—a ninety-degree angle—which is disharmonious. Still, Sagittarius is sometimes quite drawn to Virgo because, as a fellow mutable sign, Virgo is equally changeable and adaptable, and tends to live in the present. Sagittarius may also find Virgo to be admirably clever and competent in a way that fills a gap that the Archer can't address. Always looking at the big picture, Sagittarians are impressed by Virgo's ability to focus on details, although this can be exactly what causes problems between them when they couple up. Sagittarius tends to find his or her enthusiasm punctured by Virgo's analytic and critical observations, and this, in turn, leads to estrangement further down the line. Dave Stewart (Virgo) and Annie Lennox (Sagittarius) were an example of this volatile bond.

Sagittarius and Virgos can have enjoyable friendships, because Archers value Virgo's efficiency and clarity of mind. Often, the Archer will seek the Virgo out to help him or her solve problems of various kinds, because Virgos tend to be proficient at exactly what Sagittarians find difficult: bringing big plans and ideas down to earth. Sagittarius will also enjoy Virgo's company, although if the Virgo becomes critical, which Virgos sometimes do, the Archer will feel deflated and will quickly withdraw.

Sagittarius parents will admire and enjoy engaging with their Virgo child because of the fascinating differences between their natures. A very positive bond can exist between these two, and the Sagittarius will tend to be supportive of the Virgo's interests and proud of their little Virgo's abilities.

Sagittarius and **LIBRA** are complementary, but may be better on paper than in real life. Still, Sagittarians are often quite attracted to Libras, whose tendency to go out of their way to please works its special charm. Sagittarians also find Libra's calm demeanor soothing and feel relaxed and able to unstress in their company. What can be tricky about this combination, though, is Sagittarius' need to be a free spirit versus Libra's desire for togetherness. Libra's desire to prettify his or her environment, versus Sagittarius' disregard of appearances, can also cause conflict between these two. It will generally be the Libra's willingness to adapt to the Sagittarius' behavior, though, that makes this connect fly. Soon-Yi Previn (Libra) and Woody Allen (Sagittarius) are an example of this bond.

Sagittarius and Libras usually like each other and generally harmonize well. Libra's focus on one-on-one connections isn't really Sagittarius' style, though, and Archers don't tend to bond with Libras over sports-related activities, because Libras aren't nearly as drawn to outdoorsy pursuits like hiking and camping. Sagittarius will appreciate Libra's thoughtfulness and normally positive attitude, though, and will bask in Libra's attention, which is often supportive and flattering. Still, Sagittarius' friendships with Libras often don't have enough glue to endure.

A Sagittarian parent will get along famously with his or her Libra child and will be particularly thrilled with Libra's innate social skills, which attract all the right kind of attention. Archers will also be inclined to encourage their little Libra to be adventurous, do and dare, which will benefit this gentle child.

Sagittarius is often drawn to **SCORPIO'S** aura of self-containment, inner power and intensity. In fact, Sagittarius tends to view the differences in Scorpio's behavior and character as complementary and admirable and feels a respect for Scorpio that can lay the foundation for a very positive bond. Sagittarius is also intrigued by Scorpio's passion and evident sensuality. What can trigger issues, though, is Scorpio's possessiveness and tendency to get jealous, because Scorpio may be prone to misinterpret and overreact to Sagittarius' lighthearted flirtatiousness. Still, this combination can be a successful and enduring one. Kate Capshaw (Scorpio) and Steven Spielberg (Sagittarius) certainly seem to have made it work.

Sagittarius and Scorpio can be great friends, and Archers feel strengthened by their relationships with Scorpios, which keeps them coming back for more. Sagittarius particularly appreciates Scorpio's ability to level with them honestly and directly, because this is a quality Archers look for in their friends. Scorpio's independence also appeals to Sagittarius, and he or she will tend to place a lot of value on the bonds forged with those born under this Pluto-ruled sign and make a particular effort to keep it alive.

A Sagittarius will tend to be a kind and loving parent to a Scorpio child, although, not being secretive by nature, the Archer may sometimes be puzzled by the Scorpio's fierce need to conceal his or her emotions. Because the Sagittarius won't fail to give this child the space he or she needs, though, their connection will tend to be open and positive.

Sagittarians can be drawn to other **SAGITTARIANS,** but romance doesn't often flame up between these two, because they don't really complement each other, even though they're compatible. They may playfully flirt and bask in mutual admiration, but in the end, they are prone to go off in their own separate directions without really connecting. When they do come together as a couple, though, it's often because they share a mutual vision or goal. Examples of this pairing are difficult to find because it is so rare.

As friends, Sagittarians can bond brilliantly and harmonize well. Mutual interests can bring these two together, and often there will be an undercurrent of competition in their connection. Equally playful and idealistic, two Sagittarians will also tend to distract each other and feel a bit undermined as a result. Their tendency to identify with each other can have both a positive and negative effect; they will usually have mixed feelings about each other as well as a powerful and affectionate warmth.

A Sagittarian parent with a little Archer will naturally see him or herself in this child, with mixed results. On the plus side, Sagittarius parents will quickly connect with and understand their same-sign child's feelings and natures, but on the downside, they may also be stricter and more critical as a result.

CAPRICORNS can have one of two effects on Sagittarians—either they find them too critical and negative, or they are drawn by their determination and strength. And if romance does flare up between the two, these diverse effects can create a push/pull energy within the relationship so that the connection, while powerful, is often challenging. What Sagittarius admires about Capricorns is that Goats see reality as it is and chart their courses accordingly. Being with a Capricorn can give the Archer a feeling of safety and security, but the Capricorn's tendency to puncture holes in the Sagittarius' big plans and schemes—which inevitably happens—creates strife and can eventually undermine the positive potential in this connection. Carolyn Bessette (Capricorn) and John Kennedy, Jr. (Sagittarius) were an example of this pairing.

Sagittarians form friendships with Capricorns because they value the way Goats organize and plan, and they admire their ambition. Ruled by Saturn, Capricorns are in some ways Sagittarius' opposite, because Jupiter, Sagittarius' ruler, represents expansion while Saturn is all about contraction. What Archers gain from Capricorns is a needed balance, and a positive exchange can happen between these two that makes their friendship mutually beneficial.

A Capricorn child will tend to impress a Sagittarian parent as being admirably strong-minded and capable. The Sagittarius will have the ability to inspire the little Goat and support him or her in his endeavors, although the Archer might not be as hands-on with this particular child as with others because of the Capricorn's apparent self-sufficiency.

AQUARIUS and Sagittarius are the free spirits of the zodiac, and Archers tend to feel stimulated and buoyed up in Waterbearers' company. Attractions can spark up that have a magical quality, and Sagittarius may feel as if he or she has found a soul mate and friend in the same person. Since emotional self-expression doesn't come easily to either, though, they may drift apart even when they don't intend to. Sagittarius may feel distanced by Aquarius' cool manner and not see what's actually going on beneath the surface. Still, the Aquarius has a wonderful ability to inspire the Sagittarius, who does the same for the Waterbearer in return. And if these two are able to keep their relationship intact, they will be rewarded by each other's support and understanding. Abraham Lincoln (Aquarius) and Mary Todd Lincoln (Sagittarius) are a wonderful, historic example of the combination.

As friends, Sagittarius and Aquarius sense they have a great deal to share, and particularly the ability to encourage and inspire each other. Sagittarians find Aquarians

upbeat and original, and will go out of their way to seek out their company. Aquarius' eccentricity appeals to Sagittarius, who admires Aquarians' ability to march to the beat of their own drum. Friendships between the two are usually mutually satisfying and enduring.

Sagittarius parents with an Aquarius child is likely to be delighted by their little Waterbearer's spirit and bright ideas. Feeling very much at home with this child, the Archer will particularly enjoy sharing adventures and thoughts with him or her, and this connection is likely to continue to be a positive and close one when the Aquarius matures.

PISCES and Sagittarius aren't considered compatible, but they can get along surprisingly well, even though their signs form a difficult square to each other. What may magnetize a Sagittarius to a Pisces is the Fish's idealism and openness. Archers often find Pisces to be sympathetic in a comforting way that allows the Sagittarius to open up and relax. And Sagittarians may come to feel protective of the Pisces, because Fish can often appear vulnerable and sensitive. What may be difficult for the Sagittarius, though, is likely to be one of the qualities that drew him or her in the first place: Pisces' emotionality and sensitivity. Being a water sign, Pisces can have a dampening effect on Sagittarius' spirits, especially if the Fish becomes needy or clingy, which triggers a pulling-away response in the Sagittarius. Sharon Stone (Pisces) and Garry Shandling (Sagittarius) are an example of this combination.

Sagittarius and Pisces can be great friends, yet the two sometimes rub each other the wrong way. Sagittarius feels comfortable with Pisces and enjoys the Fish's playful and whimsical side. Pisces' far more emotional way of reacting to everything he or she experiences is likely to trigger a negative reaction in the Sagittarius, though, because, being fiery rather than watery, Sagittarians just don't understand why Pisces is so hypersensitive. Still, friendships between these two can be strong and enduring.

There will be a tender bond between a Sagittarian parent and a Pisces child, and the two will be drawn together by their shared sense of humor. The Sagittarius won't find this child easy to understand, though, and will sometimes grow impatient with their little Fish's sensitivity and dreaminess.

COLORS, GEMS AND FRAGRANCES

Although many sources state that purple is Sagittarius' color, following the logical sequence of the zodiacal wheel, blue is the right and true choice for this astrological sign. After all, the Archer is shooting his arrow into the blue sky. Dark and rich tones of blue seem to particularly accord with Sagittarians and to enhance their vibrant

energy. The vastness of the sky attracts Sagittarius' gaze and reflects the inborn nature of this zodiacal sign.

Sagittarians do seem to be attracted to purple as well, and to bright shades of green. Both colors will simultaneously soothe and bring out Sagittarius' inner spirit, which is idealistic and yet at the same time powerfully clued into the natural world. Green is particularly good for Sagittarius, because it evokes thoughts of growing things—plants and leaves and grass, which Sagittarius delights in—while purple is spiritualizing and raises vibrations to a higher level.

Red and orange are also colors that attract Sagittarians because they are fire signs. Their inner passion is expressed by these tones, and they will do very well wearing them in situations that put them in the spotlight. An orangey/gold shade can be particularly enhancing, but probably the most expressive color for Sagittarius of all remains in the blue family: turquoise.

Sagittarius' birthstone is traditionally the imperial topaz, and this semiprecious stone is reputed to encourage self-realization, draw love to the wearer and bestow charisma. It is a stone that glows with an inner fire that is flattering to Sagittarius; it reflects Sagittarius' nature and enhances this sign's innate optimism. The topaz can be worn at all times by Archers.

Quite a number of other gems are considered appropriate for Sagittarius as well, including amber, jasper, malachite, tourmaline and especially turquoise, which is always perfect for Sagittarius no matter what the circumstances. In fact, turquoise's brightness and spirit-lifting quality seem to accord with Sagittarius so accurately that there is some debate as to whether this stone, not the topaz, is Sagittarius' birthstone.

The flower generally considered to match up with Sagittarius is the carnation, which is hardy and prolific, like the dandelion, also said to accord with this birth sign. The peony is also often mentioned as belonging to Sagittarius, and so, sometimes, are the flowers known as pinks. The trees mentioned as being somehow under Sagittarius' jurisdiction are the lime, the mulberry and especially the oak.

When it comes to herbs, those considered especially healing for Sagittarians are red clover, chicory, agrimony and burdock. The properties of these particular herbs are said to be "cooling" when Sagittarius experiences difficulties in the parts of the body ruled by this birth sign: the liver and spleen. Oak bark is also a healing herb for Sagittarians, as is dandelion root, and rosemary is considered to be soothing and relaxing for Archers, especially in the form of an herbal sachet placed under the pillow when sleeping.

The fragrances expressive of Sagittarian's lively and playful spirit are those that contain a combination of spicy and bright tones: a base note of anise and/or spicy mace blended with a sweeter fragrance such as lavender or neroli. Pine, ruby wood, hyssop and thyme all accord with Sagittarius' nature, and it is always right for Sagittarius to wear light, mood-lifting scents. ♐

IO

Capricorn

22 DECEMBER – 20 JANUARY

270°

Every man's task is his life preserver.

—RALPH WALDO EMERSON

What a shame Capricorns are so often portrayed as gloomy, uptight conservatives! They may have some of these qualities and can, admittedly, come across as a bit rigid once they've formed an opinion. But what I can say unreservedly about the Capricorns I know is that they all are impressively competent and together. In fact, that's it in a nutshell. Capricorns impress me. They have a wonderful aura of self-containment and purpose. They are people who get things done.

What's more, the challenge of taking on even the most boring chores seems to put more spring in their step. My friend Louisa (December 24) is the absolute best person I know to take along on an excursion to load up on feed for the horses; she hoists hefty sacks of barley into my truck with a kind of glee that's quite contagious. She delights in doing things that are difficult. She's not deterred by the thought of how much effort any task demands.

And she's fun to be with, no matter what we're doing. All of the Capricorns I know are great companions, not only for roll-up-the-sleeves-and-get-on-with-it undertakings but also for playful outings, like nights on the town. Capricorns are energetic and motivated. They are also pragmatic. One of the three earth signs of the zodiac (Taurus and Virgo are the other two), they are correspondingly down-to-earth, feet planted on terra firma, no-nonsense people who face life as it is.

Ruled by Saturn—an admittedly difficult but also much-maligned planet—Capricorns are the realists of the zodiac. They pride themselves on zeroing in on the facts, and the truth is that they are brilliant at it. What's more, they possess a sardonic sense of humor that springs from their ability to see things as they are. I can't help but smile when I think of my friend Joe (December 26), a talented artist, because his often grim observations about various situations and people are simultaneously so funny that they make me laugh out loud.

He's also so predictably full of conspiracy theories (Capricorns are said to be born paranoid) or in a state over the detestable taste of art-buying tourists that his consistency in itself is endearing and entertaining. Consistency is another characteristically Capricornian quality. You can always count on Capricorns to stay in character, react

sensibly and do what they said they would do. And they are brilliant people to have around in a crisis, because they won't lose their heads, and they will immediately zero in on solutions.

Capricorns come through. They stick to the program. And this is why they are often so successful. They embrace discipline in a way that can make all the other signs of the zodiac seem soft and self-indulgent by comparison. They also know they are good at whatever they do. Capricorns never fail to push themselves hard, and as a result they achieve what they set out to do. (None of this will be true, though, if a Capricorn's birth chart holds Neptune or Saturn afflictions to his Sun—but that's a whole other story.)

All of what Capricorns are about comes down to Saturn, their planetary ruler, also known as "the tyrant of the zodiac" or "killjoy Saturn." The work ethic is Saturn's territory, and "no pain, no gain" is a Saturnian sentiment. So is "Anything worth doing is worth doing well." Capricorns seem born with a worldly wisdom beyond their years. They are serious students of life from the start, and they continue to keep learning as they go, spurred on by the urge to be perfect.

My niece, Genevieve (January 16), is one of the most hard-working people I know and also one of the most scrupulous. Everything she does is entered into with the intention of getting it right. And this is another aspect of what being born under this achievement-oriented sign is all about: Capricorns are powered by their strongly held convictions about the way things should be. They have extremely high standards, and they hold themselves to them.

Which is why they are often so critical and intolerant of others' weaknesses and foibles. Capricorns find it unimaginable to do sloppy work or fall short on a promise. They have an uncompromising firmness of character that comes across in everything they do. They also seem quite certain about what they think, what they want to do and what's important in life in a way that lends them a rare quality of credibility.

My longtime client Jake, for instance, a filmmaker, has a deep, gruff voice and speaks in a way that conveys such authority that anything he utters seems unquestionably true. And he really has done and accomplished a great deal in his life, including a solid marriage and a successful career. He gives the impression that he knows the ropes, because he does. His is a been-there-done-that kind of knowledge.

Capricorns come across as people you can trust: the woman next door you'd feel comfortable asking to feed your cat while you're away for the weekend; the friend you call when you're stuck at home with the flu and can't cope. It's not that Capricorns are angels of mercy (though they can be) but that they have such sturdy characters, you know they'll come through.

You can usually count on them to be cheery and reassuring, too—even if this is the birth sign that's described as "pessimistic." Capricorns' tendency to fear the worst is

actually a protective device they employ to save themselves from disappointment and being let down. Of course, this is something all of us do from time to time, but most of the Capricorns I know are particularly prone to worst-case-scenario mind-sets. They do not believe in the power of positive thinking, which to them is the pitfall of credulous fools.

Instead, they reason—and my friend Louisa (December 24) has explained this to me exactly in these terms—that if they expect the worst to happen, whatever occurs, they won't be unpleasantly surprised or thrown into a panic. Capricorns can't bear to be disillusioned. It's an admission of how fallible they are, and it's just too painful. Capricorns are past masters at trampling down their own expectations and not living in the future. And when they do succumb to fantasies about what might be, they make light of their hopes and poke fun at their own gullibility.

Not appearing to be a credulous fool is of supreme importance to those born under this Saturnian sign. All the Capricorns I know want and strive to give the impression of being acquainted with the facts and in control of their lives. But even if they do make a wrong call and take a tumble, those born under this enterprising sign will get back in the driver's seat and regain control. Having self-discipline is something Capricorns pride themselves on, and it is one of their greatest strengths. And discipline and hard work are known to lead to success, which they desire and hanker after more than any other zodiacal sign.

Even the most enlightened, high-minded Capricorns glory in reaching the top of the mountain and looking down at all the other mortals struggling far below. And Capricorns have enormous respect for those who have gone before them and scaled the peaks. Fame thrills Capricorns to the core. But they are rarely attention-seekers in an obvious way. The Capricorns I know are not inclined to self-advertise or talk in loud, commanding voices. Instead they strive to be distinguished by how perfectly they fit in. Many have an instinct for always being fashionably turned out, are masters of making all the right gestures and have a knack for turning up at the trendiest happenings and night-spots. Because they are inclined to buy into the prevailing zeitgeist and take it very much to heart, Capricorns have their fingers planted squarely on the public pulse.

On the other hand, some Capricorns are oblivious to fashion and appearances, because they're so completely wrapped up in their work or the pursuit of an ambition. My friend Sam (December 29), a micro-biologist and researcher who is usually clad in non-descript trousers and shirts, clearly doesn't give a hoot about what he's wearing, since it has no relevance in his professional world. (All of his peers dress exactly the same way.) He is, though, very conscious of the pecking order at the academic institution where he works, and possesses the savvy to play his cards right.

This is not to say, though, that self-interest drives all Capricorns, even though the Goat has been dubbed "the most ambitious sign of the zodiac." Capricorns are, in fact,

quite prone to get caught up in causes and belief systems that are not at all about gain or recognition. They can become quite fanatical about their ideas as well. This is, after all, a sign that is described on an online site (www.famouswhy.com/Zodiac) as simultaneously "rigid, intolerant, stoic, suspicious, pessimistic, fatalistic…domineering, materialistic, patient, prudent, ambitious, honorable…responsible…perfectionist and hardworking"— traits that cover a lot of ground and seem to contradict themselves in the process.

Some Capricorns are driven by a hunger for success, some by their high principles; and then there are those who fail to satisfy the demands of their unforgiving consciences and become some of the most spectacularly self-destructive people you've ever met. In psychological astrology, Saturn, Capricorn's ruling planet, symbolizes the conscience— that stern, judgmental voice within that tells us what's right and wrong. And it's really the conscience and what it dictates that drives Capricorns and is at the core of their personality and behavior.

Capricorns often lack confidence in their youth, because Saturn is the critic of the zodiac, and they're prone to find fault with themselves, particularly as teenagers. Their imperfections are a source of torment to them, and the appearance of a blemish can be almost an unbearable agony. I have met shy, insecure Capricorn adults as well, and while Saturn can impart a steely strength, it can also inhibit and curtail so that some Capricorns have an instinct to withdraw—or even hide.

Capricorn's public face can be quite different than the one he or she reveals in private. I have known Capricorns like my friend Dee (January 15) who always appear self-certain and upbeat when they're out and about, even when they're crumbling inside and feeling completely unsure of themselves. Capricorns tend to be very private about their emotions; noisy outbursts are not their style. They try to observe a certain decorum and maintain control at all costs, and they often pay a price, because their stress tends to come out in various physical issues and ills.

Capricorns are generally stoical, driving themselves ever onward even when they're in pain or under duress, but they can become obsessed by health matters and will get involved in strict regimes if they believe they will be helpful and health-improving. The majority of Capricorns I know are regulars at health clubs, practice yoga or tai chi or belong to walking groups. And this is very much part of the overall theme that runs through this sign's psychology: always striving and bettering themselves and their situations in a particularly disciplined way.

Adhering to a structure appeals to Capricorn's desire for order and control; it also enables them to accomplish what they aim for. This is one of the qualities I admire in the Capricorns I know: the way they organize their time and pursue their ambitions. How well they succeed, though, has everything to do with their self-esteem, and while I know some Capricorns with huge egos, I know even more who think less of themselves than

they should. Saturn's critical influence is so evident in the way they view themselves—a nagging inner voice that's always poking holes in their ideas and plans. I can see this in my friend Mia (January 11), who, after performing (brilliantly and faultlessly) in a local play, was convinced she'd flubbed the part and was full of self-recriminations; I can see it in my long-term client Maria (December 28), who excels at everything she does but doesn't have the confidence to go after the high-flying job she really deserves.

What is most intriguing—but perplexing—about this birth sign is that there's no such thing as a typical Capricorn even though the majority of them share certain traits. For example, ambition is said to be their defining characteristic, but are all Capricorns ambitious? When I think of all the Capricorns I know, I'd have to answer this question with a "no." The truth is that while a little over half of the Capricorns I know really are out there pursuing fame and fortune with all the contained intensity that is so unmistakably their birthright, the other forty-odd percent don't appear to be interested in grabbing for the brass ring at all.

In fact, they actually seem unfazed by being small fish in a big pond. They have no desire to be out there clawing their way to the top. But then again, a good many of the Capricorns I know (though not all) who aren't caught up in making their mark do have a characteristically purposeful manner when it comes to pursuing their own aims—like the way Alice, (January 19), a British expat I know in France, so determinedly attends local garage sales, conducts a search for a new home and organizes her friends' affairs; or the way my friend Louisa (December 28) rolls up her sleeves and gets to work at the Village Pizza parlor (which she manages), her brisk, get-on-with-it manner and capability an example to all.

Capricorns' perfectionism really does make them superior at any task they take on, but it's also obviously a source of torment to them. Alice's search for the "right' property seems heavily burdened (if not doomed) by her rigid requirements: It must be this, that and the other thing exactly, with no room for adjustments, and she seems to be consistently disappointed by whatever house she sees. And another Capricorn I know is caught in the same bind when it comes to finding the man of her dreams. No one ever quite makes the grade.

I think Capricorn's perfectionism can be inspiring to others, though, even if it's a difficult quality for those born under this motivated sign to live with. Capricorns are brilliant role models, because they show everyone else how to get out there and do what must be done in the most committed and clear-minded fashion. Those who have worked for a typical Capricorn have likely found themselves in the contradictory position of feeling pressured and challenged but then rising to the occasion and excelling themselves. (I briefly worked, years ago, as an assistant to a Capricorn magazine editor and had just this kind of anxiety-producing yet ultimately exhilarating experience.)

Capricorns teach us to work hard and get results—unquestionably one of the most useful lessons in the world.

Unfortunately, Capricorns are also prone to worry, and since they generally dwell on worst-case scenarios with almost morbid passion, they can worry themselves into a state of near-hysteria. I know several Capricorns who regularly put themselves through the wringer this way, and it's difficult to reassure them when they're convinced their affairs are on a downward slide. It doesn't help either that Capricorns feel responsible for everything, shouldering blame even when they are entirely blame-free. This again, is their stern ruler Saturn's doing, and one of the most difficult qualities shared by those born under this highly honorable sign.

I think Capricorns' reputation as being conservative comes from their ingrained tendency to cautiously assess situations and always look for the most practical solutions. No matter what their ideologies or views, Capricorns are down-to-earth realists who tend to take a time-tested approach. They are also traditionalists in the sense that their manners are usually polished, polite and correct—just the way their parents taught them to be. When it comes to taste, though, while many, like my niece Genevieve, are drawn to furniture and interiors that hold a hint of nostalgia for the past, others are inclined to go to the other extreme and favor trendy, bold and modern forms that are also quite colorful.

When it comes to cold cash, though, I have never met a Capricorn who was anything but cautious and controlled. Capricorns are astute bargain hunters who know how to recognize true value and who refuse to pay more for anything than it's worth. Capricorns can stretch a dollar better than any other sign—even Virgo—and they are able to control their impulse to splurge in a way that's awe-inspiring.

Capricorns possess a certain intensity that is fueled by their urge to achieve and succeed, and some seem to be born leaders who step in and ruthlessly take control. In fact, quite a number of notable figures of recent times have been Capricorns, including Anwar Sadat (December 25, 1918), Mao Tse-tung (December 26, 1893), Konrad Adenauer (January 5, 1876), Lloyd George (January 17, 1863) and Fulgencio Batista (January 16, 1901) not to mention Richard Nixon (January 9, 1913) and Barry Goldwater (January 2, 1909).

Millionaire moguls Conrad Hilton (December 25, 1887), Aristotle Onassis (January 15, 1906) and Howard Hughes (December 24, 1905) were a testament to Capricorn's drive to make it to the top, and so were cosmetic queens Helena Rubinstein (December 25, 1870) and Elizabeth Arden (December 31, 1886), both of whom could be said to have established empires. Jeff Bezos (January 12, 1964), the founder of Amazon, is another and more recent Capricorn success story.

Paranoid, powerful J. Edgar Hoover (January 1, 1895), the first director of the F.B.I., was an example of the controlling, rigid side of the Capricornian character., Another archconservative, the cynical Rush Limbaugh (January 12, 1951), also illustrates the tough-minded attitude of this birth sign in its most exaggerated form, as does another aggressive radio personality, Howard Stern (January 12, 1954).

At the other end of the spectrum, though, there's Martin Luther King (January 15, 1929), whose character, courage and ideals influenced a nation. His inspiring life is an example of the Capricornian character at its best: disciplined, dedicated and undeterred. Nobel Peace Prize-winner King was a deeply religious man, as was another Capricorn Nobel Prize-winner, Albert Schweitzer (January 14, 1875). Believing, according to his Wikipedia profile, that "we must make atonement for all the terrible crime we read of in the newspapers" (atonement is very much stern Saturn's territory), he become a medical missionary in Africa and a voice for the oppressed people of that land.

The enlightened spiritual leader Paramahansa Yogananda (January 5. 1893) was another Capricorn who performed an enormous service to mankind by bringing meditation to the Western world, and writer Alan Watts (January 6, 1915) was a brilliant interpreter of Zen Buddhism and Eastern philosophy who had a profound influence on his generation and on generations to come. Carlos Castaneda (December 25, 1925) could be said to have accomplished the same mission in his intriguing exploration of the philosophy of the ancient seers of Mexico, and Capricorn's ruling planet Saturn is also known as "the great teacher of the zodiac," a role that all of these extraordinary men acted out and fulfilled.

The art of Henri Matisse (December 31, 1869) is sometimes said to have been influenced by earlier, fellow Capricorn artist Paul Cézanne (January 19. 1839), and the similarities in their approach can be seen quite clearly in a comparison of Cézanne's *The Large Bathers*, and Matisse's *Bonheur de Vivre*. There is also an intriguing similarity between Capricorn Edgar Allan Poe's (January 19, 1809) morbid and gloomy preoccupation with death and cartoonist Charles Addams' (January 7, 1912) fascination with the macabre. Stephenie Meyer (December 24, 1973), the creator of the vampire series *Twilight*, has also ventured into the same dark and yet oddly fascinating territory.

Simone de Beauvoir (January 9, 1908) and Susan Sontag (January 16, 1933) were two Capricorn women who were outstandingly strong and self-determining and who, alike, shared the particular distinction of being intellectual celebrities of their times. Their ability to make their way—and their mark—in a man's world was also characteristic of Capricorn's hard-driving approach and reality-oriented mind-set.

Charismatic actress Ava Gardner (December 24, 1905) and equally charismatic actor Cary Grant (January 18, 1904) shared a potent magnetism that could also be described as distinctly Capricornian. The riveting Elvis Presley (January 8, 1935) was also born under

this fascinating sign, as were Patti Smith (December 30, 1946), David Bowie (January 6, 1947), Joan Baez (January 9, 1941), Rod Stewart (January 10, 1945) and Janis Joplin (January 19, 1943).

Two notable Capricorns, Howard Hughes (December 24, 1905) and J.D. Salinger (January 1, 1920), were known as recluses—another well-documented Capricornian trait. Poet Robinson Jeffers (January 10, 1887) was said to love solitude and possessed the distinctively rugged character associated with Capricorn, as did the extraordinary writer, Jack London (January 12, 1876), who, true to his birth sign's attributes, rose, against great odds, from poverty to fame and fortune.

THE CARE AND FEEDING OF A CAPRICORN

If there's an important Capricorn in your life, you probably rely on him or her in even more ways that you realize. Capricorns are born with a kind of savvy about how the world works (Capricorns are said to be "born old"), and your Capricorn probably smoothes the way for you in many situations with an ease and aplomb that is tremendously reassuring. With a Capricorn by your side, you can get through those boring tasks that invariably crop up day after day with mind-numbing frequency—trips to the appliance store to look for parts for your vacuum cleaner, reorganizing the crammed attic or weeding the lawn—with a minimum of fuss or bother that frees you up and unburdens your mind of needless trivia.

Your Capricorn is also knowledgeable about many things that you might not otherwise clue into, from obscure foreign affairs to the politics and power struggles going on in your community, or the new hours when your local dump will be open or closed. It's as if your Capricorn has special powers of observation or sources of information that elude everyone else but are really quite necessary for coping with the often tedious complexities of day-to-day living.

In fact, your Capricorn usually seems to be so self-sufficient and on top of things that you have the impression that he or she doesn't need you or anyone else at all—at least not very much. Self-contained and cool, your Capricorn will resist your efforts to aid or abet him or her with whatever business is at hand and will brush you off and smile obliquely, so that you feel superfluous and somewhat rejected.

What you need to remember, though, is that your Capricorn's refusal to cave in and ask for help even when it's needed is merely a defense mechanism. It's part and parcel of your Capricorn's inborn survival kit that impels him or her to stoically rise to every occasion, no matter what. And not successfully overcoming the obstacles in his or her

path will eat away at your Capricorn's self-esteem and dredge up feelings of guilt that are quite hidden from sight. Capricorns have high standards for their own behavior, and when they don't meet them, they will turn against themselves in any number of ways which are not apparent to you or any observer.

The truth is that your Capricorn may be tough, clued-in and together, but this outwardly independent person is not the lone wolf he or she appears to be. Capricorns need people. And they will admit that they do, even if their actions belie their words. Deep down, they are far more vulnerable than anyone would ever guess, because they're sharply aware of all the dangers that pose a threat to existence.

Saturn—Capricorn's ruling planet—is a stern taskmaster, and it is also the arouser of fear, which is not to say that Capricorns are fearful people. In fact, they do everything in their power to avoid dangerous situations and keep fear at bay. But deep down, they know how precarious life really is, and what they long for is security. Your Capricorn's longing for security is the trigger that ignites his or her ambition, and it's also the reason why Capricorns cleave to family values and emotional connection. Your Capricorn wants to be safely ensconced in a warm, protective relationship even when striving to prove how independent he or she can be.

Understanding the contradictory message that Capricorns send out is the key that unlocks their true selves and natures. Another person's ability to be there when needed and to clue into a Capricorn's struggles and trials means the world to one born under this self-controlled and driven sign. Capricorn's appreciation of others' willingness to witness them and come through for them when needed should never be underestimated and will be rewarded in kind. Your Capricorn will be happy to be the rock that you cling to, because Capricorns love to be the strong one who takes care of everything difficult and onerous—but he or she will need you to be able to reciprocate when push comes to shove.

Remember, too, that all the rituals that give each day a certain, reliable form are wonderfully reassuring to your Capricorn. Those born under this zodiacal sign have an innate tendency to create and hold onto structures. They are creatures of habit who like everything to be kept in the same familiar place and everything to happen at the same appointed time. Their habits give their lives the consistency they long for, and in their own day-to-day existences, they are also amazingly consistent.

Which is why your ability to be reliable and consistent will mean so much to your Capricorn. As will your willingness to stick to certain shared schedules such as eating lunch and dinner together at the same time and attending hallowed family occasions and annual trips to the same familiar and beloved getaway spot. Which is not to say that Capricorns aren't adventurous or interested in new experiences. Capricorn is one of the four cardinal signs (the others are Aries, Cancer and Libra), and the cardinal modality as

it's called is all about beginnings and start-ups. Capricorns are initiators. The need to feel that they are moving forward and opening doors that put a new spin on life's possibilities. They are always looking for fresh opportunities to further their aims and to reality-test what can be.

Remember that the astrological symbol for Capricorn is the goat, and goats love to climb. In fact, they seem impelled to climb everything, which makes them notoriously difficult to fence in. The celebrated answer to the question "Why do you climb mountains?" "Because they're there," is a quintessentially Capricornian response. (This quote is attributed to English mountaineer George Mallory, who was not a Sun sign Capricorn but did have a Capricorn moon.)

Your Capricorn may be a mountain climber who thrills in the challenge to his or her superb instinct to survive. But even if he or she isn't particularly sporty (and most Capricorns are concerned with staying fit, one way or another), the urge to overtake obstacles and push on is very strongly ingrained in his or her nature. Your attunement to your Capricorn's drive, and your acceptance of his or her need to go for it, will ensure that your relationship stays on track.

Of course, if you're partnered with a Capricorn, his or her forward-moving spirit is probably one of the reasons you were drawn in the first place. Let your Capricorn know that you understand how hard he or she tries and how much effort is being expended. This is the kind of support a Capricorn needs and appreciates. But even if Capricorns like to know that they're being noticed and admired, as you probably know they are not always gracious about receiving compliments. So if you say something flattering (this is truer of male Capricorns than females) and receive a cool or even brusque response, remember that Capricorns actually love to hear nice things about themselves, but that they cannot help but be a bit superstitious about compliments, and of good fortune.

Their worry—again, a Saturn-influenced quality—is that if they draw attention to their attributes or luck, they may somehow tempt fate and draw the wrath of God down onto their heads. You should not let yourself be deterred by their uneasiness, but should, instead, be as complimentary and optimistic as you feel. Capricorns sometimes need to have their qualities and extremes countered. It's one reason why they really do need people and thrive in relationships. You should always encourage your Capricorn to hope for the best and also to relax and lighten up now and then.

Most Capricorns are strict with themselves and will find it difficult to stop working even when they're exhausted. You won't be able to deter them if they're caught up in some demanding task, but you can and should encourage them to loosen up and get out and away from their desks and chores. You will find that your Capricorn is a warm and enjoyable companion once pried out of the workplace, and this is when you will see how important it is for your Capricorn to relate, connect and stop pretending to be an island.

Capricorns blossom when they're feeling bonded with another, and all their hidden gentleness and kindness come to the fore. And despite their sometimes reclusive streak, Capricorns like to entertain and to socialize. Get out and about with your Capricorn and bask in their protective affection. You can count on this strong, self-reliant person in a way that makes you feel truly secure.

CAPRICORN IN LOVE

Capricorns are choosy about whom they confer their affections on, and the high standards they impose on themselves are the same standards they expect others to meet. They are also highly sexed, though you might never suspect this unless they let down their guard and let you into their private world. The combination of a strong character, powerful eroticism and innate caution about the affairs of the heart results in a buildup of inner passion that can quite overwhelm them even when they struggle to contain it.

Capricorns can be very romantic, and they believe in old-fashioned virtues like fidelity and commitment. The bonds they form—when they form them—can be very enduring. They will do their utmost to fulfill their roles and will put duty before pleasure in order to do so. The institution of marriage appeals to them because, deep down, they believe in structure and tradition and the security that these provide.

Due to their strongly sexual natures, though, Capricorns may sometimes stray or get caught up in relationships that compromise their ideals. They may also tend to bottle up their emotions, not letting even their loved ones know what they're feeling inside. Additionally, Capricorn's perfectionism puts many demands on them as well as on those around them. This is why their love lives are often far more complicated than they bargained for even, though they never stop trying to be good partners and never stop dreaming of the kind of love that lasts forever.

* * *

Capricorns may find **ARIES** to be fascinating and exciting, but these two often clash when they spend time in each other's company. Capricorn admires Aries' spirit and enterprise and feels enhanced when he or she is in Aries' company. What particularly intrigues Capricorn is Aries' air of independence, although this is exactly what can also rub Capricorn the wrong way. Aries won't tend to take Capricorn's advice or counsel to heart or play by the rules that Capricorn expects. And Capricorn often feels undermined by Aries, who seems less interested in being a couple than in going off and doing

his or her own thing. The result is often a power struggle that may initially intensify passions, but can also break out as conflict that has a long-term and destructive effect. Nicholas Cage (Capricorn) and Patricia Arquette (Aries), whose five-year marriage ended in divorce, are an example of this pairing.

Capricorns and Aries can be friends more easily than they can be lovers, but similar conflicts are likely to spring up. What Capricorn likes about Aries is their feisty spirit and inner strength, and these two can—on occasion—be wonderful comrades-at-arms. The question of who is calling the shots, though, is bound to come up from time to time, and is one that can't be resolved without conflict. Capricorn doesn't take kindly to Aries' tendency to ignore his or her ideas or directives and will tend to fall out with Aries friends over various issues.

Capricorn parents with an Aries child will be delighted by and proud of their little Ram's sense of purpose and strong character. But battles of will are almost bound to ensue from time to time that alienate these two from each other and are difficult to resolve unless the Capricorn is willing to give way.

TAURUS and Capricorn have a certain natural affinity for each other, since both are earth signs. Taurus' practicality strikes a chord with Capricorn, who feels comfortable in the Bull's company and calmed by Taurus' easygoing warmth. On paper this is a great combination, and it's true that, together, these two can make a perfect team. But Saturn-ruled Capricorn can feel stymied by Taurus' lack of ambition and tendency to focus on emotional issues. Taurus' passive but stubborn resistance to Capricorn's ideas can also create difficult undercurrents. Still, these two are capable of forming a relationship that endures and of providing each other with the kind of support both long for. Martin Luther King (Capricorn) and Coretta Scott King (Taurus) are an example of this combination.

As friends, Capricorn and Taurus can be highly complementary. Capricorn feels understood by Taurus in a deep-down way that drives Capricorn to seek out friends born under this sign when he or she needs comfort and companionship. Capricorn does not feel threatened by Taurus, either, since Bulls are not particularly competitive or power-hungry. A friendship between these two can prove very durable because they're likely to have a number of interests in common.

A Capricorn parent senses an underlying harmony in his or her relationship with a Taurean child that stirs the Goat's affections and makes it easy to bond. The Taurus child's adolescence, though, may trigger some storms between these two, because the Bull will tend to stubbornly resist the Capricorn's attempts to counsel or control.

Capricorns admire **GEMINI'S** wit and charm and can become quite attracted to those born under this effervescent sign. Gemini's fluidity initially fascinates Capricorn because it contrasts so sharply with the way he or she operates, but misunderstandings can quickly arise between these two. What becomes difficult for Capricorn is Gemini's

changeability and tendency to scatter his or her energy. This can trigger Capricorn's critical side—but the real problem is that Capricorn doesn't feel really secure with Gemini, who begins to come across as someone he or she can't really count on. And as the Gemini becomes more distant, which inevitably happens when the Twin senses Capricorn's dissatisfaction, the resultant rifts can prove difficult to mend. An example of this coupling is Elvis Presley (Capricorn) and Priscilla Presley (Gemini).

Capricorns and Geminis don't tend to bond all that easily, so the friendships that do form between the two are often based on shared pursuits and work-related matters. Capricorns often find Geminis to be flighty and not especially sympathetic, and Geminis react by finding Capricorns too judgmental or rigid. Still, open conflicts aren't likely to flare up between these two, and on the surface they will get along reasonably well.

When Capricorns have a Gemini child, they will react in a very positive way to their little Twin's precocity and charm. The Gemini child's ability to adapt to new situations will also inspire admiration in the Capricorn, but the Twin's tendency to scatter his or her energy will not go over well with the Capricorn, who will react critically.

Some opposite signs seem to be strongly attracted to each other, and Capricorn and **CANCER** are particularly prone to experience a magnetic pull that feels quite irresistible and inevitable. Both are extremely security-oriented signs, and they can tune in to each other's needs and hopes with very little said. There's something classic about the way they can balance and complete each other, but since they really are opposites, they can also misunderstand each other at times in a way that is extremely polarizing and conflictual. For this reason, their relationship can have a seesaw-like quality, with periods of closeness and periods of distance in sharp contract. Capricorn can be put off by Cancer's moods and by the Moonchild's defensiveness, but will be drawn back in by Cancer's tenderness and emotionality. Diane von Fürstenberg (Capricorn) and Egon von Fürstenberg (Cancer) were an example of this combination.

As friends, Capricorn and Cancer are likely to bond very strongly or not at all. Capricorn may find Cancer to be too defensive and touchy or else will immediately identify with Cancer, who strikes a highly sympathetic chord. When these two do become friends, they are highly companionable and can play or work together harmoniously and well. Similar values create an understanding between them that stands the test of time.

Capricorn parents with a Cancer child will feel emotionally stirred by his or her sensitivity and emotionality. A very powerful bond will develop, and the Capricorn will enjoy parenting and instructing the little Cancer, who will strike them as sensible and receptive. As adults, these two often become fast friends.

Capricorns are drawn to **LEOS** because they appear so centered and confident, and this attraction is often mutual. Capricorns sense that they will be stronger and better

off with a Leo beside them. Their ambitions are fired up by Leo's dynamic energy and certainty of success, and Leos, in turn, feel empowered by Capricorn's savvy and inner strength. Leo's sunny confidence is also a balm to Capricorn, who can descend into pessimistic gloom when anything goes wrong. Capricorn can become critical of Leo, though, because Lions will often take the easy way and don't ascribe to the same stern work ethic that continually drives Capricorn forward. Still, these two are often mutually supportive in a way that makes them a real team. This combination makes for power couples like David Bowie (Capricorn) and Iman (Leo) as well as Michelle Obama (Capricorn) and Barak Obama (Leo).

Friendships between Capricorns and Leos are often based on work-related interests. When these two team up together, they are impressive and much stronger than when they're on their own. In situations in which they aren't focused on a mutual goal, though, they may become competitive. Capricorn may admire Leo, but also resent the way in which Leo attracts attention and upstages everyone else. When Capricorns feel on an equal footing with Leo, though, their connection with the Leo will thrive.

Capricorn parents will be by turns delighted by, proud of and exasperated by their Leo child. The little Lion's confidence will thrill the Capricorn, but this willful child's demands for attention and sense of entitlement will bring out the sterner side of Capricorn, who will feel impelled to lay down the law.

Capricorns and **VIRGOS** are instinctively at home with each other, and they can connect with ease and confidence. Great passion isn't likely to erupt but may develop over time. Both are highly discerning, and Capricorn appreciates Virgo's dry wit and efficiency. What Capricorn most values in this relationship is the feeling of being backed up and supported. Virgo's resourcefulness also impresses Capricorn, who is similarly able to seek out and find solutions when challenges arise. Emotionally, though, things can go a little flat between these two. Capricorn needs inspiration and encouragement, and Virgo's tendency to analyze and pick apart can rub Capricorn the wrong way. On paper this is a great combination, but in reality it may lack the magic to make it work. Lyndon Johnson (Virgo) and Lady Bird Johnson (Capricorn) were an example of this combination.

As friends, Capricorn and Virgo can be a complementary duo who admire each other's qualities. Capricorn feels noticed and supported by Virgo's attention and companionship, and more secure in Virgo's company. Virgo's down-to-earth way of seeing life strikes a chord with Capricorn, who responds by opening up more than usual. Capricorn also tends to seek out Virgo for advice and support, which is not easy for those born under the sign of the Goat to do. Friendships between these two can be extremely durable.

A Capricorn will feel at ease with his or her Virgo child in a way that enables them to bond very closely. The Capricorn will be very supportive of this child, but will be

inclined to push or motivate the Virgo, who in the Capricorn's eyes may appear to lack the kind of ambition that will lead to success.

Traditionally in astrology, Capricorn and **LIBRA** aren't considered compatible, but powerful attractions can spring up between these two. Capricorn is drawn by Libra's calm, diplomatic manner and logical mind as well as by Libra's charm. Libra's innate desire to please and to adapt to others bolsters Capricorn's confidence as well and Capricorns will sometimes idealize Libras because they fulfill so many of their expectations and ideals. Relationships between them can run smoothly as long as both partners feel that they are playing their own parts well, but they can fall out over issues having to do with closeness and intimacy. Libra's need for one-on-one connections and Capricorn's ambition and drive can set them at cross-purposes. Linda Kozlowski (Capricorn) and Paul Hogan (Libra) are an example of this combination.

Capricorns and Libras can form strong friendships, and they seem to very much appreciate each other's best qualities. Capricorns enjoy the attention and care their Libra friends lavish on them when they are together, and they also feel secure with Libras, who tend to be reliable and supportive. Saturn—Capricorn's ruling planet—is in its best placement in the sign of Libra, and this may be why a kind of harmony exists between these two.

Capricorn parents will tend to be quite charmed by their Libra child's affectionate nature and will also generally be pleased by their little Libra's behavior. Few problems are likely to arise, although the Libra's tendency to say "yes" to avoid arguments, while secretly doing what he or she wants, will cause the Capricorn's temper to flare.

Capricorn and **SCORPIO** can experience a kind of complicit understanding that bonds them together, but they can just as easily distrust and judge each other. If they click, though, they will form a very strong connection, and romantic liaisons will be powerful and magical. As a team, these two can be extremely effective. Capricorn admires Scorpio's intensity and this Pluto-ruled sign's ability to focus on goals and achieve them. Power struggles can and will crop up between the two, though, because both like to control. Capricorns won't be able to tolerate situations in which they feel relegated to the passenger's seat and will tend to withdraw if they sense that a Scorpio partner is determined to call the shots. Diane Sawyer (Capricorn) and Mike Nichols (Scorpio) are an example of this pairing.

Capricorns and Scorpios tend to admire each other, which is the basis on which their friendships are formed. They share a similar sense of humor, and they feel empowered by being together. From Capricorn's point of view, Scorpio is very much on the same wavelength; at the same time, Capricorn feels flattered by Scorpio's attention, sensing that Scorpios aren't that easy to win over. These friendships may be volatile, though, since both signs are moody and intense and may sometimes clash.

A Capricorn parent will instinctively admire and respect his or her Scorpio child and will feel strongly attached. The little Scorpio will prove difficult to discipline and control, though, and this will tend to lead to clashes of will which can, in some instances, result in estrangement.

Capricorn and **SAGITTARIUS** are so different that they can sometimes complement each other. Powerful attractions can spring up, although in many cases they will also prove fleeting. Capricorn finds Sagittarians refreshingly upbeat and playful, and their spontaneity will, at first, strike a very positive note, but as this relationship progresses, Sagittarius' breezy style will begin to irritate Capricorn, who is inherently organized and precise. What Sagittarius brings to Capricorn is inspiration, and Capricorn finds this valuable enough to try to make this relationship work. But the signs operate so differently that both are bound to get on each other's nerves and become increasingly estranged. Diane Keaton (Capricorn) and Woody Allen (Sagittarius) are an example of this combination.

Capricorn-Sagittarius friendships may form on the basis of shared associations and mutual interests—especially of the sports-related type. Because their styles are so different, these two can balance each other. Capricorns may be motivated by Sagittarius' excitement and anticipation to undertake projects and events that they might otherwise avoid. But they also tend to become critical of Sagittarius' impulsiveness, which leads to fallings-out.

Capricorn parents will appreciate their Sagittarius child's exuberance and naturally high spirits, but will try to bring their fiery little Archer down to terra firma by keeping them clued into life's realities in various ways. And in the process they may, in fact, have a positive and grounding effect on this child.

Capricorns usually get along with other **CAPRICORNS** very well on first meeting. Those born under this earthy and energetic sign appreciate each other's common sense and strong drive and may bond quite strongly. Intense and riveting attractions can flare up, and these two may quickly become attached. Inevitably, though, their need to excel and control will create conflicts between them. Each will tend to compete with the other, and will try to be the one who calls the shots, which will pit them against each other and create friction. Only when they are caught up in a common cause will they be able to harmonize in a way that makes this relationship work. Jude Law (Capricorn) and Sienna Miller (Capricorn) are two Capricorns who couldn't sustain their apparently passionate connection.

Capricorns often befriend each other and very much enjoy each other's company—and together they can team up and accomplish great things. Issues about who is in control and who is responsible for what will arise, setting them at odds from time to time. They will also tend to be highly critical of each other, precisely because they are so alike.

Still, their friendships will often endure in an on-and-off fashion, and they will maintain real affection for each other

Capricorns will find a child born under their own Sun sign satisfactory in practically every way. They may still tend to be a bit critical, though, since Capricorns believe that criticism can be helpful and illuminating; and this is likely to lead to battles of will. The potential for the two to form an intensely affectionate bond is very strong, however.

AQUARIANS march to the beat of their own drum, which Capricorns quite admire. And these two can be drawn to each other because both possess strong characters and are very self-contained—a challenging combination they find difficult to resist. The expression of emotion, though, doesn't come easily to either one, and this can result in a kind of stalemate where neither one is really opening up and allowing the other in. Capricorn may feel completely intrigued by the Aquarius but, at the same time, unsure as to whether he or she reciprocates the feeling enough to make the relationship worth pursuing. Lack of communication can cause this bond to run aground; Capricorn may withdraw self-protectively, and his or her coolness may be mistaken for lack of feeling by the Aquarius. The unusually short-lived marriage of Ethel Merman (Capricorn) and Ernest Borgnine (Aquarius) is an example of this combination.

Capricorns and Aquarians can become fast friends and can appreciate each other's independent natures and initiative. Secretly, though, Capricorns may be a bit taken aback by Aquarians' eccentricity and seemingly outlandish ideas. At the same time, though, they can feel quite affectionate toward the Waterbearer, whom they will sometimes try to take under their wing and steer in the right direction.

Capricorn parents with an Aquarius child will appreciate their little Waterbearer's strong individuality, but will try to curb this child's rebelliousness when they feel it is leading him or her astray. The relationship will tend to be a bit volatile for this reason, and the Capricorn will not find it easy to give the Aquarius child the freedom he or she demands.

Capricorns and PISCES can strike a very sympathetic chord with each other, and they may also stir up romantic feelings in each other's hearts. Capricorns are drawn by Pisces' receptiveness and emotionality, which make the Capricorn feel appreciated and secure. Pisces can also tend to instill quite protective feelings in Capricorns, who enjoy being thrust into this role. For Capricorns, Pisces can be exactly the kind of supportive and caring partners they dream of, but because they tend to see the Pisces as being the more vulnerable and dreamy part of the pair, they may tend to take over and behave in a dominating fashion, which can throw this relationship out of balance. Still, the harmony that's possible between these two makes it a particularly positive combination. Alex Kingston (Pisces) and Ralph Fiennes (Capricorn) were an example of this pairing.

As friends, Pisces and Capricorn generally click and can get along with a minimum of stress on either side. Capricorns feel comfortable and easy with Pisces, who tend to draw them out and calm them down. As friends, both will make an effort to be helpful to each other, and Capricorns will often be especially giving to those born under the sign of the Fish, because they arouse their protective instincts. Their friendship may be sporadic, but it may also be quite enduring.

Capricorn parents will tend to be highly responsive to their little Fish's gentle and dreamy nature. The Capricorn will also feel a need to shelter this child and may be overly controlling in an effort to steer him or her in the right direction. As a result, the Pisces child may become too dependent, or rebellious.

COLORS, GEMS AND FRAGRANCES

Dark blue is almost universally acknowledged to be Capricorn's color, and this accords with the progression of colors in the zodiacal wheel. This shade of blue, though, often holds a hint of purple, as if blending into the next sign (Aquarius) and next color on the wheel, indigo. And purple as well as maroon are colors that suit Capricorns particularly, and they often seem to prefer them.

Brown and tan are also colors associated with Capricorn—earth tones that are grounding and do not stand out and draw attention. Capricorns seem to instinctively avoid loud tones, like bright reds; they feel an urge to fit in and blend in. This also inclines them towards the color green, which is soothing and harmonious to those born under this Saturn-ruled sign, as is a medium to light shade of blue.

Pink also can be very enhancing to Capricorn—especially a rosy pink, or one that veers towards purple. And while Capricorns avoid fire-engine red, they do very well in a particularly dark shade of crimson, particularly when they feel a need to take a leadership role or want to make a strong impression. Black is another color that Capricorns are drawn to, and some prefer black to all other colors because it is both unobtrusive and distinctive.

The garnet is known to be Capricorn's birthstone, and it is said to boost self-esteem as well as enhance business success. The garnet is also reputed to cure depression if placed under a pillow during sleep. The blue topaz is a gem associated with Capricorn and is considered to be calming and emotionally uplifting. In nature this gem is also quite rare; many blue topazes on the market have been artificially altered from their originally colorless state.

The onyx is also associated with Capricorn and is thought to possess magical properties that ward off negative influences. The carnelian—which can be orange or red—is another stone connected with Capricorn and said to be an energy enhancer and stabilizer, associated with abundance. The metal that accords with Capricorn is lead.

Capricorn's primary flower is the carnation—especially the red variety, which is said to express deep love and affection. The wildflower heartsease, also known as viola tricolor, is strongly associated with Capricorn, and the folklore holds that it has many healing qualities, especially for respiratory ailments and skin diseases.

Similar in appearance, the pansy is also one of Capricorn's flowers, as are the blue cornflower and Solomon's seal. The lovely, winter-flowering snow drop is also associated with Capricorn. Statice, also known as sea lavender because it tends to grow near coasts and marshes, is yet another flowering plant said to belong to Capricorn, and so are holly, ivy and the African violet.

The trees traditionally connected to Capricorn are the tamarisk, cypress, lime and linden. Another plant associated with this Saturn-ruled sign is hemp—the nondrug variety of cannabis, which is very usefully employed in the production of clothing, food and fuel. Fumitory, a somewhat obscure herb used in folk medicine for skin conditions, among other things (Saturn is said to rule the bones and skin), is also connected with Capricorn, and so is the wonderful wound-healer comfrey.

Capricorn's fragrances hold earthy and grounding tones as well as those that stimulate the senses, like spicy oriental vetiver. Mimosa is also said to be appropriate for this birth sign, and the unmistakable fragrance of patchouli is considered to accord with Capricorn as well. Many Capricorns are drawn to the evocative, soothing and yet sensual tones of sandalwood—which seems to enhance and complement their complex natures. ♑

II

Aquarius

21 JANUARY – 19 FEBRUARY

300°

Two roads diverged in a wood, and I—
I took the one less traveled by,
And that has made all the difference.
—ROBERT FROST

W hy is it that every time I think about or try to describe Aquarians I invari-
ably get a smile on my face? It's certainly not because they are laughable or
not to be taken seriously—quite the contrary. No, it's due to the fact that
those born under this complex and fascinating sign arouse a wonder and affection that
belongs to them alone. Aquarians occupy their own territory in our hearts because they
are so unmistakably themselves.

Every Aquarius I know shares the quality of being distinct, like a very strong flavor
that once tasted cannot be forgotten. Not that Aquarians are dominant or overbearing;
they are a perplexing combination of breezy, zany and downright stubborn. They are
kind, amenable and impossible to control. Or as my friend Cara says of her February
12-born husband, John, "He's the nicest person in the world, but when he makes up his
mind not to do something, forget it. It will never happen."

Contradictions are the name of the game when it comes to Aquarius. My friend,
Lorraine (February 4) is a perfect example of this: while she is very open, caring and
thoughtful, she is at the same time so adamant about her own ideas and opinions that
it's difficult to reconcile her vulnerability with her toughness, or her eagerness to please
with her built-in inclination to resist. But that, of course, is what makes her such an
interesting and enjoyable companion. She really extends herself to people, and her gen-
erous heart steers her to shower her friends with attention and sympathy. She can't be
manipulated or controlled, though, and when push comes to shove, she is completely her
own person.

Not all Aquarians are the eccentric rebels portrayed in most astrological descriptions
of this sign, though some are. Actually, quite a few are more or less conformist in their
behavior and views. I have known many Aquarians who really tried to fit in and wanted
nothing more than to be part of the crowd. What's painful for these Aquarians is that,
however hard they've tried, they have rarely succeeded in blotting out the aspect of their
natures that makes them that telling little bit different.

My friend Barbara's daughter, Ellen, upon leaving the rural atmosphere of a small Midwestern town for a prestigious college in the Northeast, seemed to crave, above all else, acceptance by her peers; she so strongly wanted to look and act like one of them that her personality appeared to become subsumed. And after college she went on to a very good job in the public sector, where she is well on her way up the ladder to a high level of success.

This is not textbook Aquarian behavior. Where is the revolutionary spirit so associated with this individualistic sign? Where is the refusal to play by the rules? The truth is that despite all of Ellen's attempts to be one of the gang, she still comes across as somehow more distinct and out of the ordinary than those around her. Her strong will is apparent in her behavior, which, while politically correct, is just a little too forceful to insure the kind of acceptance she so clearly longs for. And her differentness also makes her special in positive ways, a person to be reckoned with and taken seriously.

It's interesting to consider that before Uranus—Aquarius' current planetary ruler—was discovered in 1781, the sign of the Waterbearer was purported to be under the influence of Saturn—the most structured and conservative planet of the zodiac. This is quite weird when you think about it, because Saturn is in many ways the opposite of eccentric Uranus, whose action is to break forms and structures and refuse to play by the rules. And maybe this explains why Aquarians have the characteristics of these unlikely planetary bedfellows embedded in their contradictory natures—some being more clearly dominated by traditional Saturn and others by rebellious Uranus, but all subject to a kind of tug-of-war between freedom and responsibility, or between being a joiner or a loner.

Ellen seems to be the more Saturn-dominated type, but please note that, despite her ambition, she has chosen to work in the public sector. Her choice reflects a distinguishing characteristic of one born under her Sun sign—a wish to contribute to the good of society and to place their principles above any thoughts of material gain. Every Aquarian I've known is a humanist in one way or another, and the majority have chosen work that enables them to make a difference.

Are Aquarians a little bit more evolved than everyone else? In certain ways, they really do seem to be like my friend Roberta (January 28)who is both impressively nonjudgmental and kind in the way she reaches out to and tries to help everyone she meets and also someone who never wavers in her efforts to be there when she is needed. She's also active in women's-rights organizations and environmental causes and grows her own organic vegetables.

Her attunement to the welfare of others and the planet itself is such a part of her that she never seems to be trying to be a good person; it's just her nature. It truly does seem as if Aquarians have their far-seeing gaze fixed on the horizon and that they are several

steps ahead of everyone else in deducing the shape of what's to come. And they also seem to do everything in their power to insure a better future. Of the several people I know who've bought hybrid cars, all but one is an Aquarius.

Roberta has one, and so does Peter, a filmmaker who, in true Aquarian style, has throughout his life chosen to devote his talents and energy to a worthy cause: working for the David Lynch Foundation, which teaches transcendental meditation to students and prisoners. Material gain has never been Peter's goal, although he's perfectly capable of commanding a high salary.

In fact, Aquarians are so often spiritual in various ways; it's one of the sign's signature characteristics. But as dedicated as they are to their causes and beliefs, Waterbearers don't tend to proselytize or foist their views on others. One of their best attributes is that they really do treat others with respect. Seeing everyone as an individual and part of the all-inclusive family of man is Aquarius' most brilliant quality. This vision is embedded in their astrological DNA, and it informs everything they do.

There's a flip side to Aquarius' all-embracing view of humanity, though; when it comes to one-on-one interactions, they can sometimes appear oddly detached. Their cool, pulled-back stance can actually come as quite a shock if, for instance, you've observed some admirable and typically socially active Aquarius from afar and then had an opportunity to sit down and converse with him or her. Their heartfelt involvement in worthy causes might lead you to expect them to be both emotionally responsive and self-revealing, but in person, Waterbearers are often quite guarded and appear unnervingly aloof.

One of my long-term clients, Sheila (January 24), is a bit like this: so passionately dedicated to her work for an African-based children's charity that talking about some of her cases can bring tears to her eyes. When it comes to any discussions about her personal life and feelings, though, she can appear weirdly distant, almost as if she's a reporter discussing a scene she witnessed from afar. And the sad truth is that Aquarians are often disastrously inept at negotiating emotional realms and situations that make them feel vulnerable in any way.

Several friends of mine who've married Aquarians have made strikingly similar remarks about their spouses' remoteness and the way they clam up and don't communicate. Aquarius is a genius at seeing matters with clear objectivity, but when they try to maintain their distance in emotionally charged situations, their behavior can come across as simply cold.

Of course, Aquarians really aren't cold at all. Their tendency to intellectualize everything is typical of all those born under air signs (the others are Gemini and Libra), and their hesitation about imposing their unruly emotions on others or exposing what they see as their own weaknesses is all about self-protection. But one of the keys to really

understanding this complex and fascinating sign is that, as strong as Aquarians appear— and they can seem as impenetrable as rocks—they are actually insecure.

I'm sure most of the Aquarians I've known would disagree with this statement. But the truth is that while Aquarians are firmly dedicated to their principles and beliefs and would stick to them even under torture, they aren't comfortable with the whole idea of having an ego. Their sense of self is wrapped up in their causes and ideals, not in their private needs and desires. Their instinct is to disown their egos and stamp them underfoot, which is why so many Aquarians are self-deprecating to an extreme.

From a strictly astrological point of view, the Sun, which among other things represents the sense of self or ego in the scheme of things, occupies a very unfavorable position in the sign of the Waterbearer. It's called being "in detriment"—as far from its home sign, Leo, as it's possible to get. Ego doesn't have a place in Aquarius' world view, and Aquarians aren't self-certain or commanding of attention as is their opposite, the royal sign of Leo.

Instead, they are the self-proclaimed commoners of the zodiac. They are strictly opposed to the idea of pulling rank or ordering other "lesser" beings around. To an Aquarius, no one is more or less deserving than anyone else. All men were created equal. Or to put it in more Aquarian terms, all people were created equal. Gender distinctions are another thing that rile those born under this intriguing sign, as do all depictions that place people in different and therefore possibly unequal categories. Some of the most committed feminists I've known have been Aquarians, and most of the Aquarian men I've known have been more inclined than most to step away from traditional roles and behaviors when it comes to male/female relations.

The kind of insecurity Aquarians experience springs from their ingrained sense that they have no right to put themselves above anyone else. The result is that they tend instead to hang back, avoid the limelight and let others push and claw their way past them. This can make them appear weak and ineffective under some circumstances, but the idea of entitlement is not something they feel comfortable with or can embrace with ease.

I remember how Phoebe (February 18), a childhood friend of mine, returned from a visit to a very wealthy and privileged friend's country home full of horror at having been waited on by the aging staff, who hovered over her and attended to her every need. "I wanted to get up and help them," she told me. "It was so weird to have these people, who seemed so creaky and old, serving me my food and running my bath when I could have done it all so much more easily."

While a Leo might have reveled in the experience of being treated like royalty, Phoebe couldn't stomach it. It went entirely against the grain of her egalitarian nature. Aquarians don't take to the role of being the boss and will almost always go out of their way to let anyone who works for them know that they have no intention of lording it

over them. Instead, their tendency is to treat their supposed "underlings" as though they were on an equal footing with them, and to make it abundantly clear that they don't consider them to be inferior in any way.

My friend Roberta invariably befriends everyone she encounters, and bends over backward to reassure anyone who seems to be on a lower economic strata that she considers them an equal in every way. Aquarians are also drawn to anyone who has, for whatever reason, been marginalized and thrust down in life. I remember how my friend Phoebe was the one person in my third-grade class at elementary school who consistently made an effort to sit next to a mentally disabled girl, whom most other students were inclined to ignore.

She also befriended a little girl who suffered from polio and was always ignored and overlooked by all the others, especially when they adjourned for recess on the playground; Phoebe would patiently stay by her side and talk to her in a way that could never have been construed as patronizing or effortful. This intrinsic kindness is very much a part of Aquarius' nature, and one of this sign's most admirable characteristics.

The rebel factor is another characteristic deeply embedded in Aquarius' nature, though, and if you've ever had a relationship with anyone born under the sign of the Waterbearer, you already know that they can be impossibly difficult if they think that anyone is trying to control them. Aquarius seem to have a built-in need to resist anything and everything that symbolizes outside pressure, and they will often appear to behave in a contrary way just to be contrary, and for no other reason.

A friend of mine who happens to also be an astrologer recently set up the chart of a client who has a double Aquarius daughter (Sun and Moon); this made us both laugh and roll our eyes since, classically, this adolescent girl is impossible to discipline or control. As the mother confided to my friend, "If I tell her to do anything at all, she just seems to go out and do the exact opposite!!" My friend, having been married to an Aquarius herself, advised the mother to stop trying to make her daughter do what she wants her to do (a prescription for disaster in this case) and to have the forbearance and faith to let her find her own way—really, given the nature of Aquarius, the only course to take.

If you don't push the Aquarius into assuming a rebel stance by suggesting anything, you're far better off than if you try to counsel or advise them. One of Aquarius' ways of defining who they are is by asserting that they are *not* the person anyone assumes them to be. And this kind of rebelliousness seems to be built into the Aquarian nature. Waterbearers react against what they interpret as any kind of pressure. They sometimes take this resistance to ridiculous extremes, refusing even simple, good-sense advice, like the suggestion to wear a scarf around your neck on a blustery day—a well-meaning bit of advice my friend Carole proffered to her sixty-year-old husband the other day.

Of course, Carole's used to her mate Arnold (February 7) countering her counsel by brusquely shaking his head or simply ignoring her, but it can be a bit hard to take, given that Arnold has excruciating pain caused by his bad back and absolutely refuses to see a physical therapist, as his doctor advised, or to take any kind of painkiller.

It's not uncommon for Aquarians to choose to suffer rather than to succumb to others' ideas about what's good for them. Asserting their independence is what it's all about, even when their choice doesn't seem to be in their best interests. Their inborn instinct is to stand tall and march to the beat of their own drum. Resisting others' demands and pressures seems to provide them with a feeling of strength and clarity; giving in seems to make them feel weakened or even negated.

I remember one outing I went on with a friend of mine (whom I won't name) and her Aquarian husband (January 29), a normally delightful person, which culminated in my friend and I having to succumb to the Aquarian's choice of restaurant because, against all reason, he found fault with every place we suggested. The power-struggle element was so obvious that it was ridiculous. The Aquarian was not going to be led by his nose by two women; he refused to budge until he prevailed, which meant that we ate in a noisy, crowded place with not the best service or food. And we did not even get the satisfaction of having him admit that his choice was a poor one. He just couldn't bear to go gamely along with others' agendas. It was a matter of principle and possibly of pride.

Which is not to say that Aquarians are pigheaded or domineering (although under some circumstances they can be) but that their need to be true to themselves can sometimes cause them to behave unreasonably. The tendency to rebel is at the same time one of Aquarius' most valuable qualities, separating those born under this complex sign from those who—like sheep—blindly follow the leader. Many brilliantly distinctive individuals have been Waterbearers, and it's been their ability to break free from tradition and dare to follow the path less traveled that has enabled them to make their mark, like evolutionist Charles Darwin (February 12, 1809) who Wikipedia describes as "one of the most influential figures in human history."

Born on the same day and in the same year, Abraham Lincoln (February 12, 1809) was another truly great Aquarian who changed the course of history (a surprising number have) by taking an unpopular stand (as befits an egalitarian Aquarian) against "the monstrous injustice of slavery" (*Peoria Speech*). It was also Lincoln who made the celebrated statement, "You can please some of the people some of the time…but you can't please all of the people all of the time." And Aquarians really do seem less concerned about pleasing anyone than they are in doing what they believe is good and right, like another world-changing Aquarian, Franklin D. Roosevelt (January 30, 1882), whose views and New Deal policies still make him—despite the good he did—one of the most reviled presidents of all time.

What do Virginia Woolf (January 25, 1882), Colette (January 28, 1873), and Gertrude Stein (February 3, 1874) have in common? They were all Aquarian women writers whose refusal to be pigeonholed was one of their most notable characteristics. What's more, their distinctive styles and originality enabled them to carve out their very own niches, which could also be said of various male Aquarian writers: Lewis Carroll (January 27, 1832); James Joyce (February 2, 1882), whose stream-of-consciousness style effectively created a new genre; Norman Mailer (January 31, 1923); Anton Chekhov (January 29, 1860) and the notably humanistic Charles Dickens (February 7, 1917).

Stendhal (January 23, 1783) was also an Aquarius as were W. Somerset Maugham (January 25, 1874), Stephen Crane (February 7, 1917), Jules Verne (February 8, 1928), Rabelais (February 10, 1494) and Boris Pasternak (February 10, 1890)—quite a testament to Aquarian brilliance and wit. It's no coincidence that two of the most vocal and visible feminists of all were Aquarians, Germaine Greer (January 29, 1939) and Betty Friedan (February 4, 1921), or that Oprah Winfrey (January 29, 1954), considered by some to be one of the most influential women of our times, was also born under this extraordinary sign.

In typical Aquarian fashion, Winfrey has had a profound and revolutionary effect on the tabloid talk-show genre, fearlessly foraying into new territory and daring to be true to herself in everything she's taken on. Bold and outspoken Ellen DeGeneres (January 26, 1958) is also an Aquarius, as is the controversial Jerry Springer (February 13, 1944).

Following their own stars, Aquarians invent their own style, which makes them stand out from all the rest; consider the unforgettable Anna Pavlova (January 31, 1882), Franz Schubert (January 31, 1797), Plácido Domingo (January 21, 1941) and Marian Anderson (February 17, 1902), not to mention Andrès Segovia (February 18, 1894). Sports figures born under the sign of the Waterbearer also seem to possess larger-than-life personalities, or a special kind of charisma that turns their names into household words: Babe Ruth (February 6, 1895), Jackie Robinson (January 31, 1919), Mark Spitz (February 10, 1950) and Michael Jordan (February 17, 1963).

The quirky style that so many Aquarians perfect seems to stamp them with the kind of charm that surrounds them like an aura like Tallulah Bankhead (January 31, 1903), Carol Channing (January 31, 1921), Zsa Zsa Gabor (February 6, 1915) and Gypsy Rose Lee (February 9, 1914), as well as Dick Martin (January 30 1922,) John Belushi (January 23, 1949), Jack Lemmon (February 8, 1925), Paul Newman (January 26, 1925) and Alan Alda (January 28, 1936). Typically both rebellious and humanitarian, Newman was also a philanthropist of note, as is Alda, who has also been highly vocal about women's rights.

Aquarians are also often multitalented—true renaissance types whose abilities enable them to straddle different disciplines as did John Ruskin (February 8, 1819) simultaneously a writer, an artist, a prominent social thinker and a philanthropist. A more modern

example might be Geena Davis (January 21, 1956), whose Wikipedia description reads, "American actress, film producer, former fashion model and a women's Olympic archery team semi-finalist."

Aquarians hate to be classified or put into categories, and whatever they undertake, you can always count on them to do it in their own inimitable way, to think out of the box and invent new forms, so that descriptions of them can cover an immense amount of ground. It's also quite striking how often "humanitarian" and/or "activist" is an intrinsic part of the description as with Mia Farrow (February 9, 1945), "American Actress, humanitarian and former fashion model," and Yoko Ono (February 18, 1933), "Japanese artist…Wife of John Lennon…peace activist".

And what other sign could the eccentric and brilliant Lord Byron (January 22, 1788) have been than an Aquarius? What it comes down to, and when all is said and done, the most defining characteristic of the Waterbearer is that he or she is, like all of those mentioned above, "One of a kind."

THE CARE AND FEEDING OF AN AQUARIUS

What your Aquarius wants and needs from you most of all, whether he or she is your partner, best mate, child or daughter, is that you treat him or her like a true friend. Of all the signs of the zodiac, Aquarians value friendship most of all, probably because this is the only type of relationship that's more or less exempt from role-playing or definition. Friendship is free-form; it's dictated by the heart. And interestingly, of the twelve houses of the zodiac, all of which are "ruled" by or consigned to one of the birth signs, the eleventh house, Aquarius' house, is often called the "house of friends."

What makes friendship so important to Aquarians is that, unlike many other ties, it's so completely based on choice. Friends come together because they want to; they also respect each other's autonomy. And this is what Aquarians are looking for in all their relationships: the freedom to be who they are and to be with whom they choose. Friendship doesn't impose restrictions—which Aquarians hate. It's about enjoying someone's company, appreciating them for who they are and opting to have them in your life for those reasons alone.

If your Aquarian feels that you truly see him or her as a friend and not as the designated partner, child or sibling, your Waterbearer will open up to you in wonderful ways. And when your Aquarius treats you as a friend, you'll feel valued and respected in the best possible way. That friendship is the highest form of love is something Aquarians

believe wholeheartedly. And they live it, too, which can make having them in your life a genuine blessing.

Granting them the right to be and do what they choose is the golden rule as far as Aquarians are concerned. The minute you try to impose on them by telling them what to do or how to do it, you begin to drive them away. A Waterbearer might not react immediately, but you will sense a subtle shift in the energy between you. And, above all, you must always try to treat him or her as an equal. Admittedly, this is difficult to do if your Aquarius is a child. But even if you're thrust into an authoritative role, your ability to respect your child's individuality will make a huge difference in the quality of your connection.

What you most need to understand is how invaded and diminished your Aquarius feels when someone tries to impose their will on him or her. The key to understanding Aquarians is that they actually don't possess the degree of self-certainty that they project. Still, they really do have very strong characters, and they will defend their independence with enormous ferocity.

Or look at it this way: Aquarians may act very sure of themselves because, at times, they actually aren't. It's all part of their contradictory natures. Not dissimilar to Descartes' declaration "I think therefore I am," Aquarius' behavior says, "I'm not what anyone else tells me to be, therefore I am." Your Waterbearer is bound to resist your efforts to tell him or her what to do, or even to proffer advice, so your best strategy for coping with someone born under this wonderful and exasperating sign is to just not go there.

It may require enormous self-control on your part to not, for instance, suggest that your Aquarius put on some snow boots before going out on a blizzardy day, but since you run the risk that he or she will therefore sail out the door wearing sneakers, it's better to say nothing at all. It's essential to let Aquarians decide for themselves. This is the motto that should be emblazoned in any manual about dealing with an Aquarius. And it's not as easy as it sounds. You have to be prepared to hold your tongue when your Aquarius returns from tramping around in the snow storm with wet, freezing feet and not succumb to the urge to triumphantly declare, "I told you so!"

Just remember that it's all about respect. Aquarians are touchy in a singular way. They can be completely humble about most everything, and endearingly gentle, but they possess a prickly kind of pride that is part and parcel of their contradictory natures. In fact, the best way to get an Aquarius to do something can be to suggest the opposite. The odd tendency to react against rather than go along may seem perverse, but it's the Waterbearer's modus operandi. And it's often when Aquarians feel most vulnerable that they become more resistant to help. Aquarians can't stand to be babied. Those born under this willful sign find it unbearable to be treated as someone who can't fend for him- or herself.

Try to cultivate your faith in your Aquarian's good sense instead, and act as if you harbor no doubts that he or she will do what's right under all circumstances. This can be a stretch, especially if you do feel qualms about your Waterbearer's judgment, but the way in which you step back and project an attitude of respect and faith can have an astonishing effect on him or her. A truly laissez-faire attitude on someone else's part frees Aquarians up to make choices based on what they feel is right, rather than trying to resist what others seem to be foisting on them. And while sometimes eccentric, Aquarians can also be quite sensible.

Clear-headed and objective in a way that escapes most people, Aquarians really do possess brilliant minds. Waterbearers have the ability to see the big picture, and you can count on your Aquarius to broaden your own views and open your mind to intriguing ideas and angles. You can also count on your Aquarius to be cool, calm and collected in times of crisis.

Aquarius is the most intellectual and abstract sign of the zodiac, and because Waterbearers dwell in the world of thought, they tend to appear detached. If, at times, your Aquarius seems a bit distant and remote, this is due to his or her inclination to always think things through rather than to react emotionally. But the truth is that your Aquarius may actually be a very emotional person, even though he or she isn't likely to succumb to intense feelings in a showy fashion. As with all the air signs (Gemini and Libra being the others), it's hard not to get the mistaken impression that your Aquarius' controlled way of expressing his or her emotions means that those feelings aren't actually strong and gripping.

The trouble is, the last thing your Aquarius is likely to do is to admit this. Waterbearers tend to resist being overwhelmed by emotion, in the same way that they resist anyone outside of them trying to coerce or control them. They can, at times, be amazingly articulate about what they feel, but they still aren't likely to actually show it by publicly bursting into tears or engaging in other displays. And it's all too easy to misinterpret your Aquarian's detachment as coldness or lack of caring, a common mistake many make about people born under this sign.

Having a great relationship with an Aquarius means being able to refrain from personalizing their behavior when it's really not about you. When your Waterbearer rebels against something you're trying to get him or her to do, or turns a bit distant and remote, all you need to do is to step back and give him or her space and any problems or issues will swiftly resolve.

For the most part, Aquarians are affable, fun-loving and highly companionable. And no one can be kinder or more responsive when misfortune visits or genuine need arrives. You'll never own your Aquarius or be able to control him or her, but that's doubtless one of the reasons you love and respect this quirky and unique person as much as you do.

AQUARIUS IN LOVE

Aquarians aren't known to be hotly passionate or wildly emotional, so when it comes to romantic love, they aren't likely to behave like passionate lovers. Analytical and intellectual by nature, Waterbearers will even try to elude the dizzying feeling of falling in love as long as possible. And once they are head over heels, they still aren't prone to dramatic displays. All of which is not to say that those born under this complex sign don't love deeply and well.

The Aquarian ideal will always be based on the premise that friendship is the most important element in a close connection. Aquarians must really like and respect someone to tumble hard enough to fall in love, and respect and admiration will always continue to be a vital factor in their ongoing relationships. What an Aquarian is looking for above all else is a true equal. And companionship is also what Aquarians crave.

To be with a partner who's capable of meeting them halfway is the Aquarius' dream—not that passion and sex don't play a role in their attractions. But when it comes to giving their hearts and making commitments, Aquarians are idealistic, and very discriminating. Commitment is probably more difficult for Aquarian men than women, although anyone born under this freedom-loving sign is prone to experience doubts at the thought of being tied for life to another person.

Aquarians will sometimes resist marriage on the grounds that relationships should be based on choice rather that regulated by law. Or they will categorically balk at the idea of being dragged to the alter. At the same time, though, Waterbearers tend to be very committed partners, and loyal to a high degree. Aquarius is a strongly principled sign. As partners those born under this Uranus-ruled sign can be very tolerant and open-minded too, encouraging their mates to be and to do everything they dream about.

And this is the essence of real love as far as Aquarius is concerned: to support and encourage the beloved to be the individual he or she truly is.

Aquarius and **ARIES** are both highly independent and headstrong signs, so when they come together it's likely to be more in the manner of a collision than a pleasurable merger. As much as Aquarius may admire Aries' bold manner and daring approach to life, Rams are usually too aggressive to match up with Aquarius in a way that creates a sense of connection. What Aquarius does appreciate about Aries, though, is that those born under this strong-minded sign are not inclined to be needy or dependent. They are, in fact, capable of meeting the Aquarius halfway and as an equal, and this can set the stage for a particularly positive exchange between these two, if they get together in the first place. If the Aries tries to run the show, though, which is bound to happen at some point, most Waterbearers will rebel and dig their heels in in a manner that

makes negotiation impossible. And the passions that flare up between these two are likely to be anger-tinged, rather than erotic. The brief and volatile romance between Jennifer Aniston (Aquarius) and Vince Vaughn (Aries) typifies this bond.

When it comes to friendship, Aquarius and Aries are prone to admire each other and may form a mutually enjoyable bond. Aquarius is impressed by Aries' daring and independence and particularly enjoys sharing adventures with those born under this energetic, bold sign. What can create distance between these two, though, is that Aquarius sometimes finds Aries to be too competitive, or mistakenly interprets Aries' need to outdo others as a put-down or insult. Aquarians also aren't likely to feel a strong emotional connection with Aries, since those born under this Mars-ruled sign are singularly self-contained.

Aquarius parents with an Aries child are bound to find their little Ram both delightfully self-certain and entertainingly lively. The Aries child's independence will also please the Aquarius parent, who will feel confident that this little person will thrive, but battles between these two are bound to arise when their strong wills clash.

Aquarius and **TAURUS** are not considered astrologically compatible, because these two signs are ninety degrees apart and form a conflictual square. But a kind of warmth and sympathy can spring up between these signs that makes them more harmonious than might be expected. Aquarius is drawn by Taurus' gentle strength and also by Taurus' unthreatening brand of emotionality. Ruled by Venus, the most related and caring planet of the zodiac, Taureans' efforts to please as well as their ability to express their feelings draw Aquarius out and encourage this sometimes defensive sign to drop his or her guard. What can be tricky for the Aquarian, though, is Taurus' innate possessiveness, since Waterbearers are the most free-spirited sign of the zodiac. This unfortunately can cause rifts between the two, as can both signs' innate stubbornness. Ryan O'Neal (Taurus) and Farrah Fawcett (Aquarius) were an example of this pairing.

Aquarians find Taureans innately likable and easy to get along with, which can create the basis for a pleasant association. Aquarius also appreciates Taurus' reliability and feels secure with those born under this solid sign. On the other hand, the Bull's tendency to move slowly and purposefully along can, at times, rub Aquarius, who is much more fleet of foot, completely the wrong way. If these two attempt to undertake anything as a team or go on outings together, their different ways of going can create an uncomfortable push and pull that may lead to misunderstandings.

Aquarians who have a Taurean child will tend to form a strong and loving bond with their little Bull. As different as their Taurus may be from them, they will identify with and understand this child's strong will and solid depth. What they will need to guard against, though, is a feeling of impatience with their little Taurus' slowness of pace.

On paper, Aquarius and **GEMINI** make a brilliant match, and Aquarius does tend to immediately like and admire those born under the sign of the Twins. Aquarius finds Gemini playful and entertaining, and a wonderful feeling of companionship can crop up between these two that is also brilliantly enduring. Aquarius also appreciates Gemini's fluidity and spontaneity and senses that those born under this Mercury-ruled sign are similar in some basic and reassuring way. On an emotional level, though, Aquarius doesn't always find it easy to open up and reveal him- or herself to one born under this airy sign, and this is when their similarities can work against them. Gemini's apparent detachment, like Aquarius', can strike the Aquarius as uncaring (which it actually isn't) and lead to rifts and misunderstandings. Dixie Carter (Gemini) and Hal Holbrook (Aquarius) are a happy example of this combination.

As friends, Aquarians and Geminis are naturals and tend to like and enjoy each other in equal measure. Aquarians feel buoyed up by Gemini's lively and communicative presence and will seek Geminis out for companionship. What can make this connection difficult to sustain, though, is Geminis' tendency to be so much on the go that they appear to make themselves unavailable to the Aquarius. This can cause the Aquarius to feel rejected and hurt and to respond by stepping back rather than continuing to reach out.

A Gemini child will be a delight to Aquarian parents, who will genuinely enjoy their little Twin's company. This child's wit and adaptability will strike just the right note with the Aquarian parent, and a particularly resilient and comfortable bond will often crop up between these two that lasts throughout their lifetimes.

Of all the signs of the zodiac, **CANCER** is the most difficult for Aquarius to understand, because these two signs are so entirely different. And this difference can draw Aquarius to this moody, Moon-ruled sign like a moth to a flame. Emotional and subjective, Cancer intrigues and stirs Aquarius, who is, conversely, so intellectual and objective that those born under this airy sign feel uncomfortably disconnected and detached. Being with a Cancer forces Aquarius to confront his or her emotions more directly, which can begin as a welcome challenge but may eventually become an irritant that then pushes the Aquarius away. Still, the Aquarius senses that the Cancer is the perfect foil for him- or herself and may feel more fulfilled in the presence of the Cancer than with anyone else. This is not an easy bond at times, but it can be a particularly enduring one, as in the case of Ronald Reagan (Aquarius) and Nancy Reagan (Cancer).

As friends, Aquarians and Cancers tend to experience a kind of unevenness in their connection because they are so different. Aquarians sometimes find Cancers difficult to approach, because Crabs are naturally self-protective and not particularly forthcoming. If a friendship springs up between these two, it's likely to have an effortful quality rather than happening in an easy and natural way. These two may also have a difficult time working together, since they often tend to rub each other the wrong way.

Aquarius parents with a Cancer child will be challenged to be sensitive to their little Crab's emotional response to everything he or she encounters. But because Aquarians do appreciate others' differences, the Waterbearer will make an effort to really witness and appreciate this Moon-ruled child who is so unlike him or her that it's bound to be a stretch.

Aquarius and **LEO** are opposites—but, in this case, opposites which clash rather than attract. There may be some initial frisson between the two, but Aquarius is prone to find Leo to be too self-involved to be truly sympathetic, and too caught up in self-serving activities rather than what Aquarius considers to be worthwhile endeavors. What Aquarius may find attractive in Leo, though, is that royal sign's inborn self-confidence, which is something many Aquarians lack. When this happens, the Aquarius is drawn to the Leo in the unconscious hope that some of that self-certainty will rub off, or that by being with the Leo, the Aquarius will be elevated and made to feel more sure and complete. Not that these signs can't enjoy each other's company but because the Sun is at home in Leo and in detriment in Aquarius, there's a kind of inequality between them that isn't easy or comfortable. Peter Bogdanovich (Leo) and Cybil Shepard (Aquarius) were an example of this combination.

As friends, Aquarius and Leo can—at least on the surface—connect in a pleasurable way, but their very different ways of acting in the world can become a source of misunderstanding and conflict. Aquarius can be put off by Leo's assumption of importance and by that fiery sign's need to command attention. Feeling inwardly diminished and critical, the Aquarius can find it difficult to hide his or her feelings of awkwardness and, as a result, the Waterbearer is likely to withdraw and not try to maintain this connection.

With a Leo child, on the other hand, Aquarian parents are generally delighted by their little Lion's clear sense of self-importance and by his or her cheerful spirits and positive attitude. The Aquarians are likely, though, to try to deflect their Leo child's demands for attention by not always responding and by trying to instill humanistic values in this child.

Aquarians and **VIRGOS** generally appreciate each other's cool and analytical approach to life, and while both are likely to take their time, they're capable of forming a particularly resilient and satisfying bond. Aquarians are impressed by Virgo's thoughtful response to what's going on around them and by their willingness to go that extra mile to accomplish what they've set out to do. They're also drawn to Virgo's earthy practicality, which complements their own airy, intuitive qualities. What can be a drawback, though, is Virgo's innate reserve, which Aquarius can wrongly interpret as a lack of feeling. Still, Aquarius is calmed and simultaneously charmed by those born under this Mercury-ruled sign and feels instinctively that the Virgo is capable of meeting him or her halfway. Richard Gere (Virgo) and Carey Lowell (Aquarius) are an example of this pairing.

As friends, Aquarians and Virgos are well matched because in some ways they are quite different, and in others, somehow alike. Aquarius enjoys Virgo's sharp intelligence and ability to step back and observe and also admires Virgo's efficiency and patience. And Aquarians often find that they have a great deal to learn from Virgo's attitudes and approach and feel somehow improved by their connection. Aquarians and Virgo are also highly complementary as associates and work partners.

Aquarian parents will tend to find their Virgo child satisfactory in every way. Little Virgos' precise and clear-minded way of going about whatever they do is likely to impress the Aquarius and to also reassure him or her that this child can handle whatever life brings his or her way.

Because **LIBRA** is a complementary air sign, Aquarius generally finds those born under the sign of the Scales extremely easy to connect to and to get along with. Aquarians admire Libra's ability to sympathize and get along with others, and they're also drawn to Libras because Libras think matters through—as Aquarians do—and enjoy discussing their reactions and thoughts. In fact, Libras can bring out the romantic side of Aquarius' nature more than almost any other sign, and these two really do have the ability to harmonize. What can pose a problem, though, is Libra's need for continual one-on-one connection versus Aquarius' urge for freedom and independence. And this issue can create insurmountable problems unless both partners make an effort to bend. John Lennon (Libra) and Yoko Ono (Aquarius) exemplify this bond.

As friends, Aquarians and Libras tend to both appreciate each other and to enjoy one another's company. Aquarians find Libras thoughtful and sympathetic and appreciate Libras' efforts to please. Because these two signs are so complementary, friendships between the two tend to thrive, although the Aquarians may find that Libra is more partial to one-on-one contact, while the Aquarian is more prone to want to socialize in a group situation.

Aquarian parents will quickly form a warm and comfortable bond with their Libra child and will tend to find him or her easy to get along with and to understand. The Waterbearer will also feel an urge to encourage this eager-to-please child to be more self-sustaining and independent.

Aquarius and **SCORPIO** are not natural allies, and the attractions that crop up between them tend to be volatile and difficult to sustain. Aquarius may admire and be intrigued by Scorpio's intensity and depth of feeling, but simultaneously put off by Scorpio's need to control. And for this reason, relationships between the two are often characterized by sudden comings together and abrupt withdrawals. Aquarius may succumb to a feeling of attraction and excitement only to quickly feel turned off by Scorpio's demands and rules. Aquarius may also admire Scorpio's strength and refusal to conform, which strikes a sympathetic chord and creates a feeling of connection.

The difficulty of sustaining this connection, though, makes this relationship a continual challenge. Tatum O'Neal (Scorpio) and John McEnroe (Aquarius) are an example of this combination.

As friends, Aquarians and Scorpios can click because both tend to be independent types who don't always follow the rules. Aquarius tends to enjoy Scorpio's caustic humor and emotional honesty and to feel buoyed up when in Scorpio's company. What Aquarius is likely to find difficult, though, is Scorpio's tendency to dominate and call the shots, which can—if this happens—create resentment and ill-feeling and drive the Aquarius away.

Aquarians can be particularly good parents for a Scorpio, because they will intuitively respect the little Scorpion's need for privacy and not behave invasively. On the other hand, some power struggles are bound to happen when the Aquarius attempts to discipline or otherwise control this strong-willed child.

SAGITTARIUS' enthusiasm and energy strike a very sympathetic chord with Aquarius. There's a basic compatibility between the two that brings a sense of companionship and affection, and this can sometimes grow into real passion. What delights the Aquarius is the Sagittarius' adventuresome spirit and independence; the Waterbearer doesn't feel any pressure to try to act in a particular way with the Archer, because he or she will tend to give the Aquarius more than enough space. What can turn difficult for the Waterbearer, though, is that he or she may not feel truly emotionally free in this relationship but will be more inclined to hold feelings in and pull back. This can eventually drive a wedge between the two which can prove difficult to address. Still, the companionship the Aquarius experiences with the Archer can go a long way in making this bond work. Brad Pitt (Sagittarius) and Jennifer Aniston (Aquarius) were an example of this pairing.

As friends, Aquarius and Sagittarius click brilliantly, and Aquarius tends to feel stimulated and enlivened when in the Archer's company. The sympathetic vibrations between these two signs' ruling planets, Uranus and Jupiter, can even make this association a somehow lucky one, and it often spurs both on to pursue their most inspiring visions and dreams. What's more, Aquarius finds Sagittarius the perfect playmate, with whom he or she can get out and enjoy life more fully. Bonds between these two may experience gaps, but they will also tend to endure.

An Aquarian parent is likely to find his or her Sagittarius child a source of delight and will be able to guide the little Archer in a positive direction. The Aquarian parent's ability to let this child's adventurous spirit blossom will set the stage for a long-lasting and loving bond.

Aquarius and **CAPRICORN** tend to clash more than they connect, but while these two signs aren't particularly compatible, because they are next to each other on the

zodiacal wheel, they may sometimes share other planetary connections that act magnet-ically. Still, Capricorn's very structured and controlled way of approaching life can rub the Aquarius the wrong way, and so can the Goat's brand of ambition, which is generally fueled by a status-hunger which Aquarius tends to despise. And while the Aquarius may find the Capricorn's disciplined ways and work ethic admirable, these qualities also are likely to stir up a kind of rebelliousness or resistance in the Waterbearer. On the other hand, there are instances when these two feel a mutual respect for each other that makes their connection work. This was not the case with Ernest Borgnine (Aquarius) and Ethel Merman (Capricorn), though, whose thirty-eight-day marriage was a notorious disaster.

Aquarius is capable of enjoying a feeling of friendship with those born under the sign of the Goat, but there will likely be ways in which this connection is difficult for the Waterbearer to sustain. If he or she senses that the Capricorn is trying to ex-ert some kind of control, the Aquarius will quietly draw away, and the Aquarius also is prone to find the Capricorn's values at odds with his or her own. Still, the Aquarius will sometimes be drawn to a Capricorn because of the Goat's down-to-earth honesty and practicality.

An Aquarian parent with a Capricorn child will generally have quite an agreeable and warm connection with this sturdy and self-possessed child. Few conflicts are likely to crop up, and the Waterbearer will tend to be supportive of whatever ambitions their little Goat may foster or at least will have the ability to let this child develop in whatever way he or she chooses.

Aquarians really can and do experience strong attractions to other **AQUARIANS**, and these matches can even work out, although they're rare. Often it's because these two link up through some mutual interest or involvement in a cause that they meet each other to begin with, and their shared commitment and values can be the glue that binds them to each other. Their relationship and lifestyles are almost always noncon-formist, and they grant each other a great deal of freedom and scope, which can—but doesn't always—keep their bond in tact. When two Aquarians link up they are both so independent and freedom loving that they can drift apart without even realizing what is happening. This may be due to the fact that they have difficulty acknowledging how much they need each other. Examples of this pairing are difficult to find, and no well-known couples seem to match this combination.

Friendships between Aquarians can spring up quite spontaneously, because these two instinctively like and respect each other. Like Aquarian couples, what can hold them to-gether are their mutual interests and involvements, and they have the ability to spur each other on and to wonderfully support each other. These two may have difficulty main-taining a close connection, though, because neither is inclined to reach out to the other,

even though they may strongly value the other's friendship and company. Their mutual independence in this case can result in rifts.

An Aquarian can be an ideal parent to another Aquarian because, of course, he or she will so strongly understand and identify with the little Waterbearer's need for freedom and independence. But since expressing emotion isn't always Aquarius' forte, a certain coolness may characterize this connection.

Aquarius and **PISCES** are as different as the elements water (Pisces) and air (Aquarius) can be, but what they do share is that each, in his or her own way, listens to the voice of intuition and travels a distinctive path as a result. Aquarians often find much to admire in Pisces' ideals and empathetic responses to others, and the Fish's sensitive emotionality can powerfully appeal to Aquarius. On the other hand, Aquarius can sometimes find Pisces to be bewilderingly contradictory and difficult to understand. But this, in turn, can trigger a protective or at least a tolerant response in an Aquarian, who is inclined to respect and like anyone who is true to him- or herself and is inspired by his or her principles and visions, as those born under the Fish are inclined to be. Joanne Woodward (Pisces) and Paul Newman (Aquarius) were an example of this bond.

Friendships between Aquarians and Pisces can thrive, although their associations are often sporadic. A certain mutual admiration often exists between these two, and Aquarians enjoy Pisces' insistence on following his or her feelings and expressing them, come what may. Aquarius also finds Pisces to be complementary in a particular way, because those born under the sign of the Fish can offer views and insights that seem to open up new vistas for them.

Aquarian parents with a Pisces child will be sympathetic to this sensitive and curiously psychic child, but may find it difficult to really understand him or her. For the Aquarians, the greatest challenge in this relationship will be tuning in emotionally rather than being too brisk and demanding.

COLORS, GEMSTONES AND FRAGRANCES

The color that accords with Aquarius on the astrological wheel is purple, or in some cases indigo. And Aquarians usually like and are enhanced by this shade, which has a brightening and uplifting effect on their spirits. Aquarians seem to feel empowered to reveal their emotions and be more open in general when they wear purple.

Blue is another color associated with the sign of Aquarius, perhaps because the symbol for Aquarius is the Waterbearer, and water, in reflecting the sky, tends to look blue. Blue is soothing, and Aquarians like it because it allows them to blend in when

they wish to—particularly the lighter shades of blue as well as blue/green, the most common color of the sea. Turquoise is another color often associated with Aquarius, maybe because those born under this sign seem to favor it and wear it more often than other colors.

On the other hand, red is a color Aquarius tends to avoid precisely because it is so showy. Not wanting to draw the wrong kind of attention to themselves is an Aquarian trait, and Waterbearers seem, in their color choices, to stay on the cooler side of the spectrum and to find the louder colors somehow disturbing. All the tones from green to purple seem flattering to Aquarians and to soothe or uplift them; the color silver is also a very positive one for Waterbearers and seems to be somehow in tune with their natures.

The aquamarine is usually said to be the Aquarian birthstone, and this semiprecious gem is also known as the "stone of the sea" in Greek and Roman lore and as the "stone of the seer" in the middle east. The aquamarine is also said to promote psychic abilities, peace, courage and communication and to help in overcoming depression, grief and phobias.

Other stones connected with Aquarius are the moss agate, the garnet, the turquoise and the amethyst. Crystals are particularly beneficial for Waterbearers and they can feel empowered by wearing them or keeping them near.

Silver is a metal often connected with this birth sign, and it does seem that reflective metals, gems and colors are somehow particularly appropriate for Waterbearers. It's interesting to note, too, that although Aquarius is an air sign, it enjoys a connection with water by being known as the Waterbearer and being assigned a birthstone that is closely associated with the sea.

The principle flower assigned to Aquarius is the orchid, perhaps because it is similarly rare and unique. And because Saturn is the ancient ruler of Aquarius, and according to some, the co-ruler, Solomon's seal—which is associated with Saturn—is also accorded to Aquarius. Another rare and special flower, the bird-of-paradise, seems to be associated with Aquarius as well, as does goldenrod.

The reason why the blue cornflower, or bachelor's button, is connected to the sign Aquarius probably has to do with its color, which holds a hint of purple, the color considered Aquarius' own. The flowering plant known as the star of Bethlehem is another flower assigned to Aquarius.

A number of trees have traditionally been considered Aquarius' own, among them the poplar, the tamarind, the cypress and the lime as well as the linden. These are also trees that have been associated with the sign Capricorn, and the reason why Aquarius shares them is that it was originally—before Uranus was discovered—ruled by the same planet, Saturn; historically, no trees other than Saturn's trees were matched with the sign of the Waterbearer.

As far as herbs are concerned, some of them, like hemp, that have been connected with the sign Capricorn have also been assigned to Aquarius. Lavender has also been occasionally claimed by Aquarius, and those born under this often nervy sign can be calmed by its scent and may also be cured of insomnia if they place a sachet of lavender under their pillow. Skullcap is another herb sympathetic to Aquarius, and it is known to support exhausted nerves and to be an effective relaxant. Then there's lobelia, which can be helpful in respiratory complaints and is also a muscle relaxant (this herb can be poisonous, so must be used with care).

Among the fragrances connected to Aquarius, vetiver is said to be particularly cheering to Waterbearers and enhancing of this sign's energy. Patchouli and myrrh are sometimes accorded with Aquarius, but here again, fragrances that contain lavender are more in keeping with this birth sign's nature. Lemony scents and also lime-based perfumes can be quite good on Aquarians, and geranium is another scent that seems especially right for Waterbearers.

Woodsy fragrances based on amber, sandalwood and cedarwood with a touch of patchouli, though, can have a desirably grounding effect on those born under this airy and changeable sign. ♒

I2

Pisces

330°

I am part of all that I have met.

—ALFRED, LORD TENNYSON

W hat is it about all the Pisces I've known that make them so difficult to describe? I find their definitive qualities nearly impossible to pin down. So I asked another astrologer I know what she thought Pisces were like. She paused for a moment and then said, with discernible caution: "Sensitive." And while this is most certainly true, it could also be said most convincingly of Pisces' watery cousins the Cancers, who are notoriously emotional as well as highly reactive.

Interestingly, a hairdresser I recently visited, and who turned out to be a Pisces (March 12) told me the same thing when I asked her what she thought Pisces were like. "Sensitive," was the first word she used to describe herself, and she went on to say that she didn't show it and, in fact, made an effort to keep her sensitivity well hidden. But sensitivity clearly stood out in her mind as her most distinguishing characteristic, and she also revealed that she picks up on people's feelings and thoughts in a way that could easily be described as "paranormal."

I've noticed this about a number of other Pisces I've met and known, too, like Brice (March 2), a French friend of mine who will often turn up at my door just when I need his help with something and who has a disconcerting way of reading my mind when we're having a relatively normal conversation. I wouldn't describe Brice as especially "sensitive," though, at least not in the sense that his feelings appear to be easily hurt (although he may be carefully hiding his reactions). On the other hand, he may well be a "sensitive," which my Webster describes as "a person with psychic powers."

Not all the Pisces I've known are so magically tuned in as Brice seems to be, though, and I've actually known some Pisces who were glaringly clueless about others' feelings and completely misinterpreted them. That in itself, though, is possibly what the sign of Pisces is really like: indecipherable, elusive and highly contradictory. In fact, what all the Pisces I know do share is really that they *are* so difficult to interpret or sum up at all. I find it impossible to predict how Brice will react to possible scenarios or to situations that might come up, and I could say the same for my friends Martine (February 28) and Pamela (February 26).

Pamela, actually, is one of those Pisces women who belies all those textbook descriptions like "dreamy and otherworldly" that are often associated with the sign of the Fish. She is the exact opposite: clear-minded and altogether down to earth. She has brilliant organizational skills and what could only be described as "street smarts," though this could well be an aspect of Pisces' famous psychic radar—an ability to pick up on subliminal messages and act on them without question. She also displays another often-touted Pisces characteristic, empathy, in her ability to feel and identify with others' woes and needs.

I have found that numerous Pisceans are enormously empathic, even to an extent that undermines their own needs, and yet again some seem so entirely self-involved that they appear to harden themselves to others' upsets and misfortunes and just not care. In short, Pisces aren't just difficult to define or describe, they also defy any sort of categorization. Why, after all, would their birth sign be depicted by two fish swimming in opposite directions? What is happening here? Are the fish trying to get away from each other? Are they having a disagreement? Or are they simply unrelated, each focused on his or her intentions?

I think it's worth noting that the symbol for this, the last sign of the zodiac, is so completely ambiguous. Some astrologers define the two fish swimming in opposite directions as indicating that Pisces is torn, like Gemini, in dual directions, but Linda Goodman has another take on this which, I think, is far more apt. She thinks this symbol shows "the choice given to Pisces: to swim to the top or to swim to the bottom."

Being the twelfth—and last—zodiacal sign, the symbol of the two fish is all about the challenge in this last phase of the spinning wheel of life: either make the evolutionary leap onto a higher plane off the wheel or fall back into the primordial muck and begin the whole great cycle again. Pisces has a huge reputation for self-destructiveness and also for an almost angelic kind of selflessness, and like Virgo—the Fish's opposite sign—Pisces are often saints or sinners and can often be both.

At least half the Pisces I've known have struggled with addiction (more about this later), and some have been total hedonists who succumbed to every passing impulse and desire like the brother (March 9) of a friend of mine who continually hooks up with the type of woman who adores and takes care of him (he really is quite cute and charming). He also drinks like a fish (where did that phrase come from?), is the kind of pathological liar who will say anything to get out of a tight spot and is also incapable of holding a job.

This man does have a tender side and is invariably kind to children and animals, but he is an extreme example of the kind of Pisces who drifts aimlessly though life in a kind of self-destructive stupor. At the other end of the spectrum, Daryl (March 2) is a living example of the high-minded and saintly Pisces type: an immensely gentle and self-sacrificing young man who works tirelessly as a missionary, building hospitals in Uganda.

The only way to really understand this bewildering and complex sign is to decipher the complexities of Pisces' ruling planet, Neptune. This is, after all, the planet that rules drugs and dreams—the highest level of consciousness and, at the same time, complete oblivion. What Neptune is all about, in fact, is very difficult to convey, which is probably why Pisces themselves so elude definition.

Pisces are often called escapists, and some really are. But who can blame them, when they bear the mark of a planet that's all about the ideal state of unity achieved by high-level yoga masters and other enlightened beings? What Neptune is about is the complete release from the prison of self that all the spiritual practices strive to achieve—not so much the death of the ego but its merging with the immeasurable and unknowable divine.

Is it any wonder that Pisces are drawn to all kinds of self-obliterating activities that run the gamut from overindulgence in alcohol to the priesthood? Their astrological DNA is coded with Neptune's message: "Get free from your self," and there are many ways and levels on which this can be interpreted, some mystically elevating, others simply aimed at blotting out consciousness.

Pisces also run the gamut from idealists to cynics, but scratch a cynical Pisces' surface and what you'll find is a disillusioned romantic. The idealism that Neptune stands for reaches as high as imagination can carry the human mind: to a level where there is complete harmony, beauty and unity between all. I've met Pisces who simply found the reality of this world so unbearable that they withdrew behind a mask of indifference, but many of the Pisces I've known have had a special light in their eyes, almost a bemused expression as if they're seeing something others simply aren't aware of.

Susie (March 1), a longtime client and friend of mine, has just that kind of sparkle in her eyes. She's spent years living and teaching at Findhorn, a spiritual community and eco-village in Scotland, and has pursued healing and consciousness-raising techniques throughout her life. What Susie sees and knows is just a little off to the side—or out of the box—compared to what the majority of people accept as reality. Stirred and charged with Neptune's visionary powers, Pisces tunes into the vibrations and currents that sweep through the sea of feeling known as the collective consciousness.

Even if they're ambitious, Fish tend to seek success in the arts or helping professions rather than the world of business. When I think of the Pisceans I've known, an unprecedented number seem to have been musicians, and those who haven't been professionals have played an instrument or sung in a group or choir. Maybe this is because music is so very Neptunian, seeming to enter right into us, sweeping through like a sea of vibration and at the same time breaking down boundaries and bringing everyone together.

The Pisces musicians I knew in Greenwich Village where I lived in the mid-Sixties were, in fact, such classic Fish that I still can't think of them without remembering their

birth signs as well. And without naming names, the only one who went on to national success was one who somehow side stepped the pitfalls of drugs and self-destructiveness that the other three succumbed to. All of them loved making music with an abiding passion, though, and all were extraordinarily gifted. And possibly the most talented of them, who didn't hit the jackpot (although he did write a song that became a hit) would periodically become so frustrated with his own performance and his instrument while onstage that he'd smash his guitar and storm off in a rage.

With a voice like molten chocolate, this musician was someone who should have rocketed to fame. But he continually sabotaged himself, as Pisces so often seem to do. Is this because Pisces is somehow a tragic sign? It obviously can be, but it mostly isn't. What's so hard for Pisces, though, is how, time and time again, reality falls short of their dreams.

For some, the gap between reality and fantasy conveys the message that they need to try harder to bring their visions down to earth or live up to them. But many become bitter and disillusioned, like the guitar-smashing guitarist who couldn't bear the frustration of not playing as perfectly as he felt he should, or who found the experience of performing itself to be painfully out of whack with his hopes.

What you always need to remember when dealing with Pisces is this: Fish are filled with dreams and expectations that are beyond the realm of the possible, and they find a continual challenge not to be disappointed with the crushing reality of day-to-day life. Some learn to live in two worlds at once, keeping their inner selves tuned to their visions and negotiating their way through the experience of daily living with careful trepidation. Others struggle with anger and bitterness, keeping these difficult emotions at bay in whatever way they can.

I've known Pisces who have managed to stay attuned to their visions and in many instances to bring them into focus in the world, transmitting light and hope into others' lives. These people stand out like beacons—a brilliant example of what we're capable of if we're truly selfless and aware like Daryl—the missionary—who never seems to think of his own needs, but only those of others. Self-sacrifice really is a theme that runs through this sign's life story more often than not, and I know of more than a few Pisces who have put up with difficult, demanding and needy partners and tried endlessly to help and sustain them at the cost of their own happiness and well-being.

Fortunately, most Fish have a wry, edgy sense of humor, and their ability to flow along through life helps them let go and move on because they're so focused on the present. Pisces is one of the four mutable signs (Gemini, Virgo and Sagittarius are the others) and this modality, as it's called, expresses itself as flexible, changeable and flowing. All the mutable signs tend to live in the now—far more than any of the other zodiacal

signs—and Pisces, being of the element water (since water is all about feelings) is inclined to dwell entirely in the emotional quality of each and every moment.

Neptune—Pisces' planet—rules the sea. And, of course, what else would be fitting for the Fish? Unlike any of the other signs of the zodiac, Pisceans are immersed (the two other water signs are depicted by land or land/sea creatures) in the continually moving and changing waters of the ocean of life. Their tendency to live in the now and let life carry them along gives them a fluidity that can sometimes be quite maddening. Sam (March 6), my friend Heidi's son, invariably arrives at family gatherings several hours later than expected, because he gets caught up in a phone conversation before leaving the house or becomes sidetracked by some intriguing shop or detour along the route.

It's impossible to get mad at him, though, because he's such a nice and generally thoughtful person. Before Neptune was discovered, in 1846, the planet designated as Pisces' ruler was jaunty Jupiter. And Pisces' good nature and native optimism often holds a strongly Jupiterian flavor. The Jupiter element can also spur Pisces to be a bit of a gambler, often banking on impossible odds; or, on a more positive note, it induces those born under this gentle sign to not worry about matters over which they have no control and to hope for the best possible outcome.

Staying in soft focus and not fixating on what's jarring and upsetting is one way Pisces may choose to cope with life, which is one reason Pisces is sometimes described as dreamy or spaced out. I've met Fish who are always talking about the great record deal they're about to sign or the book they're going to write, and before long, it's impossible not to realize that these particular individuals are deluding themselves and drifting along in their own little fantasy world.

All kinds of dangers accompany the mesmerizing and sometimes deceptive influence of Neptune, which is why some Fish have such a penchant for *self*-deception. It's the less evolved types, though, and those who don't have the force of will to assert themselves and become the embodiment of their dreams, who somehow expect that life will deliver what they want on their doorstep.

Romantic love, especially, can be a huge test for those born under this idealistic sign, and many Pisces really do believe and expect that they will find their soul mate and achieve that perfect union that poets and love songs promise. And some undeniably do. This all goes along with that ingrained Neptunian urge to "lose the self," and Pisces truly do seem to be particularly inclined to somehow confuse romantic love with the spiritual quest for completion and union with the Divine.

I find it impressive, though, that certain Pisces I know will persist in seeing their chosen other in a particularly flattering light when to others it's fairly obvious that the person in question is not the amazing creature he or she has been painted to be.

Maybe this is yet another instance of Piscean self-deception, but even if so, it can work to keep their relationships satisfying to them and glowingly alive in a way that helps to keep them afloat.

What isn't so nice to see, though, is the Pisces who falls in love with someone who is actually somewhat despicable and/or unkind to them, because all too often, the Pisces will persist in wishing and hoping that their bond with this individual will have a silver lining or will magically work out, which it clearly never will. Believing in their dreams, though, is what makes those born under the sign of the Fish so singularly magical —or, inversely, tragic.

This double-edged quality of encompassing great joy and dark sorrow can be what makes some Pisces such riveting performers, like Liza Minnelli (March 12, 1946), for instance, who seems to capture rapt attention whether she's singing, acting or simply talking. In fact, her intense—even blatant—emotionality, coupled with her talent, has had such a powerful effect on her admirers that she is one of the best-selling entertainers in television.

She has also, in classic Piscean style, struggled with serious addiction issues, as did another epic Fish, Johnny Cash (February 26, 1932), whose ups and downs and magnetic personality also played a part in his popularity and appeal. It's intriguing, in fact, how many Pisces celebrities' personal lives have been a source of enormous interest, capturing the public imagination, like Elizabeth Taylor, whose many difficult marriages and personal tragedies seemed to endear her to those who were also mesmerized by her beauty and excesses.

Pisces' tendency to succumb to their weaknesses and suffer (for all of us) touches a deep chord in our collective depths. And those Fish who enter the public eye may tend to play out tragedies and dramas that strongly hold our attention. They are also prone to be thrust into the role of scapegoat or victim, like Hearst heiress Patricia Hearst (February 20, 1954), whose abduction by the Symbionese Liberation Army in 1974 ironically turned her into what might be called a "double victim," first of her captors, who imprisoned and tormented her until she joined their ranks in a clear bid for survival, and then by the U.S. government, which captured and imprisoned her for the crimes she committed as a result.

Unbelievably, there are some who still see Hearst as the guilty party for her participation in crime while in captivity, but this kind of cruel misinterpretation and misunderstanding is typical of the situations in which those born under this elusive and singular sign may find themselves. But while Pisces are often described in astrological textbooks as victims and martyrs, the upside of being born under this Neptune-ruled sign is an inborn sensitivity that may express itself in rare and transcendent forms like the artistry of dancer and choreographer Vaslav Nijinsky (March 12, 1889), who was reputed to defy

gravity in his balletic leaps into the air. Another enormously talented dancer, Rudolf Nureyev (March 17, 1938), was also a Pisces; and so was Michelangelo (March 15, 1475), often described as the greatest artist of all time.

The impressionism of Pierre Renoir (February 25, 1841) has a dreamy Neptunian quality, with its boundless forms merging into each other; and the musical compositions of Maurice Ravel (March 7, 1875) hold a similar, soft-around-the edges quality. Pisces' ingrained urge to be released from the confines of form or self can also be discerned in the poetry of Elizabeth Barrett Browning (March 6, 1806): in her celebrated "How Do I Love Thee?" her expression of her emotions enters almost transcendent realms ("I love you to the depth and breadth and height my soul can reach...").

In "Within You Without You," one of his first song-writing efforts, Beatle George Harrison (February 25, 1943) articulated what could be described as the quintessential Neptunian (or Piscean message) in the song's final lines: "The time will come when you'll see we're all one, and life flows on within you and without you." And while many Pisces don't follow mystical paths as Harrison did, this search for a connection to all life is what powers the Fish's emotions. In fact, it does seem that those Pisces who do become spiritually aware feel far more at peace and fulfilled than those who don't.

The brilliant Piscean physicist Albert Einstein (March 14, 1879) eschewed organized religion but embraced, instead, what he termed a "cosmic religion," which reflected his conviction that the existence of the universe was not accidental but created by a divine consciousness. Einstein was also a renowned humanist and peace activist, as was another brilliant Piscean scientist, Linus Pauling (February 28, 1901), who was the only person in history to receive two undivided Nobel Prizes, one for chemistry and one for peace.

While it's particularly difficult to find commonality amongst those born under this difficult-to-define sign, what Piscean singers Nat King Cole (March 17, 1919), Harry Belafonte (March 1, 1927) and James Taylor (March 12, 1948) do share is a similar, low-key, easy and what might be called "impressionistic" singing style that's somehow soothing and evocative at the same time. Taylor, like quite a number of artistic Pisces, waged a long battle against addiction, which he ultimately won, unlike Beat writer Jack Kerouac (March 12, 1922), who sadly died from alcohol-related causes at the age of 47.

Diarist Anaïs Nin (March 14, 1879) was another quintessential Pisces—highly sensitive, creative and unabashedly sensual, and while her writings are replete with what might be called typically Piscean sentiments, this one best sums up some basic truths about this elusive Sun sign: "Reality doesn't impress me. I only believe in intoxication, in ecstasy, and when ordinary life shackles me, I escape one way or another. No more walls." (*Incest: From a Journal of Love*).

THE CARE AND FEEDING OF A PISCES

The truth is that your Pisces isn't always easy to understand even if you know him or her very well. Pisces are mutable and changeable, and their responses differ from day to day and even from minute to minute. So your biggest challenge in your connection to your Fish is to be as flexible as he or she is, or at least to try to refrain from imposing rigid expectations. If you do, you're bound to be either disappointed, nonplussed or bewildered.

Try to understand that your Pisces is highly reactive to the minute changes in the emotional atmosphere he or she inhabits at any given time. The Fish's apparent changeability is a direct result of this. It's not a deliberate ploy to confuse you, nor is it an indication that he or she isn't sincere. If your Fish promises something one moment and then changes the script later, it's because your Pisces' sensitive antennae have tuned into something that has shifted his or her focus in a new direction. And often, your Pisces will pick up on undercurrents you're entirely unaware of.

In short, your Pisces—whether he or she acknowledges it or even knows it—is a bit psychic. This is simply an aspect of being born under this watery, Neptune-ruled sign. Your Pisces' emotions flow along with the universal sea of emotions that we define as "the collective." This can make your Pisces a wonderful survivor, because he or she intuitively knows when to go forward and when to step aside or move in a different direction, without actually being aware of why these actions seem desirable or correct.

Your Pisces also picks up on your inner state. Whatever's going on beneath the face you wear in public, your Fish will be responding to your hidden emotions, and even to feelings that you yourself don't express or even know about. If this sounds mysterious, it is. Pisces themselves don't know what they're responding to in many situations, but their sensitivity to unseen forces is a constant for them. It's important that you accept and understand that your Pisces is tuned in to channels that you don't necessarily pick up on, so that when his or her behavior doesn't quite add up, you can make an effort to understand, or better still, tune in more clearly yourself.

Probably one reason you were drawn to your Pisces in the first place, and why you treasure this interesting and sometimes enigmatic person as you do, is that he or she has a way of being totally present, embracing the moment without any hesitation or question. This quality of being in the now makes your Pisces spontaneous, open and responsive. It enhances your connection and facilitates communication, and it also makes you feel validated and witnessed in a special way.

The flip side of this, though, is that your Fish can become so caught up in what he or she is doing at the moment that everything else (at least *momentarily*) loses importance. This is why your Pisces might, for instance, call to tell you that he or she will be arriving in ten minutes and instead, turn up forty minutes later, breathless and full of apologies.

It's also why your Pisces might make a plan to go to town to shop and will instead turn up at an art museum that he or she passed on the way and that happened to be having an intriguing exhibit. Always try to remember that your Pisces' priorities are flexible, because something might come up that proves to be grippingly important precisely because it's occurring at the same moment that your Pisces happens to be there.

What your Pisces has to teach you is to go with the flow. Don't discount the value of this: so many of us are rigid and set in our ways. Or we're so caught up in our agendas that we don't appreciate what's happening right now. Your Fish brings you (sometimes kicking and screaming) into the moment. He or she encourages you to let go and just be. You didn't notice that the sun had come out and all the clouds had been chased out of the sky, but he or she did and is outside, glorying in the beauties of the day. Take a deep breath and enjoy being with your spontaneous, tuned-in Pisces. It's an exercise in being fully present and fully alive.

If you're the parent of a Pisces (or even a partner), though, you may come to believe that it's your job to teach this apparently distractible person to focus on outcomes or specific goals rather than seeming to lose the plot. What most astrologers are likely to say about such a plan, though, can be summed up in two little words: "Good luck!" Fish live in a different element than the rest of us. In fact, they are the only sign in the zodiac that is depicted by a creature that doesn't live—at least part of the time—on the land.

Pisces go with the flow because that is their nature. It feels right to them. Trying to get a Fish to behave otherwise is like taking a fish out of the water and expecting it to survive on solid ground. Your Pisces' fluidity is an asset to him or her, and it's also an essential ingredient of the Fish's character. Pisces' agreeable and easy-to-get-along-with nature is a direct result of his or her tendency to negotiate around obstacles in a graceful and flowing manner. It goes against the Fish's grain to be combative and aggressive.

When he or she does go off the deep end in this way, you will know something is very wrong. Pisces' innate urge is to feel a part of (you, situations, etc.), rather than separate and disconnected. It's only when Pisceans have diverged from their true nature that they become completely overcome by anger. It's not likely to last long, though, and so quickly that it will be impossible to clock, your Pisces will be agreeable and charming again as if nothing happened.

Remember that as sensitive—or even hypersensitive—as your Pisces is, those born under this birth sign are not as fragile as they appear. They may become overwhelmed by their emotions and reactions, but their ability to adapt and adjust is nothing short of phenomenal. Don't underestimate your Pisces' strength or be tempted to cushion or coddle him or her against the world's cruelty. Pisces take their cues from their environments and those around them, and if you see them in a positive light and expect them to rise to the occasion, they'll tend to adapt to this version of themselves and come through with flying colors.

On the other hand, if you're fearful that they will fail and anxious about their reactions, they will tend to pick up on these negative feelings and thoughts and be strongly effected by them. Not that they can't counteract them, but your worries will be more destructive to them than you might realize or understand. What can be difficult to reconcile is Pisces' malleability and their core strength. This is one aspect of Pisces' nature that makes them so difficult to figure out and understand. And too many people do tend to underestimate Pisces' basic resilience and ability to triumph over the odds.

It's important to realize, too, that while self-pity is a destructive emotion for all of us, for Pisces it can be particularly lethal. This is part and parcel of being born under the twelfth sign of the zodiac, which is also known as the sign of the victim...or martyr. Quite a few Pisces really do sacrifice themselves for others with an almost angelic willingness to help and support those weaker or in need. But when a Pisces falls into the trap of seeing his- or herself as played upon or abused, he or she can get stuck in this role in a dangerous way and sink into what could only be described as a "slough of despond."

Your challenge is to be sympathetic but to find a way to help your Fish gain his or her perspective. Self-pity can be like a drug for certain Pisces, draining their strength and obscuring their vision. But generally, Pisces bounce back from spills and upsets swiftly and get back into the swim of things with admirable ease.

The wonderful upside of being close to a Pisces is that he or she is so responsive to what you feel, and so full of perceptions that you're always learning something or having your eyes opened in new ways. What it comes down to is that no other sign is as clued into what is going on and what really matters as the Neptune-ruled sign of the Fish.

PISCES IN LOVE

It's no coincidence that Venus—the planet of romantic love—is what's known in astrological text books as in "exaltation" in the sign of Pisces. Venus can express itself perfectly in this birth sign because emotions can vault to the highest realms without any censure. Pisces aren't afraid to love, and they will take a chance on it without fear or misgivings, even if they've suffered from a broken heart in the past. This is because Pisces believe in their dreams with an utter conviction that many other astrological signs seem incapable of sustaining.

In fact, no matter how many times they may have failed, Pisceans will keep on believing that true love will come their way, even while they hide behind a façade of cynicism. And when they are in a relationship, most Pisces do their utmost to make it work,

even if they run into difficulties and obstructions. To them, their dream of love keeps shining on, like a star they are bound to follow, come what may. No sign is really more romantic that Neptune-ruled Pisces.

Pisces is also a highly sensual sign and will not hold back when in love on any level. What Pisces seeks in life—to feel a part of, rather than separate—is what romantic love so abundantly offers: the chance to feel at one with another. Pisces are in their element when in love, and they don't try to fight or disown their overpowering emotions. It could accurately be said that Pisces are "born to love," because being in a state of transcendent bliss is the ideal state that those born under this sign seek.

Pisces and **ARIES** are so different that they may—under certain circumstances—complement each other. Soft around the edges Pisces, though, may find aggressive Aries a bit abrasive initially. On the other hand, Aries' direct approach may cut through Pisces' reserve in a way that ignites sparks. Because these signs are next to each other on the zodiacal wheel, there are often powerful connections involving their Venuses or Mars that can be intensely exciting and erotic as well. What can go wrong between the two, though, is the way their styles tend to clash. Pisces can be put off and thrown into a defensive state by Aries' no-holds-barred comments, and when wounded, Pisces tends to withdraw, which can end up driving these two apart. Pisces also may perceive of Aries as being too caught up in his or her own affairs to be the dream partner the Fish longs for. The long-lasting marriage of Sarah Michelle Gellar (Aries) and Freddie Prinze (Pisces) is an example of this bond at its best.

As friends, Pisces and Aries are likely to struggle with their differences. Pisces' sensitivity makes those born under the sign of the Fish all too prone to be hurt by Aries' unintentionally sharp remarks although Pisces will find Aries' energetic approach to life inspiring and often motivating. If these two do form a strong connection, though, it will tend to be enduring. Pisces can often discern the almost childlike innocence inherent in Aries' nature, and this will endear the Ram to the Pisces, who will respond by being protective and sympathetic.

Pisces parents with an Aries child will be extremely nurturing to their little Ram and will be supportive in every possible way. Because Aries is such a strong and decisive sign, Pisces may also come to rely upon their little Ram's help and advice.

TAURUS is a sign that is generally quite complementary to Pisces. The Fish feels easy and comfortable in the company of those born under this gentle, Venus-ruled sign and feels inclined to open up and let down barriers. Romantic sparks may fly between the two, but Pisces may be reluctant to make the first move or to expose him- or herself prematurely, which may lead to come confusion since Taurus, not a particularly aggressive sign, may tend to hold back as well. Pisces will be quite drawn, though, by Taurus' sensuality and warmth, and once the initial getting-together barriers are overcome,

Pisces will feel strengthened and supported by Taurus' down-to-earth energy in a way that leads to lasting closeness and connection. Pisces will also sense that Taurus balances him or her in a way that is essential and also reassuring. Cindy Crawford (Pisces) and Rande Gerber (Taurus) are a happy example of this combination.

As friends, Pisces and Taurus will tend to form a particularly solid bond. Pisces appreciates Taurus' steadiness and feels grounded in his or her company. Mutual interests, especially an attraction to music and the arts, can also draw these two together. Pisces sees Taurus as a positive influence on his or her life and will seek those born under this Venus-ruled sign out and endeavor to spend as much time as possible in their company.

Piscean parents will have no trouble appreciating their Taurean child's gentle and sometimes slow-moving ways and will tend to feel very protective of their little Bull. Few conflicts are likely to arise between these two, and they will tend to form an extremely durable bond.

What Pisces and **GEMINI** have in common is a kind of fluidity and love of change that can appear to make them compatible. Pisces does admire Gemini's quick wit and can be fascinated by Geminis' ability to charm others and thrive in whatever situation they find themselves in. On the other hand, Pisces can become critical of Gemini's tendency to rush around and spread him- or herself a bit thin, and put off by Gemini's sometimes distracted manner. Pisces may also interpret Gemini's airy intellectuality as a sign of coldness and lack of feeling. The difficulty for Pisces is that while Gemini initially appears to be something of a soul mate, the differences between these two are actually greater than their similarities. Donald Trump (Gemini) and Ivana Trump (Pisces) were an example of this challenging combination.

Pisces' conflicting feelings about Gemini can make it difficult for the Fish to maintain a strong connection with those born under the sign of the Twins. On one hand, Pisces enjoys Gemini's playfulness and sense of humor. On the other, Fish often feel slighted and put off by Geminis' tendency to not pay attention because they are so caught up in various activities and plans that they don't appear to care. At best, these friendships tend to be on-and-off relationships that lack depth.

Pisces parents will dote on their witty, active Gemini child and will generally feel quite proud of their little Twin's versatility and charm. At times, though, the Pisces parent will feel a bit distanced by the Gemini child, who isn't inclined to display his or her emotions as openly as the Fish.

Watery, emotional **CANCER** is a sign that Pisces feels a powerful connection with, and when these two do click, they tend to form a lasting bond. Pisces identifies with Cancer's obvious sensitivity and often responds in a protective manner. On the other hand, emotions between these two can become a bit murky and difficult, because Pisces' tendency to absorb and pick up others' feelings can drag the Fish into the Cancer's dark

moods. What's tricky for the Pisces is remaining centered and optimistic with one born under the sign of the Crab rather than getting too caught up in his or her dramas. Pisces' gentle manner is soothing to the Crab, and Pisces senses that he or she can have a healing affect—which appeals to the Fish's ingrained altruism. The bond between these two can be extremely durable, even if it appears to flounder on the surface. The long-lasting relationship of June Carter (Cancer) and Johnny Cash (Pisces) is a perfect illustration of this pairing.

As friends, Pisces and Cancers are usually appreciative of each other and mutually supportive. Pisces senses the vulnerability beneath Cancer's often crusty façade and is drawn by this sign's emotionality, which the Fish identifies as similar and safe. Cancer's moodiness can get on Pisces nerves, though, and if Pisces may also tend to interpret Cancer's behavior as selfish, which can create difficult-to-repair rifts.

Pisces parents with a Cancer child will be very tuned in to their little Crab's needs and feelings and will be loving and protective in a way that is deeply reassuring to this child. As the Cancer matures, a strong but volatile bond will develop, full of emotional ups and downs.

The attraction between Pisces and **LEO** lies in their mutual playfulness, although Pisces can easily feel overwhelmed by Leo's strong and attention-seeking presence. Pisces is drawn to the childlike side of Leo's nature and by Leo's *joie de vivre*. Tuning into the vulnerability that lies behind Leo's assured façade, Pisces can form a strong bond with those born under this Sun-ruled sign. The danger, though, is that it may become too one-sided, with Pisces supplying the support and adulation that Leo seeks but not receiving the same in kind. Leo's need to rule the roost can relegate Pisces to a subservient position and, in the end, leave the Fish feeling alone and misunderstood. This relationship can work under some circumstances, but it's not as naturally balanced and reciprocal as it should be. Lucille Ball (Leo) and Desi Arnaz (Pisces), whose twenty-year marriage ended in divorce, are an example of this combination.

As friends, Pisces and Leo may enjoy each other, but Pisces is likely to find the Lion too dominant or self-involved to be truly sympathetic. If the Pisces is helping the Leo in some way, though, the Pisces will feel needed and valued, which can be very satisfying to the Fish. Pisces often admire Leo's apparent self-confidence from a distance without feeling comfortable enough to draw close and form a bond. Work, though, can draw these two together, as can their senses of humor which can enable them to enjoy their connection most fully.

Pisces parents with a Leo child will be loving and supportive and will generally feel obligated to give their royal Lion as much attention as he or she demands. The Leo child can become very dominating of the Pisces parent, which can lead to issues that are difficult to resolve.

Pisces and **VIRGO** are opposites, and while this may lead to a spark of attraction between the two, it can also result in antagonism. Pisces tends to find Virgo admirable, but also a bit too critical and sharp to be an agreeable companion. What's tricky about this combination is that while Virgo is extremely precise and careful, Pisces tends to be vague—or, more accurately, not as focused on the physical aspects of situations as on the emotions in the air. Pisces quickly senses that Virgo isn't on the same wavelength, and also that he or she is not truly sympathetic to the Fish's way of going and doing. If these two do get together, the Pisces will always be in the position of trying to some-how change or adjust him- or herself to please the Virgo. Cindy Crawford (Pisces) and Richard Gere (Virgo) are an example of this tricky combination.

Friendships between Pisces and Virgos aren't particularly common, but when Pisces feels comfortable enough with a Virgo to reach out and communicate, the two can enjoy each other's company and form a complementary bond. The problem is that Pisces of-ten senses that Virgo isn't similar enough or understanding enough of Pisces' feelings to open up and make an effort in the first place. Pisces' sensitivity tends to cause Fish to be a bit wary of those born under this down-to-earth and critical sign.

A Pisces with a Virgo child, though, will initially be gentle, kind and supportive in a way that is very nurturing. As this child matures, though, the Pisces—aware that the Virgo is practical and efficient—may tend to place too much responsibility on the little Virgo's shoulders.

LIBRAS and Pisces tend to quickly form a sympathetic bond, and Pisces feels at home with Libra's generally open and warm demeanor. Powerful attractions can flare up between these two, and they can lead to relationships that are affectionate and satisfying. These relationships don't necessarily last, though, and this is often due more to Libra's tendency to create distance than to Pisces' dissatisfaction with this connection. As a water sign, Pisces functions on an emotional wavelength whereas Libra, being an air sign, is far more abstract and intellectual. As time passes, the Pisces will sense that the Libra isn't present in quite the way he or she had imagined or hoped, and this can lead to disillu-sionment and estrangement, although on the surface these two will both always tend to treat one another considerately and kindly. Christopher Reeve (Libra) and Dana Reeve (Pisces) were an example of this pairing.

As friends, Pisces and Libras can click quite strongly. Pisces does find Libra to be sympathetic and easy to be with, and Fish also identify with Libra's need for connection and closeness, which matches their own. Disagreements can crop up between these two, though, because, while similar in some ways, they are actually quite different. Pisces' basi-cally emotional approach to life can clash with Libra's cooler and, in a sense, drier way of seeing the world, so that Pisces ends up feeling unappreciated and misunderstood.

Pisces parents will have no difficulty forming a close and loving bond with their Libra child. Quite a warm and enjoyable relationship will tend to crop up between them, and as the Libra matures, they will also tend to become fast friends and to seek each other's company.

Pisces and **SCORPIOS** often get along famously. Pisces instinctively understands and picks up on Scorpio's emotional intensity and depth, and very passionate attractions can happen between these two. Fish feel at home with people who are as emotional as they are, which makes this connection one that's somehow comforting and supportive for both. Nor does Pisces tend to back away if the Scorpio's mood darkens, since Fish are immensely tolerant of other's feelings and differences. What can cause issues for the Pisces, though, is when, or if, the Scorpion tries to dominate or control, since the Fish will find this behavior off-putting and may tend to withdraw. On the whole, though, Pisces are very adept at coping with Scorpio's power tactics and don't take them to heart. The long-enduring bond of Goldie Hawn (Scorpio) and Kurt Russell (Pisces) illustrates the upbeat quality of this combination.

Pisces will seek Scorpios out as friends because they sense that those born under this Pluto-ruled sign are as emotionally deep as they are. Pisces feels a great deal of sympathy for Scorpio, because Fish pick up on all the turbulent undercurrents raging beneath the Scorpion's controlled surface. What can be destructive to this connection, though, is the Scorpio's need to be in control and call the shots; if this happens, the Fish will swiftly swim off and make him- or herself scarce.

Pisces parents with a Scorpio child will tend to be sensitive and supportive of their little Scorpion in equal measure. Sensing all the passion and feeling the Scorpio often tries to hide, the Fish will wisely leave their little Scorpion alone when needed but will also come through when needed.

Pisces and **SAGITTARIUS** share a zany, free-spirited side that can bond them quite quickly. Attractions can quite easily spark up between these two, but they're often difficult to sustain. One problem for Pisces is that Sagittarius isn't an openly emotive sign— or at least not in way that Pisces understands. And Sagittarius' tendency to be breezy and independent can feel like a rejection to Pisces, even if it isn't mean that way at all. In short, as good as Pisces is at picking up signals, Sagittarius can be difficult for Fish to read. As a result, they may end up feeling hurt and may withdraw, throwing cold water onto the fire that they have initially aroused. In the end, these two may end up going off in different directions from each other, despite their good intentions to form a connection. Martin Scorsese (Sagittarius) and Julia Cameron (Pisces) were an example of this often tenuous pairing.

As friends, Pisces and Sagittarius can be companionable and close, although neither seems inclined to put a great deal of energy into the connection. Pisces sees Sagittarius

as a free spirit who really doesn't need anyone—least of all the Fish, who actually wants to feel needed. If for some reason, the Sagittarius does send out a message of wanting help of some kind, though, the Pisces will be quick to respond and will make a real effort to be caring and attentive.

A Pisces will generally be a very loving and supportive parent to the Sagittarius, and will greatly enjoy the bubbly spirit of this child. The Sagittarius' directness, though, can sometimes wound the Pisces parent, and he or she will sometimes feel as if this child doesn't need them enough.

Pisces and **CAPRICORN** may resonate together and can form a very strong tie. Pisces feels reassured and supported by Capricorn's down-to-earth approach to life and by Capricorn's protective way of showing attention to those around him or her. What can be a challenge in this connection is likely to be Pisces' dawning awareness that Capricorn sees the Fish as somewhat inept or unworldly—in short as someone who doesn't cope as well as the Goat tends to do. If the Capricorn assumes a superior or condescending attitude toward the Pisces, which can happen, the Pisces will eventually withdraw and become increasingly distant, although this will tend to occur over a period of time and be difficult to detect until the damage becomes impossible to repair. Richard Nixon (Capricorn) and Pat Nixon (Pisces) were an example of this bond.

Pisces and Capricorns can become very good friends, and both will usually benefit from the connection. Pisces appreciates Capricorn's sardonic sense of humor as well as the Goat's very practical way of doing things. Pisces also finds Capricorns to be sympathetic and supportive and feels strengthened by being in the Goat's presence. These two can work together well and lighten each other's moods, and their friendships will generally be long-lasting.

Pisces parents with a Capricorn child will usually find their little Goat admirable and easy to get along with. The Goat's inherent sense of responsibility tends to impress the Pisces parent, who will have a great deal of faith in this child's ability to cope.

Pisces often finds **AQUARIUS** highly sympathetic and may even identify someone born under this birth sign as a true "soul mate." Because these signs are close together, the positions of Venus and Mercury may dovetail in a particularly enhancing way, and when this happens, true compatibility will be the result. But the inherent differences between these signs may become problematic for the Pisces, since Aquarius' airy (intellectual) coolness contrasts sharply with Pisces' watery (emotional) nature. Pisces will tend to make allowance for Waterbearers, though, because those born under this sign are so often humanitarians and idealists—qualities that are extremely important to Fish and which they also possess. And while this connection may at times be difficult, it may also be one which has the power to last. Joanne Woodward (Pisces) and Paul Newman (Aquarius) were a happy example of this combination.

Pisces and Aquarius will often strike up friendships, and they will tend to be of an enduring nature. Pisces sees in Aquarius that he or she is also somehow "different" and more individual than most others, and this in itself can be the basis for a sympathetic bond. And although the Pisces may at times feel misunderstood by a Waterbearer friend, this is not something the Fish particularly takes to heart, finding a value in this bond based in shared ideals.

Pisces parents with an Aquarius child will generally be drawn to and genuinely like their little Waterbearer because he or she is such a distinct individual. While finding their Aquarius child a bit too independent, the Pisces will nonetheless give him or her space.

Two **PISCES** may bond quite strongly, but they generally don't couple up, since they don't find the balance or solidity in this connection that they're looking for. The problem is that they are just too alike—receptive, soft around the edges and hypersensitive. They may experience a strong attraction to each other initially, but there's a chance that it will never come to anything since neither is inclined to be the initiator. If these two do manage to forge a romantic bond, though, they can become quite intricately involved and be mutually supportive to each other. Examples of this connection are quite difficult to find.

Two Pisces can easily become friends and remain friends, because they do identify with each other and may also have interests in common. They often tend to enjoy similar pursuits, and their styles will be harmonious, so that they feel soothed and eased in each other's company. Another aspect of the friendship that might keep them tuned to each other will be the tendency to supply support and be there when needed, which is why their friendships usually last.

Pisces parents will naturally identify with their Pisces child, and the bond they form may be quite intense. The Pisces will be especially, even fiercely, protective of their little Fish, which can—in some instances—lead to an unhealthy dependence on the child's part.

COLORS, GEMS AND FRAGRANCES

As the very last sign of the zodiac, Pisces' color is the purple (touched with crimson) that's found at the end of the rainbow. It is indescribable in the same way that Pisces are...not quite this or that, but lovely, evocative and elusive, and it also seems iridescent, as if it's transparent and full of light. Pisces benefits from wearing colors in this range: they are vibration-raising and magical. Pisces also seem to favor pinks and blues (which

together make purple), and both these colors are right for them, as are all colors that mimic the sea: misty green, turquoise, blue/gray.

Soft colors fit Pisces' soft-around-the-edges nature, and dark or extremely vibrant colors generally don't (unless the Pisces in question has a great deal of the sign Aries in his or her chart). White attracts some Pisces, and I know one Pisces who will wear only that color. Black can sometimes draw Pisces, and it may suit certain moods and occasions, but red is so out of sync with Pisces that it rarely works at all on one born under this sensitive, absorbent sign.

There's a certain amount of debate about whether Pisces' birthstone is aquamarine or amethyst, but traditionally amethyst is associated with this birth sign and its color—violet—accords perfectly with the other colors associated with Pisces. What's more, the amethyst is known for its psychic attributes and for facilitating a connection between the earth and other planes and worlds, which is precisely what Pisces requires. Amethyst is also said to aid with lucid dreaming and with meditation. This is the perfect stone for Pisces to wear, because it's so entirely in harmony with the nature of this sign.

Aquamarine—known as the mermaid's stone—harmonizes with Pisces as well, and so does coral (being from the sea), blue lace agate, clear quartz and bloodstone. The opal is also thought to be a good stone for Pisces, due to its iridescent qualities, and so is clear quartz and turquoise.

When it comes to flowers, the lilac is very much under Pisces' influence, but Pisces' principle flower is often said to be the waterlily since it lives in water as does the Fish. And waterlilies do possess a certain evocative beauty that very much accords with this unique birth sign. Roses are also associated with Pisces—especially the white rose. The lotus is another flower connected to this birth sign, and so are the Amazon lily, cosmos and lavender, not to mention the poppy. Violets, too, can be considered to be associated with Pisces, because their color vibrates on the same wavelength.

The trees said to fall under Pisces' influence are the willow and the elm, and both these trees are considered to connect to the water element and to enhance psychic powers. As for Pisces' herbs, rose hips head the list; the high vitamin C content of this plant makes it particularly healing. And seaweed, so rich in nutrients like iodine, is also intimately connected to this watery sign. Other plants that fall under Pisces' jurisdiction are heliotrope—in Greek mythology, associated with a water nymph named Clytie who was turned into a flowering plant by a god, because she was heartbroken and suffering over an unrequited love.

Heliotrope is said to aid sleep and to evoke prophetic dreams. Chicory is also thought to be associated with Pisces, and so is sage, which is sometimes referred to as "blessed"

sage and was used in Native American ceremonies to clear negative energy from the air. Lavender, both the flower and the fragrance, is connected to Pisces and is known to freshen the air and to aid with sleep.

Pisces' best fragrances are lilac and lily, both of which are sweet and intoxicating at the same time. And perfumes that accord with Pisces' nature and vibrations often hold notes of ambergris, frangipani, gardenia and tuberose. ♓

Appendixes

Fig. 3

THE MOON

Fig. 1

Fig. 2

Biographies

KATHARINE MERLIN, a Libra with a Sagittarius Moon, has been fascinated by astrology since her early childhood and began her study with the magical and renowned Isabel Hickey of Boston at age nineteen.

She first started her practice in New York City in 1976, where she also studied analytical psychology at the Jung Institute.

Katharine has been writing the *Town&Country* Horoscope column since 1989 and authored *Town&Country Yearly Horoscope Guide*. She also penned the *Elle* horoscope column for four years beginning in 2001 and has published articles in numerous magazines including *Harper's Bazaar, Cosmopolitan, Self* and *the Ladies' Home Journal*. Katharine also wrote the book *Character and Fate, the Psychology of the Birth Chart*, (Penguin/Arkana). She lives in Rhode Island.

PAMELA FIORI is the former editor in chief of *Town&Country*, America's premier magazine for the elegant in America, a position she held for seventeen years. Before that, she was editor in chief of *Travel & Leisure* as well as editorial director for American Express Publishing. She is the co-author of *A Table at Le Cirque* (Rizzoli) and has also written *In the Spirit of Capri, In the Spirit of St. Barths, In the Spirit of Palm Beach, In the Spirit of Monte Carlo (Assouline)* and *Stolen Moments*, (Glitterati) based on the photography of Ronny Jaques.

Index

The various appearances of VENUS as she revolves round the SUN.

Mm

Acknowledgments

My heartfelt gratitude to Pamela Fiori—without her kindness and support this book simply wouldn't have happened and to Marta Hallett, whose vision and fiery spirit spurred me on my way. My dear friend Melanie Griffin's enthusiasm and boundless optimism also helped to carry me though the long days of writing, as did my sister Joan Merlin Palmer's unending support.

I am also eternally grateful to the late Isabel Hickey, who opened up a new world of understanding and inspiration to me.

Magnitudes of the Stars.